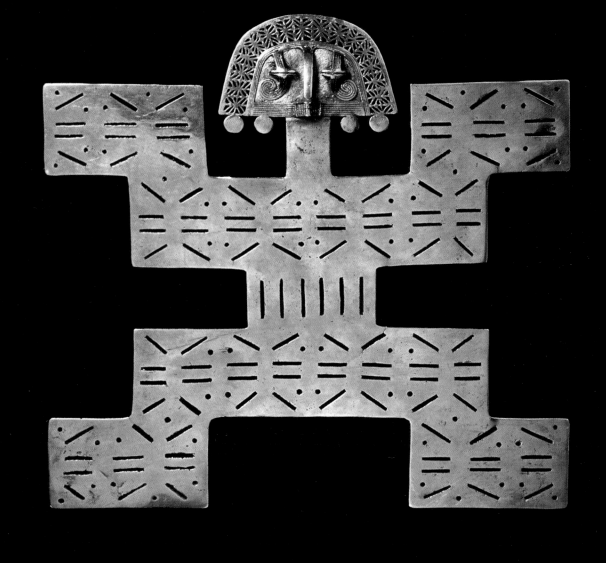

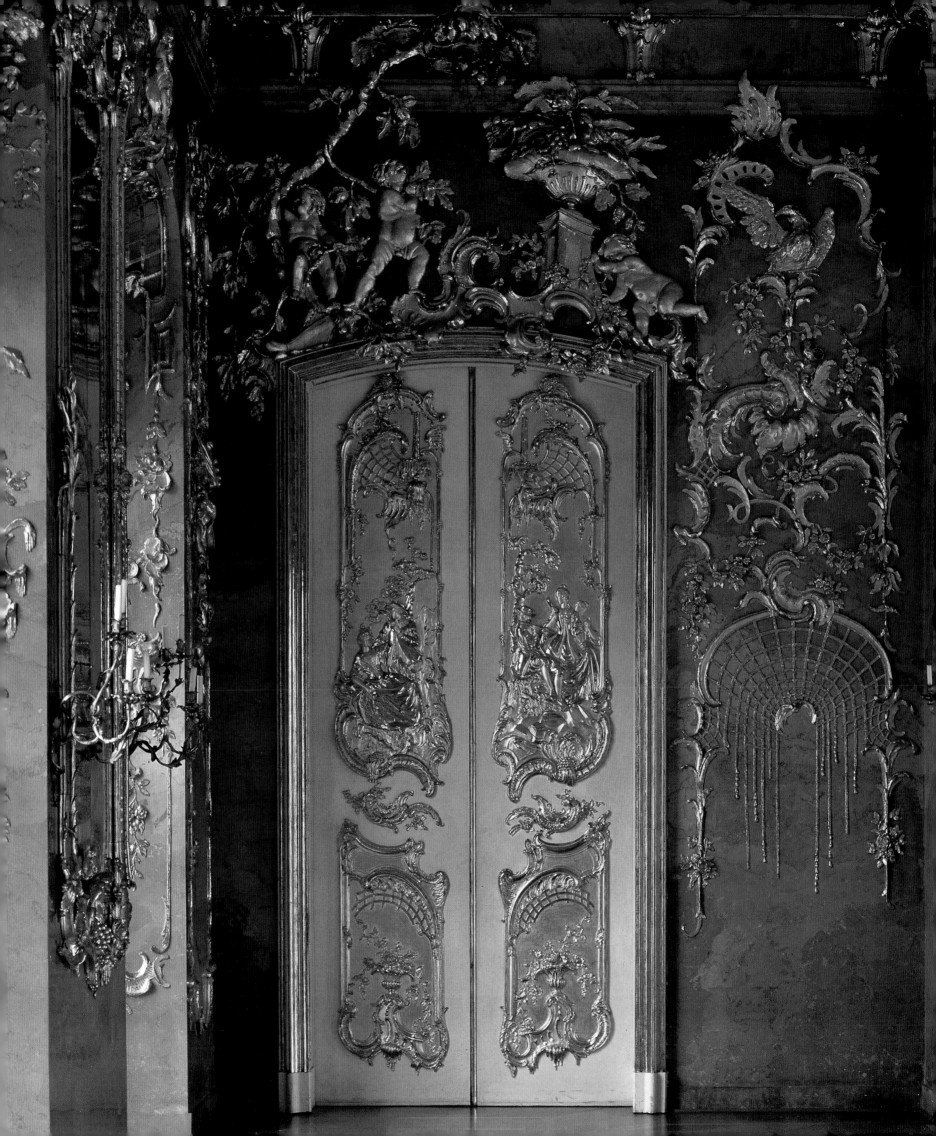

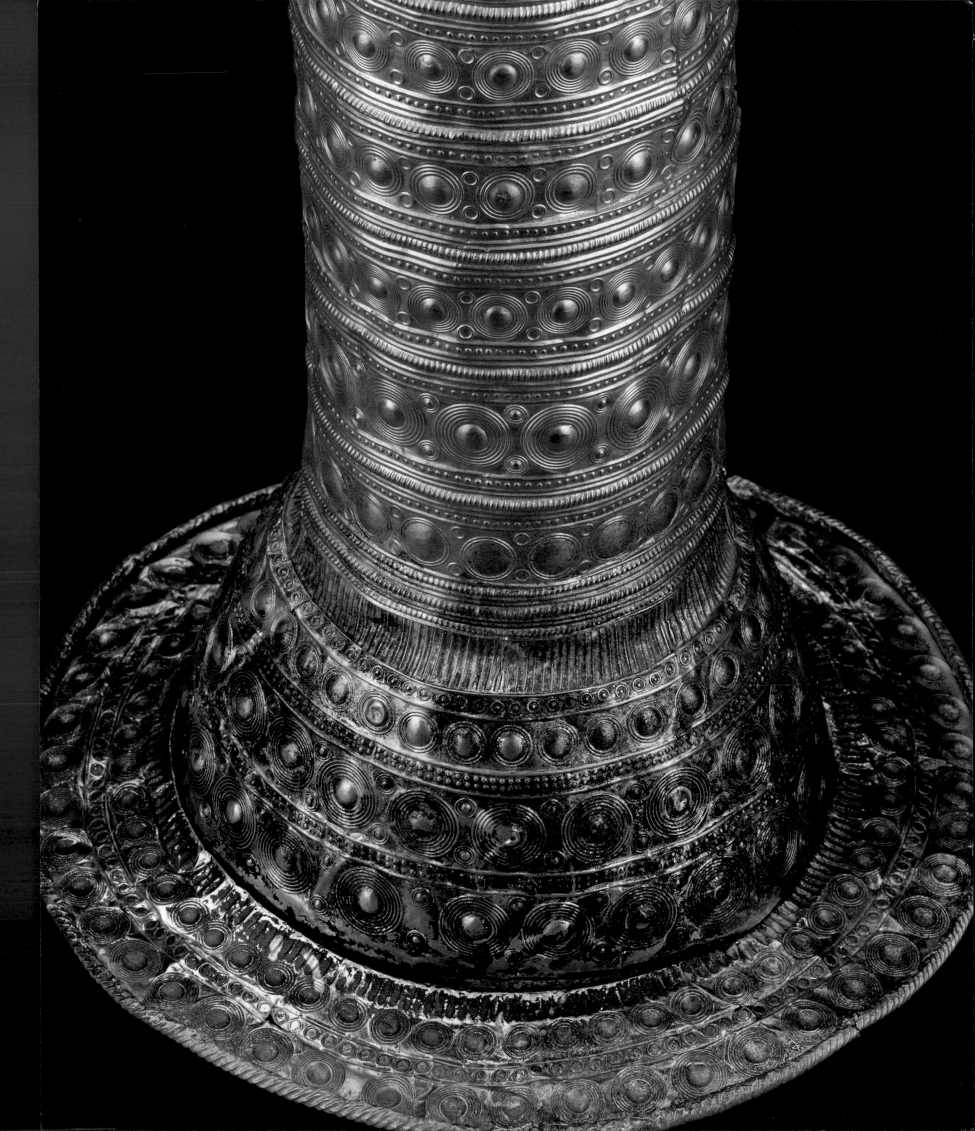

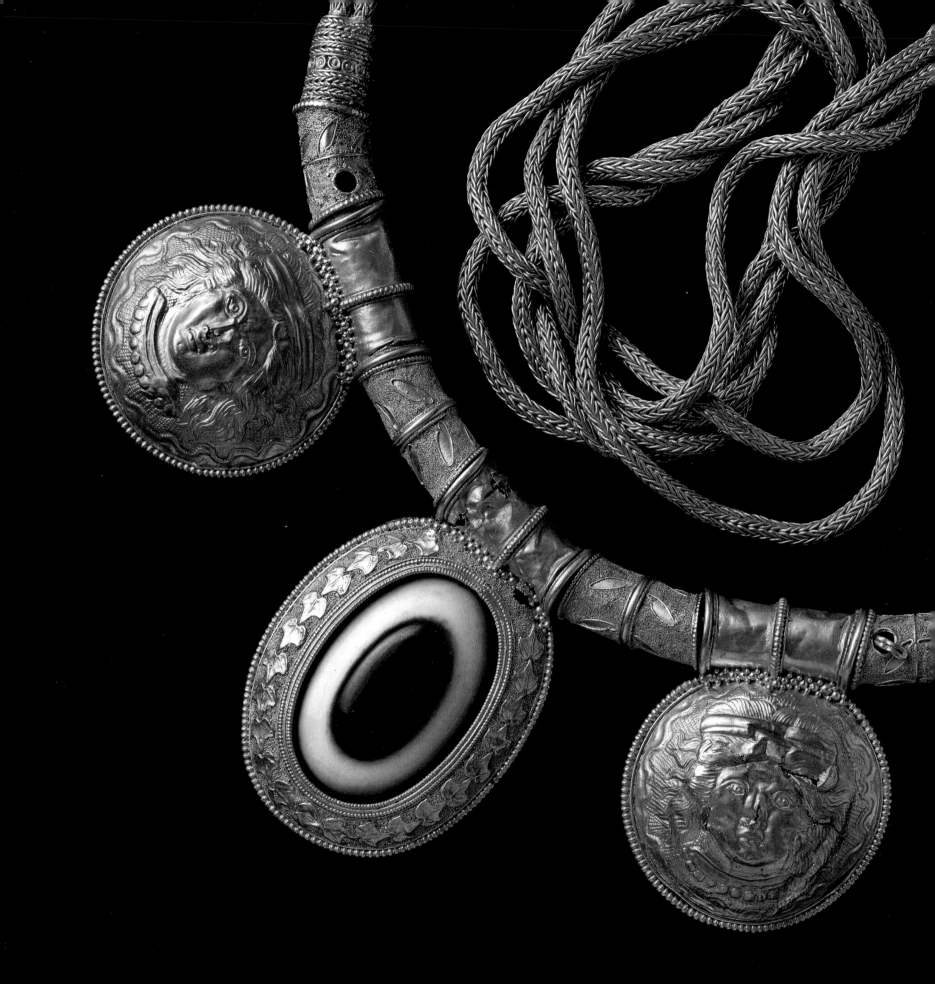

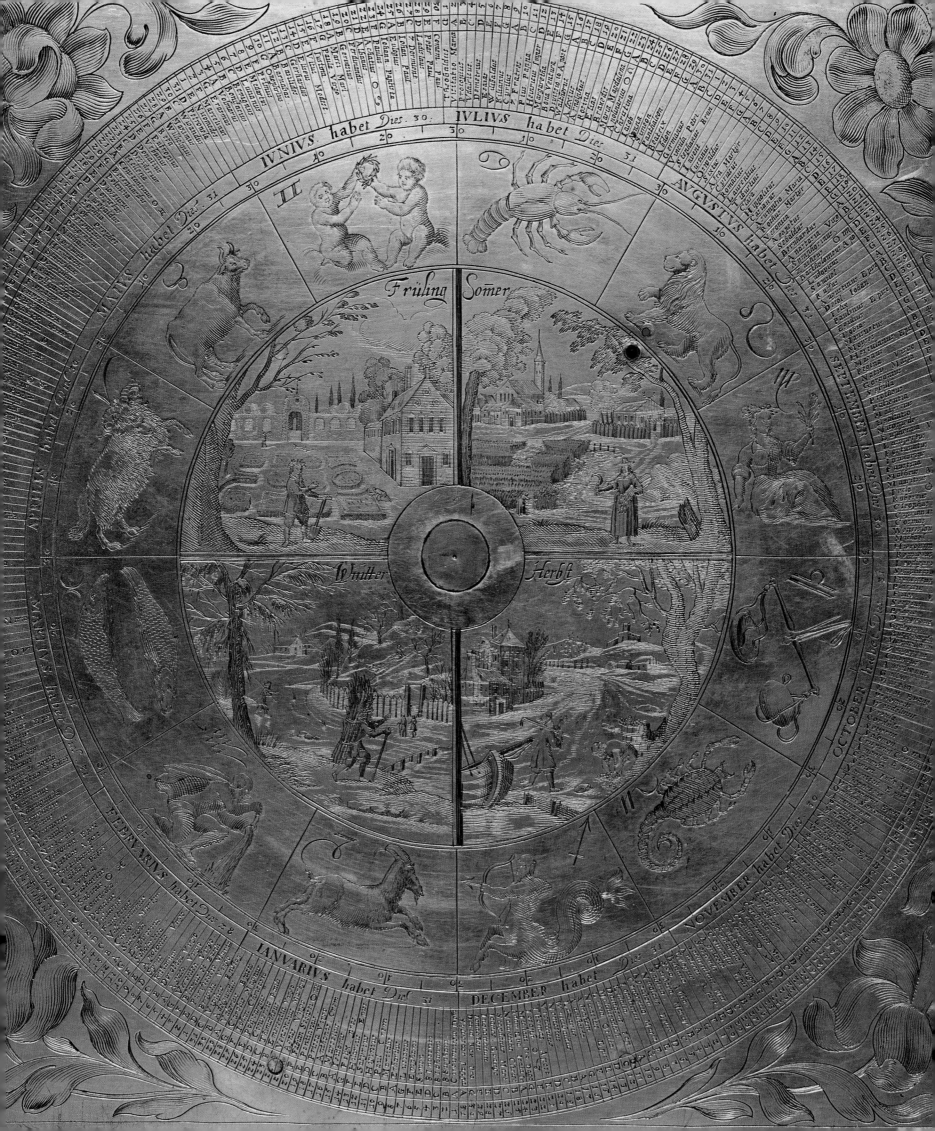

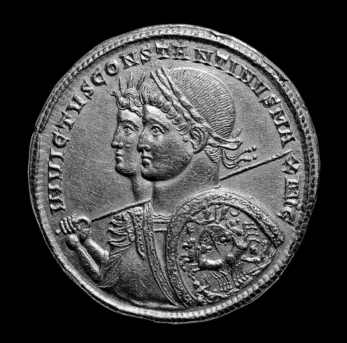

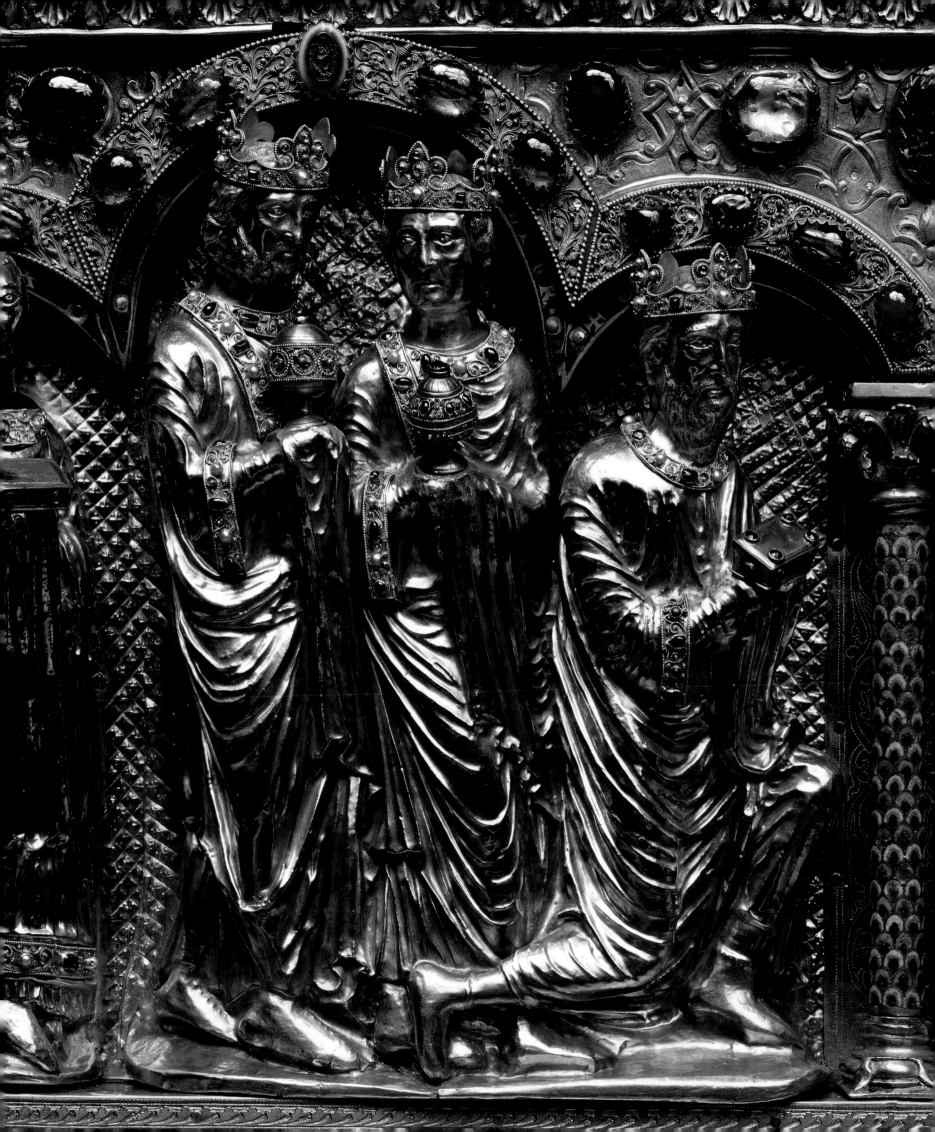

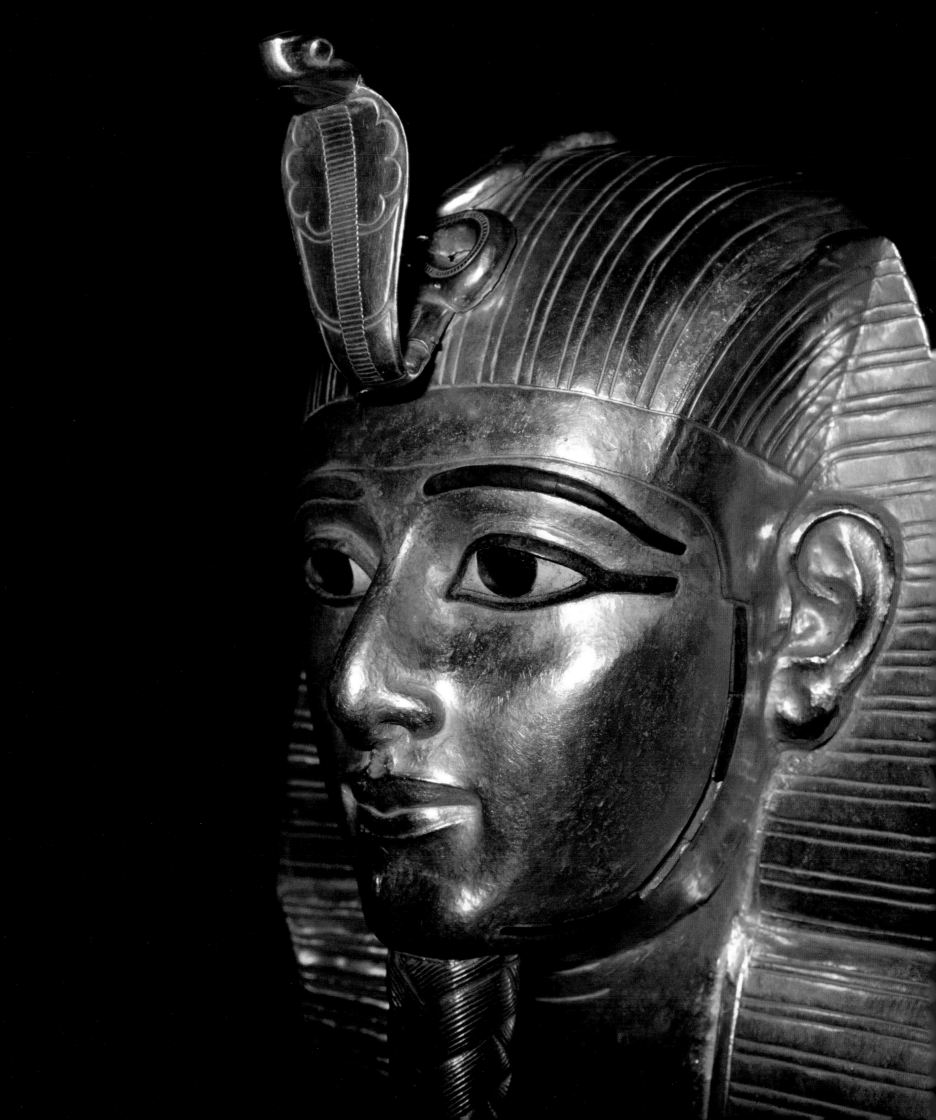

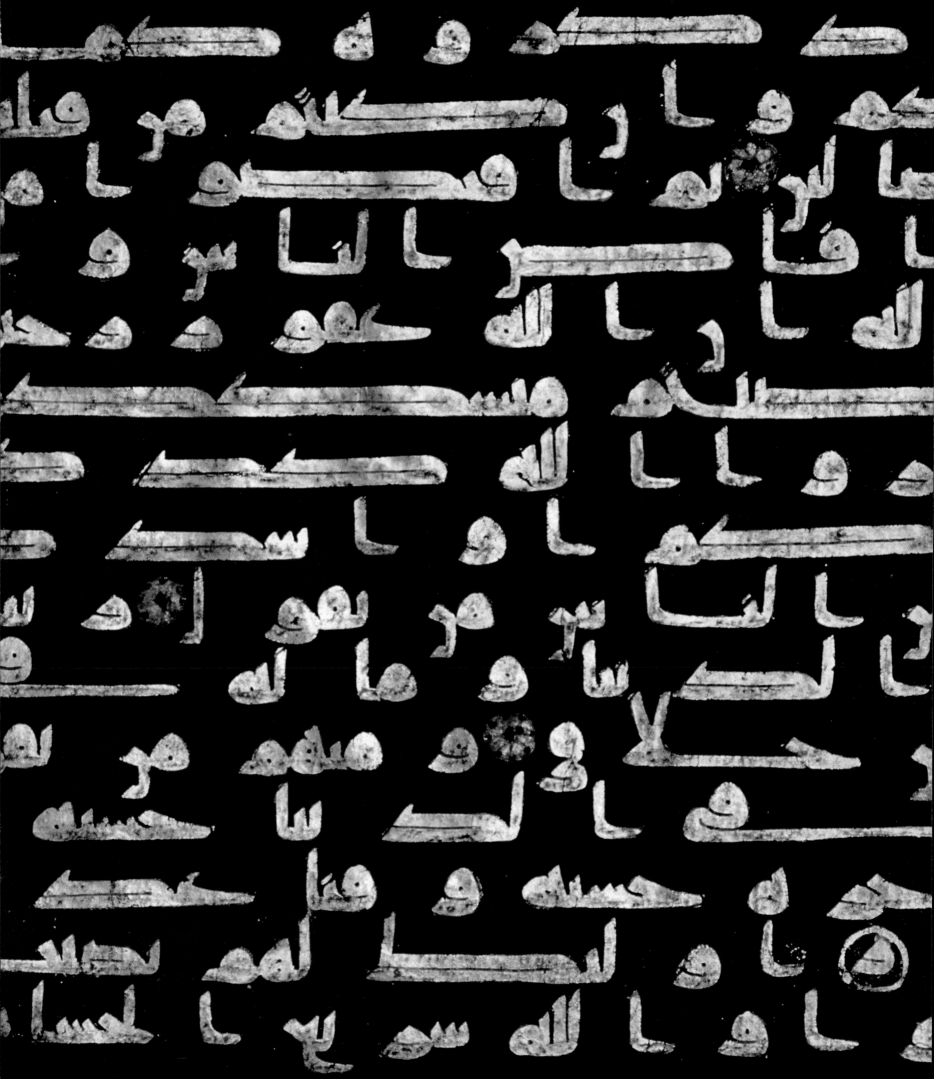

AN ARTISTIC
AND CULTURAL HISTORY

HANS-GERT BACHMANN

With a contribution by Jörg Völlnagel

Translated by Steven Lindberg

THE LURE

ABBEVILLE PRESS PUBLISHERS

New York London

OF GOLD

Chapter 17, "The Modern Age," was written by Jörg Völlnagel.

FOR THE ORIGINAL EDITION
Concept and editorial direction: Kerstin Ludolph
Picture editing: Karen Angne
Production: Peter Grassinger

FOR THE ENGLISH-LANGUAGE EDITION
Editor: David Fabricant
Copy editor: Ashley Benning
Proofreader: Marian Appellof
Production manager: Louise Kurtz
Composition: Robert Weisberg
Jacket design and typography: Misha Beletsky

First edition
10 9 8 7 6 5 4 3 2 1

ISBN 13: 978-0-7892-0900-9
ISBN 10: 0-7892-0900-4

Library of Congress
Cataloging-in-Publication Data

Bachmann, H. G.
 The lure of gold : an artistic and cultural history /
by Hans-Gert Bachmann.
 p. cm.
 Includes bibliographical references and index.
 ISBN-13: 978-0-7892-0900-9 (alk. paper)
 1. Gold in art—History. 2. Gold—Social aspects.
 3. Gold—Economic aspects. I. Title.

 N8217.G6B33 2006
 704.94'97392—DC22
 2006013685

For bulk and premium sales and for text adoption procedures, write to Customer Service Manager, Abbeville Press, Inc., 137 Varick Street, New York, NY 10013, or call 1-800-ARTBOOK.

FRONT COVER: Tutankhamun with harpoon, Thebes West, Valley of the Kings, tomb of Tutankhamun, New Kingdom, Eighteenth Dynasty, 1334–1325 BC; gilded wood, sandals, harpoon, rope, and asp of bronze. Egyptian Museum, Cairo (see plate 49).

BACK COVER: Benvenuto Cellini, *Saliera*, 1540–43; gold, enamel, ivory, ebony base, 10¼ × 13³⁄₁₆ in. (26 × 33.5 cm). Kunsthistorisches Museum, Vienna (see plate 246).

1. Pectoral, Tolima culture, Colombia, AD 1–500; sheet gold, height: 9³⁄₁₆ in. (23.4 cm), width: 10⅛ in. (25.7 cm). Museo del Oro, Bogotá.
This flying shaman—a hybrid of man and beast—is crowned with a semicircular headdress. A fantastic, mysterious creature, it probably functioned as an apotropaic amulet for the person who wore it; its lasting value came from the use of gold.

2. Golden Gallery, partial view of the east wall, north door, Charlottenburg Palace, Berlin; built 1740–46 by Georg Wenzeslaus von Knobelsdorff, with stucco ornaments by Johann August Nahl.
The virtuoso stuccowork that characterized the Baroque and Rococo periods was often accented with lavish gilding. This should not be misunderstood, however: the material value of the gold leaf was relatively minor, and the art of skillfully applying it should be judged far more important.

3. Detail of a writing box with matching desk, Japan, c. 1700; decorated using a variety of techniques for applying gold, as well as silver and gold inlay, 2¹⁄₁₆ × 8⅞ × 9¹⁵⁄₁₆ in. (5.3 × 22.6 × 25.2 cm). Museum für Lackkunst, Münster, Germany.
Among the typical products of Japanese artisans are lacquerware, of which writing boxes (suzuribako), pendants, etuis, and furniture with gold lacquer (kinji) from the Tokugawa shogunate (late sixteenth to mid-nineteenth century) are particularly esteemed. Flat applications of gold powder lacquer (hiramakie) with grainy scattered gold were frequently combined with relief lacquer (takamakie), which brings out delicate contours especially well.

4. Ceremonial hat, the so-called golden hat of Berlin, detail of plate 40, probably found in southern Germany, late Bronze Age, 1000–800 BC; sheet gold, chased and decorated with circular ornaments, height: 29⅛ in. (74 cm), diameter: 4¹⁵⁄₁₆ in. (12.5 cm). Museum für Vor- und Frühgeschichte, Staatliche Museen zu Berlin.
This hat, purchased on the art market in 1996, is a hollow body shaped like a sugarloaf, with a narrow brim; it is made of sheet gold that has been hammered very thin. The brim is reinforced with wrapped, twisted bronze wire; where it is not covered with sheet gold, a green crust of decomposition can be seen.

5. Gold necklace, Etruscan, Todi, Italy, fifth to third century BC; length: 21⅝ in. (55 cm). Museo di Villa Giulia, Rome.
The Etruscans, masters of the goldsmith's art, were not only skilled artisans but also artists who were well aware of the effect of combining gold with semiprecious and colored stones. Their creations are not subject to fashion and are as elegant today as they were twenty-five hundred years ago.

6. Perpetual wall calendar with six adjustable concentric circles, Augsburg, c. 1670; bronze, engraved and gilded, diameter: 10⅞ in. (27.7 cm). Städtische Kunstgewerbesammlung, Bielefeld, Germany; Stiftung Huelsmann.
This disk, designed with great precision and a masterly use of space, was probably intended as a calendar for astronomers. In order to give the surface with the astrological signs, seasons, and engraved numbers a lasting luster, the engraver chose a durable and permanent gilding.

7/8. Medallion worth nine *solidi*, obverse: Constantine I and Sol, reverse: the emperor on horseback, Ticinum mint, Pavia, Italy, AD 313; gold, diameter: 1⁹⁄₁₆ in. (4 cm), weight: c. 1¾ oz. (50 g). Cabinet des Médailles, Paris.
This unique gold coin was minted on the occasion of the Milan Edict of Tolerance, which ensured Christians the right to practice their religion freely in the areas ruled by the emperors of Western and Eastern Rome; it was not used as currency but as a special memento. It shows Constantine, the Maximus Augustus, accompanied on the front by the sun god as a tutelary god. This suggests that the emperor was not yet exclusively Christian in his orientation.

9. Nicholas of Verdun and workshop, *Dreikönigsschrein* (Shrine of the Three Kings), detail of plate 235 showing the Adoration of the Magi, c. 1181–1230; gold and gilded silver, copper, and bronze on an oak core, with precious stones and gems, filigree, cloisonné, champlevé, and émail brun, 60¼ × 43⁵⁄₁₆ × 86⅝ in. (153 × 110 × 220 cm). Cologne Cathedral.
The front face of the largest, most splendid, and figurally elaborate shrine of the Middle Ages shows the figures of the three Magi kneeling before the Virgin and Child beneath a depiction of Christ as judge of the world. This wall of the shrine is pure gold, whereas the other walls are gilded bronze. The chasing of the nearly three-dimensional figures called for sheet gold of considerable thickness and a technique that only certain masters commanded.

10. Gold mask of Psusennes I, Tanis, Egypt, royal tomb chambers, Third Intermediate Period, Twenty-first Dynasty, 1039–991 BC; height: 18⅞ in. (48 cm). Egyptian Museum, Cairo.
The gold mask of Psusennes I is approximately four hundred years younger than that of Tutankhamun. The workmanship is outstanding, and it shows that gold played the same role in the cult of the dead and the deification of pharaohs throughout that period.

11. Page from a manuscript of the Koran in the colors of heaven, Kairouan, Tunisia, ninth century AD; Kufic script in gold on blue silk. Collection of Mrs. Bashir Mohammed, London.
Islam's sparing use of gold did not prevent calligraphers from employing the most expensive material available to them for copies of the Koran. This splendid handwriting in gold script on blue silk is an outstanding example of early Islamic calligraphy, whose practitioners knew how to combine gold ink and background to produce a declaration of faith.

12. Hermann Jünger, brooch, 1995; gold, 1¾ × 1¹¹⁄₁₆ in. (4.5 × 4.3 cm). Schmuckmuseum, Pforzheim, Germany.
Jünger has combined the individual elements on the nearly square base of his gold brooch as if in a coded system of signs. In his late work he thus moved away from the more playful, colorful, and often figural forms of his early work (e.g., plate 286).

Contents

Introduction: Six Millennia of Gold

The Copper, Bronze, and Iron Ages are established terms in human history—they refer concretely to the metals that were characteristic of the given historical period. By contrast, "golden ages" or "golden times" only ever truly existed in the imagination—as expectations or idealizing memories attached symbolically to a mythic metal that represented power, and to which magical significance and supernatural powers were attributed. The fascination that the yellow precious metal inspired has not diminished over millennia, and the symbolism associated with it has been the same across cultures and epochs: gold stands for the divine, the royal, the powerful, for the sun, light, and purity. Even as cultures have changed in response to economic, social, and intellectual revolutions, certain ideas have remained the same. The privilege that reserved gold above all for rulers, gods, and saints may have disappeared in the present, and it may have become a commodity available to all, but it has lost none of its timeless allure in the process. People today are attached not so much to the magic as to the beauty of the metal and its yellow gleam, which is why three-quarters of the world's production of gold is used for jewelry to provide pleasure and display status.

Gold is a rare, valuable metal, but the high regard in which it is held is not based on that alone. It is immortal in that it resists corrosion. In human consciousness it has thus been associated with those other symbols of the permanent, the eternal, and the supernatural: the gods in early conceptions of spirituality and the beyond and the omnipotence of God in the monotheistic religions. For the god-kings of Egypt, gold was the flesh of the immortals. *El Dorado*, the gilded one, was the Colombian name for a ruler considered the equal of the sun, who was coated with mud and dusted with gold to make him the visible personification of the beliefs and ideas of his subjects. The apostate Israelites danced around Aaron's golden calf. Every Bible concordance has a reference to the gold-covered columns of the temple that Solomon built.

Gold was such a desirable, valuable gift that from the Middle Ages to the early modern period alchemists attempted to transform base metals into "pure" gold by means of mysterious, mystical operations. Gold became the symbol of the sun, silver of the moon. Tracing the noun "gold" and the adjective "golden" through literature could become a life's work. The metal has always had a place in language as the epitome of the beautiful, the noble, the unique.

13. Flakes of gold from the Olt River (Valea Oltului) in the Carpathian Mountains, Transylvania. Museum of Gold, Brad, Romania.

Placer or alluvial gold can take rather different forms in terms of both size and the ratio of gold to silver. The spectrum ranges from pinpoint-size particles to small flakes or grains with diameters as large as an eighth of an inch (several millimeters), and from 50 percent to nearly pure gold.

 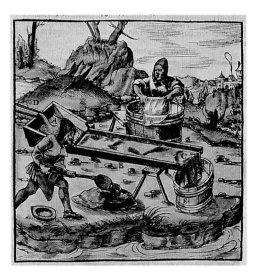

14/15. *The Expedition of the Argonauts* and *Washing to Extract Placer Gold from Riverbed Sand*, from Georgius Agricola, *De re metallica*, Basel, 1556; hand-colored woodcuts. Bibliothek der Technischen Universität und Bergakademie, Freiberg, Saxony, Germany.

On the left, in the outlet of a spring, near the beached Argo, *is the Golden Fleece, a ram's fleece, including horns, in which gold flakes are caught. The illustration on the right shows a wooden sluice lined with cloth into which a miner is shoveling gold-bearing sand. Flowing water removes the lighter particles of stone, while the gold clings to the cloth. In the background, a woman is washing a cloth with gold flakes in a tub, in which the gold particles will sink to the bottom.*

The curse of gold and the greed for it have also become proverbial. Virgil spoke of the "auri sacra fames," the sacred hunger for gold. Even an ancient author as sober and as concerned with facts as Pliny the Elder (AD 23–79) remarked in the thirty-third book of his *Natural History*, "O if only gold could be completely removed from life," which did not stop him from paying it respect as something special. The English political economist John Maynard Keynes (1883–1946) called gold a "barbarous" metal, and he was well aware that during the nineteenth century people from all countries streamed to the United States, Canada, and Australia in the hope of quick riches when they heard the news of sensational finds of gold.

JASON AND THE ARGONAUTS: A MYTH OF GOLD'S ORIGINS

Until the early modern age, people had no idea how metal was formed or where it was most likely to be found. Diviners claimed to be able to search out both veins of water and metal deposits. Myths, sagas, and legends invoked the actions of the gods or mysterious powers to account for the existence of deposits. Pliny mentions, among other tales, that the Scythians believed that griffins had brought gold from unknown distant lands. For the Greeks, the tale of the Argonauts was an allegory of divine intervention in the discovery and extraction of the noble metal. The hero Jason was given the task of finding the Golden Fleece, a ram's fleece filled with gold glitter that lay in a gold-bearing stream and was guarded by a dragon. To help him accomplish this mission, the goddess Athena directed that the ship *Argo*, after which the Argonauts were named, be built and sailed to Colchis, a coastal area on the eastern Black Sea. There, the reigning king, Aetes, promised Jason the Golden Fleece on the condition that he perform several tasks first. The hero fulfilled them, with the help of Medea, Aetes' daughter, but the untrustworthy king refused to hand over the Golden Fleece and instead tried to kill the Argonauts. Medea then put to sleep the dragon who guarded the fleece, so that Jason could seize it. He

and the Argonauts quickly boarded their ship and sailed away. The presence of gold in the sand of rivers, the associated tale of the Argonauts, and the extraction of gold glitter caught in the coats of animals long held a place in the human imagination, which is why Georgius Agricola (1494–1555) illustrated the Argonauts in his book *De re metallica* of 1556 (plate 14).

GOLD DEPOSITS AND GOLD MINING

Gold is in fact a widespread element in nature, though it is found only in limited concentrations. It makes up one part in five hundred million of the earth's crust—silver is fifteen times and copper a million times more common. These statistics tell us little, however, because they do not take into account local deposits.

Apart from seawater, which contains such extremely small traces of gold that it cannot be extracted economically—just thirty billionths of an ounce per gallon (0.02 mg per m³)—gold is accumulated in primary and secondary deposits on the land (plate 20). Primary deposits are solid stone or veins of ore that contain gold, whereas secondary deposits consist primarily of so-called placers, which result from the disintegration of gold-bearing stone and the deposition of the gold as sediment in water (plate 13). Placers can be either loose deposits (recent placers) or stable, geologically older formations (fossil placers). Although it is usually found as dust, flakes, or grains, placer gold is occasionally found in larger clumps called *nuggets* (plate 16), which are very rare but can be quite large. In the nineteenth century a gold nugget supposedly weighing 2,975 pounds (1,350 kg) was found in the West Indies; it must have been about the size of a small chest of drawers. Australia has also boasted record nuggets of 193 pounds 6 ounces (87.74 kg) and 149 pounds 14 ounces (68 kg). Numerous rivers on all the continents have sometimes more, sometimes less gold.

It can pay to mine placers with as little as 0.02 ounces of gold per ton of sand (0.5 g/MT). The oldest method for extracting gold, washing, is based on gravity—that is, the specific gravity of gold, which, at around 19 grams (0.67 oz.) per cubic centimeter (0.061 in.³), is high in comparison to that of the materials with which it is found, like sand, which has a specific gravity of about 2.7 grams (0.095 oz.) per cubic centimeter. Using everything from panning dishes and simple sluice boxes to modern extracting equipment, gold has been separated out of promising areas from time immemorial in both small- and large-scale operations. Simple extraction methods—like those described and illustrated by Agricola (plate 15)—have hardly changed at all since the premodern and early modern periods. Even today, 20 to 25 percent of world gold production is based on simple methods of separation by gravity. The washing of river gravel and sand is practiced not only by amateur mineral hunters and collectors but also by professionals in Indonesia, Brazil, and other countries. Sometimes the yield is lucrative, which can lead to headline-producing gold rushes. Until the middle of the eighteenth century there was gold washing on many

16. Gold nugget, found in Melbourne, southern Australia; height: c. 2⅜ in. (6 cm), weight: 8¼ oz. (234 g). Private collection.
Finding a gold nugget has always been the dream of gold seekers and washers, but it seldom happens. A small gold clump or even a large aggregate is far more valuable than just the weight of its gold, for rarity and collector's value come into play as well.

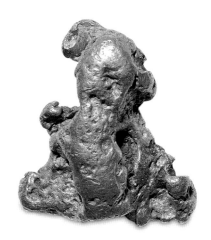

17. Ducat of Rhine gold, reverse: view of the
city of Mannheim with the silhouette of the
castle and, in the foreground, the Rhine
with four gold washers on its banks, minted
in 1767 by Elector Karl Theodor of the
Palatinate; diameter: ¹³/₁₆ in. (2.1 cm),
weight: ¹/₁₀ oz. (3.25 g). Private collection.
 *The amount of precious metals in a river
depends on which mountains it passes through,
and which products of erosion from those
mountains it transports. In the Rhine,
particularly in the eighteenth and nineteenth
centuries, there was gold washing on the stretch
between Darmstadt and Basel. The small yields
were highly esteemed, and sovereigns minted
commemorative coins from them.*

riverbanks, including those of the Rhine. Ducats of Rhine gold were
minted for Elector Karl Theodor of the Palatinate, whose residence was in
Mannheim (plate 17).

Because placers are the product of the disintegration of primary de-
posits, gold in solid stone has often been located by following the course of
rivers and streams and constantly measuring how much placer gold their
sediment contained. An increase in the gold content of the placer was a sure
sign that one was getting closer to gold-bearing rock formations. Primary
deposits of gold can develop in various ways and can be found in a wide
variety of stones of different geological ages. Gold in quartz veins, com-
monly known as hard-rock gold deposits, is particularly widespread
(plates 18, 19). It is considerably more difficult to extract than placer gold,
requiring both mining techniques and experience in underground excava-
tion. That is also true, however, of hard, fossilized placers, which can be lo-
cated at a considerable depth, as they are in South Africa. The gold particles
have to be freed from the extracted hard ore by pounding and grinding.

Mining gold ore requires planning and organization. It also requires the
use of many trained laborers. The exploitation of slaves and prisoners in gold
mines has rightly been denounced, but even with forced labor efficient extrac-
tion was possible only when experienced foremen and expert miners super-
vised and took responsibility. Providing for so many people and supplying
necessities like wood and water called for practiced logistics, so in antiquity
the mining of hard-rock gold deposits on a large scale was undertaken only
by empires that had that kind of organization, like Egypt and Rome.

The purely mechanical separation of the valuable metal from the ac-
companying stone was already being replaced in Roman times, according
to Vitruvius (first century AD), by the process of amalgamation, in which
the gold particles are compounded with mercury to form a gold amalgam.
The gold thus forms a solid bond with the mercury, while the particles of
stone and sand float in the liquid mercury, because they do not react with
it, and can be skimmed off. The excess mercury is separated from the gold
amalgam by pressing the mixture through a solid cloth or goatskin. The
mercury passes through in droplets, but the gold amalgam remains be-
hind as a waxlike mass. When heated, the mercury evaporates and pure
gold is left behind in the form of a mustard-colored powder. Even today
this process is the method of choice for small or family operations in newly
industrialized and developing countries, despite the health risks posed by
the poisonous fumes.

The most important high-technology method for extracting gold is only
about a century old; it involves leaching gold-bearing ore with diluted
cyanide solutions (plate 22). Without this process, which is employed
worldwide, modern gold production would not be cost-effective. Many
variations of this method have been developed in the meantime, differing
mainly in how the precious metal is precipitated. The use of cyanide, which
is extremely poisonous, means that mine operators have to maintain con-
stant conscientious control and ensure that wastewater from the mines is
completely decontaminated.

A third type of gold deposit is the so-called refractory ores, minerals that have gold atoms built into their crystal structures or that contain the metal in tiny cracks, crevices, and fissures. Such gold cannot be isolated by the usual methods (gravity or treatments with mercury or chemicals). The ore has to be pretreated, by roasting, for example. This destroys the minerals and liberates the gold they contain, thus allowing it to be extracted by the methods described above. It was generally thought that such deposits became significant only in the modern age, but a few years ago archaeologists discovered a Roman gold mine in northern Portugal in which the metal was clearly extracted from refractory gold ores. Hence this type of deposit already played a role in antiquity.

The Geography of Gold Deposits: A Historical Overview

Gold deposits and placers have been worked at various times in nearly all parts of the world—that was true in the past and remains true today. The places that continued to produce gold over long periods have now, for the most part, been exploited and forgotten. However, some secondary deposits that were thought to have been exhausted have "regenerated"— that is, they have been enriched again by the constant erosion of primary deposits (often stones with low concentrations of gold).

The gold used in the prehistoric and early historical periods sometimes came from local deposits and sometimes followed trade routes to storerooms and workshops. Gold, which was known from the fifth millennium BC, was an important trading commodity for early advanced cultures. The textual documentation is sparse, however, and most of it indicates only the excavation figures. Tomb paintings in Thebes and descriptions by Agatharchides of Cnidus (second century BC) have provided us with some details on how gold was extracted by the Egyptians in the Old, Middle, and New Kingdoms. The Bible mentions large reserves of gold stockpiled by

18. Quartz with veins of gold from Valea Morii, Transylvania. Museum of Gold, Brad, Romania.
Gold ore—that is, gold extracted by mining— is commonly found mixed together with quartz. Often it is so fine, or so well distributed in the stone, that it is not visible to the naked eye. To separate it from the accompanying impurities, the gold ore must first be ground and then the gold isolated from the powdered stone; the simplest and oldest method is washing with water.

19. Gold crystals in flake form on quartz from the Hondol mine, near Certje, Transylvania. Museum of Gold, Brad, Romania.
Geologists and miners are constantly surprised at the various forms that gold can take in nature. Gold flakes and crystals are, however, the exception, for gold is often found in quantities that can be detected only by sensitive analytical procedures.

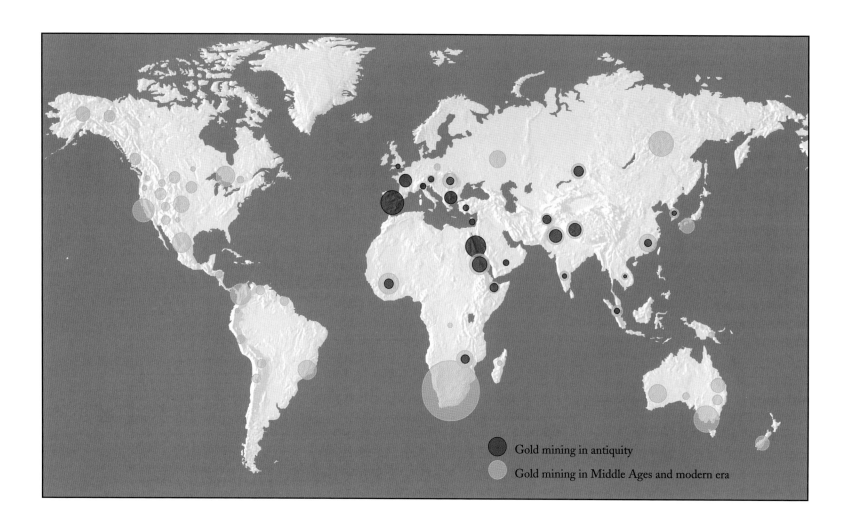

Gold mining in antiquity

Gold mining in Middle Ages and modern era

20. Map of the world's most important gold deposits.

This map shows the main regions where gold mines have been operated in antiquity, in the Middle Ages, and up to the present. Gold washed from rivers, streams, and beaches—one of the primary sources—is included only when the placer gold deposits are of more than local significance.

Kings Solomon and David; this gold came from the land of Ophir, which is said to have been located between Zanzibar and present-day Zimbabwe. Herodotus, Diodorus, Plutarch, and other ancient authors report on the gold treasures of Babylon, Nineveh, and Persepolis, which could have been imported from either India or Asia Minor (its west coast, which belonged to the Lydian kingdom). According to Herodotus (484–after 430 BC), the yellow metal was already being extracted in the Ural and the Altai Mountains in antiquity. The Greeks obtained their gold from Phoenician traders, who got it in turn from Thrace, Bithynia, Thessaly, Cyprus, and the Cycladic island Siphnos. In recent years, the first discoveries of rich gold offerings in Scythian burial mounds (*kurgans*), and the possibility that they were produced by Greek artisans, have suggested that the myth of the Argonauts may have had a contemporary basis: the coast of Colchis lies in present-day Georgia, whose rich deposits of gold were being exploited, as was recently demonstrated, as early as the second millennium BC and are once again the object of exploration and development. The Romans mined gold deposits in Spain (Asturia and Lusitania) and in the Balkans, and Caesar brought lavish spoils from Gaul back to Rome. The Gauls in turn not only extracted placer gold but also operated underground mines.

In the Middle Ages, Bohemia, Hungary, Transylvania, Moravia, the Salzburg countryside (Rauris), and Carinthia were known as sources of gold. Small local deposits and gold-washing sites were found in many other places, and in many countries they provided modest quantities of the valuable metal. When Marco Polo dictated his experiences at the court of Kublai Khan in 1299, he also mentioned Cipango, present-day Japan. He did not go there himself, but he that said enthusiastically that the country had gold in abundance, which the Portuguese and Dutch later confirmed when they brought considerable quantities of it back to Europe from Japan in the sixteenth and seventeenth centuries.

In the early modern age the need for gold increased, and so did the search for new resources of the precious metal. Spain was able to import gold to the motherland from Central and South America after its campaigns of conquest, but the hope for genuine mining of gold in the new colonies was never fulfilled (plate 21): all the gold that reached Spain had been stolen. Only in the early seventeenth century did Brazil emerge as an important source of gold in South America, but its production peaked in the eighteenth century.

In the middle of the eighteenth century, Russia became an important producer of gold for the world market, thanks to deposits in eastern Siberia. In the mid-nineteenth century, California, Nevada, Canada, Australia, and Africa joined the ranks of gold-producing regions. The list of important gold-producing countries today includes, in order of significance, South Africa, the United States, Australia, China, Indonesia, Canada, the former Soviet Union (the CIS states), Peru, Ghana, Papua New Guinea, and several others of lesser importance.

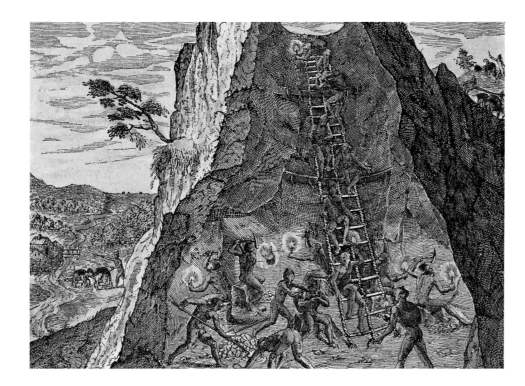

21. Theodor de Bry, *Indian Gold Mine*, 1596; engraving.
 This depiction of an underground gold mine in South America, from de Bry's Historia Americae sive Novi Orbis *(History of America, or the New World), is based on the artist's creative imagination, for gold there was extracted overwhelmingly from alluvial placers.*

22. Crystals of fine gold; weight: 1/16 oz. (2 g),
purity: 99.99 percent.

*This so-called four-nine gold was extracted
by electrolytic precipitation from cyanide solutions
with gold. All of the impurities remain in the
solution, so that the precious metal extracted is
of the highest purity and has the unmistakable
reddish-yellow color of pure gold.*

REFINING AND ASSAYING GOLD

Gold does not occur in nature in pure form, though placer gold is sometimes found at 98 percent purity. Placer gold is often purer— that is, has less silver—than gold from hard-rock deposits. Silver, the metal that most commonly and regularly accompanies gold, makes up as much as 50 percent of native gold. The Greeks called such "pale" gold electrum. Other impurities found in gold include copper, platinum, iron, and several heavy metals such as galena and chalcopyrite. Although copper is often alloyed with gold and silver, it plays an insignificant role as a natural impurity in gold, as native gold never contains more than 3 percent copper, and usually much less.

Melting can be used to remove from gold certain impurities, which can be separated out as a slag crust and extracted from the melt. It is not possible to separate gold and silver by this method, however. One process for removing the silver from gold was evidently mastered by the second or even the third millennium BC, as early gold artifacts found, for example, in the royal tombs of Ur in Mesopotamia are clearly artificial alloys of gold, silver, and copper. The process used to achieve this has been documented in archaeological finds and ancient texts. Grains or sheets of natural gold containing silver would be hammered flat and then layered with salt and an absorbent additive like brick dust or firebrick in a porous crucible. The vessel would be heated for several hours, carefully maintained under the melting point of gold. The silver contained in the gold would react with the salt to form silver chloride, which would be absorbed by the brick dust. The gold left behind would now be free of silver, or at least have a low silver content, and could be processed further. Until the Middle Ages and the early modern period, this method for purifying gold, known as cementation, was widespread, and on other continents and in other countries, such as South America and Japan, it was practiced as late as the nineteenth century.

Analysis is required to assess both native and purified gold. Archimedes developed a test to see whether the crown made for King Hieron II of Syracuse (306–215 BC) was in fact made of the gold-silver alloy that had been ordered. His test was based on the difference in density between gold and silver, which makes it possible to estimate the percentage of each metal in an alloy.

A simple test for judging the purity of gold that dates back to the Bronze Age is streak testing (plate 23). The piece of metal to be tested is used to make a heavy streak on a hard, black siliceous rock, or touchstone. The color of the streak left by the metal of uncertain composition is then compared with a second streak, of a known alloy. An experienced gold worker can judge from the nuances in color the gold content of the object of unknown composition.

Fire assaying, which is still used today, must also have been mastered in antiquity or even earlier. Here the sample to be tested is melted together with lead; the resulting mixture is heated in a small oven with an oxidizing

atmosphere. The lead oxide that forms is absorbed by the porous crucible, and the grain of precious metal is left behind. Even modern analysis has by no means entirely replaced fire assaying.

Whereas for precious stones the carat is a unit of weight, for gold alloys the *karat* is a unit of purity, that is, gold content. Twenty-four karats correspond to 100 percent pure gold; a gold alloy of twelve karats thus contains 50 percent gold, and one of eight karats, 33.3 percent.

The Material Properties of Gold

Gold is not used up, just used. Unlike iron, which is corroded by rust and vanishes, gold, once it has been mined or found, survives. It can be buried, forgotten, or lost, but, though hidden, it still exists physically, and chance may reveal it again. The reprocessing of "used" gold has always been common, and doubtless it represents the historical origin of recycling. The gold robbed from the tombs of pharaohs was melted down and, after a chain of reuses, may even form part of the gold bracelet that is given as a wedding gift to an Egyptian woman today. Gold from the treasury of Darius, which Alexander the Great took as spoils, may have traveled many detours to end up in coins minted by the doges of Venice. Theoretically, therefore, we might assume that all the gold that has been extracted since the beginning of human history still exists and that this quantity increases annually. According to estimates, approximately 110,000 to 130,000 tons (100,000–120,000 MT) of gold have been

23. Touchstone and touch needles; streak testing to estimate the gold content of an alloy.

This tablet of black siliceous rock has a number of streaks from gold testing. The set of calibration needles, brass bars with various alloys of gold at their tips, permits an approximate estimate of purity in karats.

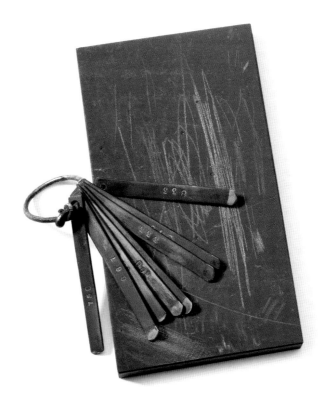

extracted from the earth from the earliest times to the present day. Roughly 2,200 to 2,800 tons (2,000–2,500 MT) of gold are extracted annually from deposits and approximately 1,100 tons (1,000 MT) reprocessed.

Gold is a very heavy metal, roughly twenty times as heavy as water and nearly twice as heavy as lead. A gold sphere that weighs 2.2 pounds (1 kg) has a diameter of about an inch and a half (4 cm), about the size of a plum. Hence the volume of all the gold that has been extracted and processed by human beings amounts to a cube with edges sixty to sixty-five feet (18–20 m) long; that corresponds approximately to an apartment building with six units. The quantity added to that each year could fit in a two-car garage measuring twenty by twenty by ten feet (6 × 6 × 3 m).

According to an etymological dictionary, the word *gold* derives from a Germanic word meaning "yellow." Gold is thus the yellow metal, in contrast to the white one, silver. The Latin word *aurum* emphasizes its gleam (*ausum*). The word for gold in all of the Romance languages derives from the Latin. "Yellow" and "gleaming" identify two of the qualities that characterize gold and make it a special element.

24. Large scale for gold coins with twenty-two weights, Johann Caspar Mittelstenscheid, Lennep, before 1815; wood box with dark stain and two brass latches, 7³⁄₁₆ × 4⅛ × ⅞ in. (18.3 × 10.6 × 2.3 cm). Private collection.
 The box has spaces for the balance beam, the scale, and twenty-two square coin weights. The latter are of brass and are marked with the name of the type of coin to be tested. If the coin and control weight correspond, the coin being weighed is genuine.

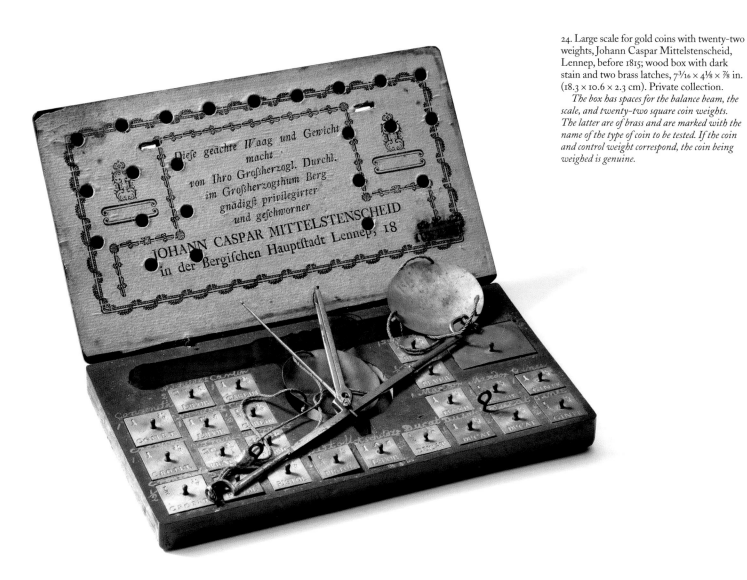

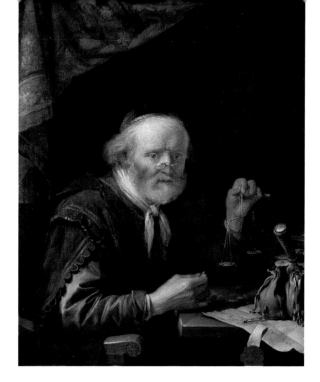

25. Gerrit Dou, *Man Weighing Gold*, 1664; oil on panel, 11¼ × 8⅞ in. (28.5 × 22.5 cm). Musée du Louvre, Paris.
The weighing of gold coins was a common practice, for their supposed weight was all too often reduced, with fraudulent intent, by cutting or filing their edges.

In addition to its beautiful luster and polish, gold is pliant and ductile, the most malleable of all metals. Because gold is so soft, it must be polished very carefully to avoid scratching it. Sheet gold can be hammered into thin foils (plate 27). If it is placed between skins or leather and hammered, the result is gold foil, which can be thinner than three millionths of an inch (0.00008 mm). As early as 2400 BC, artisans were capable of producing gold foils as thin as four ten-thousandths of an inch (0.01 mm). Gold foil that is only eight millionths of an inch (0.0002 mm) thick has survived from the Roman period. In extreme cases, gold can be hammered so thin that it appears dark red from the light shining through it. A gold cube with a volume of a cubic centimeter (0.061 in.³) weighs two-thirds of an ounce (19 g), and from it a wire can be formed that is nearly thirty miles (50 km) long. A tenth of an ounce (a few grams) of the finest gold leaf is enough to gild a football field.

At 1945 degrees Fahrenheit (1063°C), the melting point of pure gold is relatively low, so that from early in human history it could be melted easily in crucibles over coals using a blast pipe to stoke the fire (plate 28). Gold is extremely stable and resistant to disintegration and nearly all chemicals.

26. Pocket gold scale, Stephen Houghton & Son, Makers, Ormskirk, England, late eighteenth or early nineteenth century; mahogany case, brass scale, 5⅜ × 1½ × ¾ in. (13.6 × 3.8 × 1.8 cm). Private collection.
When the top is opened, this pocket scale springs into position. Hinged weights permit one to measure various sorts of gold coins, whose standard weights are indicated on the inside of the scale case. An additional sliding weight enables one to determine any short weights.

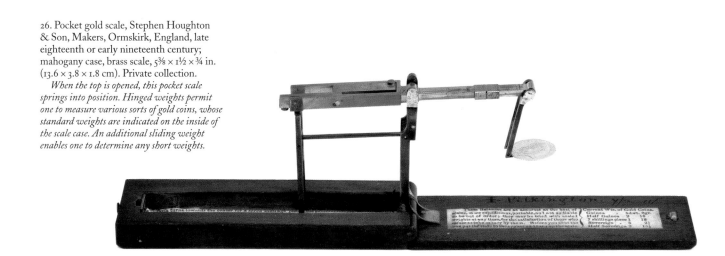

27. Sheet gold for gilding sculptures and furniture, Egyptian, sixth to fourth century BC. Musée du Louvre, Paris.

The Egyptians already knew how to hammer gold into thicknesses of a fraction of a millimeter. Sheets of papyrus were probably placed between the sheets of gold foil to keep them from sticking together.

Not until the Middle Ages, not least thanks to the efforts of alchemists, was *aqua regia*, Latin for "royal water," discovered: a mixture of three parts concentrated hydrochloric acid and one part nitric acid that could dissolve gold.

These properties of gold are the prerequisites for its many uses. Goldsmiths have always exploited the possibilities of their metal, which can be shaped in numerous ways using simple craft techniques. Pure gold is precious and soft (plate 30). When alloyed with silver and copper, it can be not only used more sparingly but also made harder—a technique that was already mastered in the third millennium BC. Casting in open or closed forms—especially in lost forms, known as *à cire perdue*—was also known by around the same time. Chasing and hammering are techniques especially well suited to gold. Punching, engraving, and etching all belong to the goldsmith's repertoire, along with gilding. Gold will adhere to nearly any base, including other metals, wood, lacquer, ceramic, porcelain, and glass. Even a sparse application of gold leaf will achieve a radiant luster. Techniques for gilding range from amalgam gilding to applying gold leaf with simple adhesives like albumen. Granulation, an ancient technique for producing and applying small grains of gold, long remained a mystery for later periods until it was finally understood and reproduced successfully in the early twentieth century. Many other applications of gold over the course of history could be mentioned: gold mosaic, gold glass, gold inlay (plate 29), gold ink, and much more, for each age had its own relationship to gold and characteristic preferences for certain methods for processing it, inventing new ones or retaining the traditional approaches.

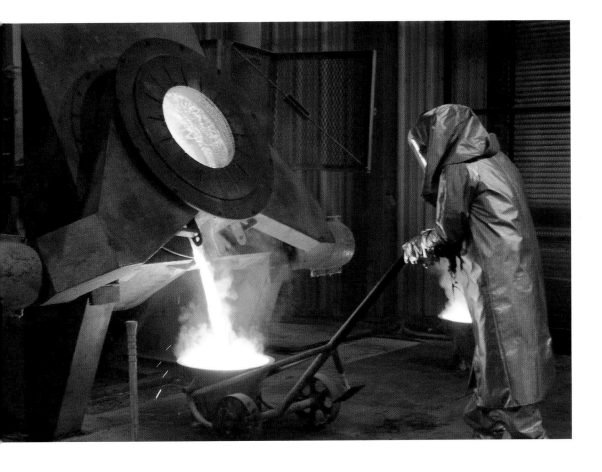

The Uses of Gold

In the previous sections, gold as "matter" was the focus, but gold is a dual concept. "Transcendent" gold, as a symbol of myth, power, and magic, has been an indicator of esteem and honor since the beginnings of human history. Gold adorned (and still adorns) the living, accompanied the dead, and delighted the gods. The challenge of working with a metal that possesses unsuspected possibilities has resulted in gold artifacts that represent an everlasting cultural legacy. They reflect the attitude of human beings to this metal: from the earring to the reliquary, from the death mask to the gold-illuminated Psalter.

Many of the ideas behind such uses of this precious metal have proven constant over the ages. The expression of veneration for pagan gods during the pre-Christian millennia corresponds to the manufacture of precious objects in gold in Christian sacred art for ecclesiastical treasuries or the decoration of houses of worship. The same thing that served in the worship of gods and saints was claimed by rulers—often in excess: there is no real difference between the gold mania of the pharaohs and the vanity of August the Strong of Saxony (plate 31). All the common people could do was see and admire these precious objects, for they were not permitted to possess them.

30. One-kilogram bar of fine gold (purity: 99.99 percent) from a Umicore refinery, Wolfgang, near Hanau, Germany.
Refineries convert fine gold into convenient bars of one, ten, one hundred, and one thousand grams for sale. This one-kilogram (35 oz.) bar is illustrated here at close to its actual size; it is about five-eighths of an inch (1.5–1.8 cm) thick. At a gold price of 600 dollars per ounce, such a bar has a value of approximately 21,000 dollars.

31. Johann Melchior Dinglinger, sun mask with the facial features of August the Strong, 1709; chased and gilded copper, height: 19⁵/16 in. (49 cm), weight: 23 oz. (650 g). Staatliche Kunstsammlungen Dresden, Germany; Rüstkammer.
Gold and the sun are related, allusive concepts in many cultures. The sun, the life-giving star, was the symbol of gold not only for alchemists. August the Strong also loved gold, had faith in his goldsmiths, and—following his model, the Sun King Louis XIV—saw himself as the earthly representative of the sun in the festive luster of gold.

Among the few gold objects that were not reserved exclusively for certain social classes were gold coins. From the seventh century BC, when the first electrum coins were minted in Asia Minor, into the first half of the twentieth century, gold served as the metal of currency, as a measure and standard for material goods, commodities, and services (plates 24–26). Even before minted coins were introduced, gold was esteemed as an object of exchange: small gold bars or pieces, known as *shats*, weighing a quarter to a third of an ounce (7–8 g), were used as a means of payment in Egypt in the second and first millennia BC, and in Japan gold dust was weighed and filled into bamboo cylinders.

The selection that remains of all the objects created since gold began to be mined and processed was determined by chance. A great many—surely the majority—have been lost, destroyed, or melted down, but we still derive pleasure from those that remain, for, as Saint Hildegard of Bingen (1098–1179) noted, "gold is warm and contains something of the sun."

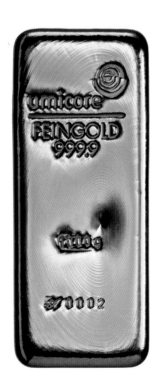

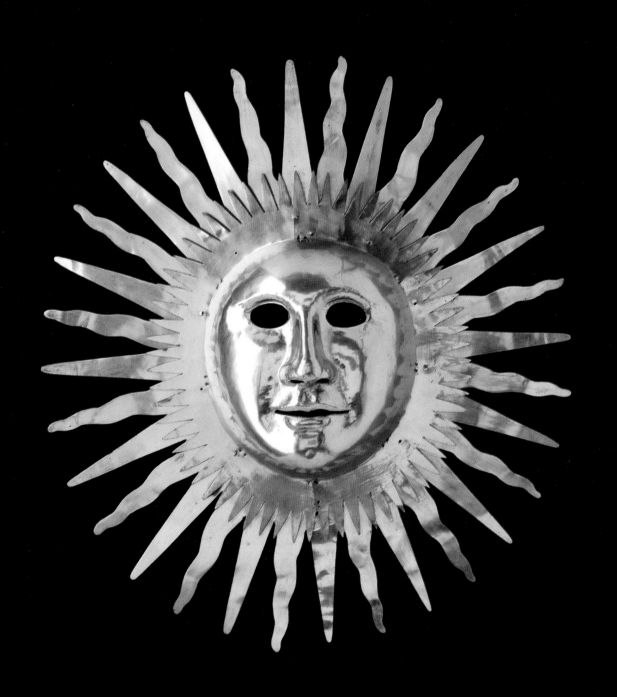

4000 3000 2500 2000

I. THE BRONZE AGE AND EARLY ADVANCED CIVILIZATIONS

Prehistoric and Early Historical Times

Egypt

The Ancient Near East

The Minoans and Mycenaeans

1500 1000 0

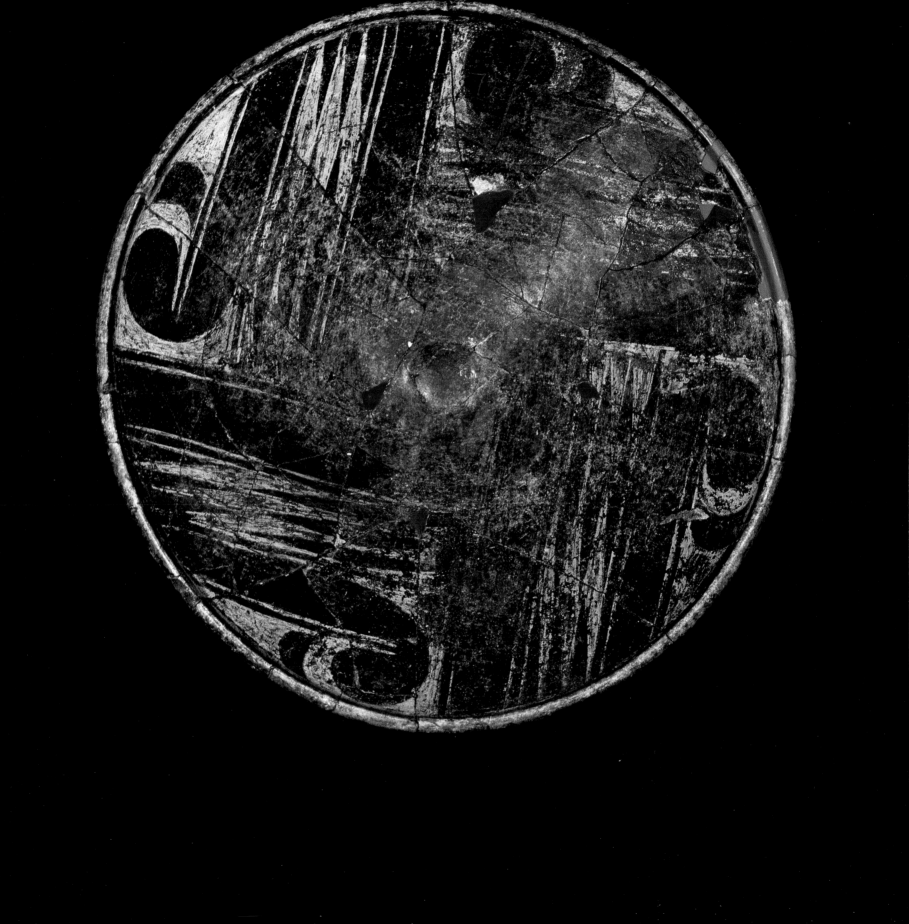

CHAPTER I

✤✤✤✤✤✤✤✤✤✤✤✤✤✤✤✤✤✤✤✤✤✤✤✤✤✤✤✤✤✤✤✤✤

Prehistoric and Early Historical Times

THE DISCOVERY OF THE "SUN METAL"

Archaeologists have used the term *Metallschock* (metal shock) to describe the effect of Stone Age man's dawning awareness of this new material. Naturally occurring metals required methods of working completely different from those for stone, horn, bone, or wood. The new material could be hammered, shaped, and tempered, or even melted and cast, which led to previously unsuspected possibilities for use and design. Was gold the first metal that humans discovered and learned how to use? The question cannot be answered yet, since the age of gold artifacts can be determined only when they are excavated together with other objects that there is a means of dating.

The question of the origins of worked gold has been raised repeatedly, but the provenance of the metal from which a given artifact was first produced is not usually known. In the prehistoric and early historical periods, gold was probably worked at the site where it was mined. However, in the case of finds from later periods, the precious metal may sometimes have traveled long routes to reach its goldsmith. It may be assumed, in all probability, that all too often the gold to be worked did not come from a single location but was produced by melting a number of gold grains together, including scrap metal such as used jewelry, and hence was a mishmash of "gold types" of various origins. The results from studies of the trace elements in a gold sample thus cannot be taken without reservation as an indication of origin.

EASTERN EUROPE: THE BIRTHPLACE OF GOLD WORKING?

For a long time it was assumed that the oldest gold artifacts came from Mesopotamia or the Old Kingdom of Egypt, but more recently the dating of finds from a Copper Age tomb field near Varna on Bulgaria's Black Sea coast has been confirmed: some of these objects are over six millennia old and come from the period around 4400 to 3900 BC. Gold objects weighing as much as thirteen pounds (6 kg) have been found thus far, and their material definitely came from the rich deposits in the Balkans. Among the tomb finds from the early Copper Age are more than thirty rings made from thin sheet gold (plate 33). Burial offerings in the form of figures of bulls in sheet gold were probably a widespread symbol for cosmic forces (plate 34). The tombs in Varna were primarily those of women

◁ 32. Ceramic bowl with geometric decoration, Varna, cemetery, tomb 4, c. 4900 BC; gold dust on fired clay, diameter: 20½ in. (52 cm). Archaeological Museum, Varna, Bulgaria.
The delicate, well-defined decoration in gold dust was applied either before or after firing with an organic adhesive (resin, honey, plant sap), possibly using a template. No comparable ceramic objects from the Chalcolithic or Copper Age are known.

▽ 33. Cylindrical beads, Varna, cemetery, tomb 3, c. 4400 BC; rolled strips of sheet gold, diameter: 3/16–¼ in. (0.4–0.6 cm), total weight: 0.2 oz. (4.5 g). Archaeological Museum, Varna, Bulgaria.
These thirty-one small cylindrical beads or rings not only belong to one of the earliest finds in the cemetery of Varna but are also among the earliest man-made gold artifacts of any kind. They were probably used to adorn the deceased.

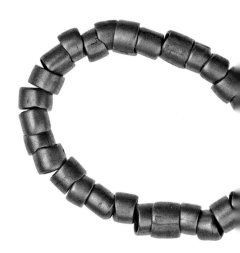

34. Two animal figures, Varna, cemetery, tomb 36, c. 3900 BC; cut from sheet gold, punched, and chased, 0.4 oz. (11.7 g) and 0.2 oz. (6.74 g). Archaeological Museum, Varna, Bulgaria.

The objects were taken from a symbolic tomb—that is, a grave without a skeleton. They may have been cultic offerings having to do with cattle breeding.

35. Animal figure (bull?), Maikop, Russia, northern edge of the Great Caucasus, second half of the third century BC; gold, height: 2⅜ in. (6 cm). Hermitage, Saint Petersburg.

This small bull figure, probably made using cire perdue, *or lost wax, casting, from the tomb chamber of a tribal chief is a characteristic example of the Bronze Age style of Kuban culture, which like later Scythian art had a fondness for depicting animals.*

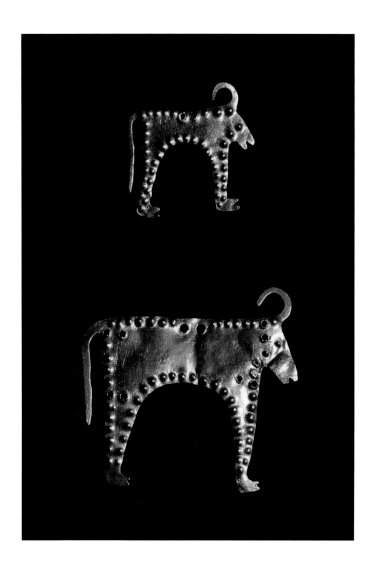

of high standing, and their burial offerings included not only jewelry but also garments and ceramic vessels decorated with gold paillettes. A shallow bowl, decorated with a timeless geometric design in gold consisting of lines and semicircles, is reminiscent more of Art Deco ceramics than of objects from the Copper Age (plate 32). Many tombs in the cemetery in Varna were empty, holding no skeletons, only a wealth of gold objects. In others were buried clay figures of gods with gold ornaments. The meaning of such practices remains mysterious. Were the gods supposed to be adorned and then preserved until their resurrection? Were empty graves dug in preparation for later burials or in anticipation of an afterlife?

In the summer of 2005, scholars at the Bulgarian Academy of Sciences made an astonishing discovery: while studying their country's rich deposits of placer gold, they came across sand containing not just naturally formed particles of the precious metal but also fragments of gold artifacts, like melted pellets, pieces of rings, and chain links. One possible explanation for this find is that earlier settlements or graves were flooded and

eroded by waterways that later changed their course. Remains from older gold workshops might have ended up in the alluvial sediments from which they were later washed out, together with the placer gold. The objects have not yet been dated, but they may be assigned provisionally to the fifth millennium BC; this would be additional evidence that the Balkans are one of the regions where the origins of metalworking should be sought. The rich deposits of precious and nonferrous metals in the Balkans would certainly have provided the necessary materials.

GOLD ARTIFACTS AS BRONZE AGE STATUS SYMBOLS

Gold finds from the fourth millennium BC include the objects found in 1981 in the remote Nahal Qanah Cave in the Judaean Mountains of Israel. Together with Neolithic ceramics from the sixth millennium BC, archaeologists recovered eight massive gold rings with hammered surfaces, each weighing about 4.4 ounces (125 grams; plate 36). Comparable rings have also been found in tombs in Varna and in Egypt. Were such rings expressions of the wealth or symbols of the social rank of those buried with them? It is also possible that they represent an early stage of gold money or a trading form of gold, as rings can be easily strung together and transported.

In Hungary and the Kuban region of northern Caucasia, Bronze Age jewelry has been discovered, which may also have been manufactured there. Maikop, the most important archaeological site for Kuban culture, has a tumulus (*kurgan*) forty feet (12 m) high, with richly decorated royal tombs. One of the skeletons in a tomb opened in 1897 was entirely covered with sheet gold decorated with lions and bulls—presumably symbols of power, strength, and fertility. Jewelry of gold, silver, and precious stones; diadems; chains; vessels; and weapons and tools testify to both the extraordinary wealth of Kuban royalty and the skill of their artisans (plate 35). The artifacts date from the second half of the third millennium BC and are influenced stylistically in part by Asia Minor, from whence the Kuban people may have originally come. It is also true of Kuban culture that goldsmith work of this period is closely connected to techniques for bronze. Processes specific to gold evolved only in later centuries.

Ireland is one of the western European countries where many gold artifacts from the early Bronze Age have been found, and the area once had its own rich deposits of the metal. Among the more remarkable finds from this period are the crescent-moon-shaped gold collars known as *lunulae*, which were cut from thin sheet gold and engraved with simple geometric ornaments (plate 37). These jewelry products, more than four millennia old, were probably worn around the neck or in the hair by privileged women as a sign of their elevated status. Outstanding examples of jewelry made from Ireland's placer gold continued to be produced into the first millennium BC, such as the Dal Riada gold fibula (ninth century BC) or a heavy gold chain weighing 9.6 ounces (273 g; c. 700 BC).

▽ 36. Eight solid rings, Nahal Qanah Cave, Judaean Mountains, Israel, late fourth century BC; gold and electrum, outer diameter: c. 1⅛–1¹³/₁₆ in. (2.9–4.6 cm), width: ⁵/₁₆ in. (0.8 cm), thickness: ⁵/₁₆ in. (0.8 cm), total weight: c. 2.2 pounds (1 kg), average weight per piece: 4.4 oz. (125 g). The Israel Museum, Jerusalem.
Two rings with hammered surfaces of pure gold and six others of electrum with 70 percent gold and 30 percent silver. They were probably forged from gold rods or bars.

▷▷ 37. *Lunula*, Blessington, Wicklow County, Ireland, c. 2000 BC; cut from thin sheet gold. British Museum, London.
This half-moon-shaped piece of jewelry, found in a bog in 1864, has symmetrical decorative elements like triangles and zigzag lines that are also found on ceramics from this period. The ornamentation was applied with small chisels or burins. Lunulae, Latin for "small moons," are among the oldest forms of jewelry of the early Bronze Age, and they spread from Ireland to England, northern France, and Germany.

▷▷ 38. Beaker, Eschenz, Canton of Thurgau, Switzerland, 2300 BC; gold, height: 4⁵/₁₆ in. (11 cm), weight: 4.8 oz. (136 g). Museum für Archäologie des Kantons Thurgau, Frauenfeld, Switzerland.
This gold cup, found during excavations for railroad construction in 1906, resembles in form the ceramic objects of the Bell Beaker culture from this period. The goldsmith tried to imitate precisely the decorative elements (grooves, dots) found on such ceramic beakers.

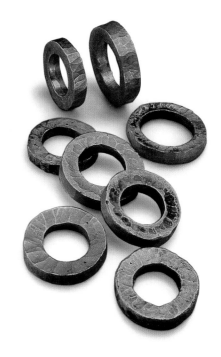

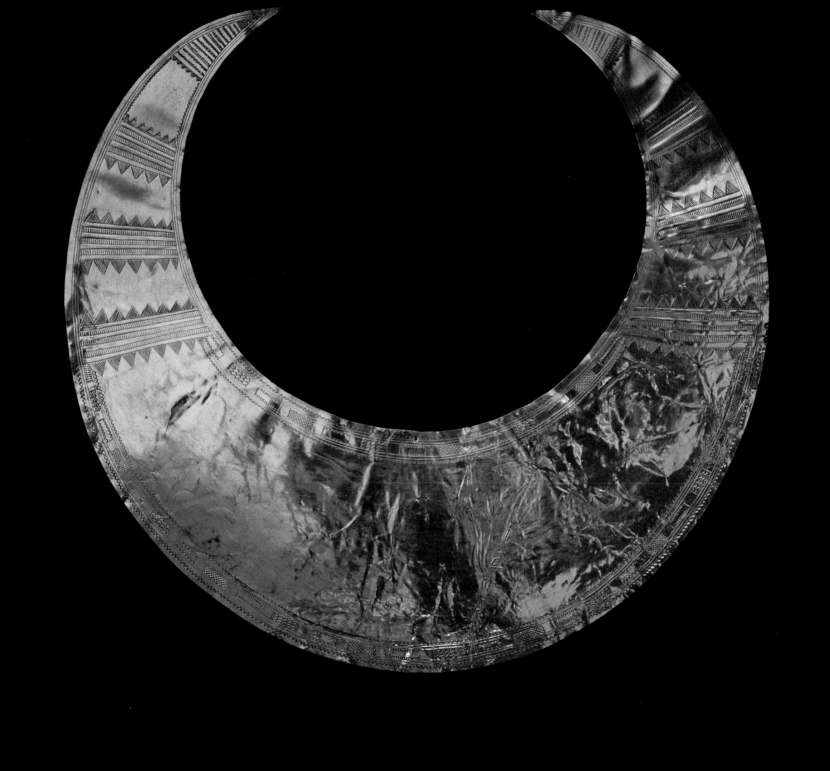

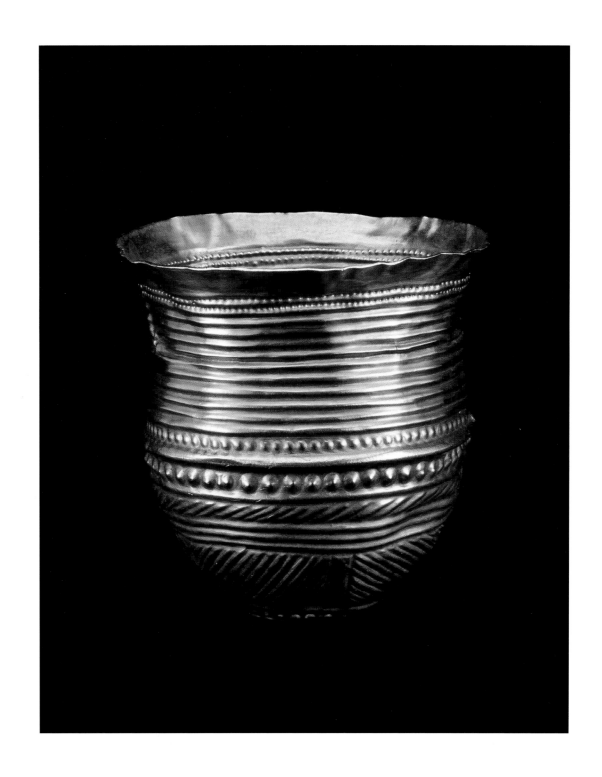

39. Ornament of the golden hat of Berlin (plate 40).

Punches were used to create single- or double-ringed dots, rings, round bosses with concentric circles, recumbent crescents with a dot in the center, and almond-eye patterns on the golden hat of Berlin. These motifs are thought to be connected to astronomy but are not fully understood.

▷ 40. Gold ceremonial hat, the so-called golden hat of Berlin, probably found in southern Germany, 1000–800 BC; sheet gold, chased and decorated with circular ornaments, height: 29⅛ in. (74 cm), diameter: 4¹⁵/₁₆ in. (12.5 cm). Museum für Vor- und Frühgeschichte, Staatliche Museen zu Berlin.

The mysterious Bronze Age sacred hats from central Europe represent extremely delicate chasing work in gold that was washed from rivers and streams with great effort and persistence. Their probable ceremonial function demonstrates that gold had a significance beyond simply being beautiful and enduring. The connection between the sun and gold is one that transcends many cultures in the prehistoric and early historical periods.

In comparison to Ireland and the Balkans, gold was relatively rare in central Europe. The widespread Bell Beaker culture, which owes its name to the shape of the ceramic drinking vessels characteristic of this Bronze Age group, did, however, produce outstanding pieces. This culture extended from the center of Europe to the Iberian Peninsula, southern France, and northern Italy. The oldest gold finds in Switzerland are from this period. The gold beaker of Eschenz in Canton Thurgau (plate 38) has been dated to 2300 BC and is chronologically and culturally related to comparable cups and beakers that have been found on the British Isles and in Germany. These showpieces were exclusively reserved for the ruling class and were found in storage areas and treasuries. Only smaller pieces of gold jewelry were placed in tombs during this period.

BETWEEN ASTRONOMY AND RELIGION

A number of finds in Denmark, France, and Germany derive from the Bronze Age of central and northern Europe. These include the mysterious conical gold hats that date to around 1000 BC. The golden hat of Schifferstadt was discovered as early as 1835; those of Berlin and Ezelsdorf, both in Germany, and of Avanton, France, were found later. All of these golden hats or cones were chased from paper-thin sheet gold; they probably served as ceremonial headdresses. Their embossed ornaments are based on solar and lunar numerology. The nineteen horizontal ornamental zones of the golden hat in Berlin (plates 39, 40), which has been carefully studied, contain circles of various sizes, crescent moons, and so-called almond-eye patterns. Their overall concept suggests astral or divine relationships to the temporal course of the sun and the moon, that is, of day and night. Astrology and the first beginnings of astronomy were an integral element of Bronze Age religious practices from the fourteenth to the ninth century BC. Gold liturgical equipment and priestly regalia were found alongside the golden cones. Among these were gold capes intended to transport priests from the earthly realm during ceremonial rites. The religion these objects served probably originated in Asia Minor.

Two other objects that remain mysterious probably belong to the cosmic imagination of Bronze Age peoples. The sun chariot discovered in 1902 in Trundholm, Denmark (plate 41), dates from the fourteenth century BC. Its right side is decorated with a golden disk of the sun that is visible only when the bronze vehicle drives past the viewer from left to right. The ungilded side symbolizes the path of the darkened sun through the underworld when the chariot is passing in the opposite direction. The 3,200-year-old disk of the heavens from Nebra, near Halle, Germany (plate 42), belonged to the same cultural circles as the sun chariot. This unique bronze disk has appliqué decorations in sheet gold of a crescent moon, a sun traveling on a bark, two horizontal arches, a starry night sky, and the seven stars of the Pleiades. Dating from the same period as Stonehenge in England, which marked the solstices, this disk served religious purposes. According to Bronze Age ideas, the sun god, who was also the god of the

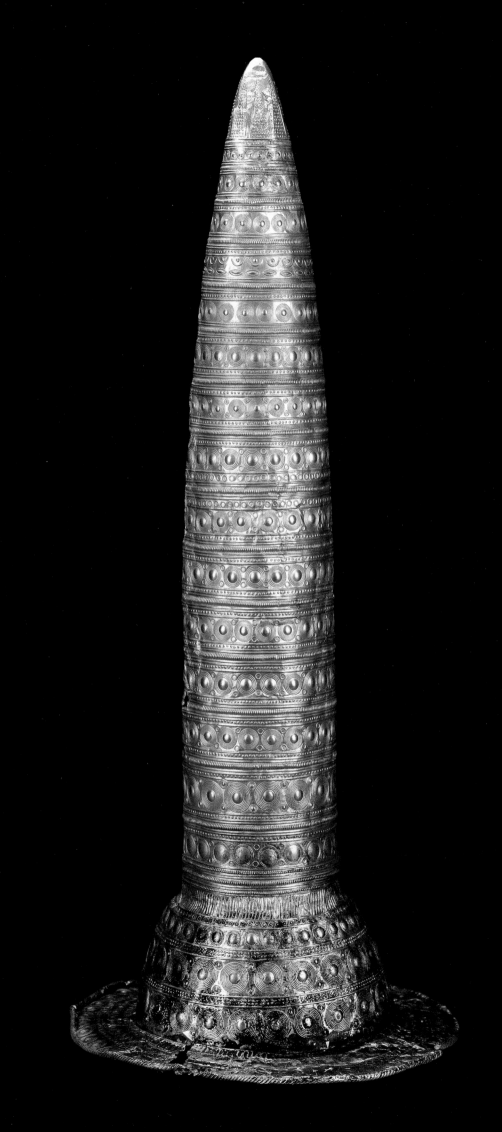

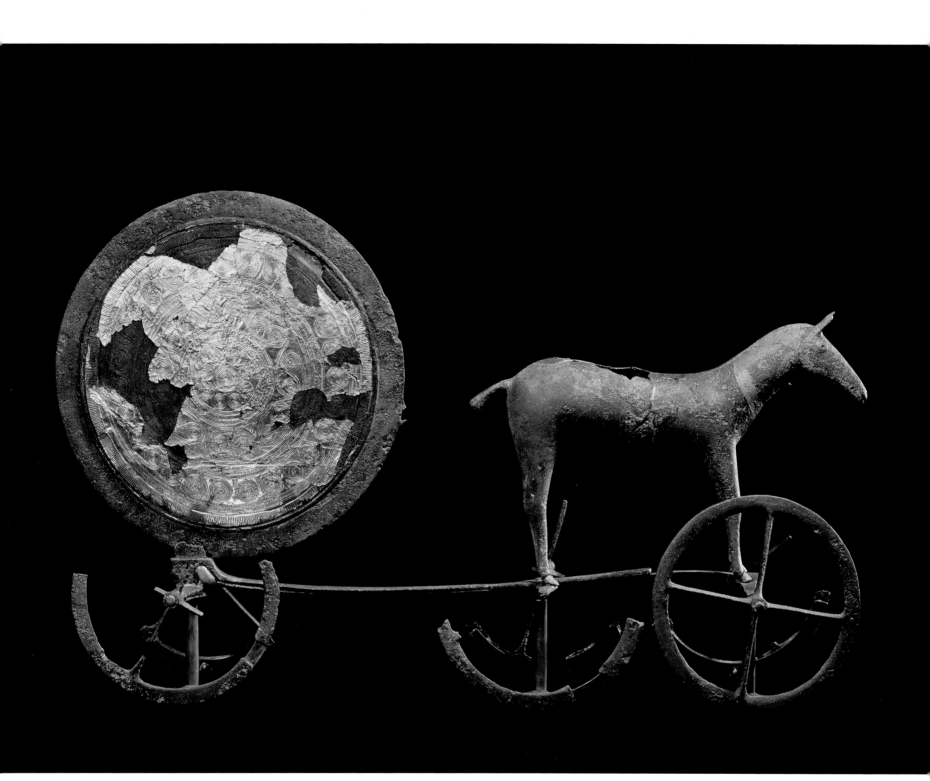

dead, descended every evening into the underworld, was reborn trium-
phantly at sunrise, and then glided across the horizon. The sign of the
sun in the center symbolizes death and rebirth, the cycle of the seasons,
and the obligations of sowing and harvesting. The associated rites,
which derived from ancient Eastern religions, were practiced by priests
and sages in an observatory in which the sun disk was once buried. Trace
analyses have shown that the gold for the appliqué came from deposits in
the Balkans.

Gold, the new, radiant metal, became, not least because of its durability,
the preferred means for expressing cosmic connections in the Copper and
Bronze Ages. Gold was the symbol of divine light. The sun stood for life,
rebirth, and the promise of the afterlife. But the use of precious metals as
jewelry for the living and the dead was reserved for those who had power
and ruled.

◁ 41. Chariot of the sun, Trundholm, Denmark,
first half of the fourteenth century BC;
bronze with sheet gold plating, length of
the chariot: 23⁷/₁₆ in. (59.6 cm), diameter
of the disk: 9¹³/₁₆ in. (25 cm), total weight:
c. 6.6 pounds (3 kg). Nationalmuseet,
Copenhagen.
 *This realistic model of a Bronze Age chariot
was produced by casting bronze in several
parts; it symbolizes the daily path of the sun
and the change from day to night. The golden
sun disk has survived only in part, but that
does not diminish the significance of this find.*

▷ 42. Bronze disk, Nebra, Saxony-Anhalt,
Germany, twelfth century BC; bronze with
gold appliqué, diameter: c. 12⅝ in. (32 cm).
Landesmuseum für Vorgeschichte, Halle.
 *This astronomical disk of the sky has been
interpreted in many ways, but its true meaning
is still an object of study. It does show that
Bronze Age peoples had ideas of space and time
that derived from observations of the course of
the stars and planets in the firmament.*

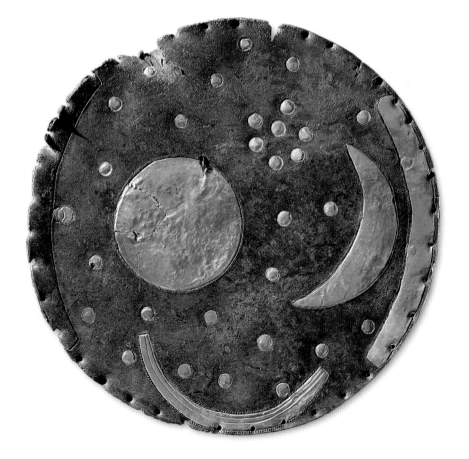

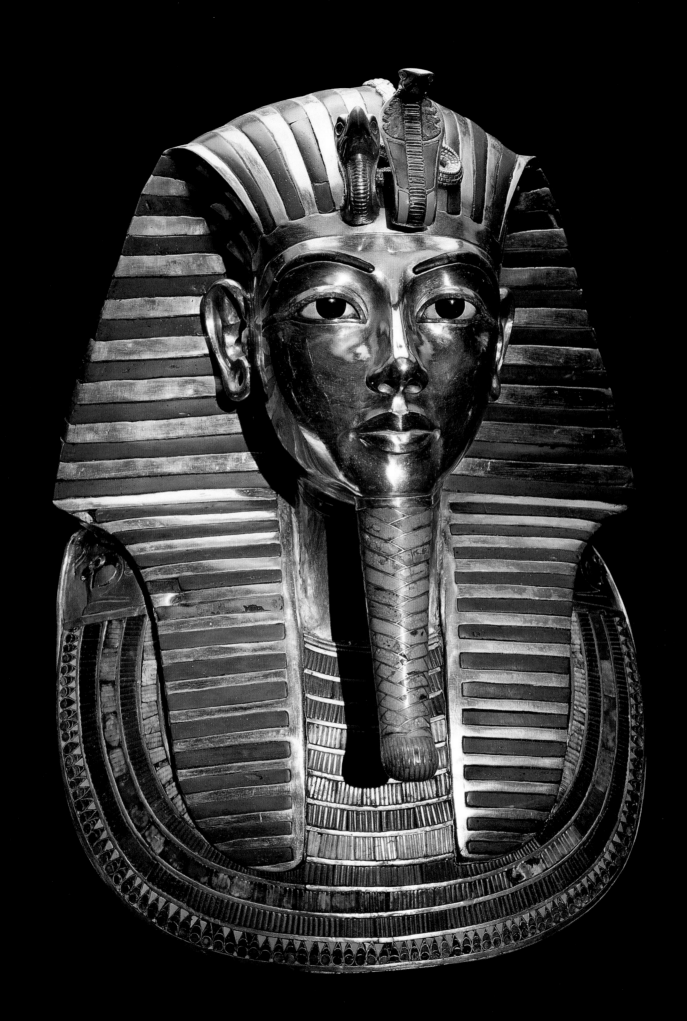

CHAPTER 2

❀❀

Egypt

THE GOLD OF THE PHARAOHS AND GODS

E gypt's advanced culture was one of the most important and longest-lived in history, lasting more than three millennia. It also had access to a nearly limitless wealth of gold that made Egypt the almost legendary land of gold for the ancients. Already in the early third millennium BC and in the Old Kingdom (2620–2061 BC; plate 46), gold was so highly valued that Egypt's own deposits were being efficiently exploited.

The oldest mine is said to have been located in northern Sudan. In the twentieth and nineteenth centuries BC, mines near Coptos, on the right bank of the Nile north of Thebes, began to be excavated. The gold was extracted not from the sands of the river but from the solid stone of the mountains on both sides of the Wadi Hammamat, which became an important center of gold mining in Egypt. Transportation routes and the locations of the mines in this area have survived in a sketch on papyrus, now held in Turin, that is the oldest mining map in the world (plate 44).

Over time the mining area extended farther south. By the time of the reign of Amenhotep III (1386–1349 BC), Egypt no longer owed its wealth either to the spoils of the campaigns of conquest that had been common

◁ 43. Mask of Tutankhamun, Thebes West, Valley of the Kings, tomb of Tutankhamun, New Kingdom, Eighteenth Dynasty, 1334–1325 BC; chased and polished gold, lapis lazuli, semiprecious stones, faience, height: 21¼ in. (54 cm), width: 15⁹/₁₆ in. (39.5 cm). Egyptian Museum, Cairo.

This mask of solid gold, most likely a realistic depiction of the king, is probably the most famous piece from the tomb treasures of Tutankhamun. Creating a three-dimensional object of this size and capturing the individuality of the person represented is something only a master goldsmith can achieve, when artistic empathy meets craft skills.

▽ 44. Map of the Wadi Hammamat, New Kingdom, Twentieth Dynasty, 1151–1145 BC; papyrus fragment, height: 16⅛ in. (41 cm), length: 27¹⁵/₁₆ in. (71 cm). Museo Egizio, Turin.

The so-called Turin Papyrus dates from the reign of Ramses IV. The full reconstruction is 111 inches (282 cm) long, showing details of the roads and positions of the gold mines and stone quarries in Wadi Hammamat, probably to orient the foremen who led the workers to the mines and the facilities for grinding and washing ore.

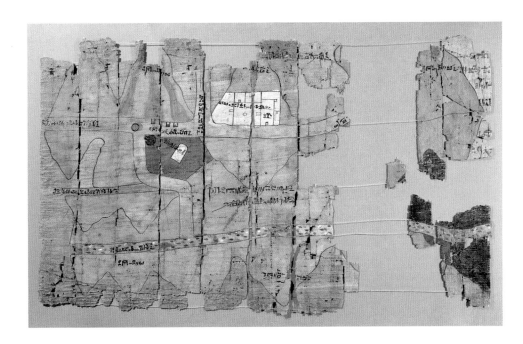

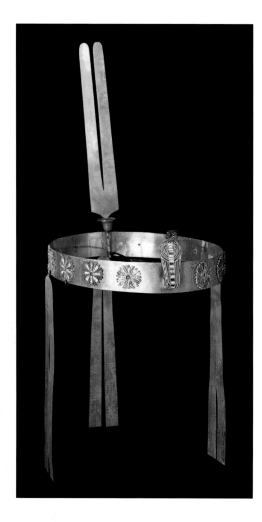

45. Diadem of Sit-Hathor-yunet, Dahshur, tomb area of Sesostris II, tomb of Princess Sit-Hathor-yunet, Middle Kingdom, Twelfth Dynasty, 1842–1779 BC; gold, lapis lazuli, carnelian, green faience, height: c. 17 5/16 in. (44 cm), width: 7 9/16 in. (19.2 cm). Egyptian Museum, Cairo.

This gold hoop, ornamented with gold ribbons, looks more like a headdress than a diadem, and it is perhaps an expression of the fashionable taste of the princess. The combination of gold with blue lapis lazuli, as well as reddish carnelian and colorful faience inlay, is taken from the standard repertoire of court jewelers.

under Thutmosis III (1504–1450 BC) or to international trade. Rather, its prosperity was based above all on the considerable extraction of gold from the mines around Wadi Hammamat and from the productive placer gold deposits of Kush in distant Nubia, which came under Egyptian control for an extended period beginning in the nineteenth century BC and whose name means "land of gold." The advanced Egyptian culture could wallow in gold, as deposits that had been used up were soon replaced by others. Hence it is not surprising that, around 1370 BC, King Tushratta of Mitanni, a country whose territory extended over northern Mesopotamia, northern Syria, and southern Anatolia, wrote to his son-in-law Pharaoh Amenhotep III: "May my brother send me large quantities of unworked gold, for in the land of my brother gold is as numerous as specks of dust. May the gods ordain that gold be as abundant in Egypt as it has been thus far."

Extracting the metal from the hard stone, into which galleries were cut as much as four yards wide and a hundred yards long and deep, was extraordinarily arduous. The report on this process from Agatharchides of Cnidus dates from the second century BC, but the methods of extracting gold and parting it from silver described therein will not have differed at all from the earlier period: "The gold-bearing earth which is hardest they first burn with a hot fire, and when they have crumbled it in this way they continue the working of it by hand; and the soft rock which can yield to moderate effort is crushed with a sledge by myriads of unfortunate wretches." The mined ore, which contained perhaps two- to six-tenths of an ounce (5–20 g) of gold per ton, was ground fine in mortars after being crushed. The precious metal could be enriched from the ground material by elutriation and removed from the worthless powdered stone. The above-mentioned account describes at length how gold and silver were parted by heating them with salt (cementation). Cautious estimates suggest that in the Eastern Desert, as the area around Wadi Hammamat was also known, approximately one and a half to two tons of gold were extracted annually; presumably it was mined on a similar scale in Nubia.

THE OMNIPRESENCE OF THE DIVINE METAL

All of the gold mined in the Egyptian empire was reserved exclusively for the pharaohs, because the precious metal itself, its use, and its transmission were royal monopolies. At his discretion, the ruler could found temples with it, hoard it in treasuries, or give it as gifts to worthy servants. Gold artifacts remained reserved for a privileged circle; it was taboo for subjects outside the courtly hierarchy. Tomb robbery, which was already common in the early Egyptian period, was the only way for those outside the court to obtain gold, but it was a crime punishable by death.

Goldsmiths' workshops were assigned directly to the court or to a temple. The artisans employed there were extremely skilled, and there was hardly a metalworking technique that was not applied to this precious material. They knew how to hammer out gold leaf to a thickness of

46. Horus falcon with asp and feather crown, Nekhen (Hierakonpolis), Old Kingdom, Sixth Dynasty, c. 2345–2181 BC; chased gold, eyes of obsidian, height: 13⅞–14¾ in. (35.3–37.5 cm). Egyptian Museum, Cairo.

This piece, forged from a single sheet of gold, is one of the few surviving goldsmith works of the Old Kingdom. Its execution is on the same high level as later products of the Middle and New Kingdoms. This head was probably originally placed on a reclining wooden figure, most likely of a pharaoh, that was covered with copper sheets.

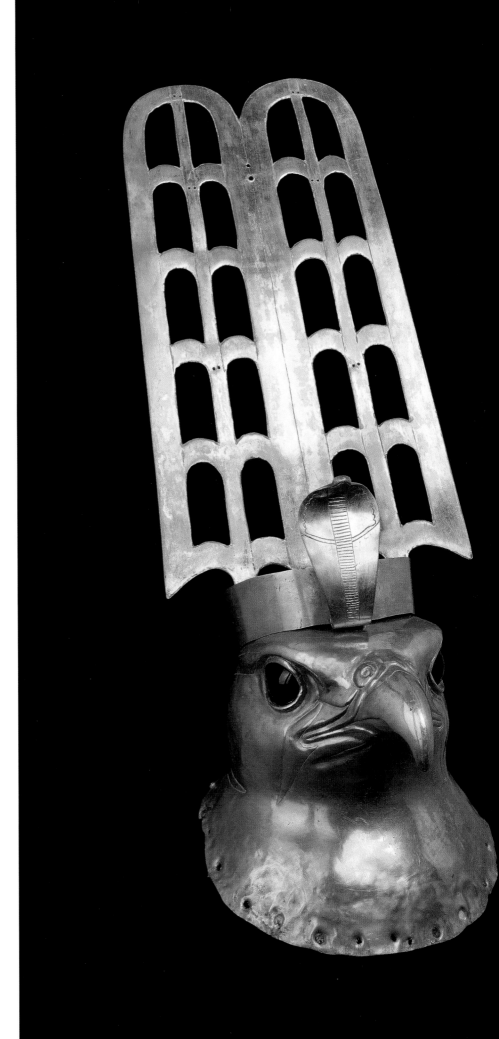

four hundred-thousandths of an inch (0.001 mm), and this was used to gild furniture, statues, and even the tips of obelisks. Already by the Sixth Dynasty (c. 2400 BC), they knew how to roll sheet gold onto a copper base, which can rightly be called *doublé* (plated), although that term for this kind of plating was not coined until the nineteenth century AD. The Egyptians also used the *cire perdu*, or lost-wax, casting process: A wax model of the object to be cast was produced and then coated in clay. When the clay had dried, the wax could be liquefied by heating and then poured out. The resulting hollow form was carefully filled with molten gold, and after it had cooled, the clay sheath was smashed to reveal the gold object.

Hammering, chasing, welding, enameling, and granulation—that is, the application of small gold balls to a base of sheet gold—were all part of the repertoire of Egyptian goldsmiths. These artisans had a special talent for gold wire. Because iron was unknown until 1200 BC, and hence there could be no drawplates to produce wire, they managed to make it by winding strips of gold foil into spirals, pulling them apart, and then hammering them while turning them frequently. Settings of gold wire were used for semiprecious stones or colored glass. This technique was frequently used for jewelry, in which a studied symmetry of color symbolism seems to have been programmatic (plate 47). In addition to lapis lazuli from the distant Hindu Kush and local carnelian, beginning in the third millennium BC turquoise from deposits on the Sinai Peninsula was especially popular. According to inscriptions, Snefru (2613–2589 BC) was already sending expeditions across the Red Sea to the Sinai, where the rare bluish-green stone was mined.

Gold jewelry was known in Egypt in prehistoric times, and early objects reveal design influences familiar from bronze work. A truly autonomous goldsmith's art developed later, from the Middle Kingdom (2010–1551 BC) and into the New Kingdom (1551–712 BC), and the Twelfth and Eighteenth

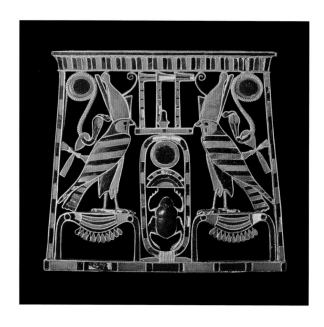

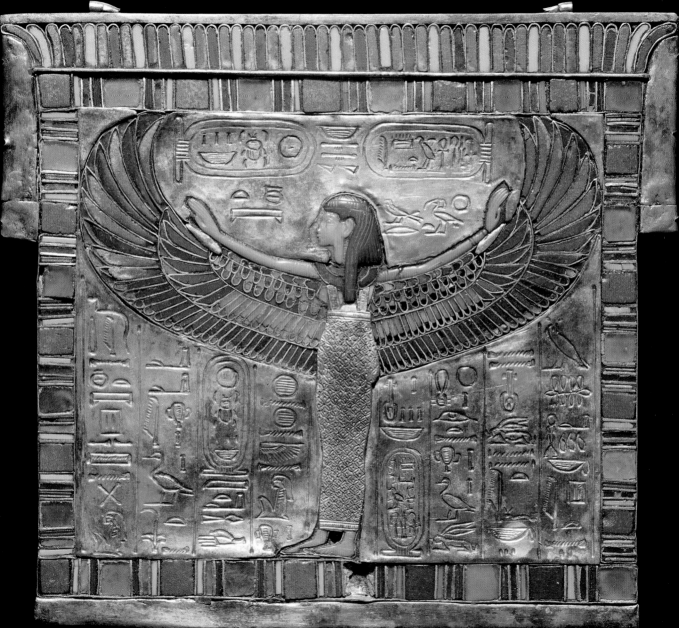

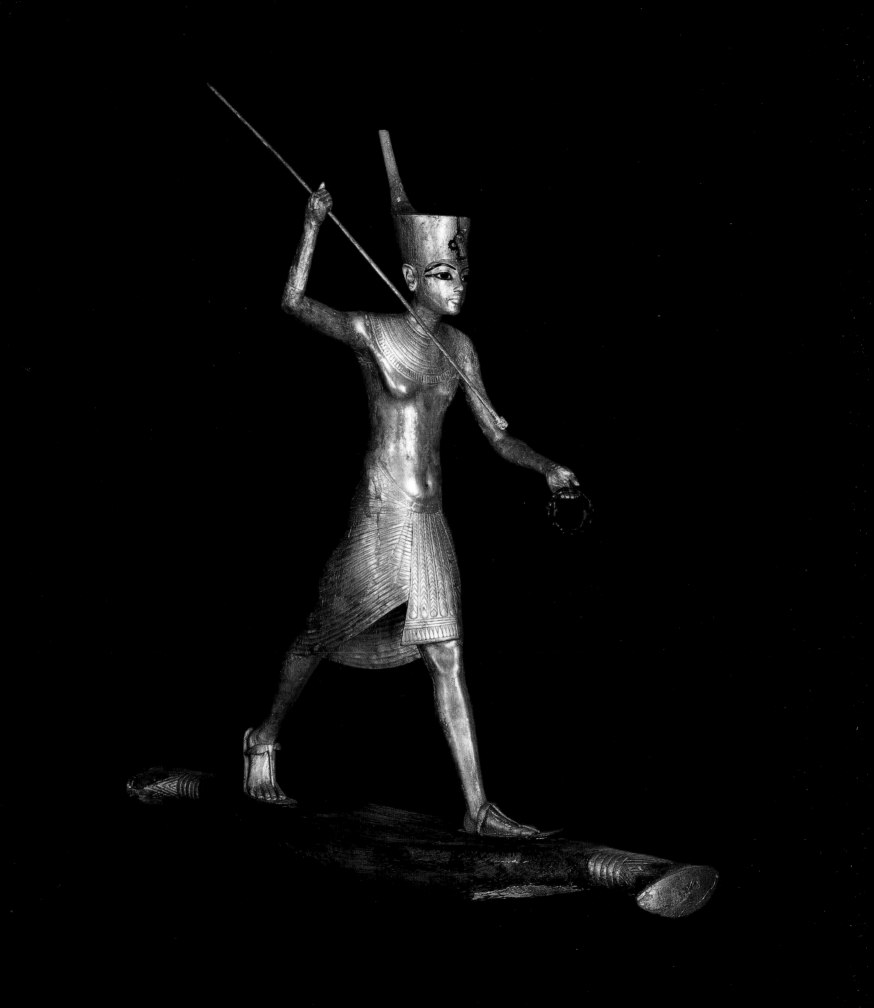

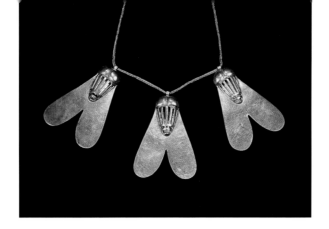

Dynasties may be said to represent high points. The jewelry of the royal princesses from the tombs of Dahshur from the twentieth and nineteenth centuries BC is equally perfect in terms of its artisanship and its artistic, decorative design (plate 45). Among the especially fine treasures from the New Kingdom—in addition to the fabulous finds from the tomb of Tutankhamun—are the pieces of jewelry belonging to Queen Ahhotep, from the sixteenth century BC. Among her numerous attractively designed burial gifts was the order of the Three Golden Flies, which was awarded for special bravery (plate 50).

In Egyptian art in general, but with gold objects in particular, the cult of the dead took precedence. The gold-wrapped mummies, symbols of rulership, objects for an afterlife appropriate to their station, and statues of tutelary deities turned the burial chambers of the pharaohs into treasury chambers. In the Egyptian imagination, gold was the flesh and silver the bones of the gods. The power of the pharaoh over the people was based on his absolute authority as ruler, as priest, and as the highest deity. The complex, elaborate ritual of the dead completed the transformation of his earthly body into an everlasting divine being. The lavish use of gold, whose luster symbolized the sun god, was based on the notion that only this pure metal was a genuine symbol of the divine body.

THE TREASURE OF TUTANKHAMUN

One of the greatest sensations in the cultural history of gold was the discovery of the tomb of Tutankhamun in 1922 by the British archaeologist Howard Carter. This most famous pharaonic burial site dates from the Eighteenth Dynasty (1334–1325 BC), and its chambers contained golden sarcophagi, jewelry of every conceivable sort, delicately ornamented furniture, statues and statuettes (plate 49), ceramic vessels with animal deities (canopic jars), and much more. The young, politically insignificant pharaoh was buried with more than five thousand individual pieces. What the pharaohs that history has called "the Great," like Ramses II or Amenhotep III, must have received as attributes for the hereafter exceeds our powers of imagination.

The mummy of Tutankhamun wore gold finger guards and sandals to avoid touching anything unholy. It was placed in a sarcophagus of solid gold that weighed 243 pounds 6 ounces (110.4 kg), the most valuable of the pieces in terms of materials (plate 52). More significant in terms of artisanship is the embossed mask of the young Tutankhamun, which covered his head and chest (plate 43). Twenty-one and one-quarter inches (54 cm) high, it is made of sheet gold with inlaid precious stones and colored glass

◁ 49. Tutankhamun with harpoon, Thebes West, Valley of the Kings, tomb of Tutankhamun, New Kingdom, Eighteenth Dynasty, 1334–1325 BC; gilded wood, sandals, harpoon, rope, and asp of bronze, height: 27⅜ in. (69.5 cm). Egyptian Museum, Cairo.
This rendering of the pharaoh hunting a hippopotamus is an outstanding example of the sculptor's ability to depict a human figure in motion. Gesso was applied to a wooden sculpture to smooth out the structure of the wood and provide a surface to which the gold leaf would better adhere.

△ 50. Gold necklace with fly pendants, Thebes, Dra Abu el-Naga, tomb of Queen Ahhotep I, Seventeenth to Eighteenth Dynasty, 1650–1550 BC. Egyptian Museum, Cairo.
This unusual necklace was a decoration for service in battle. The goldsmith faced a special challenge here, as not only the bodies of the insects but also their wings are made of gold.

▽ 51. Wooden shrine in the tomb chamber of Tutankhamun, historical photograph, c. 1927; height of shrine: c. 78 in. (198 cm).
This gilded shrine contains the vessels for preserving the organs removed from the body prior to embalming. It has sheet-gold plating on all sides, showing scenes from the life of the ruler (see plate 54). It was guarded by gilded wooden statues of the goddesses Isis, Selket (visible on the right), Neith, and Nephthys with outstretched arms.

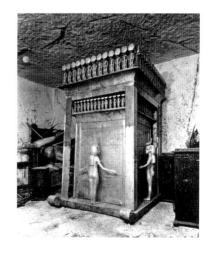

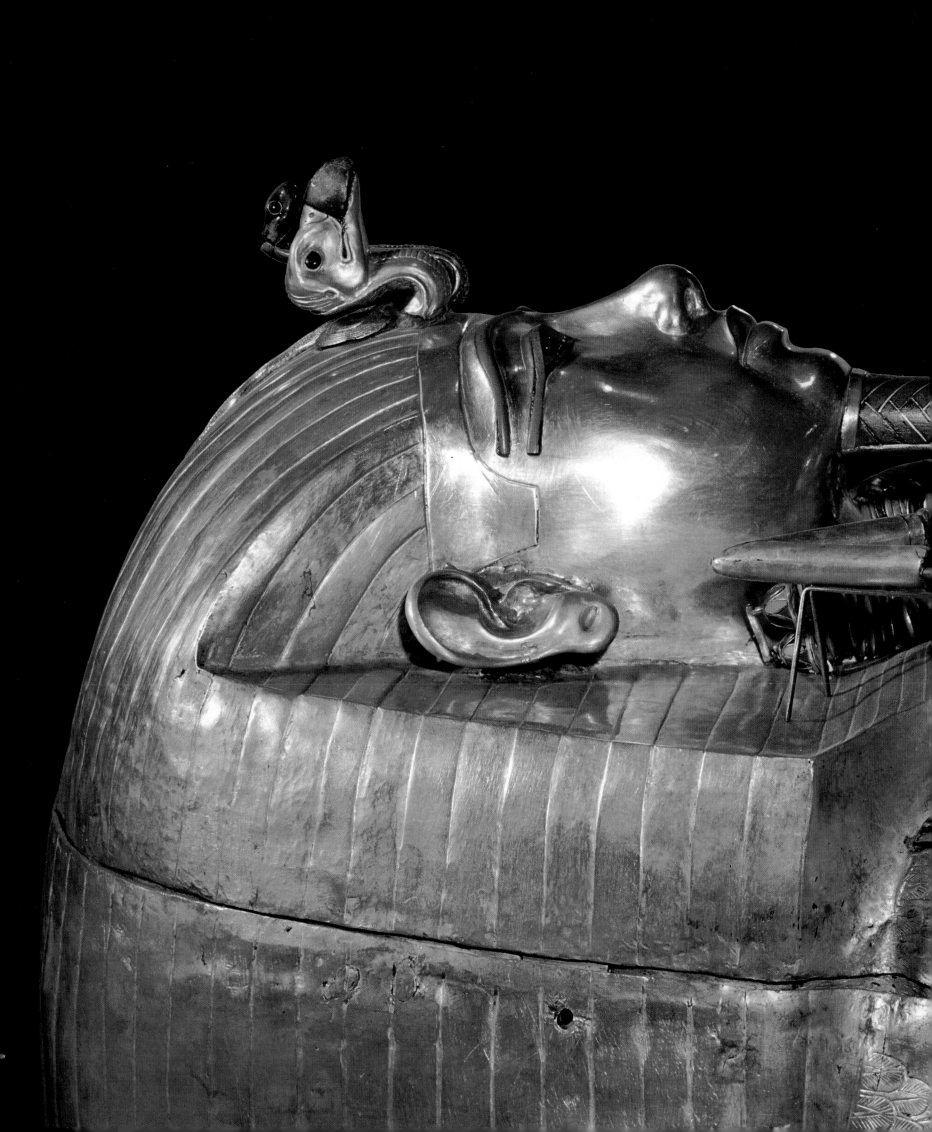

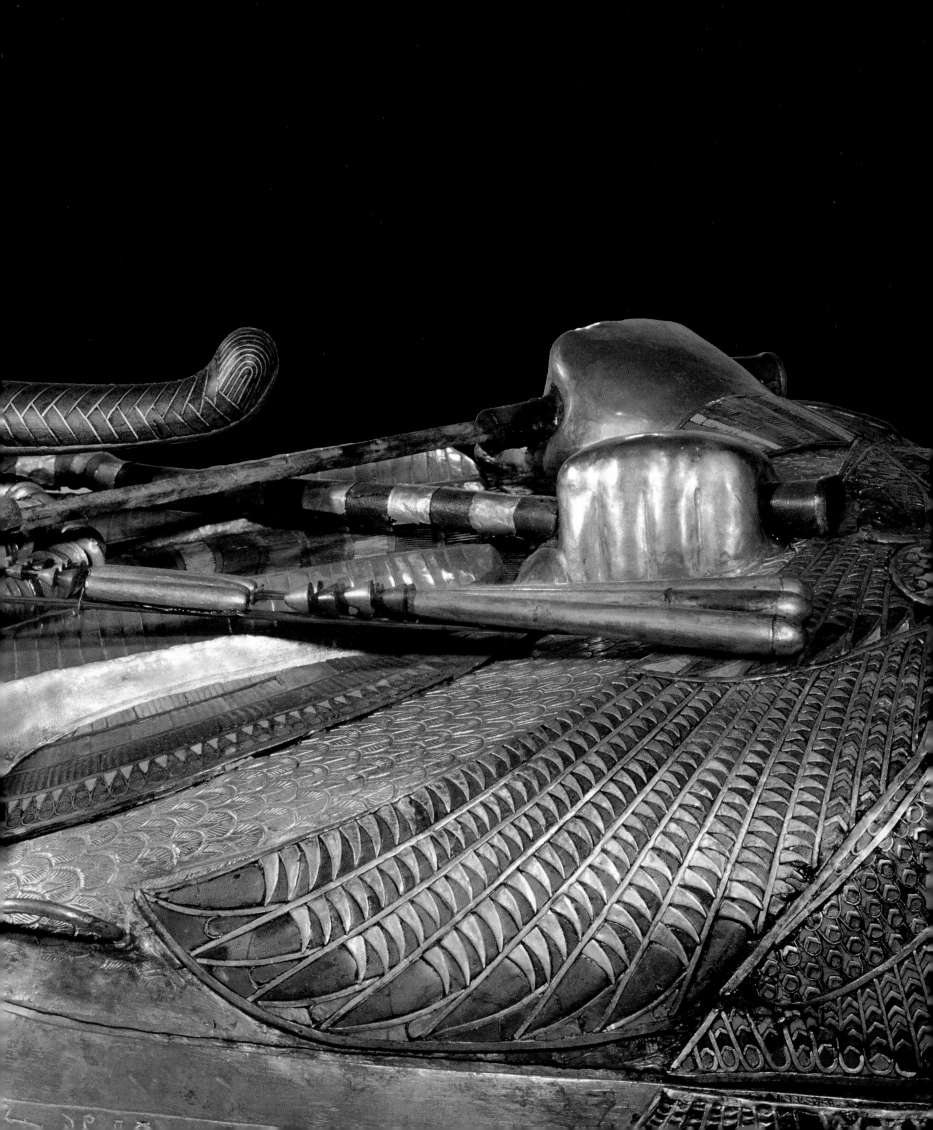

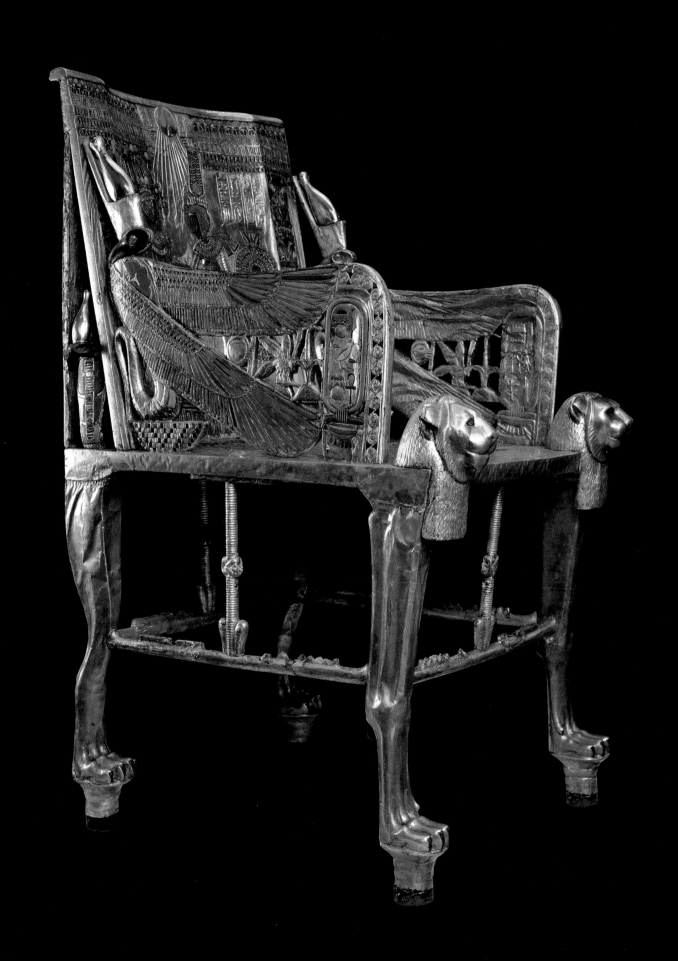

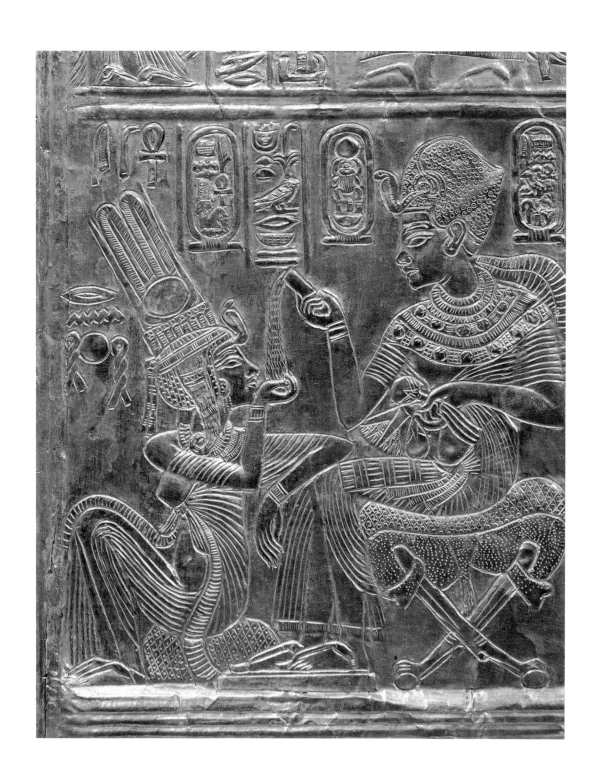

52. Gold coffin of King Tutankhamun, Thebes West, Valley of the Kings, tomb of Tutankhamun, New Kingdom, Eighteenth Dynasty, 1334–1325 BC; solid gold, carnelian, lapis lazuli, length: 72¹³⁄₁₆ in. (185 cm), thickness of walls: c. ⅛ in. (0.25–0.35 cm), weight: 243 lbs. 6 oz. (110.4 kg). Egyptian Museum, Cairo.

This coffin, hammered from 22 karat (91.67 percent) gold, is decorated with glass paste and inlay of semiprecious stones and is unique in both its dimensions and weight—a masterpiece of chasing work.

53. Throne of King Tutankhamun, Thebes West, Valley of the Kings, tomb of Tutankhamun, New Kingdom, Eighteenth Dynasty, 1334–1325 BC; gold and silver mounted on wood, with opaque glass and semiprecious stones, 40 × 21¼ × 23⅝ in. (102 × 54 × 60 cm). Egyptian Museum, Cairo.

Of the many pieces of furniture placed in the tomb when this pharaoh died, this richly decorated throne is the most splendid. The sheathing was made not only from sheet gold but also hammered silver, which was rare in Egypt and hence unusual.

54. Shrine of King Tutankhamun, Thebes West, Valley of the Kings, tomb of Tutankhamun, New Kingdom, Eighteenth Dynasty, 1334–1325 BC, wood sheathed with repoussé sheet gold, height: 19⅞ in. (50.5 cm). Egyptian Museum, Cairo.

This detail of the shrine shows Tutankhamun and Queen Ankhesenamun at his feet in a domestic scene of mutual affection. The chased sheet gold was backed with a plaster or chalk ground and reinforced with a linen bandage before being applied to the rear wall of the shrine.

55. Foot ring from the mummy of Psusennes I, Tanis, tomb 3, Third Intermediate Period, Twenty-first Dynasty, 1039–991 BC; gold, lapis lazuli, carnelian, diameter: 2⅜ in. (6.1 cm). Egyptian Museum, Cairo.

This relief of a winged scarab with the disk of the sun—symbol of resurrection and eternal life—is mounted on thick sheet gold.

paste, with the outlines of the eyes and the brows in lapis lazuli. The symbolic gold of the sun king is thus convincingly combined with the luminous blue of the god of the Nile.

The figural works like the gilded statue of the goddess Selket guarding the young pharoah's shrine (plates 51, 54) unmistakably reveal the influence of the Amarna style of Tutankhamun's ancestor Akhenaten. The static frontal view seems to be overcome, and the expression of the goddess comes alive in the turn of her head. The throne of the pharaoh (plate 53) depicts scenes that are well suited to this new conception of art and seem almost familiar and intimate. The lavish use of colored stones and glass, and the combination of gold, a little silver, faience, and alabaster give a warm tone that relieves the object of abstract ceremony. Particularly fascinating burial objects include the pectoral, or chest decoration (plate 48), whose cells filled with colored stones combine the hues of lapis lazuli (deep blue), carnelian (brownish red), and turquoise (light blue) harmoniously with the luster of gold.

The outstanding quality of all these pieces shows that under Tutankhamun the Egyptian goldsmith's art had reached a high point in terms of perfection, harmonious design, and the combination of the available materials. Despite the rich variety and worthiness of all the treasures found and excavated in Egypt previously, what would we have missed if Carter had not discovered the tomb of Tutankhamun?

The Fading of Egyptian Gold Culture

The only completely undisturbed royal tomb in Egypt contained the gold mask of Psusennes I (1039–991 BC) from the Twenty-first Dynasty (plates 10, 55). This piece, which is strikingly beautiful in its artisanship, covered the face of the pharaoh's decayed mummy, which had been placed in a silver sarcophagus with gold ornamentation. Silver objects were extremely rare in ancient Egypt, since the metal was not found there and had to be imported. However, the rulers of later dynasties esteemed gold and precious stones just as much as their predecessors. This is clear from the group of three gold figures of the gods Osiris, Horus, and Isis with a stele of lapis lazuli (plate 56), taken from the looted royal tomb of Pharaoh Osorkon II (874–850 BC).

The splendor of the pharaohs and the influence of the Egyptian empire declined gradually, beginning in the eighth century BC, when Egypt had to fend off the growing threat from Assyrian, Babylonian, and Persian expansion. The conquest of Egypt by the Persians in 535 BC did not yet mean the end of the age of pharaohs, however, for the Egyptian rulers continued to enjoy a certain independence under relatively tolerant Persian sovereignty. When Nectanebo II (360–343 BC) hired twenty thousand Greek soldiers to free his country from the Persian yoke, he had gold coins minted to pay the foreign troops. In their choice of motifs these coins were modeled on the staters of Athens, though they were distinguished by a hieroglyphic inscription NFR NB (good money). Shortly thereafter began the

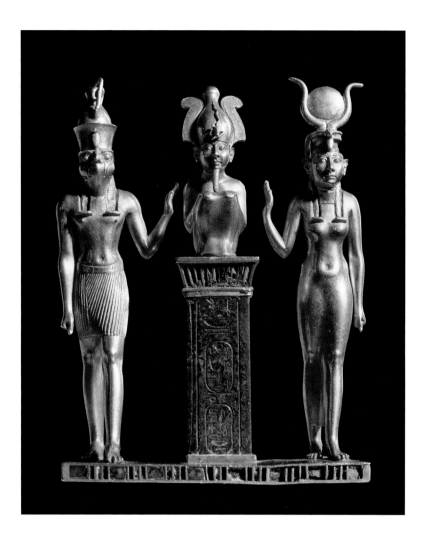

◁ 56. Small sculpture or pendant, dedicated to Osorkon II, Third Intermediate Period, Twenty-third Dynasty, 874–850 BC; gold, lapis lazuli, red glass, height: 3⁹/₁₆ in. (9 cm), width: 2⅝ in. (6.6 cm). Musée du Louvre, Paris.

This sculpture, depicting Osiris on a pedestal of lapis lazuli, flanked by Horus and Isis, is probably from the plundered royal tombs of Tanis. Osiris is supposed to symbolize King Osorkon II, toward whom the standing goddesses are gesturing with outstretched hands. The combination of gold and lapis lazuli had a tradition in Egypt dating back to around 3000 BC.

▽ 57. Octadrachm, obverse: head of Berenice II, probably minted in Ephesus under Ptolemy III, 246–221 BC; gold, 1 oz. (27.73 g). Münzsammlung, Staatliche Museen zu Berlin.

A characteristic feature of Ptolemaic coinage was the issuing of large gold pieces in whose designs masterly coin cutters often alluded to the divine origin of the ruler. Berenice II, represented in right-facing profile with diadem and veil, was the wife of King Ptolemy. In accordance with the Egyptian tradition, male heirs to the throne generally married one of their sisters, to keep the royal blood pure and to avoid severing the ruling house's bonds to the gods.

triumphant march of Alexander the Great, who was viewed as the incarnation of a new pharaoh and divine being when he arrived in Egypt in 323 BC. During a brief heyday under his successors, the Ptolemies, magnificent gold coins (plate 57) were produced in numerous large strikings that represent another distant echo of an advanced culture for which gold was always more a symbol than a material.

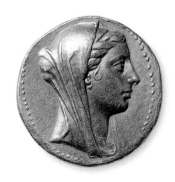

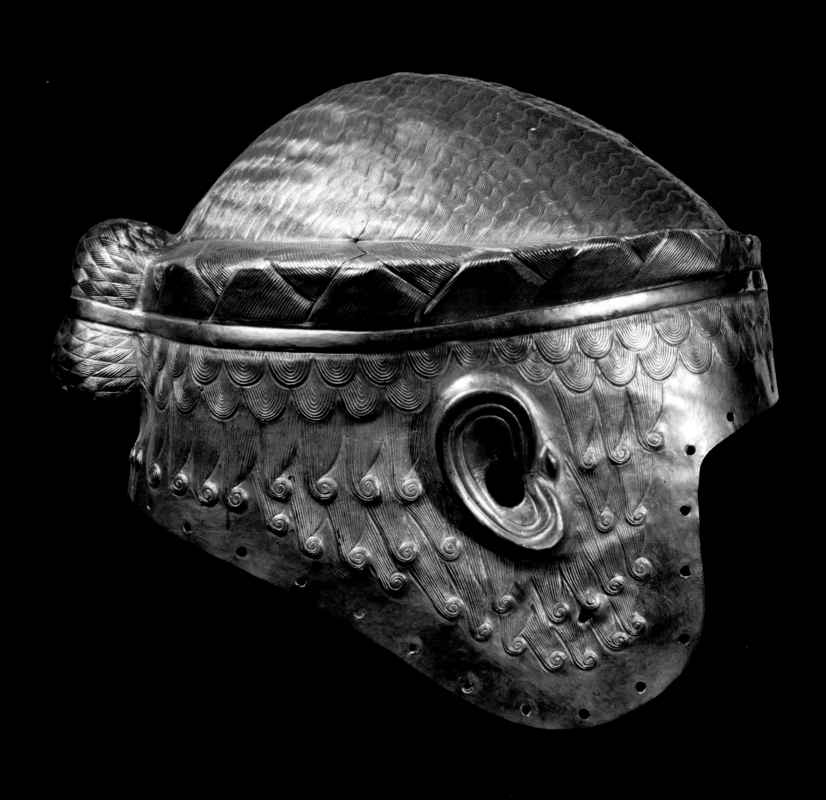

CHAPTER 3

✻✻✻✻✻✻✻✻✻✻✻✻✻✻✻✻✻✻✻✻✻✻✻✻✻✻✻✻✻✻✻✻✻✻✻✻✻✻✻

The Ancient Near East

SELF-PRESENTATION AND DIVINE RITES

MESOPOTAMIA: THE LAND OF TWO RIVERS

In the land between the Tigris and the Euphrates, relics from early cultures date back to the third millennium BC (plate 60). The Sumerian city-states near the confluence of these rivers determined the fate of the Land of Two Rivers between 3200 and 2360 BC (plate 59). Then came the Akkadian empire (2350–1950 BC), which was followed by the late Assyrian empire in the north (1800–612 BC) and the Babylonian empire in the south (1728–539 BC). The millennia-old history of this landscape, which essentially comprises present-day Iraq, was influenced by these dominating power blocs, which were often at war among themselves. Their connections and influences reached as far as Asia Minor and the eastern coast of the Mediterranean. Fertile Mesopotamia was valuable agricultural land—parts of which were irrigated naturally, others artificially—but it had no minerals,

◁ 58. Gold helmet of Prince (?) Meskalamdug, royal cemetery of Ur, Sumerian, end of the twenty-seventh century BC; maximum diameter: 9¾ in. (24.8 cm). Iraq Museum, Baghdad.
In the sarcophagus of the presumed prince, this headdress with attached ears, hammered from a sheet of gold, lay next to his head. It could have been worn as a symbol of rank or for protection in battle.

▽ 59. Map of the ancient Near East with the most important advanced civilizations of the second half of the second millennium BC.
As the map shows, the dominant power in the Land of Two Rivers and along the coasts was constantly changing during this period. The gold deposits in the so-called Eastern Desert, the highlands between the Nile and the Red Sea, are marked with a yellow point.

so its goldsmiths had to import the raw material for their creations. For that reason, solid gold artifacts are something of an exception here, and gilding and inlays of plate gold testify to a modest, economical approach to the use of precious metals.

Sir Leonard Woolley's excavations between 1922 and 1934 of the royal graves of the first dynasty of Ur caused a sensation. The burial offerings from these shaft graves (plate 62), which date to around 2500 BC, are among the oldest gold artifacts from Mesopotamia, along with contemporary finds from Tepe Gawra and the gold ornaments from Uruk from the late third millennium BC. The pieces of jewelry among the offerings of Ur reveal a high degree of both technical skill and artistic quality, and they are considered some of the outstanding masterpieces of the third millennium BC, along with finds from tombs in Assur, in central Assyria. Already in this early period, goldsmiths had learned granulation and filigree work. In addition to the methods for producing jewelry, goldsmiths must have mastered the polishing of semiprecious stones. In Mesopotamia, as in Egypt, there are early examples of royal crowns in the form of gold helmets (plate 58), which show that gold not only served religious ends but was also a means for the monarchs to display their status.

One particularly fascinating object from the necropolis of Ur is a chain of gold and lapis lazuli beads (plate 61). The combination of gold and lapis lazuli symbolized the connection of the heavens and the underworld, with gold standing for the sun and the blue lapis lazuli stones for water and the underworld. According to tradition, Inanna, the goddess of the heavens and of fertility, descended to occupy a lapis lazuli palace in the underworld. In the Sumerian-Akkadian religion she was equated with the

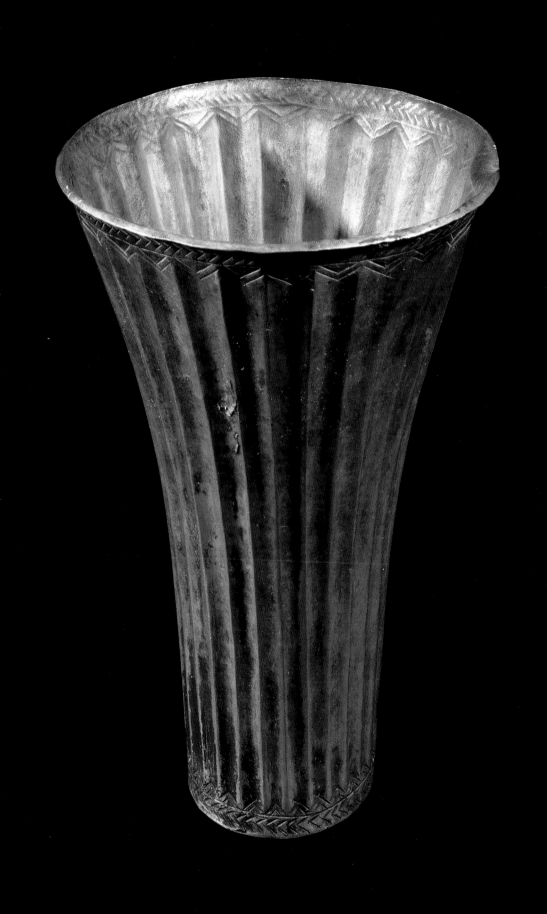

goddess Ishtar, who also represented the Venus star. Because of this association among the heavens, stars, night, and underworld, such jewelry presumably had particular importance as a cosmic symbol for Sumerian women on their journey to the hereafter, as well as representing a visual connection to the goddess of love.

Lapis lazuli must have been imported from distant Badakhshan in the Hindu Kush mountain range, but the provenance of the gold of Ur remains a mystery. It is doubtful that eastern Mesopotamia could have been the source. In Sumerian texts from the end of the third and beginning of the second millennium BC, Meluhha is specified as the land of origin for the gold, but the location of that province, which is thought to have been somewhere in the direction of India, is uncertain even today. The surviving documents indicate that King Gudea had gold brought up from a mountainous region in the form of fine dust. In the Sumerian epic *Enki and the World Order*, it is said: "Let the Magan [Oman] boats be loaded sky-high. Let the magilum boats of Meluhha transport gold and silver . . ." Because the ships from Meluhha are also mentioned in a royal inscription from the Old Akkadian period and in an administrative document, it is highly probable that at the time gold was brought to Mesopotamia by sea from India after a stop on Dilmun (present-day Bahrain).

◁ 62. Beaker, Ur, Sumerian, twenty-fifth century BC; gold, height: 5⁵⁄₁₆ in. (13.5 cm), diameter: 2 in. (5 cm). Iraq Museum, Baghdad.
This cup for festive, celebratory use captivates us with the elegance of its slender, slightly conic form, which is emphasized by the precise lines of the hammered flutes.

▷ 63. Gold dish, Ugarit, central Syria, fourteenth century BC; diameter: 6⅝–6¹¹⁄₁₆ in. (16.8–17.5 cm). National Museum, Damascus, Syria.
The outer surface of this chased dish is decorated in concentric circles with gazelles or goats, two head of cattle, two lions, palm trees and hanging pomegranates, winged hybrids, and a hunting scene. Many of the iconographic details are borrowed from Egyptian art, others from the Aegean. They testify to the influences that were assimilated especially in the arts and crafts of central Syria.

64. Seated divinity, statuette, Ugarit, central
Syria, fourteenth century BC; gilded bronze,
height: 5⁵/₁₆ in. (13.5 cm). National Museum,
Damascus, Syria.

*This votive or temple figure in bronze, with
a visible layer of green corrosion, was probably
cast with the* cire perdue, *or lost wax,
technique. Its gilding would have been applied
afterward using gold foil.*

Modern examination procedures that permit the nondestructive analysis of valuable objects have determined the composition of a tulip-shaped gold beaker from Ur. It is an alloy of about 25 percent gold, more than 50 percent silver, and 25 percent copper. Such a triple alloy has the color of pure gold, thanks to the copper content, but it also has a lower melting point than high-karat gold. The color of the metal on the outer surface of the beaker is clearly lighter than that inside, because a sophisticated technique, which entailed heating the metal and then using organic acids like vinegar to remove the black copper oxide produced by the heat, reduced the copper content while raising that of the gold and silver by about 50 percent. Once smoothed and polished, the exterior that had been treated in this manner obtained an almost silverlike luster from the gold-silver alloy, which the Sumerians evidently found more attractive than the reddish luster of pure gold. This technique, which we will encounter again much later in the pre-Columbian gold artifacts of South America and which is known as "surface enrichment," was thus already known and employed in the third millennium in the Land of Two Rivers. It was not for nothing, then, that experienced goldsmiths from Ur were considered the equals of scribes, sculptors, tailors, and practitioners of other specialized and highly respected vocations—something that was extremely unusual at the time.

The number of surviving gold objects from Assyria is rather small, and most of them come from the outlying areas, Syria and Canaan, but the Assyrian empire had trading posts beyond its borders that were important for long-distance commerce and were always in close contact with the capital, Assur. In cuneiform texts from the Old Assyrian trading center of Kültepe-Kanesh, near the central Anatolian city of Kayseri—an enclave in the heart of the land of the Hittites that predated the founding of the greater Hittite empire around 1600 BC—gold is explicitly mentioned, and there is a reference to a gold sun disk that was said to have weighed as much as one pound one ounce (500 g).

In the Land of Canaan

The Canaanites, a Semitic people, invaded the Akkadian empire several times, beginning around 2000 BC. The cities Byblos, Tyre, and Ugarit (plates 63, 64) became somewhat independent of Assyrian dominance and emerged as centers of Canaanite culture. The riches of the pharaohs were not far south of Canaan, but the influence of Mesopotamia was incomparably more powerful. Depictions on the few surviving pieces of gold jewelry from the period between the fifteenth and thirteenth centuries BC reveal an Assyrian stylistic influence. The discovery of an unusual chain made of small squares of gold, rock crystal, and amethyst (plate 65) and gold pendants (plate 66) in present-day Israel point to Canaanite production, though the pieces may also have been brought there from Assyria by traders. There are no local deposits, so the gold for producing these artifacts must have been imported to Canaan.

Cuneiform texts from archives of clay tablets in Ugarit and the northern Syrian city-states of Ebla and Mari provide information about the history of this region's culture, particularly about its economic administration, the trafficking of goods, and diplomatic relations. Considerable quantities of gold and silver were recorded, such as one tribute payment Mari made to Ebla consisting of 2,193 minas of silver (2,417 lbs. 5 oz.; 1,096.5 kg) and 134 minas of gold (147 lbs. 11 oz.; 67 kg). These precious metals may have come via Dilmun from the land of Magan, along with tin and lapis lazuli and perhaps copper as well. The gold may also have come from Asia Minor, as both gold and silver were said to have been mined in Anatolia and its mountains and exported to the south as early as the third millennium BC.

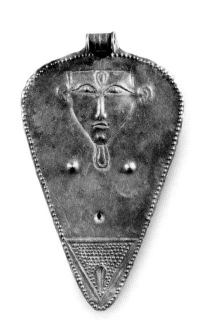

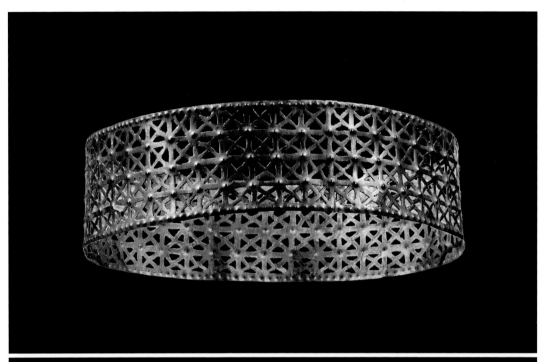

The Sun Metal of the Hittites

In Palestine, the northern outskirts of the empire of the pharaohs met the southern regions of the Hittite empire of central Anatolia (sixteenth to thirteenth century BC). The relations between the two were sometimes neighborly and friendly, sometimes aggressive and hostile. Their respective conceptions of the gods and the hereafter were fundamentally different, but the sun, which plays such a large role in iconography throughout the ancient Orient, was worshipped equally by both sides. The Hittites viewed the sun and the sun god as the highest authority, to whom the earthly kings had to subordinate themselves—to consider themselves equals would have been presumptuous—and hence on numerous rock reliefs kings are depicted smaller than, and in typical postures of adoration before, the towering figures of the gods.

Gold was esteemed by the Hittites as a metal symbolic of the sun, but relatively few artifacts have been found thus far. These include several figures of the sun goddess Arinna-Wurusemu with a large headdress reminiscent of a halo, as well as other figures of gods in solid gold (plate 70) that were clearly modeled on the above-mentioned rock reliefs. By contrast, the pre-Hittite culture of Alaca Höyük is well documented, and from it survive chased gold vessels and beakers (plates 68, 69), some with delicate grooved decorations; punched diadems (plate 67); and cast statues. All these objects came from thirteen royal graves dating from the

70. Pendant, Yozgat, near Boğazköy, Turkey, Hittite, sixteenth to thirteenth century BC; solid gold, height: 1½ in. (3.9 cm). Musée du Louvre, Paris.
The Hittites were experienced metalworkers who used not only bronze but also iron. It is surprising that gold objects have rarely been found in the areas settled by the Hittites. This figurine of a god with a conic crown, produced by lost wax casting, resembles its precursors in stone and suggests the popularization of votive offerings, as well as mass production.

71. Pendant earring, Troy II, Heinrich Schliemann excavation, 2300 BC; replica: gilded silver. Museum für Vor- und Frühgeschichte, Staatliche Museen zu Berlin.

Most of Schliemann's finds in Troy were unadorned vessels like ewers or beakers. This pendant earring with small individual gold elements is an exception in that it is executed with delicate detailing.

second millennium BC. The artists would not have lacked gold, as there is evidence of many local deposits.

THE TREASURES OF TROY

Any discussion of the gold finds of Anatolia inevitably recalls the treasures of Troy excavated by Heinrich Schliemann. When he came upon fantastic gold objects there in 1873, he thought he had discovered the legendary treasure of Priam (plate 72). He was, however, mistaken in dating his find to the time of Homer's *Iliad*. We now know these finds to have been approximately a thousand years older; they belong to the early Bronze Age, in the third millennium BC. Since the Second World War, the original pieces have not been accessible, but replicas faithful to the originals document the mastery of their artisanship (plate 71), including a gold pendant for a royal woman, a votive jar, and other vessels and jewelry of gold and electrum.

Troy, the site of numerous excavation campaigns in recent years, has yet to provide any other treasures. The find of a Hittite seal has at least revealed trade relationships with the great empire of central Anatolia. A connection between the port and trading city of Troy and the Hittite hinterlands would no doubt provide interesting perspectives. Asia Minor, with its rich metal deposits, may have functioned as a link between Mesopotamia, Canaan, Syria, and Egypt in respect to both the history of those cultures and the goldsmith's art. In any case, as early as the third and second millennia BC in those countries, gold was fulfilling its role as the metal of choice for the self-presentation of rulers, their favorites, and selected others, as well as for the visible adoration of the gods and the assurance of a brilliant afterlife.

72. Sophie Schliemann wearing gold jewelry from the "Treasure of Priam"; colored photograph, 1882.

Schliemann's wife is wearing jewelry excavated by her husband at Troy to give the viewer an impression of the effect of these precious objects.

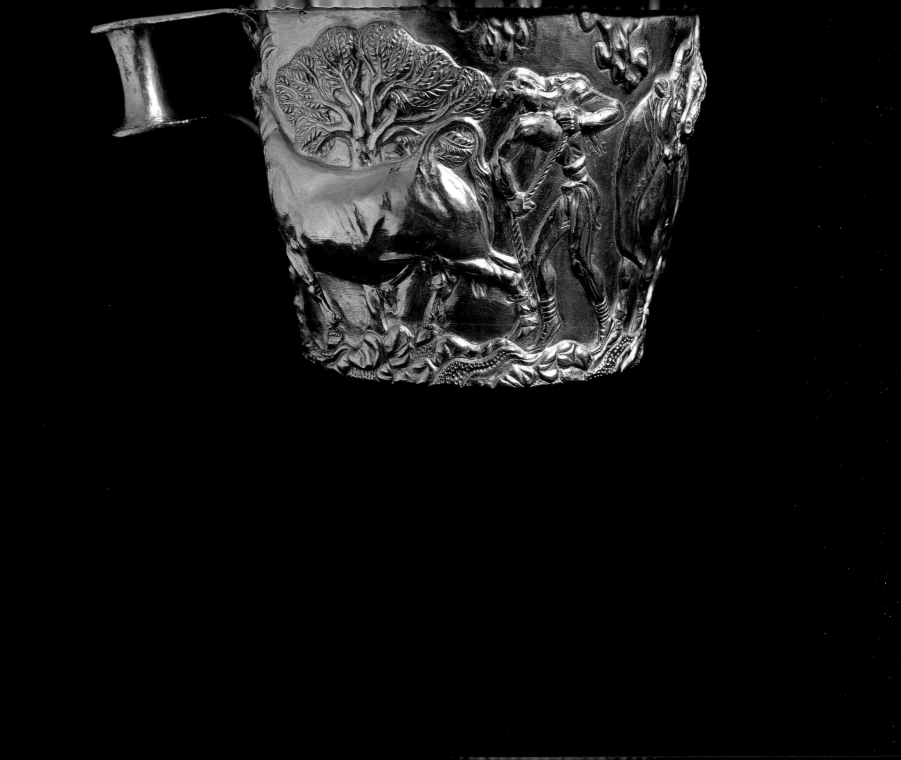

✿✿

The Minoans and Mycenaeans

JOIE DE VIVRE AND THE CULT OF RULERS

GOLD RINGS FROM ANCIENT CRETE

According to myth, King Minos I came from Egypt to Crete in the third millennium BC and founded the ruling family to which the Minoan culture owes its name. In the Mediterranean region, this advanced civilization, which lasted from 2600 to 1425 BC, was already a dominant influence during the Bronze Age. For more than a millennium, it controlled the seas with its fleet and had trade connections to the east and south as far as Cyprus, the Syro-Palestinian coast, and, above all, Egypt, and to the north as far as Transylvania and central Europe. Trade brought every conceivable sort of good and raw material to Crete: gold came from deposits on the Iberian Peninsula, on Cyprus, in Egypt, and perhaps in the Balkans, as Crete itself had no appreciable mineral resources.

Thanks to such imported metals, the Minoans were able to develop handicrafts that in many fields were exemplary for the time. Their goldsmiths mastered both granulation and cloisonné decoration, as well as the chasing of detailed reliefs on vases. However, as impressive as the remains of Minoan architecture are, few of their gold artifacts have survived. Among those that have been recovered are gold rings, of which the Minoans, who appreciated sensual pleasures, were especially fond. These engraved signet rings provide clues to the features of the culture and of the people who wore them (plate 74), and are thought to have been status symbols. To judge from them, the Minoans were as thin as rails and all but indistinguishable from lithe animals in their grace. Oddly, on one gold ring from Knossos (c. 1600 BC), all of the human figures, and even the goddesses, have bee's heads.

ARISTOCRATIC PREPARATIONS FOR THE HEREAFTER

When Crete's domination of the sea ended, nautical and economic supremacy transferred to the Mycenaeans on the Greek mainland, who also subscribed to the culture of gold. The Mycenaean civilization developed over the course of the sixteenth century BC as the native Helladic culture (plate 78) was permeated by the more advanced culture of Minoan Crete. Mycenae, the fortress and city on the northeast coast of Argolis after which the Mycenaeans were named, was one of the most important sites of the Bronze Age in Greece, but it survived Cretan culture by only two centuries and was taken by the Dorians around 1200 BC.

◁ 73. Vaphio cup (one of two), Laconia, Peloponnese, *tholos* tomb, Mycenae, 1500 BC; gold, repoussé, diameter: 4¼ in. (10.8 cm). National Archaeological Museum, Athens.
　　Among the most beautiful finds of the work of Mycenaean goldsmiths are the two Vaphio cups. Vivid sequences of images are rendered in repoussé around the entire cup.

▽ 74. Minoan signet ring, Isopata, near Knossos, fifteenth century BC; gold. Archaeological Museum, Heraklion, Crete.
　　The central field of this signet ring depicts women in an ecstatic ritual dance. The smaller figure may be a goddess who has descended from the heavens. This engraved ring is a masterpiece of the art of Minoan goldsmiths from the Late Minoan II period.

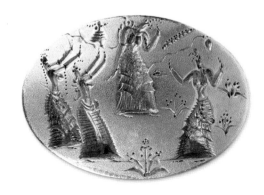

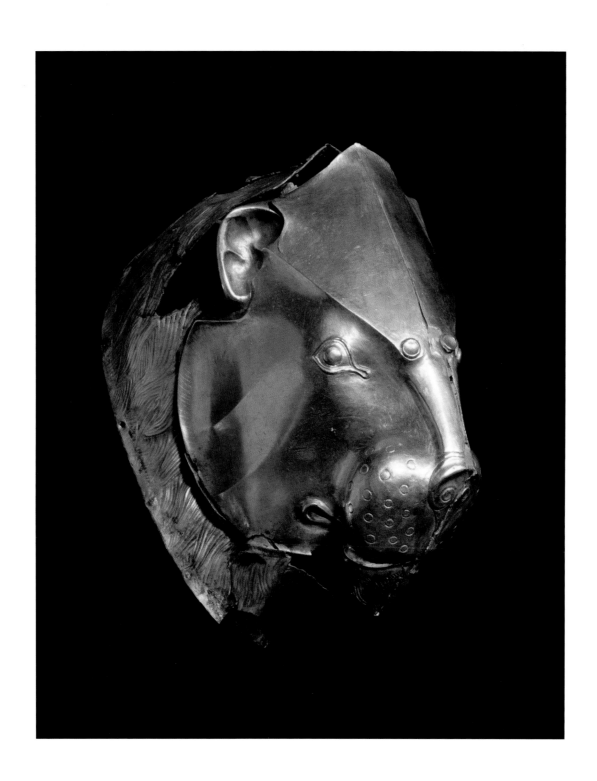

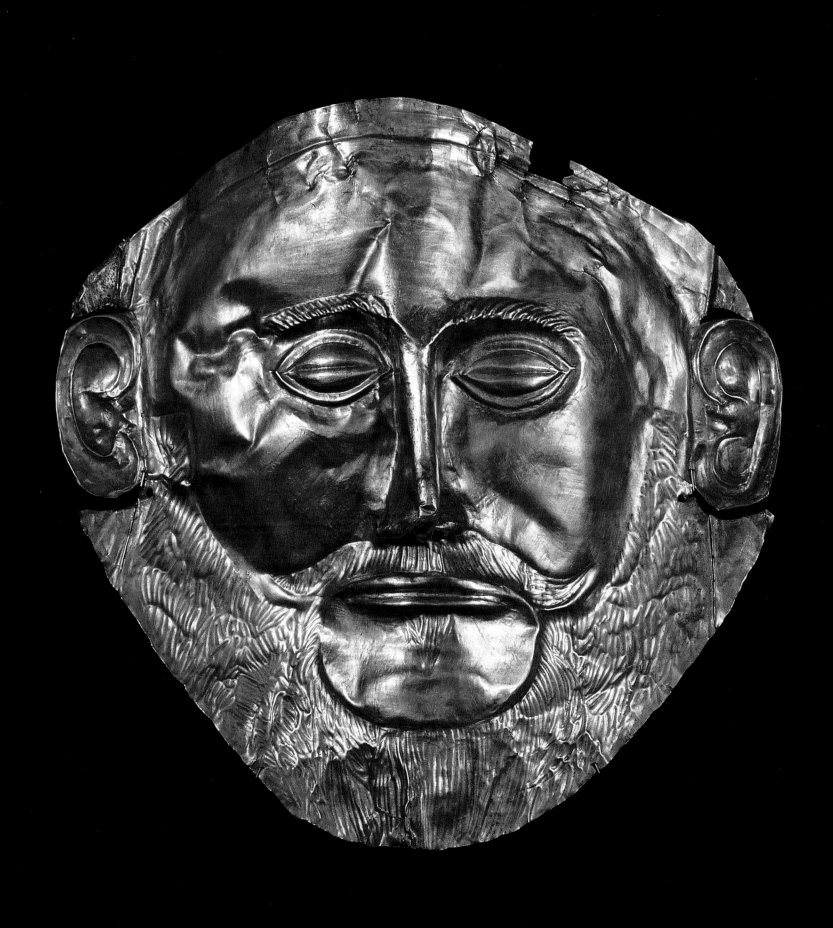

The Mycenaeans had little difficulty obtaining gold, as presumably they had been able to prospect and mine it from deposits in the Balkan, Carpathian, and perhaps even the Sudeten mountains since about 2000 BC. The gold artifacts they left behind are incomparably more numerous than those left by the Minoans. There are outstanding chased vessels dating from the middle of the second millennium BC, including the two Vaphio cups found near Sparta (plate 73) with depictions of men hunting wild animals; they are the most valuable objects in the National Archaeological Museum of Athens. Dagger blades with multicolored inlay work in gold, silver, and copper (plate 77), and gold weapon hilts, crowns, hairpins, earrings, necklaces, and drinking vessels (plate 75) are among the attributes that adorned an aristocratic society that used gold as a status symbol and means to display its wealth.

During excavations at Mycenae in 1876, the archaeologist Heinrich Schliemann found a wealth of burial objects in the royal tombs. The most magnificent piece, the gold death mask of a warrior (plate 76), of which Schliemann said, "I have gazed upon the face of Agamemnon," dates from around 1600 BC. In the first circle of graves alone, objects with a total weight of over twenty-six pounds (12 kg) were recovered, including five more gold masks for adults and two children's skeletons entirely covered with sheet gold. Veiling faces and bodies with gold was supposed to preserve them for eternity. This radiant presentation made the dead look like figures of light. The death masks, modeled on their Egyptian precursors, suggest portrait likenesses and are among the finest examples of the art of Helladic-Mycenaean goldsmiths. Until its decline, the landscape of Argolis with Mycenae was—not least thanks to its gold artifacts—one of the centers of Bronze Age culture on the European mainland.

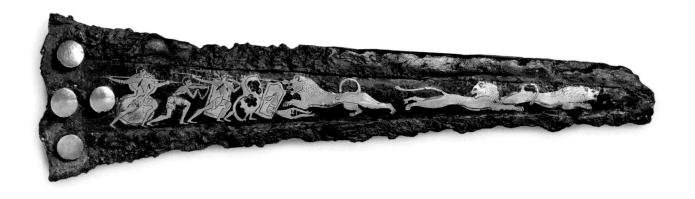

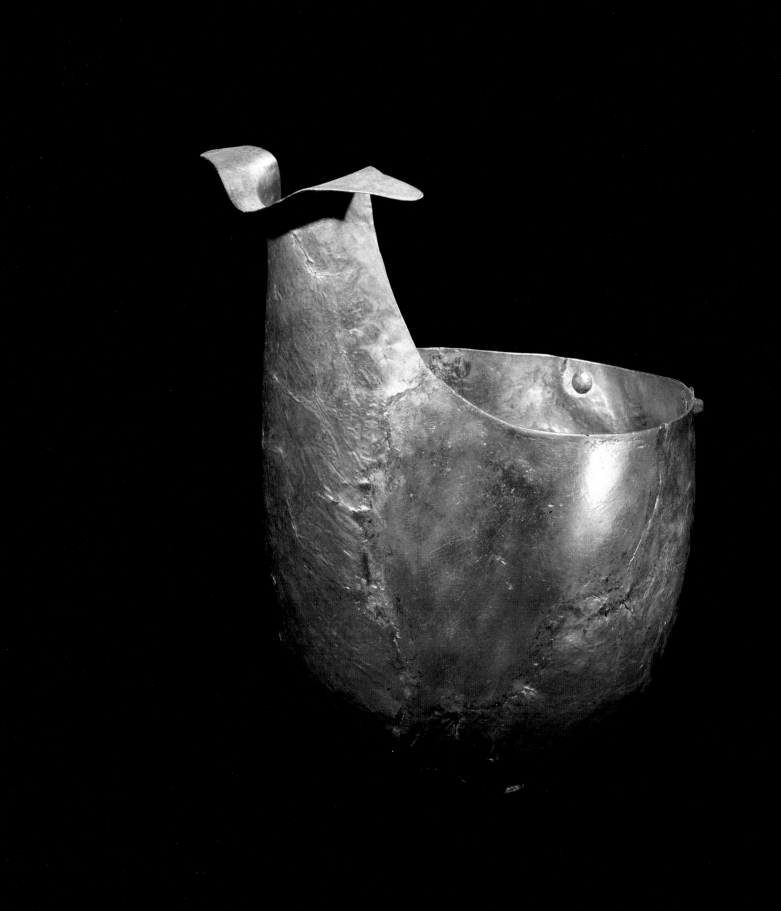

600 400

The Eastern Mediterranean

The Celts

The Etruscans

Rome

200 0 200

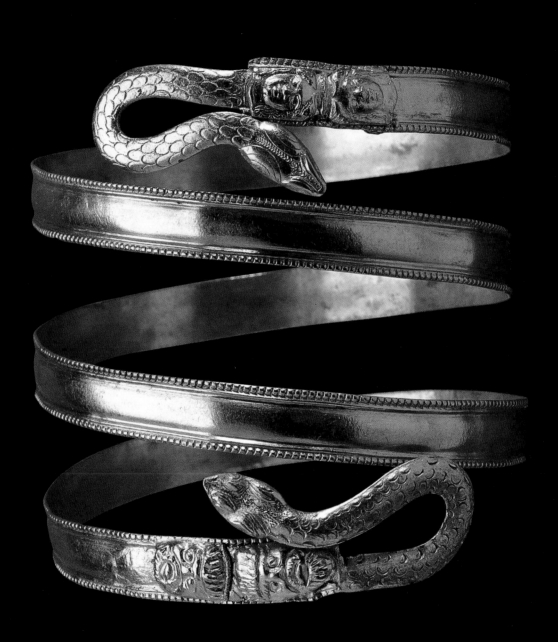

CHAPTER 5

✤❀✤

The Eastern Mediterranean

FROM THE RICHES OF CROESUS TO THE TOMBS OF SCYTHIA

THE RICHES OF CROESUS: THE LYDIAN EMPIRE

In the first millennium BC and toward the end of the archaic period (around 500 BC), two powers stood opposed on the eastern Mediterranean, battling for supremacy: Greece and Persia (plate 84). A third player in this struggle for power was the Lydian empire, which extended from the western coast of Asia Minor as far as central Anatolia. Its proverbial wealth in gold has been handed down in the story of the mythological figure of King Midas, who asked Dionysus to give him the gift of transforming everything he touched into gold. The fulfillment of this wish soon led to frustration, but the god granted him release through a bath in the Pactolus River, which since that time, the legend says, bears gold in its currents.

King Croesus, the man of the proverbial phrase "rich as Croesus," was no fairy-tale figure, however. The last king of the Lydians from the Mermnad dynasty, he lived from 595 to c. 547 BC and was wealthy beyond measure, thanks to his country's mineral resources. By offering lavish sacrifices at Delphi, Didyma, and Ephesus, he hoped to gain influence and support. When he wanted to attack the Persian empire, he first asked the oracle at Delphi what would come of his plan. He was told: "If you cross the Halys River [which marks the border between Lydian and Persian territory], you will destroy a great empire." On the assumption that this meant the empire of his enemy, he began his campaign confidently. Only after he had been defeated catastrophically and taken prisoner did he realize which empire the oracle had truly meant.

THE FIRST MONEY

Croesus is considered the originator of coined money, as he had coins with heads of lions and rams (plate 81) minted from the gold of the Pactolus River, which flowed through the Lydian capital, Sardis. These early examples were irregular in form and at first were made from natural gold, usually electrum with a high silver content. Excavations in Sardis have uncovered sites for refining gold by cementation, a process in which the natural argentiferous gold was heated with salt to remove the silver. Once they understood how to purify precious metals, the Lydians circulated coins with specific alloys of gold and silver as well as of pure silver—and this marked the beginning of bimetallic currency. These coins, which exist in many editions, and whose beautiful designs depict gods and animals,

◁ 79. Bracelet, Roccagloriosa, La Scala, tomb 9, Greek, first half of the fourth century BC; gold, diameter: 2⅝ in. (6.5 cm). Soprintendenza Archeologica, Salerno, Italy.

This elegant piece of jewelry was presumably worn on the upper arm and is carefully forged from a solid bar. The snake motifs at the ends of the spiral were worked out of the solid piece and then engraved and chased. The snake was considered a tutelary spirit for the home and was thus supposed to protect the bracelet's wearer from harm.

▽ 80. Phanes stater, minted in Ephesus (?), c. 630 BC; electrum, size: 0.63 × 0.95 in. (1.61 × 2.42 cm), weight: 0.5 oz. (14.3 g). Geldmuseum, Deutsche Bundesbank, Frankfurt am Main.

This electrum coin is among the earliest minted in western Asia Minor. The obverse depicts a stag walking. The inscription, in mirror reverse, reads, "I am the symbol of Phanes." The name Phanes is difficult to interpret; it could refer to a wealthy private citizen who had this unique coin type minted.

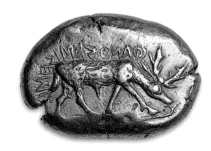

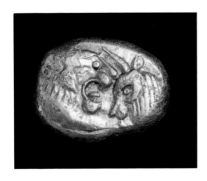

81. Stater (*kroiseios*) of King Croesus of Lydia, minted in Sardis, c. 550 BC; gold with seal, diameter: ½ in. (1.32 cm), weight: 0.28 oz. (8.11 g). Geldmuseum, Deutsche Bundesbank, Frankfurt am Main.

The obverse shows a lion, the coat of arms of the legendarily rich ruler Croesus, and to its right the front part of a bull. These animals are symbols of power, strength, courage, and perseverance.

▽ 82. ¹⁄₉₆ stater, mint location unknown, c. 600–550 BC; electrum, diameter: ³⁄₁₆ in. (0.48 cm), weight: 0.006 oz. (0.18 g). Geldmuseum, Deutsche Bundesbank, Frankfurt am Main.

The ¹⁄₉₆ stater was the smallest denomination electrum coin. This coin—decorated here with a half-moon-shaped ornament—was nonetheless rather valuable, but it is not known whether it was used as currency. Its small size may have suited it to the rounding of weights when measuring larger sums.

▷ 83. Chain with pendants, Hellenistic, late third to first century BC; gold, gold beads, garnets, length: 21⁵⁄₁₆ in. (54.1 cm). Indiana University Art Museum, Bloomington; Burton Y. Berry Collection.

The pendants on this gold necklace with small but clearly recognizable knots of Hercules include teardrop- and disk-shaped elements, a horseshoe, a fig, and a small lunula—*a hodgepodge of various talismans that the wearer clearly hoped would protect her.*

date from the fifth century BC and were produced primarily in Greek colonies on the coast of Asia Minor. In their composition they conformed precisely to the laws for coins that had been established for the Mediterranean region. These laws prescribed exact weights for the gold, silver, and copper content, though the gold content specified gradually decreased to well under 50 percent. Mytilene, the capital of the island of Lesbos, and Phocaea, a port city in Asia Minor near present-day Izmir, were famous for their small gold coins bearing miniature designs with realistic details. Known as *hektes*, these coins weighed about a tenth of an ounce (2.5 g). Coastal cities also produced the smallest known gold coins: pieces with recognizable imprinting—such as a crescent moon—that weigh about four thousandths of an ounce (0.1 g) and are just a sixth to a fifth of an inch (4–5 mm) in diameter (plate 82). They correspond to one ninety-sixth of a stater, the standard coin of the time, which weighed 0.39 ounces (10.92 g) under the Lydian standard. As coins of precious metal, especially gold, became more widespread, for the first time in early history people who did not belong to the ruling classes—traders, merchants—came into contact with precious metals.

THE TREASURIES OF DELPHI: GOLD IN CLASSICAL GREECE

In comparison to the Mycenaean period and the rich legacy of the Hellenistic period, the goldsmith works from the classical period in Greece are not very numerous. The Greek motherland had very little gold. In other areas the precious metal was more common, especially to the north in Thrace and on Cyprus, with its Oriental influence. Herodotus reported that Polycrates, the tyrant of Samos who was executed in 522 BC, had gold mines on the Cycladic island of Siphnos. Recent research has recovered traces of antique mines there, but they are not the ones that Herodotus mentioned, which were supposedly below sea level. It is, however, certain

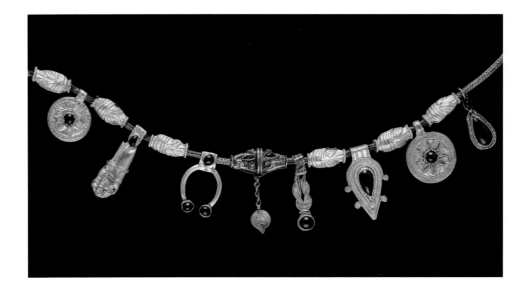

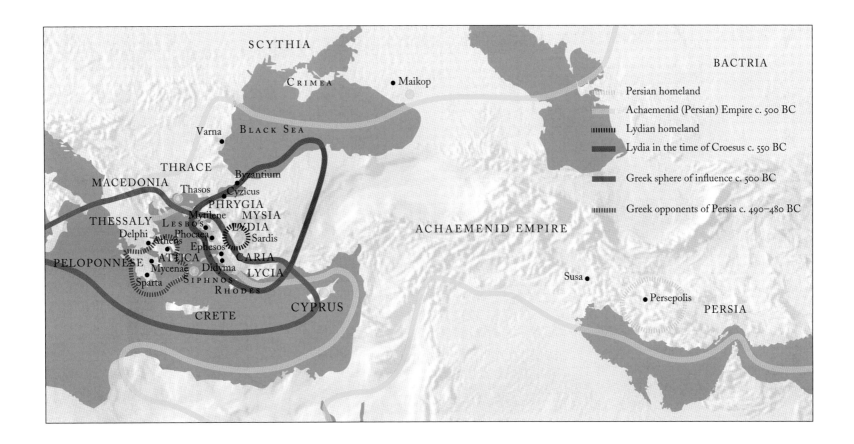

that the residents of Siphnos built a treasury in Delphi in gratitude for their deposits of precious metals. But fate did not reward them for their offerings; no trace of their gold mines survives in history.

Delphi was renowned throughout the ancient world as a shrine, the site of a famous oracle, and the location of treasuries. The autonomy of the region guaranteed free access to the extensive religious and temple area with the treasuries of Syracuse, Thebes, Megara, Siphnos, Sicyon, Tarentum, Cnidus, and the other Mediterranean cities and communities that Delphi served as a secure, autarkic bank. By making deposits there, one purchased the goodwill of the gods, especially of Apollo, and the favor of the oracle. Gyges of Asia Minor, the progenitor of the Mermnad dynasty of Lydia, brought six gold mixing vessels to Delphi as early as about 670 BC. His descendant, Croesus, donated to the shrine the enormous sum of 4,000 talents of gold—an Attic talent weighed about fifty-seven pounds twelve ounces (26.2 kg), so this came to roughly 115 tons (105 MT). After the Battle of Marathon in 490 BC, the Athenians built their own treasury for the tribute paid by the Persians. In Athens gold served a double function: gilded statues and offerings gave the precious metal, which was assigned to the divine sphere for its unique qualities, a religious significance. The poet Pindar's words should be understood in that light: "Gold is the child of Zeus; neither moth nor weevil eats it; but it, mightiest of possessions, overpowers the mortal mind." Nevertheless, from the reign

84. Map of Greece, Asia Minor, and the Middle East, c. 500 BC.

This superposition of the borders of the most important empires helps clarify the conflicts of the period. Important gold mines and the site of the alluvial gold deposits on the Pactolus River in Asia Minor are indicated by yellow points.

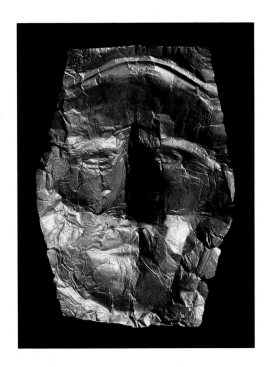

85. Death mask, tomb chamber, Sindos, Greece, late sixth century BC; gold leaf on bronze (?). Archaeological Museum, Thessaloniki, Greece.
This artifact continues an ancient tradition of covering the face, and often the upper body, of a deceased ruler with a gold mask.

▷ 86. Gold death wreath, Armento, southern Italy, Greek, fourth century BC. Staatliche Antikensammlung und Glyptothek, Munich.
This wreath of small individual elements cut from thin sheet gold and decorated by chasing and hammering served as a burial object. Oak branches intertwined with ivy and acanthus, flowers, bees, palmettes, and rosettes combine to form a fragile ensemble. The figure of Nike that crowns the wreath is accompanied by two winged genii.

▷▷ 87. Diadem, Ginosa, Italy, Chiaradonna, Girifalco tombs, Greek, fourth century BC; gold filigree work, length: 12¹¹/₁₆ in. (32.2 cm). Museo Archeologico, Tarentum.
The knot of Hercules found on this diadem is made of particularly fine gold filigree. Even the tiniest details—barely visible to the naked eye—are meticulously executed.

▷▷ 88. Earrings, Tarentum, Greek, late third century BC; gold, height: 2⅜ in. (6.1 cm). Private collection.
The countless details of these earrings, including appliqué of filigree wire, granulation, and small cast objects, are affixed to a sheet of gold in the shape of an inverted pyramid, which is decorated along its edges with pearl wire and attached to a disk. This profusion of forms was in keeping with the taste of the period.

of Solon (594 BC), every free citizen who could afford it was permitted to possess gold jewelry as a private individual; only excess was scorned under Athenian democracy. This privilege did not exist in Sparta, where the use of the precious metal for personal ends was strictly forbidden.

In the fifth century BC, the Greeks developed the so-called chryselephantine technique, which combined gold and ivory as a way of showing gold off to its best advantage. Ivory was used for the surface or "skin" of a statue, and the garments and hair were made of sheet gold or gold wire. Examples of chryselephantine sculptures include a cult image of Hera and the statues of the Dioscuri in Argos. The last work produced by Phidias during his major period of creativity, between 460 and 430 BC, was a chryselephantine statue of a seated Zeus at Olympia that was nearly forty feet (12 m) tall. A chryselephantine statue of the Athena Parthenos of approximately the same height was clad in gold sheets weighing 44 talents (1.3 tons, or 1.15 MT), which could be removed in pieces as a weight check. The gold also served as a reserve for the state and had to be available for emergencies.

The supply of gold in Greece changed radically toward the end of the fourth century BC. The four Sacred Wars, or Phocaean Wars, were fought to ensure the independence of the Delphic shrine and its temples and treasuries. In the final war (339–338 BC), Philip II of Macedonia was victorious, and he seized the treasures of the temple and completely reorganized the structure of the Greek state. His own gold resources on Mount Pangaion, which supplied him with a thousand talents of gold (roughly 29 tons, or 26 MT) annually, together with the gold of Delphi, provided a solid basis for his economic and military superiority. If one is to believe the reports of Diodorus, Alexander the Great, Philip's son, managed to add to that store with enormous spoils of 750,000 talents (22,000 tons, or 20,000 MT) when he conquered the Persian empire. His death in 323 BC marked the end of Greece's classical period, and in the years that followed the Greek peninsula declined, becoming a relatively insignificant power in the Hellenistic world. The Roman commander Aemilius Paullus finally defeated the Greeks in 168 BC, in the second Macedonian War, and turned Greece into a province of the Imperium Romanum.

THE PINNACLE OF THE HELLENISTIC CRAFTS

During the Hellenistic and, later, the Roman period, the goldsmith's art was distinguished by richly varied design. The goldsmith was much more an artist than an artisan. Gold ennobled the person who wore it, and, as a burial offering, it ensured him a worthy place in the hereafter. Greek women wore ear pendants, necklaces, and bangles that were often combinations of sheet gold chased with figural reliefs and filigree and granulation decorations (plates 79, 88). It was the practice to bury the dead with eyes and mouth shut and covered with gold foil so that the soul would remain in the body (plate 85). Laurel and oak wreaths of gold as well as gold diadems were considered symbols of high regard in earthly

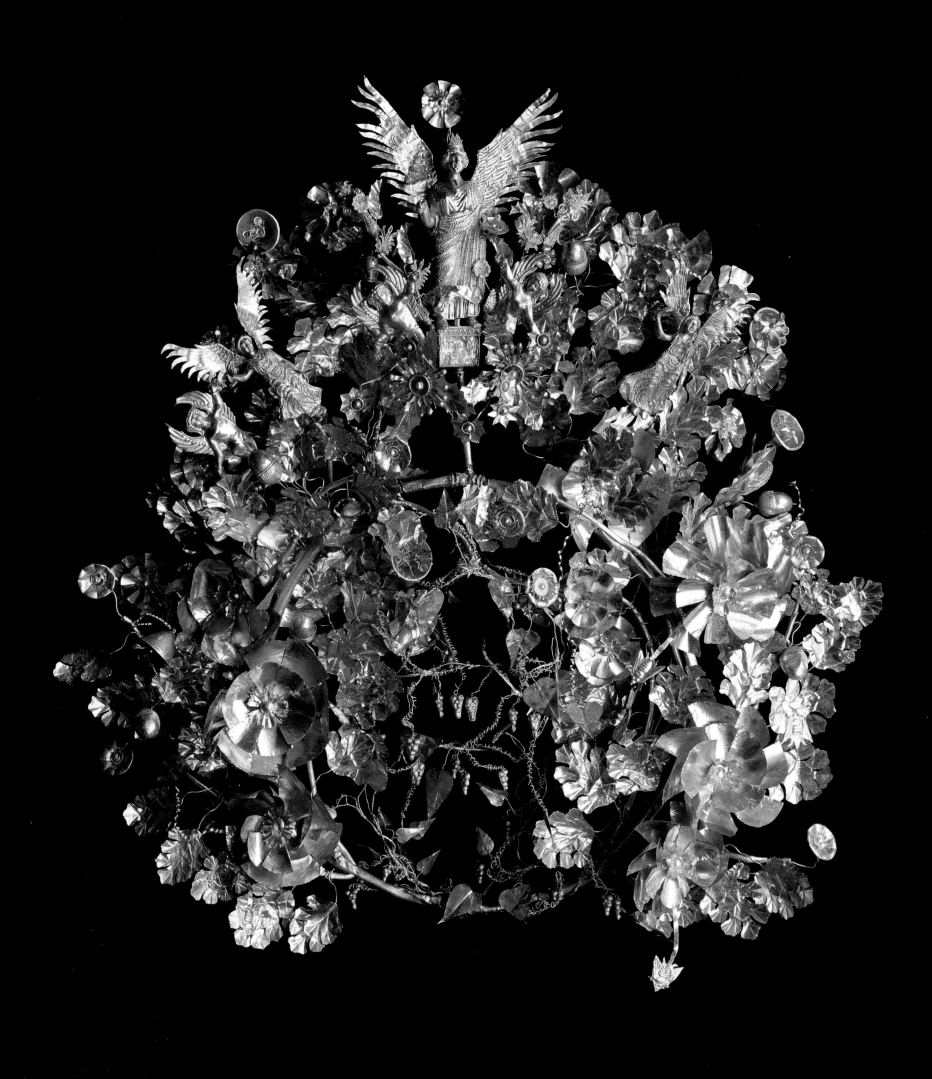

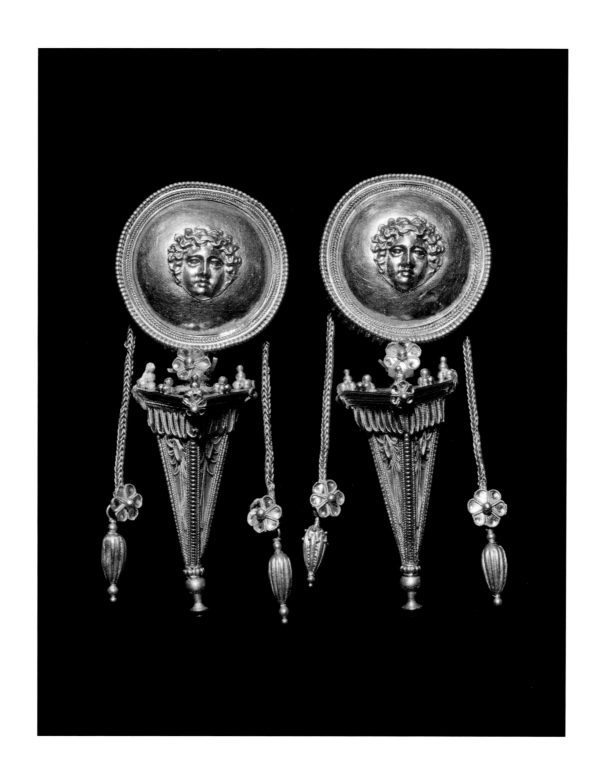

89/90. *Hektrolitron* (hundred liters), obverse: Artemis-Arethusa, reverse: Hercules fighting the Nemean lion, minted in Syracuse, Sicily, c. 413–406 BC, signed by Euainetos (c. 413–406 BC); gold, 0.2 oz. (5.8 g). Münzkabinett, Staatliche Museen zu Berlin.

After the victory over the Athenians in 413 BC, gold coins were minted in Syracuse for the first time. The head of the goddess Arethusa on these coins is extraordinarily beguiling. The reverse, showing Hercules wrestling with the Nemean lion, is perfectly composed within the round frame of the planchet.

91. Stater, obverse: head of Apollo, Macedonian, minted c. 336 BC under Philip II (359–336 BC); gold, 0.3 oz. (8.56 g). Münzkabinett, Staatliche Museen zu Berlin.

Despite their great power and the rich gold deposits in the areas they ruled, for a long time the Macedonian kings hesitated to place their own images on coins. This fine gold stater displays almost individualized features, which used to be interpreted as a portrait of the young Alexander the Great.

92. Stater, obverse: Pan, minted in Pantikapaion (now Kerch, on the Black Sea in Ukraine), 350–320 BC; gold, 0.32 oz. (9.10 g). Münzkabinett, Staatliche Museen zu Berlin.

The magnificent gold staters of the colony of Pantikapaion are entirely marked by the spirit and style of the Greek motherland. The ivy-wreathed head of Pan is also a kind of coat of arms for the city, as Pan was its protector.

93. Stater, obverse: head of Zeus with laurel wreath, minted in Lampsacus, Mysia, Asia Minor, 350–340 BC; gold, 0.3 oz. (8.41 g). Location unknown.

The representation of the god, with his expressive profile, makes the transition from the Archaic to the Classical style clear. The place of minting, Lampsacus, was once a flowering city on the east coast of the Hellespont whose goldsmith's art had a distinguished reputation, to which the die cutter of this exceedingly rare and splendid coin did full justice.

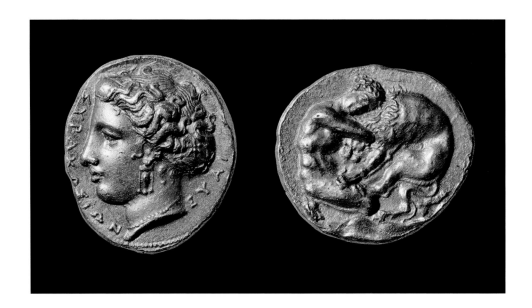

life. They were placed in the grave with the deceased so that they would be esteemed and honored in the hereafter as well (plate 86).

The Hellenistic era was unsurpassed in terms of the technical skill and inexhaustible invention of its goldsmiths. The centers of production in Macedonia, eastern Ionia, and Attica specialized in exquisitely produced gold necklaces and bands of woven wire or hollow balls, decorated with palmettes, spirals, blossoms, and rosettes, as well as figural pendants. Jewelry with the so-called knot of Hercules (plate 87) was particularly popular: fine gold wire was woven or plaited into bands and belts whose ends could be terminated by two intertwined loops (a reef knot). These were worn around the head and neck but also wrapped around the thigh or hips. The name *knot of Hercules* derives from the brooch that Hercules used to fasten the lion's pelt he wore. Gems were often combined with gold, and chains with granulation were especially prized for that purpose (plate 83). Goldsmiths also produced sheet gold fittings for weapons, armor, and boxes for storing valuables. Gold appliqué on clothes and fabrics embroidered

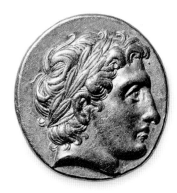

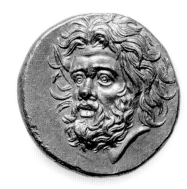

94. Decorative clasp, Letnitsa find, Bulgaria, Thracian, 400–350 BC; gilded silver, height: 2 in. (5 cm). Historical Museum, Lovech, Bulgaria.

This silver sheet shows a woman with a three-headed snake in repoussé. Here too the snake motif gives the piece an amulet-like character that warded off danger and protected its bearer. The clasp is evidently incomplete, as the object breaks off abruptly on the left edge.

with gold were precious fashion items. Vessels and tableware of silver that was wholly or partially gilded were also produced for export, so that the work of Greek goldsmiths found its way beyond Greek borders. Phoenician sailors and traders brought valuables from Greece along with other goods to the port cities of northern Africa, Spain, Sicily, and other countries.

Gold coins were minted in the heart of Greece as early as about 550 BC, on the island of Thasos—presumably using gold from local deposits—but relatively little gold was used for coins in the Greek motherland or its colonies in the Mediterranean (plates 89–93). Silver money was far more important and widespread. Yet both gold and silver coins from the Hellenistic period are fascinating works in miniature and an eloquent testimony to the skills of Greek die cutters.

THE NECROPOLISES OF THRACE

The settlements of Thrace date back to the early Bronze Age, and so does their use of metals, especially gold. In the first millennium BC there were some ninety tribes in an area centered in present-day Bulgaria but extending to Romania, Ukraine, the Aegean, and as far as northwest Anatolia. The unification of the Odrysian kingdom in the fifth century BC and the founding of several other states turned Thrace into a power in the center of the known world, between Persia, Rome, and Greece. Although it was conquered by Philip II of Macedonia in 343–342 BC, its autonomy continued to be tolerated.

The Thracians were masters of metalworking. Gold and silver were found locally or imported from Transylvania (gold) and Asia Minor (silver). The rich burials of members of the nobility, who ruled over the common people and also served as priests, included precious offerings to document their high social rank, their religious function, and their power

▽ 95. Gold ring, Ezerovo, near Parvomai, Bulgaria, Thracian, late fifth century BC; gold, diameter: 1⅛ in. (2.7 cm), weight: 1.1 oz. (31.3 g). Archaeological Museum, Sofia.

This heavy gold ring is unusual because the center, normally occupied by a seal, has an oval with engraved letters (the owner's name?); moreover, it is attached by a pivot.

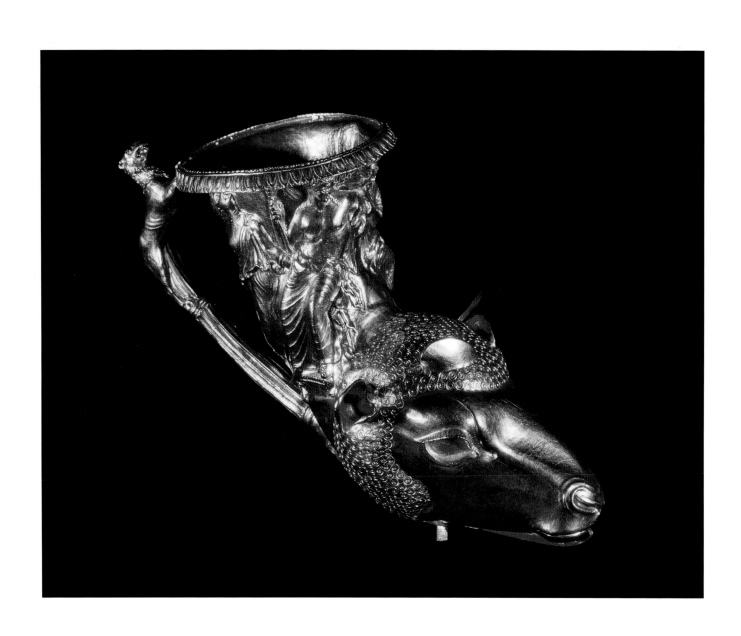

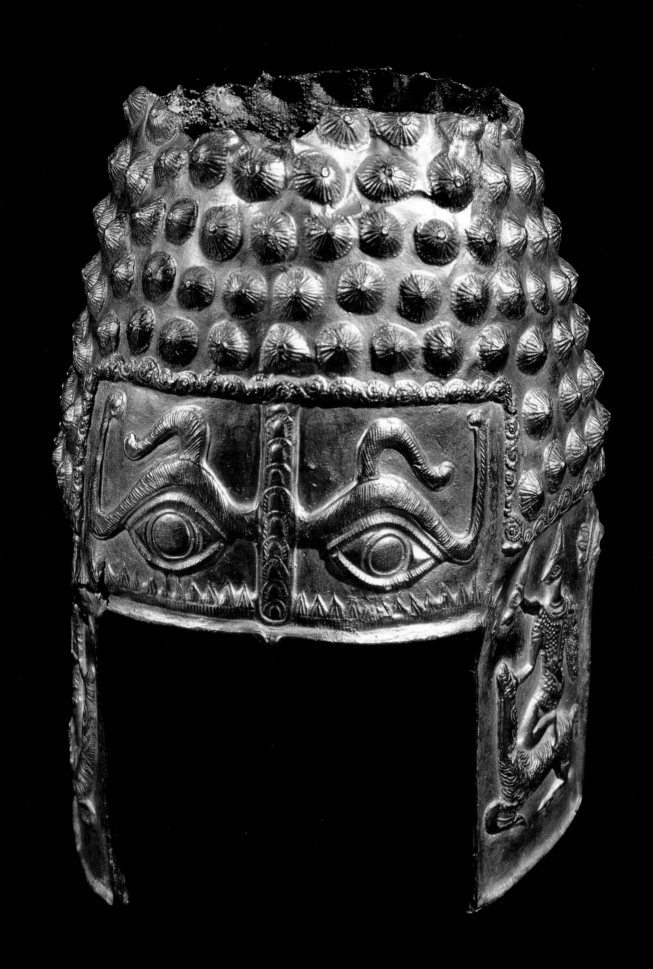

◁◁ 96. *Rhyton*, Panagyurishte find, Bulgaria, Thracian, late fourth to early third century BC; gold, height: 4⅞ in. (12.5 cm). Archaeological Museum, Plovdiv, Bulgaria.

Drinking vessels shaped like an animal's head were not uncommon in antiquity, but this Thracian rhyton *is an especially remarkable piece. The impressively worked, hollow hammered head of a ram was made into a* Gesamtkunstwerk *by adding sparing granulation on the forehead, a cup ornamented with animated women, and a handle with a sculptural decoration of an animal.*

◁◁ 97. Ceremonial helmet, Poiana Cotofcnesti, Romania, Thracian, c. fourth century BC; embossed gold, height: 9¹³⁄₁₆ in. (25.0 cm). Romanian National History Museum, Bucharest.

This unusual headdress with cheek guards was hammered from sheet gold and richly decorated with embossed geometric ornaments. We can only speculate about the ceremonies for which this helmet may have been used.

and wealth, which were to be transformed in the hereafter. There were said to be 15,000 necropolises, but 90 percent of them had already been devastated and robbed in ancient times. Armed tomb robbers have become a serious problem in present-day Bulgaria as well. Nevertheless, archaeologists have recently uncovered additional unique objects like helmets (plate 97), gold masks, and rings.

The objects produced in Thracian workshops include jewelry and decorative sheet gold like those found in the treasure of Letnitsa (plate 94). Vessels known as *rhyta*, hammered into the shapes of heads and animals and decorated with beasts of prey, mythological creatures, horsemen, and gods, were found in Panagyurishte (plate 96). Thracian writing, which uses Greek letters and exists in only a few fragments, is found on a gold ring with a rotating piece in its center, which was excavated in Ezerovo (plate 95). Another burial mound contained a wreath of two laurel branches in gold, with leaves and fruit, which would have been placed in the grave with the deceased as enduring evidence of his earthly function as ruler or priest. Among the other treasures are earrings made with all the common goldsmith's techniques. These lavishly ornamented objects are loaded with granulation, filigree, hollowed forms, and delicate chains,

98. Beard comb, Solokha kurgan, steppe of the Dnieper region, Ukraine, Scythian, fifth to fourth century BC; gold, height: 4¹³⁄₁₆ in. (12.3 cm), width: 4 in. (10.2 cm). Hermitage, Saint Petersburg.

This comb demonstrates how an everyday object can become a piece of jewelry. The goldsmith has imaginatively used the long upper edge to depict a dramatic battle scene over a frieze of lions. Animals were popular motifs in Scythian jewelry, while human figures were rarer.

and they are exemplary of delicate, detailed work. In terms of style, they are typical copies of comparable objects from the workshops of Hellenistic goldsmiths, and they confirm the enduring influence of the Greeks.

THE SCYTHIAN ANIMAL STYLE

The people referred to in Greek and Latin sources as Scythians were nomadic horsemen who lived in the area between the Don River and the Carpathian Mountains. In a broader sense, the term also includes tribes in central Asia and southern Siberia. The cultures, religions, and lifestyles of the Scythians of the steppes, the Black Sea, and the Altai Mountains were all similar. They immigrated from the east, and evidence indicates they were in the northern Black Sea region between the Danube and Don rivers from the seventh century BC onward. Their well-armed warriors, under the leadership of kings and tribal chiefs, conquered large areas. Nomadic Scythians went as far as the eastern borders of Europe, as was demonstrated by the discovery in 1882 of gold treasure from the sixth century BC in Vettersfelde, on the German-Polish border (plates 103, 108). Their supremacy ended around 300 BC, when they were defeated by the Sarmatians, who were advancing from the east, but they managed to survive on the Crimean Peninsula until the second century AD.

In the fifth century BC, Herodotus traveled in Scythia, which he wrote about at length in the fourth book of his *Histories*, describing the tombs that they constructed for their kings, in which the embalmed bodies were buried along with weapons, jewelry, implements (plate 98), and often their horses as well. The burial mounds, known as *kurgans*, could be seen from a great distance in the vast steppes, and they have always lured tomb robbers because of their rich stores of gold artifacts. The burial offerings in the few that have survived undisturbed have provided information about the lifestyles and rites of the Scythian nomads and about the social position of those interred there. Among the extraordinary finds was the tomb, discovered near Almaty, Kazakhstan, of a Scythian tribal chief, the so-called Golden Man, who was buried with four hundred delicately worked gold objects. These include not only jewelry but also many personal items and objects worthy of his status so that he could live on in a dignified manner. It is likely that there are more kurgans to be discovered and revealed.

△ 99. Plaque with tiger and wolf, Scythian, seventh to sixth century BC; gold relief, length: 6⅝ in. (16.8 cm), height: 3⅞ in. (9.9 cm). Hermitage, Saint Petersburg.
The wealth of imagination found in the depictions of animals on Scythian jewelry is as astonishing as the quality of the chasing, which was probably the work of Greek artisans. It is not certain whether gold reliefs like this one of a tiger and wolf were used to adorn clothing or decorate shields.

▷▷ 100. Shield decoration, Kelermes, northern Caucasus, Scythian, seventh to sixth century BC; gold, length: 12¹³⁄₁₆ in. (32.6 cm), height: 6⅜ in. (16.2 cm). Hermitage, Saint Petersburg.
This object depicting a panther is typical of the Scythian animal style; its abstract formal language gives it a jewelry-like character.

▷▷ 101. Jewelry (brooch?), Zoeldhalompuszta, Hungary, Scythian, sixth to first century BC; gold, height: 9⅛ in. (23.0 cm). National Museum, Budapest.
The animals found on Scythian jewelry are primarily those that were native to the vast areas settled by the Scythian tribes, especially game species that demanded particular dedication and skill of hunters. It is reasonable to suppose that vivid relief renderings like this running stag were associated with magic spells for the hunt.

▷▷ 102. Armlet, Oxus treasure, Takhti-Kobad, Tajikistan, Achaemenid, fifth to fourth century BC; cast and hammered gold, chased horns, width: 4⁹⁄₁₆ in. (11.57 cm), height: 5 in. (12.8 cm), thickness of the armlet (measured at the horns): 1¹⁄₁₆ in. (2.61 cm), weight: c. 12.8 oz. (364 g). British Museum, London.
The Oxus treasure is the most important legacy of precious gold and silver objects from the Achaemenid period. This armlet with griffin heads is one of the finest pieces. Such objects were bestowed as honorary gifts at the Persian court in Persepolis. Most of the original decoration with gemstones has been lost.

The preferred materials for Scythian jewelry were gold and silver. The cast, hammered, or chased pieces are dominated by motifs of animals or hybrid creatures; their characteristic manner of depiction has led scholars to speak of the "Scythian animal style." Deer, rams, elk, and predatory cats and birds are rendered in such a way that, for all the artisan's love of abstract and schematized representations, the essential features of the animal are unmistakable (plates 99–101, 103). Magical powers were attributed to gold brooches and pendants. They generally represent, in a complex symbolic language, game animals, and thus could have served as talismans for the hunt.

The precious metals used were probably from Kazakhstan and the mines in the Altai Mountains; they may have been imported via caravan routes. Scythian art shows the unmistakable influence of Greek goldsmiths, who most probably worked for them. Moreover, the burial offerings from tombs in the Greek colonies of southern Russia are so similar to Scythian finds that the influence, facilitated by trade contacts, clearly worked in both directions.

THE WEALTH OF PERSIA: THE SPOILS OF ALEXANDER THE GREAT

The Achaemenid empire of Persia existed from 700 to 330 BC, and until it was defeated by Alexander the Great, it was one of the greatest and best-organized empires of antiquity. We can only speculate vaguely about the treasures that must have been produced there once, for the gold that had been hoarded in the palaces and treasuries was brought back by the conqueror to his Macedonian homeland. Although gold must have been plentiful in the vast empire, only a few gold artifacts have been found that were not taken abroad with Alexander's spoils to be reused elsewhere.

Occasional chance finds like the gold treasure of Hasanlu give some impression of the wealth and splendor of the Achaemenid court. Among

other things, this site contained a remarkable golden bowl, eight inches (20 cm) tall with a diameter of seven inches (18 cm) and a weight of more than thirty-three ounces (950 g). One exceptional case is the Oxus treasure discovered in 1877 on the Oxus River in the ancient province of Bactria, now the site of Amu-Darya, where Afghanistan, Uzbekistan, and Tajikistan meet (plates 102, 104). The 175 objects found there have features of the Achaemenid style, but also of the Scythian and Greek styles, and they indicate a highly advanced, autonomous goldsmith's art, with, for example, chased reliefs, granulation, filigree, and cloisonné. These art objects, which date from the seventh to the fourth century BC, may have belonged to a temple treasury. By contrast, Achaemenid coins were stereotypical and not very inventive: their standard gold piece, the daric, was minted in large numbers; the motif on the obverse was always the Darius the Great, kneeling with a bow and a spear (plate 105). It weighed about a third of an ounce (8.35 g).

Objects influenced by the Achaemenid style have also been found in Scythian tombs. This is further evidence of the many interconnections between Mediterranean peoples and the neighboring Asian peoples during the second half of the first millennium BC. Gold, however, played considerably different roles in these countries. For the Persians it was primarily a state treasure to be accumulated; for the Scythians and Thracians it was the best material to decorate their chiefs and rulers for life in the hereafter in an enduring manner worthy of their rank. The Lydians, in turn, minted gold coins that marked the beginning of an extensive Mediterranean system of currency. The Greeks, in their democratic virtue, were initially sparing with gold, but they learned to appreciate the significance of reserves of precious metals for war and times of need, and they combined the beautiful, decorations for the gods, with the useful, a gold reserve. Finally, the Hellenistic epoch saw one of the pinnacles of the goldsmith's art: jewelry was no longer simply a means of expressing social supremacy in this world and the beyond but rather an instrument of adornment and joy for everyone—provided they could afford it.

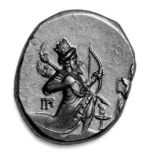

105. Double daric, obverse: Darius the Great with spear, bow, and quiver in so-called kneeling-running stance, minted in Babylon by Mazaios, satrap of Babylon, 331–328 BC; gold, diameter: 13/16 in. (2.13 cm), weight: 0.59 oz. (16.68 g). Geldmuseum, Deutsche Bundesbank, Frankfurt am Main.

Mazaios, a politically skilled satrap in Mesopotamia, was able to continue the widely known coinages of the Persians even after the victory of Alexander the Great. The somewhat more refined style of the coins issued during his reign demonstrates the influence of Greek goldsmiths and die cutters in its more meticulous artisanship.

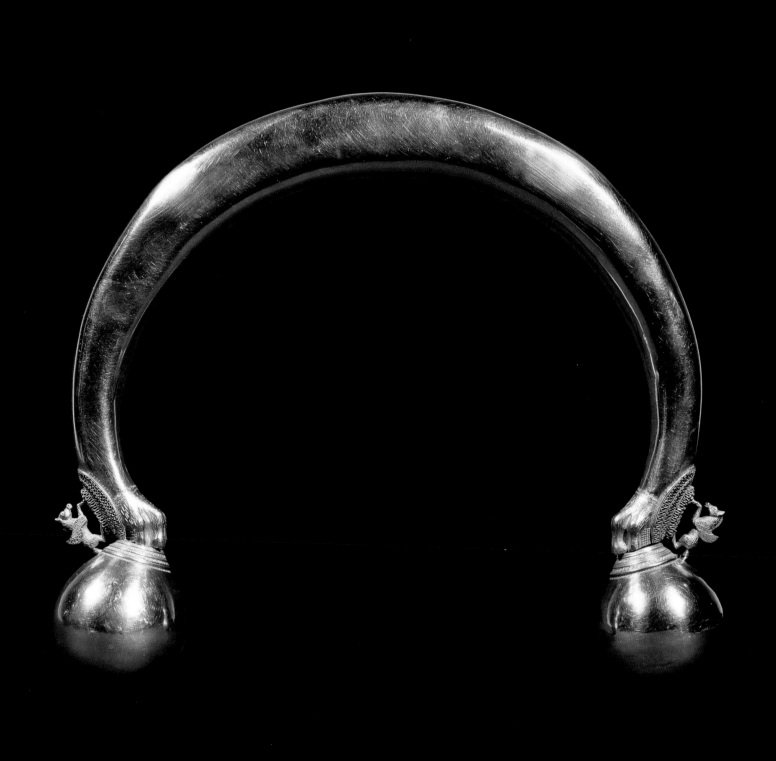

CHAPTER 6

✤✤✤✤✤✤✤✤✤✤✤✤✤✤✤✤✤✤✤✤✤✤✤✤✤✤✤✤✤✤✤✤✤✤

The Celts

THE TREASURE AT THE END
OF THE RAINBOW

There never was a Celtic empire per se, yet Celtic tribes settled a large portion of Europe and the Middle East from the seventh to the fifth century BC (plate 108). Their collective name cannot be explained with certainty; it is said to have meant something like "the brave" or "the noble"—characteristics that certainly suited the urge of this loose group of warlike tribes to expand, as well as their success in doing so. The Celts settled first in Gaul, southern Germany, Britain, and Ireland, and on the Iberian Peninsula. Around 400 BC they reached northern Italy and besieged Rome for seven months in 386 BC, finally occupying it, except for the Capitoline Hill. Other Celtic tribes moved from Bavaria to Bohemia, Hungary, Transylvania, Dalmatia, Macedonia, and Greece, and on as far as Asia Minor. Galatia in central Anatolia was named after the Celtic tribes that arrived there from Gaul. The Hallstatt and La Tène cultures were named after the sites of important Celtic finds in Austria and Switzerland, respectively. In Gaul, which lay to the north of the latter, Celtic dominance came to an end with Julius Caesar's victory, despite fierce resistance from Vercingetorix, who succeeded in uniting the tribes temporarily to face him. Other Celtic tribes located farther to the west and north were not able to resist the pressure and onslaught of the Germanic tribes, so the age of the Celts gradually came to a close in the second and first century BC.

Was the abundance of Gaul's gold the reason for Caesar's war against the Celts? As with conquerors of every period, it is reasonable to assume he too had an insatiable lust for this precious metal. He knew that there was plenty of it in Gaul, and he removed so much of it from the conquered land that its price sank drastically in comparison to silver. During their independence, the Celts had a plentiful supply of gold at their disposal, as there were many ore deposits in the regions they controlled, and these were exploited by their experienced miners and smelters. Placer gold, for example, was taken from the Rhine, the Danube, the Inn, and mountain rivers in Switzerland. In an area that is now part of the southern French province of Limousin, the Celts even ran an underground mine for gold. The mines of Dolaucothi in Wales became known as Roman mines, but they were probably first worked by the Celts. Extracting gold was only one of the skills of Celtic miners; they also knew how to mine salt and how to extract and smelt iron ore, so the Celtic centuries form part of a pre-Roman Iron Age.

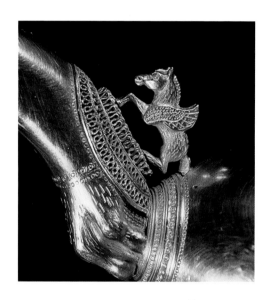

◁△ 106/107. Diadem, tomb of La Dame de Vix, Burgundy, Hallstatt period, 500 BC; solid gold, length: 8⅝ in. (22 cm). Musée Archéologique, Châtillon-sur-Seine.

This heavy gold circlet is charming for its simple form. The round arch of the diadem terminates in spherical, thicker ends with surprisingly elaborate ornamentation. Only when enlarged are the details of the lion's paws and winged horses visible, meticulously executed down to the most delicate details.

▷ 108. Map of the areas of Celtic settlement.
 *The expansion of Celtic tribes moved from
 central Europe westward, and then also to the
 south and east as far as Anatolia. Two well-
 known hard-rock gold deposits, at Dolaucothi
 and in Limousin, are marked by yellow dots.*

▽ 109. Covering of a wooden drinking bowl,
 princely tomb of Schwarzenbach, near
 Sankt Wendel, Saar, Germany, c. 400 BC;
 hammered, punched, and chased ornaments
 (reattached by restorers), diameter: 4¹¹⁄₁₆ in.
 (12.0 cm), height: 3⁵⁄₁₆ in. (8.5 cm).
 Antikensammlung, Staatliche Museen
 zu Berlin.
 *This openwork outer covering of gilded
 sheet metal was riveted to a wooden drinking
 bowl. The decoration of the bowl consists of
 rows of palmettes and lotus leaves, and the
 edges are adorned with stamped ornamental
 borders. Such decorations are typical of
 drinking vessels of the fifth and fourth
 centuries BC.*

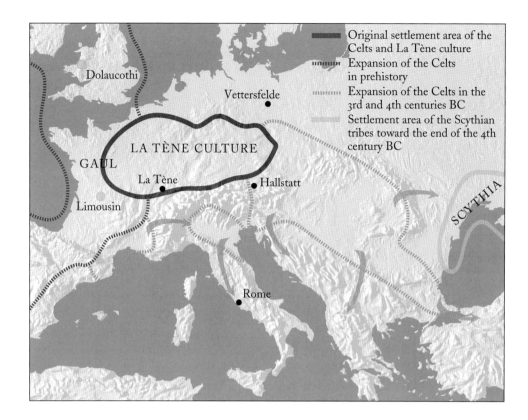

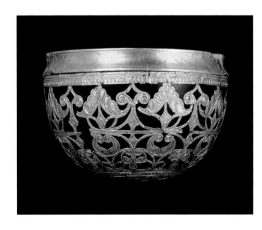

DECORATION VERSUS SYMBOLISM

Gold served religious purposes, personal needs, and, in the form of coins and bars, trade. One is immediately struck by the ways that Celtic artisans could work the precious metal. Celtic art, which was highly diverse and even now remains mysterious in the specifics of its appearance, is generally considered to have been independent and original, but it was influenced by others, such as the Etruscans, the Scythians, and the Greek artisans who worked for the latter.

As with other cultures of the prehistoric and early historical periods, we owe essential information about Celtic art and especially their gold-smiths' work to numerous grave finds. The Celts buried their royalty with lavish offerings of gold and bronze jewelry and iron weapons. They were particularly fond of so-called torques—coiled rings, hoops, and chains—which served as jewelry, status symbols for the upper classes, and attributes of the gods. Torques are often found together with other burial gifts, like chains of precious stones, glass hoops, and bracelets, in the tombs of the Celtic nobility (plates 110, 111). Gold was also combined with other materials, as in a beautifully turned wooden bowl with ornaments of gilded sheet metal (plate 109). Surviving objects provide a glowing testament to the skill of their artisans and artists, and it is fair to say that they demonstrate greater virtuosity in the goldsmith's art than is often found today.

They were not sparing with gold, so many of the artifacts are solid and heavy (plate 106). Examples include seven gold hoops from the third

century BC, weighing a total of about one pound six ounces (640 g), that were discovered near Erstfeld in the Gotthard Pass in Switzerland (plate 112). This chance find from the Helvetii, a culturally distinct Celtic tribe, came from a hidden spot in the high mountains, not a grave or a hoard created by someone on the run. It was clearly a votive offering to the gods, who according to Celtic belief lived in these mountains, just as the Greeks' gods lived on Mount Olympus. The symbolic depictions on the hoops are unique. Scholarly interpretations of the mythical animal and human figures represented here with ornamental abstraction and distortion range from ideas about the cycle of life to revelations of the hereafter (plate 113).

Our still-imperfect knowledge of the Celtic religion makes it difficult, if not impossible, to interpret such symbolic depictions, which is all the more regrettable, as the often-entangled decorations typical of Celtic gold artifacts all but cry out for explanation. The depictions of animals frequently found on Celtic jewelry (plate 107) are usually attributed to an Eastern influence, whereas the vegetal ornaments, palmettes, lotus blossoms, and other floral elements can perhaps be traced back to Mediterranean precursors. The diversity of their ornament includes geometric compositions as well (plate 114), such as complex circular patterns applied

110/111. Gold jewelry, princely tomb near Rheinheim, Germany, early fourth century BC; diameter of the torques: 6¹¹/₁₆ in. (17.2 cm), of the armlets: 3⁵/₁₆ and 2⁵/₁₆ in. (8.4 and 6.8 cm). Landesmuseum für Vor- und Frühgeschichte, Saarbrücken.
Torques and armlets from this singularly splendid woman's tomb demonstrate jewelry in keeping with the status of a princess. Only photographs of details truly reveal the wealth of forms found on such imaginative figural jewelry, like this stylized head.

▷▷ 112. Torques and necklaces, Ribitäler, near Erstfeld, Canton of Uri, Switzerland, probably around 300 BC; solid gold, total weight: 22.6 oz. (639.8 g). Schweizerisches Landesmuseum, Zurich.
The gold jewelry of Erstfeld—four necklaces and three torques—was found by chance in 1962 at the foot of the Gotthard Massif. These solid gold pieces, richly decorated with human, animal, and fantastic figures, are examples of the finest Celtic goldsmith's art. The chased motifs give these objects an unmistakable look and make them mysteriously precious.

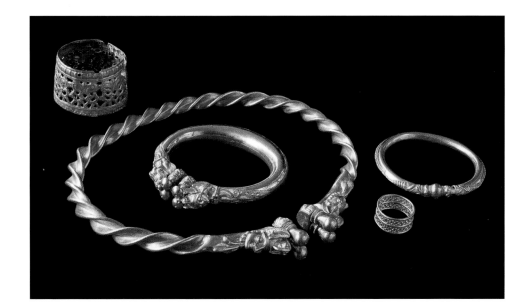

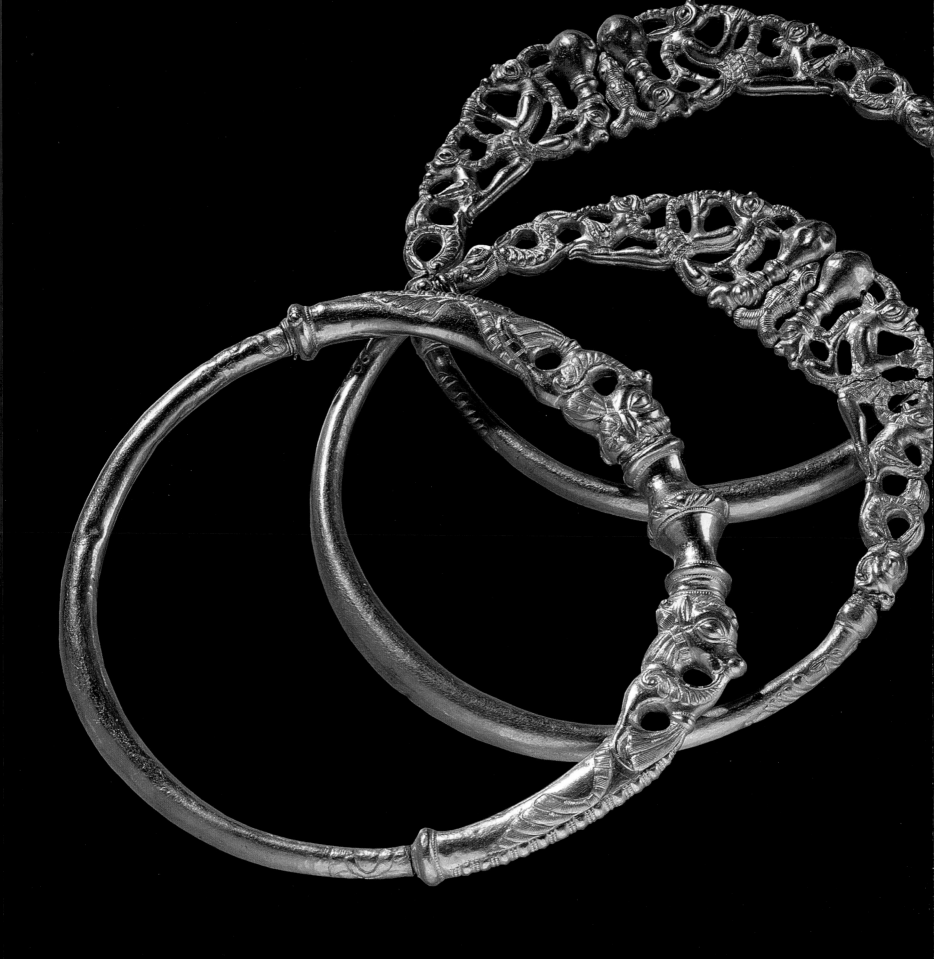

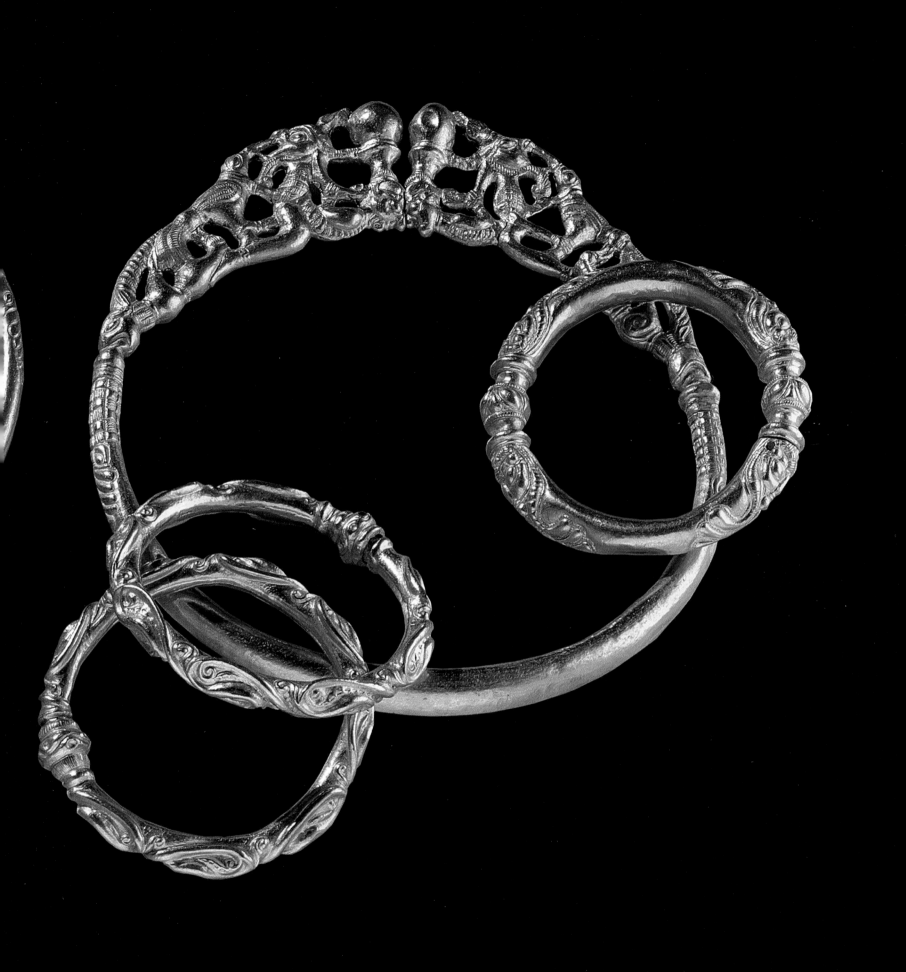

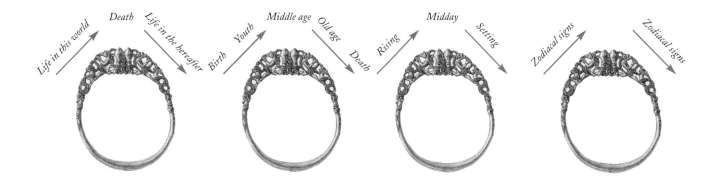

Life in this world Death Life in the hereafter Birth Youth Middle age Old age Death Rising Midday Setting Zodiacal signs Zodiacal signs

113. Possible interpretations of the gold finds of Erstfeld (plate 112).

It is still unclear what the depictions of dragons, birds, bulls, rams, and humanoid figures on the torques and necklaces of Erstfeld represent. These sketches offer four different interpretations: (a) human birth, death, and rebirth; (b) the human life cycle; (c) the daily course of the sun; (d) the course of the sun through a section of the zodiac.

with a compass. Are these motifs purely decorative, or were there religious motives behind their selection? The Celts also had a distinct penchant for colored jewelry, combining coral, amber, and artificial enamels with gold. Openwork patterns on sheet gold inlaid in dark wood or against a colorful background anticipated the *opus interrasile* of the Roman period. A very special find in Ireland dates from the late Celtic period: a model of a ship capable of traveling on the high seas, with rudders and a mast, chased from sheet gold (plate 115).

CELTIC COINS

The Celts too recognized the advantages of gold coins for trading, and in the second and first centuries BC, they minted coins not only in silver, bronze, and tin but also in gold, usually modeled on Greek money, especially the staters of Philip II and Alexander III of Macedonia. Celtic

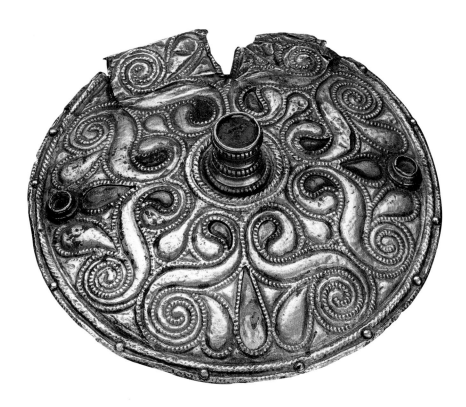

114. Decorative disk, Auvers-sur-Oise, France, early fourth century BC; hammered sheet gold with filigree ornamentation and coral inlay on bronze plaque, diameter: 3⅞ in. (10 cm). Cabinet des Médailles, Bibliothèque Nationale, Paris.

Nothing is known of the excavation of this large disk with a vesica piscis ornament. It may have been the cover for a rhyton. The sheet gold contains more than 15 percent silver and may have been made from natural gold containing silver or an artificial alloy.

115. Model of a ship, Broighter, Ireland, first century BC or first century AD; gold, length: 3⅞ in. (10 cm). National Museum of Ireland, Dublin.

This model of an open ship with oars and mast was perhaps a votive offering to the sea god Manannan mac Lir. The hull of the ship was beaten from thin sheet gold; the mast and oars were forged from small gold bars.

coins have been found from the Iberian Peninsula by way of Gaul to Britain, Bohemia, and the Balkans and even to southern Germany, Austria, and Switzerland. The gold coins are diverse and wide-ranging in terms of both type and the composition of alloys. Their gold content ranges from as high as 98 percent to less than 20 percent. The Celts' various minting sites were independent of one another—in Gaul alone the Celts were divided into more than a hundred tribes—and the weight and fineness of the coins can be used to date them: the lighter and less pure, the more recent they are.

Later Celtic coins bear deliberately distorted depictions of people and animals, especially horses (plates 116–118), which were perhaps intended to give them a new look so that they would not be confused with copies of Greek mintages. The die cutters were surely following orders when they began to cut the figures of their matrices with this restrained expressiveness. But they knew how to fill out the round shapes of their coins in such a way that harmonious figural and ornamental compositions resulted. Celtic coins may be seen as anticipations of certain Art Deco motifs that would become fashionable two millennia later.

The Celts developed a method for producing planchets—that is, metal coin blanks—that is unparalleled in the history of minting. The molten metal was cast in hollows that were pressed in ordered rows on a ceramic block, each of which held the precise amount of metal required to manufacture a coin. These multiple molds for casting planchets have been found in many Celtic settlements. The hollows in the forms are always exactly the same size, so that pouring the molten metal up to the edge of the hollow gave an exact weight. Such forms were probably directly related to the production of a group of Celtic gold coins known as "rainbow cups" (plate 119). According to popular belief, these button-shaped coins were produced by rainbows, which left behind pots of gold where they touched the earth. This story came about because farmers often found such gold pieces when plowing their fields after a rain. These coins were considered lucky and were passed down through the generations. They had symbolic meaning for the Celts as well, as is evident from the mysterious markings on them, which have yet to be adequately interpreted. More than three hundred finds of rainbow cups have been recorded in southern Germany alone, including hoards with several hundred examples. They are nearly always minted of pure gold and, like large staters, weigh about a quarter ounce (8 g); more rarely they are the size of quarter staters, from 0.06 to 0.07 ounces (1.6 to 1.9 g).

▽ 116/117. Stater, obverse: head with ornamental hairstyle, reverse: running horse, from one of the first mints of the Parisii in Gaul, sixth to first century BC; gold, diameter: c. 1 in. (2.5 cm). Moravian Museum, Brno, Czech Republic.

As a rule, Celtic coins imitated the motifs of ancient Greek coins, though the local die cutters moved increasingly far from their models. One reason for this was the use of different tools, such as punches and drills, which often resulted in spherical joints and clumsy limbs in their depictions of animals and crude features in their portrait heads. In addition, they sometimes used dies that were larger than the planchets, so that the image is cut off by the edge of the coin.

▷ 118. Head of Apollo, coin of the Ambiani, northern Gaul, second century BC; gold, diameter: c. 1 in. (2.5 cm). British Museum, London.

The Ambiani were a Celtic tribe living in the area around present-day Amiens. Like most of the Celtic tribes, they minted many coins in Gaul, and their gold coins stand out for both their numbers and the virtuosity of their design.

▷▷ 119. Rainbow cups (gold coins), Grossbissendorf, Bavaria, location of mint unknown, c. 200–30 BC. Archäologische Staatssammlung, Museum für Vor- und Frühgeschichte, Munich.

In 1986 one of the largest hoards of Celtic gold coins was discovered: initial finds and subsequent excavations revealed 384 gold coins, often differing only in nuances, primarily staters weighing around 0.3 oz. (7.7 g) and a few quarter staters of around 0.06 oz. (1.8 g).

Tests with a scanning electron microscope of several Celtic gold coins from minting sites in southwest Europe have revealed tiny inclusions of platinum grains. This metal is rarely found in gold, but it is characteristic of the gold of the Lydians, from the Pactolus River on the west coast of Asia Minor, which initially led scholars to conclude that gold was brought to Europe from Asia Minor during the Celtic era. However, after similar platinum content was found in gold from the Rhine, it became clear that since such gold was also available in the native regions of the Celts, they produced their coins autonomously, without importing precious metals.

For the Celts, the use of gold was a matter of course. Its particular properties and undisputed value offered possibilities that were exploited amply. Solid rings and hoops, as well as delicately chased weapon belts and earrings, simply executed coins, and other astonishingly expressive objects, reflect the diversity of the Celtic tribes, who never developed a uniform collective style in their handicrafts.

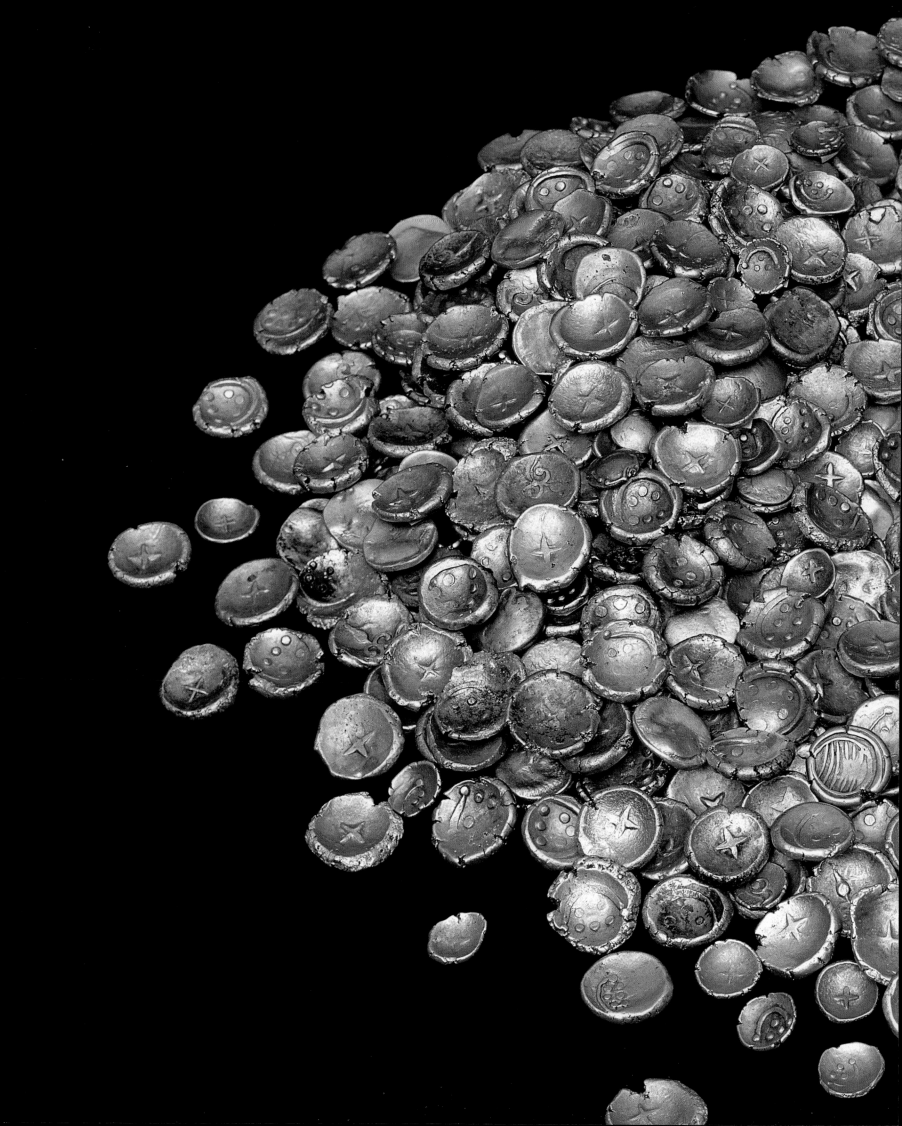

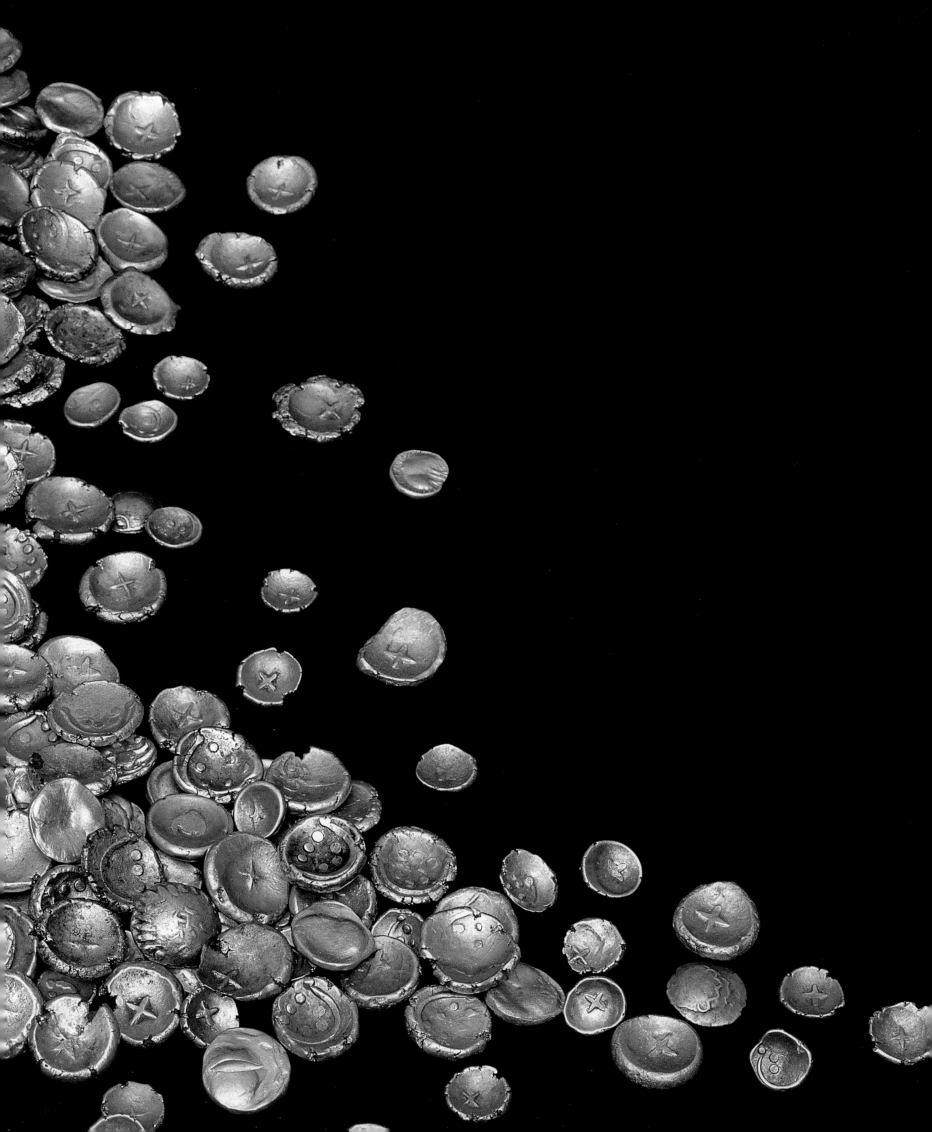

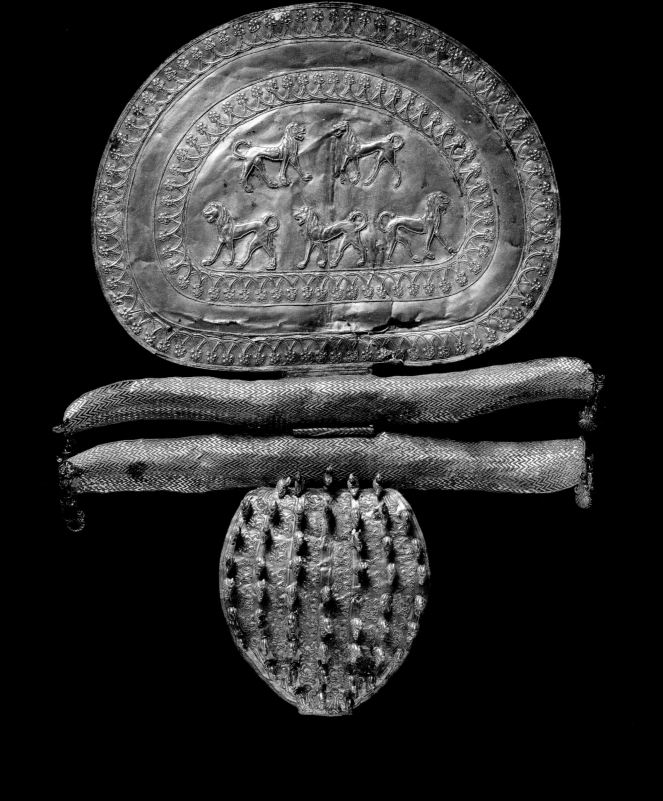

CHAPTER 7

The Etruscans

ARTISTS AND CONNOISSEURS

The area in central Italy where the Etruscans lived in a loose community of allied cities from the seventh to the fourth century BC is smaller than Switzerland. Herodotus claimed the Etruscans migrated there from Asia Minor, but it is also possible that their roots lay in the Villanovan culture, which is named for a burial ground near Bologna that dates back to the Bronze Age. The Etruscans—in Latin, *Tusci* (from which the name Tuscany derives) or *Etrusci*; in Greek, *Tyrrhenoi* (from which the Tyrrhenian Sea got its name)—called themselves *Rasenna* or *Rasna*. Their belief in gods and demons was not incompatible with their cosmopolitanism. They loved not only hunting but also dance, music, theater, and festivals, and they lived in well-furnished atrium houses. Their women enjoyed a privileged status, not only within the family but also in public life.

Among the artistic and technical accomplishments of the Etruscans—in addition to hydraulics, the mining and smelting of iron ore, large-scale clay sculptures, and colorful wall paintings—the works of their goldsmiths are particularly important; they are great achievements in terms of both artistry and execution. The skill of the Etruscans in granulation and filigree work surpassed that of any previous culture, and would never be achieved again later. With assistance from immigrant artisans from Greece and eastern lands (plate 121), they produced masterworks not only in gold but also in silver, bronze, and ivory, frequently incorporating colored stones. The precious metals for jewelry had to be imported, probably from the East, for the Etruscan lands had rich deposits of iron ore but not of gold or silver. Hence this material was used sparingly, and artisans often made do with skillfully applied gilding.

GRANULATION: PERFECTION IN MINIATURE

The decoration of jewelry by soldering on small balls of gold, a process known as granulation (plate 123), is known to have been practiced in Mesopotamia since around 2500 BC. The ancient Egyptians were also familiar with the technique, but the Etruscans brought it to its full flowering. According to experts, the spread of granulation took place in three steps (plate 122). The first began around 3000 BC, with the skill being passed from the Sumerians to Egypt, Canaan, Cyprus, Crete, Troy, and Mycenae. In a second stage, beginning around 900 BC, Phoenician traders

◁ 120. Disk fibula, Cerveteri, Nekropoli del Sorbo, Regolini-Galassi tomb, second quarter of the seventh century BC; gold, height: 12⅜ in. (31.5 cm). Museo Gregoriano Etrusco, Vatican, Rome.
This fibula for a garment, decorated with lions, is one of the finest examples of the art of the Etruscan goldsmith and probably the most famous as well. It formed part of the magnificent contents of a tomb of a noblewoman discovered in 1836. It shows how native forms were enriched with figural motifs from the Near East.

△ 121. Chain with pendant, Palestrina, Italy, third century BC; gold, height of the head: 1⁵/₁₆ in. (3.3 cm). Museo Nazionale di Villa Giulia, Rome.
The god Achelous, named after a river in Greece, is depicted in many forms in art, here, for example, as a bull with a horned human head. This depiction of the river god clearly shows the influence of Greek artisans. His beard is an exquisite example of Etruscan granulation technique.

During the prehistoric and early historical periods, familiarity with the granulation technique reached the Mediterranean region, and during Greek and Roman antiquity it was as widespread there as in the Near and Middle East.

brought granulation from Palestine and Syria to Carthage, Malta, Sicily, and Sardinia. Finally, this decoration technique was introduced to Italy beginning around 800 BC.

Why does Etruscan granulation deserve its high status? Simply put, it is the perfection of all the individual steps—something the Etruscans achieved, which remains the supreme art of the goldsmith to this day. To produce the grains, gold wire or sheet gold was divided into tiny sections, which were then embedded in layers in charcoal dust and heated in a crucible until they melted into spherical drops. The diameter of the grains that were obtained after cooling depended on the size of the initial pieces. The Etruscans were able to produce grains of less than four-thousandths of an inch (0.1 mm) in diameter, so-called powder granules. Another method for producing grains involved pouring molten gold into water; the resulting balls of gold were then sorted according to size by hand or with sieves.

Then, using organic substances such as tragacanth (a gum derived from plant sap), gelatin, or flour paste, or even soap or saliva, the grains were attached to their base plate. The adhesive was either applied directly to the grains or spread on the base plate, also known as the recipient, with a brush. For the next, all-important stage, the soldering of the balls of gold to the recipient, the Etruscans are known to have preferred the most elegant of the various methods: so-called reaction soldering. This involved adding a powdered copper compound—such as the green mineral malachite—to the adhesive. When the piece of jewelry with the glued grains

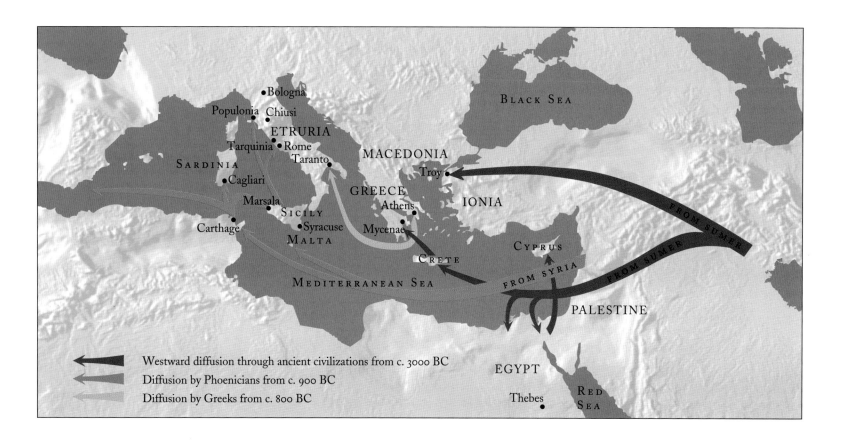

Westward diffusion through ancient civilizations from c. 3000 BC

Diffusion by Phoenicians from c. 900 BC

Diffusion by Greeks from c. 800 BC

123. Disk earring, Cettone, near Chiusi, Italy, sixth century BC; gold. Antikensammlung, Staatliche Museen zu Berlin.

Etruscan goldsmiths were masters in all the current techniques for working gold, as this disk earring shows. Hammered, welded, and chased decorations combine to form a successful object, though its granulation combining dust-sized particles and larger pellets of gold makes it particularly attractive.

was heated to about 1100 degrees Fahrenheit (600°C), the organic adhesive would carbonize, and at 1550 degrees Fahrenheit (850°C) the resulting carbon reduced the copper compounds added to the glue to metallic copper. Together with gold from the grains and the base, this copper would form an extremely thin layer of fused copper and gold. During this reaction process, the grains became solidly bound to the base. Etruscan goldsmiths used this process for grains of various sizes, designing both simple and complex borders, motifs, and surface patterns on both flat and curved bases. The technique of reaction soldering was also used to apply filigree wires and settings for cloisonné work.

After many earlier attempts had failed, goldsmiths in the early twentieth century ascertained the principle behind the Etruscans' process and successfully re-created it in experiments. Modern analysis has confirmed that alloys form where the grains and recipient touch. An international jewelry competition in 1996 dedicated exclusively to granulation paid tribute to the mastery of Etruscan artisans.

IMAGINATIVELY DESIGNED TREASURES

Vessels, pectorals, fibulae, arm hoops, earrings, and pendants are just some of the items that Etruscan goldsmiths produced using a variety of decorative techniques (plates 120, 124–26). They include such imaginative objects as supports, decorated with delicate granulation and chasing, that were probably intended for vessels containing balm imported

◁ 124. *Skyphos*, Palestrina, Italy, Tomba
Bernardi, 640–620 BC; gold, height: 3⅛ in.
(7.9 cm), maximum diameter: 3½ in. (9.0 cm).
Museo Nazionale di Villa Giulia, Rome.
 *This hammered gold beaker of ideally
harmonious form has handles with sphinx
statuettes decorated with delicate granulation.
The smooth surface of the vessel contrasts
powerfully with inconspicuous details that are
evident only on closer observation.*

▷ 125. Pendant earring, Todi, Italy, last third
of fourth century BC; gold, length: 4³⁄₁₆ in.
(10.7 cm). Museo Nazionale di Villa
Giulia, Rome.
 *Earrings have rarely been produced with as
great variety and astonishing imagination as
in the time of the Etruscans. This piece in the
form of a female head is a magnificent
example.*

126. Disk earring, Pescia Romana, Italy, last third of the sixth century BC; gold, diameter: 1³⁄₁₆ in. (3.1 cm). Museo Archeologico, Florence.

▽ 126. Disk earring, Pescia Romana, Italy, last third of the sixth century BC; gold, diameter: 1³⁄₁₆ in. (3.1 cm). Museo Archeologico, Florence.
The techniques of Etruscan goldsmiths for working in miniature are always fascinating, like those used for this small earring, whose perfection leaves nothing to be desired.

from Egypt (plate 127). One unusual object is a montage of 130 tiny gilded animals (lions, chimeras, and sphinxes) on a decorative bronze sheet (plate 128); the methods used to produce it are still shrouded in mystery. Necklaces with colored stones, like onyx and lapis lazuli, in combination with chased gold medallions (plate 5) are timeless and tasteful, like nearly all the objects that left Etruscan workshops. The goldsmiths surpassed one another in the art of fashioning small, delicate objects with meticulously worked details. When producing heads, animals, or ornaments by hammering thin sheets of gold, they used bowl-like supports that were filled with pitch or resin, which would give as the gold was hammered and chased but still hold the piece in position.

The many examples of Etruscan jewelry that have been found in tombs provide a cross section of the skills of their ingenious goldsmiths. These creations were intended not only for kings and princes, but also for wealthy, self-confident citizens who took pleasure in wearing such adornments. In the repertoire of these Etruscan finds there are no objects that were prepared exclusively and deliberately for the cult of the dead and the hereafter. The objects placed with the deceased in the necropolises, which were often furnished like residences, were the precious pieces that had been dear to them in this life.

▷ 127. Stands for ointment vessels, Ruvo, Italy, late sixth century BC; ceramic and gold. Museo Archeologico Nazionale, Naples.
The goldsmith found a brilliant solution to the problem of providing a solid support for these ceramic vessels for ointments—whose style may be of Egyptian origin—while creating an effective contrast to the colorful faience flacons. The stands' broad rims are decorated with a wreath of gold granulation.

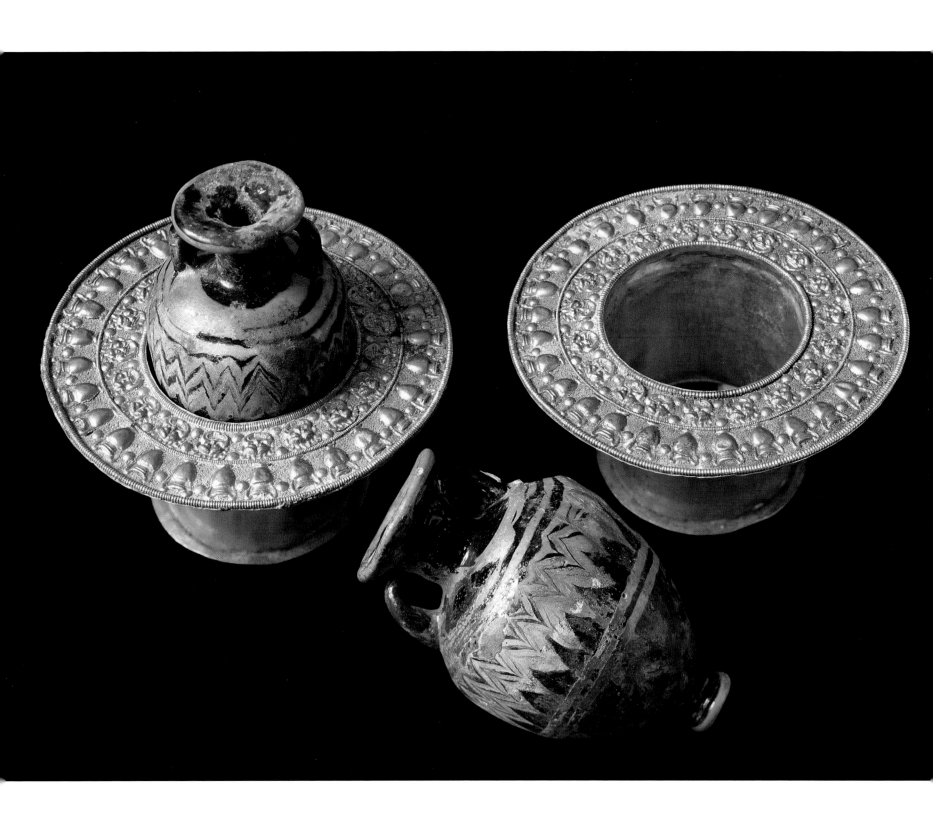

128. Decorative plaque, Palestrina, Tomba
Bernardi, 640–620 BC; sheet gold
mounted on bronze, length: 6¹³/₁₆ in.
(17.3 cm). Museo Nazionale di Villa Giulia,
Rome.
 *This decorative plaque with 130 small
figures of animals (lions, chimeras, and
sphinxes) is a unique piece that has fascinated
all who have seen it since its discovery. Only
a magnifying glass reveals its rich detail.
Probably the figures were cast in bronze forms,
covered in gold leaf after carefully removing
the seams and funnels from the casting, and
then mounted in strictly arranged formation
on the base.*

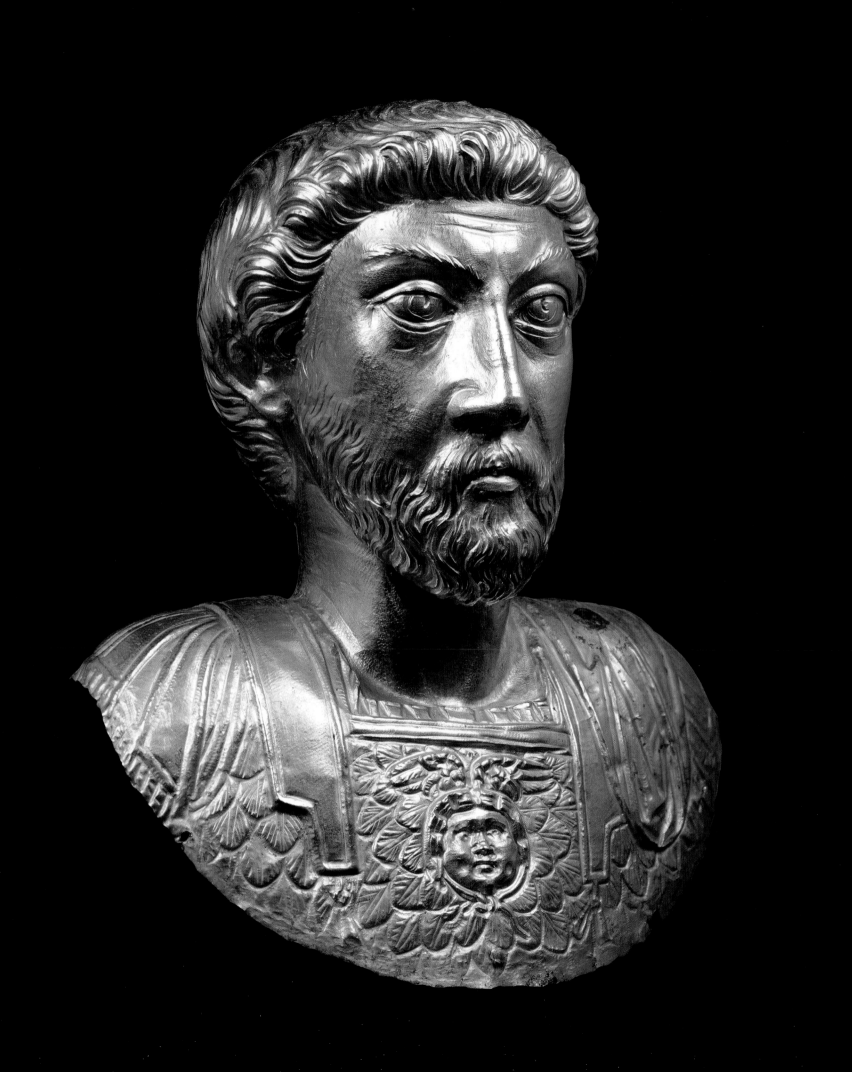

CHAPTER 8

❊❋❋❋❋❋❋❋❋❋❋❋❋❋❋❋❋❋❋❋❋❋❋❋❋❋❋❋❋❋❋❋❋❋❋❋❋❋❋

Rome

FROM REPUBLICAN MODESTY
TO IMPERIAL GRANDEUR

GOLD DEPOSITS AND EXTRACTION IN THE ROMAN PERIOD

W e trace out all the fibres of the earth, and live above the hollows we have made in her, marvelling that occasionally she gapes open or begins to tremble. . . . Man has learnt to challenge nature in competition!" wrote Pliny the Elder (AD 23–79) in the first two chapters of the thirty-third book of his *Natural History*. Although the author was living in Rome's early imperial period, in his philosophical and ethical attitudes he still very much advocated the virtues of piety (*pietas*), thriftiness (*frugalitas*), and simplicity (*simplicitas*) from the age of the Roman Republic (470–27 BC), when gold was scarce. In 387 BC, it took considerable effort to find a thousand Roman pounds (about 725 pounds, or 330 kg) to pay as tribute money to the Celts, who had conquered and devastated Rome. Gold rings with coats of arms were permitted only to noblemen like senators and knights as symbols of their standing. Luxury laws prescribed the size of other rings, which makes it clear that gold jewelry was permitted only for modest private use. That would soon change drastically.

When the Roman consul Sulla defeated the republic's bitter enemy on the Bosporus, King Mithradates VI of Pontos, in 85 BC and returned in triumph with spoils that included 29,000 Roman pounds (about 10.5 tons, or 9.5 MT) of gold, Rome already had wealth, but did not display it ostentatiously. The conquest of the Iberian Peninsula in the third century BC had brought generous metal deposits into Roman possession, including gold deposits in northern Spain and in Portugal. When Gaul was conquered, not only the precious metal deposits of the Celts but also the stockpiled treasures of the defeated enemy came into Roman hands, so that Caesar brought enormous quantities of gold back to the city.

The imperial period (27 BC–AD 476) began with an unprecedented geographical expansion, which brought with it further deposits of precious metals. Jewelry became so popular that Pliny found occasion to lament the greed and avarice of his countrymen: "The first person to put gold on his fingers committed the worst crime against human life." But he lived at the beginning of the imperial period and could not even suspect the effects that vanity, the need for splendor, and the craving for recognition would later have. Although Tiberius (r. AD 14–37) passed luxury laws that prohibited the private use of gold tableware, that did not prevent Marcus Antonius from acquiring a gold chamber pot, for example. The prohibition also applied to gold burial offerings, which appear to have been common

129. Bust of Marcus Aurelius, peristyle courtyard of the Cigognier sanctuary, Avenches, Switzerland, second half of the second century AD; chased gold (22 karat), reworked when cold, height: 13⅛ in. (33.4 cm). Site et Musée Romains, Avenches.
One of the few emperors' busts that escaped being melted down is this exquisitely chased, realistic portrait of the emperor Marcus Aurelius from the province of Gallia. The bust was hammered hollow and probably assembled from several parts, but with such care that no seams are visible.

in Rome as well. Only gold fillings for teeth were exempted from the imperial prohibition; however, the laws were not very well enforced.

Under Trajan (r. 98–117) the empire reached the height of its expansion and acquired other provinces rich in raw materials (plate 130). The province of Dacia, which corresponded roughly to present-day Romania, and Moesia Inferior to the south of it, which included parts of present-day Bulgaria, had considerable mineral resources, including large deposits of gold, with three centers in the western Carpathian Mountains—Ampelum (Zlatna), Abrud, and Alburnus Major (Roşia Montană)—and Pautalia (Kjustendil) and Philippopolis in Bulgaria. In the third century AD, under Septimius Severus (r. 193–211) and Caracalla (r. 211–17), there were even coins minted that praised in allegory the region's wealth of gold and silver. These editions were thus precursors of the so-called *Ausbeutetaler* (mining talers), coins minted from the sixteenth century onward to commemorate successful mining ventures, which sovereigns celebrated as the "blessings of the mountains" that had been bestowed on them. The deposits of Dolaucothi in Wales that had probably already been mined by the Celts also numbered among the gold mines of the Roman period.

Smaller deposits of gold, as in the sand of riverbeds, could be exploited privately. The large deposits of precious metals, however, were controlled more strictly by the state, which required a functioning bureaucracy. The actual mining was accomplished by large leaseholders (*conductores*), who then assigned parts of their area to subcontractors (*leguli*). The latter also took responsibility for the technical staff for extracting the gold. They

130. Gold in the Roman Empire.
This map shows Rome's sphere of influence during the reign of Emperor Trajan (around AD 100), when the empire reached the height of its expansion. In addition to the most important gold deposits shown here, the Romans also exploited deposits of alluvial gold.

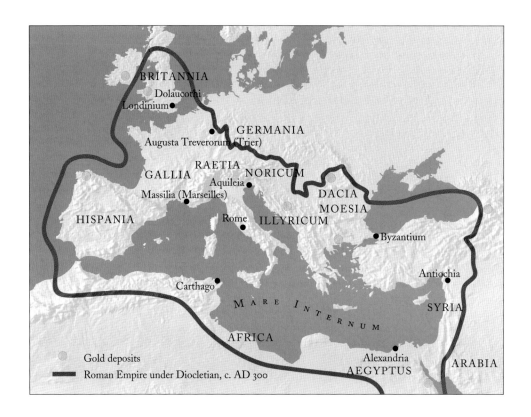

131. Cherub as goldsmith, fresco from the cycle of cherubs practicing trades and playing sports, AD 63–79. Casa dei Vettii, Pompeii.
This well-preserved realistic fresco shows a goldsmith's workshop with a cherub sitting in front of an anvil and working an object with a small hammer. The equipment of the workshop also includes a small smelting furnace (muffle kiln), scale, and a bellows.

had thousands of workers, including slaves, war prisoners, and condemned prisoners.

We can picture the Roman gold mining in northern Spain on the basis of Pliny the Elder's descriptions in his *Natural History*. From AD 72 to 74 he held the office of governor (*procurator*) of the province of Tarraconensis in northeastern Spain, so his descriptions are largely based on his own observations. The method for extraction that he describes is unique in antiquity for its advanced technology; it was not used again until the modern age, in California, Brazil, and other gold-producing countries, where it was called "hydraulic mining." Pliny calls it *arrugia* and criticizes it as a "collapse of Nature." What does he mean?

To prepare to tap a gold deposit, miners and technicians would place an enormous water reservoir on a plateau above the deposit. Then miners would punch holes in the formations of gold-bearing stone with the help of numerous galleries and passageways, until the rock barely held together. Just as the pit mine was about to collapse, when the men doing the preparation work had given warning signals, the miners would flee the mine. At that same moment, the sluices of the reservoir above the pit would be opened: within about twenty minutes, approximately three million gallons ($11,000\,\mathrm{m}^3$) of water would pour out of five sluices in torrents over the collapsed galleries and broken stone. The force and violence of the water flushed streams of stone-filled slush into canals that had been prepared at the foot of the deposit being extracted. Underbrush (brushwood, broom, and the like) that had been placed in these troughs beforehand would catch pieces of gold freed up by the hydraulic mining. The final step of this elaborate but efficient method involved burning the organic materials in which the gold particles had been caught. The heavy precious metal, which was unaffected by burning, could then easily be washed out of the ash of the plants.

In the present-day province of León, in a rugged mountainous landscape bereft of vegetation known as Las Médulas, there are still traces of Roman mining activity. Pliny mentioned other deposits that provided

132. Bracelet with onyx, Rome, second to third century AD; coil of gold wire with clasp and gemstone in gold setting, diameter: 2³⁄₁₆ in. (5.5 cm). Antikensammlung, Kunsthistorisches Museum, Vienna.
This bracelet of gold and a gemstone is an example of the penchant of Roman goldsmiths for combining colored stones or glass paste with precious metals.

133. Necklace, Pompeii, prior to AD 79; gold, emeralds, mother-of-pearl inlay, length: 13⅝ in. (34.5 cm). Museo Archeologico Nazionale, Naples.
This wonderful piece of jewelry must have belonged to a noblewoman who had to leave it behind or lost it when Vesuvius erupted. Rather than the usual onyx and other semiprecious stones, the jeweler chose emeralds, which were already extremely valuable during the Roman period, and whose deep green is truly shown off to best advantage by the glimmering white mother-of-pearl rondelles.

Rome with gold in his day—there were said to be more than two hundred in all. He even indicated the quantities of precious metal extracted annually. It is impossible to determine whether his figures were accurate, but they provide some indication of Roman resources. To judge from ancient writings, a realistic estimate of the output of the mines from quantities of stone remaining after they had been worked, and what is thought to have been the average rate of extraction from ore at the time, it is likely that by the fifth century AD, Europe alone had produced around 4,400 tons (4,000 MT), of which—at an annual rate of extraction of 4.5–5.5 tons (4–5 MT)—more than 1,100 tons (1,000 MT) had been mined on the Iberian Peninsula alone. The quantity of gold-bearing stone broken down to extract it is estimated to have been 550 million tons (500 million MT).

LUXURY GOODS OF GOLD

What purpose did this considerable quantity of gold serve? It was, of course, employed for jewelry and luxury goods for the rich, as well as status objects for the emperor—a purpose for which the use of gold has since become firmly established. Already by the first century AD, it was common for both men and women to wear several rings. Women also wore bangles, earrings, diadems, necklaces, and gold belts (plates 132, 133). Where solid gold was out of the question, because someone was not rich enough or wanted to display as much gold as possible, thin gold appliqué could produce the desired gleam, for the Romans were masters of a wide range of gilding techniques. Wealth was consciously displayed, and so gold was also used to embellish buildings: not only Nero's palatial villa, the Domus Aurea, with its gold facade, but also the private homes of privileged Romans. Both walls and wooden or ivory coffered ceilings were gilded. Using the technique of fire gilding with mercury, even statues could be effectively covered with gold: the correct mixture of gold and

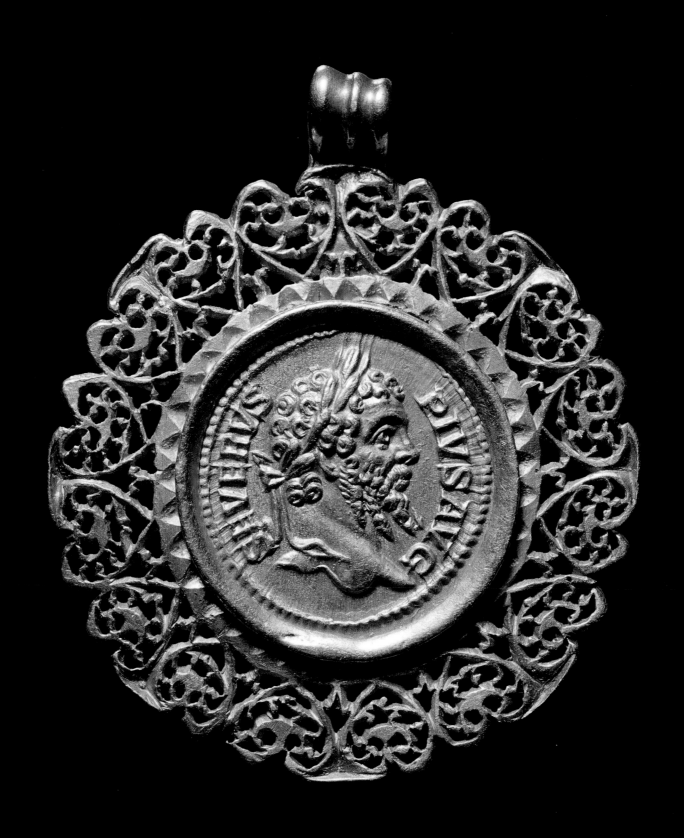

mercury produced an amalgam that was as soft as wax and could be brushed onto a metal base. When heated, the mercury would evaporate, and the gold would be left behind in a coat tightly adhered to the base. Civil servants and deserving private citizens were allowed to make gold or gilded busts of themselves; life-size statues in gold, however, were reserved for gods and members of the imperial family (plate 129).

There developed an imperial style of Roman art that from the time of Augustus (r. 27 BC–AD 14) primarily served the private needs of the privileged classes. It cannot be traced back to a specific origin, but Greek traditions played a role, as did the Italo-Etruscan heritage. Products of the crafts—especially the art of the goldsmith—were generally of high quality and were widespread (plate 131). Of the jewelry, which was often overly elaborate in its design, pieces using precious and semiprecious stones, glass paste, and imitation gems offered charming variations with nuanced colors. Engraved gems—with a portrait of the emperor, for example—were preferred as stones for rings (plate 135). Snake armbands and hollow bangles with twisting (torsion) were also popular. Only in late antiquity were new techniques introduced, as goldsmith work that recalled lace braiding in textiles became increasingly popular. This openwork technique, known as *opus interrasile*, was used for belt buckles and appliqué but above all for decorative settings for especially beautiful gold coins (plate 134). Some of these surviving medallions combine the numismatic value of the mounted coin with a refined setting.

Because gold tableware was reserved for the imperial house, in the first centuries AD it became popular to produce magnificent silver tableware with opulent gilding, thereby deftly skirting the prohibition. The Hildesheim silver find (plate 136) and the treasures of Boscoreale, Augst, and Mildenhall have provided surviving examples of chased, cast, and ornamented tableware in which talented artisans brilliantly combined the precious metals gold and silver.

134. *Aureus* in pendant setting with openwork frame, obverse: head of Septimius Severus with laurel wreath, minted in Rome, AD 202–10; gold, diameter (including setting): c. 1⅝ in. (4 cm). Münzkabinett, Staatliche Museen zu Berlin.
 The practice of setting particularly beautiful and valuable coins as medallions dates back to antiquity. Here the goldsmith carried out his task by giving the coin an elaborate setting of opus interrasile. By adding this lavish frame, a realistic portrait of the bearded emperor is elevated from currency to showpiece.

135. Ring with intaglio, portrait of Commodus, Tongeren, Belgium, late second century AD; gold, diameter (of ring): 13/16 in. (2.05 cm), length of the intaglio: 11/16 in. (1.75 cm). Provinciaal Gallo-Romeins Museum, Tongeren.
 This ring with the portrait of the emperor served imperial emissaries as a seal when they needed to certify official documents with the emperor's name while traveling in the provinces.

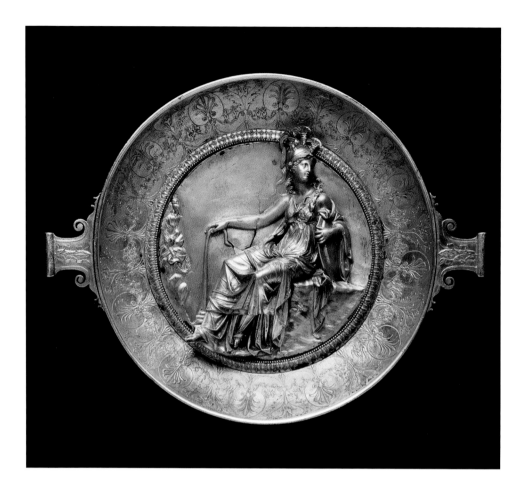

136. Platter, Hildesheim silver find, late first century AD; silver, partially fire gilded, diameter (with handle): 12¹³/₁₆ in. (32.5 cm). Antikensammlung, Staatliche Museen zu Berlin.

The festive, elegant figure of the goddess Minerva in a draped garment dominates the center of this partially gilded platter. Six ornamental elements cast beforehand in silver using the lost wax technique were welded to the undecorated platter. The partial gilding was then applied in a final step.

137. Roman coin die, Verulamium, Saint Albans, England, first to second century AD; iron. Verulamium Museum, Saint Albans Museums.

The minting of coins by hand, which was still common in Roman times, required both an upper and a lower die for the obverse and reverse of the coin. A planchet—that is, the metal blank—was placed between them and minted on both sides by giving the die a powerful blow with a hammer.

Gold was more common in the profane everyday life of the Romans than in the religious realm; the statues and busts of deified emperors were more often the products of stonemasons and sculptors than of goldsmiths. Wealthy Romans typically had a domestic shrine (*lararium*), which sometimes had small bronze statues of divinities that were ornamented with bands of gold or gold torques. In the provinces, which often had their own indigenous traditions for producing jewelry, such figures were apparently especially popular. Votive plaques in gold with dedications to divinities have been found in Switzerland and elsewhere. The encyclopedist Pliny noted that gold was even used medicinally: "M. Varro assures us that gold is a cure for warts."

Even in the Imperium Romanum, gold was subject to recycling. The reuse of precious metals was common; in fact, gold and silver busts of the emperor usually disappeared when the ruler they depicted had come to a violent end. For example, when Domitian was murdered in AD 96, his memory was extinguished (*damnatio memoriae*), and his busts ended up in the crucible. The metal was used to mint coins with a portrait of the new emperor, Nerva—or so contemporary witnesses report.

The share of gold used to flaunt status and splendor is not known exactly, but the bulk of the precious metal went to state mints (plate 137). The most important Roman gold coin was the *aureus* (plates 138–43, 145–49), which originally weighed more than a quarter ounce (nearly 8 g) but over time was reduced to about a fifth of an ounce (6 g). In the fourth century AD it was replaced by the *solidus*, which weighed only a seventh of an ounce (4 g). Multiples of the *aureus* or *solidus* were sometimes minted, as were gold medals (plate 144). The important fact, however, is that over more than three centuries of Roman minting, the purity of gold coins remained at about 98 percent—and was thus fine gold by today's standards. To meet the minting master's needs, several thousand tons of natural argentiferous gold were subjected to the elaborate refining process known as salt cementation. The workshops on the Magdalensberg in Austria where this was done have become famous. Excavations in the Roman province of Noricum and in the Balkans have revealed several other sites that may also have been used to refine gold.

Roman gold, silver, brass, and copper coins from the time of Augustus onward have a portrait of the emperor on the obverse (plates 142, 145). The art of realistic depiction, perfectly executed by the die cutters, turned Roman coins into a means for state propaganda, while at the same time making them appealing evidence of mass production in antiquity. That is especially clear from the motifs on the reverse sides of the coins (plates 143, 144, 146, 147, 149), which reflect a dynastic agenda and allude to Roman virtues like justice, charity, steadfastness, tradition, and unity, or to shrines, public buildings, victory in war, and imperial gifts (*liberalitas*) to

138. *Aureus*, obverse: Marcus Junius Brutus, c. 43–42 BC; gold, c. 0.3 oz. (7.5 g), diameter: c. ¹³⁄₁₆ in. (2 cm). British Museum, London.
 Aureus *is the name for the most common and also most valuable Roman gold coin, which contained 98 to 99 percent gold. This example, depicting the man who assassinated Julius Caesar, was coined at an eastern mint. The trophy on the reverse was intended to commemorate Brutus's capture of Xanthus and Patara in Lycia.*

▽ 139/140. *Aureus*, obverse: Marcus Antonius, reverse: Octavia, lightly draped bust with braid on the top of the head and knot at the nape of the neck, minted in Ephesus (?), c. AD 40; gold, c. 0.3 oz. (7.5 g), diameter: c. ¹³⁄₁₆ in. (2 cm). Private collection.
 The obverse of this unique coin has a portrait of Marcus Antonius, or Mark Antony; the reverse, of his wife, Octavia. It is a document of the political relationships of the time, as it was hoped that Marcus Antonius would provide a strong hand in reorganizing the state after Caesar's assassination.

145. *Aureus*, obverse: head of Emperor
Augustus, facing right, minted in Colonia
Patricia, Spain, 20–16 BC; gold, diameter:
¾ in. (1.99 cm), weight: 0.28 oz. (7.83 g).
Geldmuseum, Deutsche Bundesbank,
Frankfurt am Main.
 *Having one's portrait on a coin was a right
that dated back to Julius Caesar. Coins of the
imperial period had a portrait of the emperor.
Augustus, the first Roman emperor, made
frequent use of this privilege to promote his
image and make it known throughout the
empire.*

146. *Aureus*, reverse: Trajan's Forum, minted
AD 112–14; gold, diameter: c. ¹³⁄₁₆ in. (2 cm),
weight: 0.25 oz. (7.18 g). Staatliche
Münzsammlung, Munich.
 *Depictions of public buildings and temples
were a common alternative to portraits of the
emperor, especially when the building in
question was identified with the name of the
emperor.*

147. *Aureus*, reverse: mourning Germania,
minted in Rome, AD 88; gold. Private
collection.
 *Victory in the wars against the Chatti and
the triumph of Emperor Domitian over the
Germanic tribes are symbolized by this image.
Comparable motifs had been coined earlier.*

148. *Aureus*, obverse: Julia Domna, minted
in Rome, AD 193–96; gold, diameter:
c. ¹³⁄₁₆ in. (2 cm), weight: c. 0.25 oz. (7 g).
British Museum, London.
 *The influential empress and wife of
Septimius Severus was a highly educated,
intelligent woman who was greatly admired
by all. Her portrait spread to the most distant
provinces of the empire, though outside Rome
only on coins of copper, bronze, and brass.*

149. *Aureus*, reverse: Medusa's head,
c. AD 270; gold, diameter: c. ¹³⁄₁₆ in.
(2 cm), weight: c. 0.2 oz. (6.5 g). Staatliche
Münzsammlung, Munich.
 *This gold coin, minted in Cologne, is an
extraordinary, carefully executed frontal
depiction of the head of Medusa. It was
minted under Emperor Victorinus, and the
inscription refers to PROVIDENTIA, the
emperor's forward-looking benevolent care.*

THE DECLINE OF THE EMPIRE

In addition to the enormous quantities of gold that were expended on the growing need for luxuries during the imperial period, state expenditures on the military, tributes, the celebration of triumphs, and many other forms of spending increased. For the armed forces alone, with thirty legions of six thousand soldiers apiece (a total of 180,000 troops), each earning nine to twelve *aurei*, fourteen to nineteen tons (13–17 MT) of gold had to be paid out annually. Even when the wages were not paid entirely in gold, the precious metal had to be obtained and be available. Moreover, gold coins represented a form of investment, which in times of need or danger were hoarded and buried. The number of hoards of gold coins that have been found in all the empire's territories is well over sixty, with a total of nearly twenty thousand *aurei*. As recently as 1993, during construction work in Trier, Germany, a treasure of more than 2,500 *aurei* was uncovered (plate 141). Roman gold coins also made their way beyond the empire's eastern border as far as India and China.

Mining could not make up for this loss of gold resources forever, even with old coins being melted down and reissued. Together with expensive imports, uncontrolled expenses devastated the state finances. When mines began producing less gold, or none at all, and the recycling of old gold was minimal, the scarcity of the precious metal increased. The greatness, power, and wealth that could be saved when the western empire declined was transferred to the eastern empire, which outlived it for many centuries.

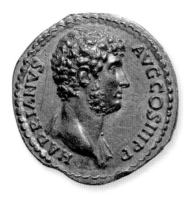 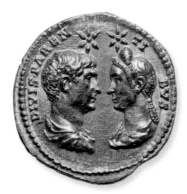

the citizens of the city of Rome, like deliveries of oil and grain (*annonas*). The famous women from the ruling houses who owe their place in posterity to memorable portraits on coins include the intelligent and beautiful wife of Septimius Severus, Julia Domna (plate 148). She was one of the most important women at the side of any Roman emperor and had the rights and title of an empress (*augusta*). One of those rights was to have her portrait appear on coins, and she took frequent advantage of it.

To ensure that gold coins were minted from high-karat fine gold, the last emperor who was able to keep the entire empire united under his scepter, Theodosius I (r. 379–395), created the high office of warden of the mint (*comes obryziaci*), whose holder had to vouch for the purity of the gold (*aurum obryzum* or *aurum coctum*). Because gold coins were also used for foreign trade, they had to be of consistent quality, for Rome's commercial partners abroad were not interested in the depictions and inscriptions, just the purity of the gold used. The only known exceptions are the coins of Emperor Alexander Severus, who was assassinated in AD 235, which contained only 8 percent gold.

◁ 141. Trier treasure of 1993, at least 2,528 *aurei*, AD 64 to 193–96 (Nero to Septimius Severus); gold, total weight: 40 lbs. 12 oz. (18.5 kg). Münzkabinett, Rheinisches Landesmuseum, Trier.

During the turmoil of civil war between Septimius Severus and Clodius Albinus around AD 196, the largest hoard of coins to be discovered north of the Alps was buried near Trier. Some notion of the value of the coins at the time is suggested by the fact that the procurator of finances for the provinces of Lower and Upper Germania and Gallia Belgica drew an annual salary of 2,000 aurei. This hoard would have purchased one or two country estates or three to five hundred tuns of wine (one tun is equal to 252 gallons, or about a thousand liters).

△ 142/143. *Aureus*, obverse: Hadrian, draped bust, reverse: double portrait of Trajan and Plotina, minted in Rome, AD 134–38; gold. Private collection.

This coin was minted to honor Hadrian's deceased adoptive parents and to emphasize his legitimacy as emperor and the dynastic concept. A star above each parent's head is a symbol of divinity, which is also expressed in the inscription DIVIS PARENTIBVS *(to the divine parents).*

▷ 144. Gold medallion worth five *aurei*, reverse: triumphal quadriga of elephants, minted c. AD 287; gold, diameter: c. 1⅜ in. (3.5 cm), weight: c. 1.2 oz. (33.0 g). Münzkabinett, Staatliche Museen zu Berlin.

The emperors Diocletian and Maximian, who shared power over the empire and alternated regularly as leader, are shown in this unusual, lifelike frontal view of a triumphal quadriga during the splendor of the processus consularis, *the inauguration of their shared term as consulate.*

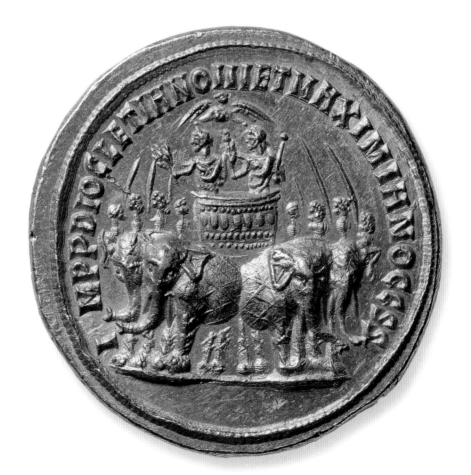

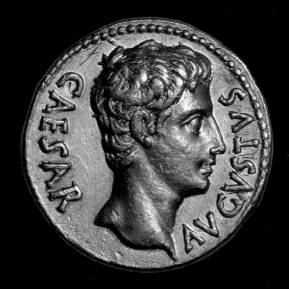
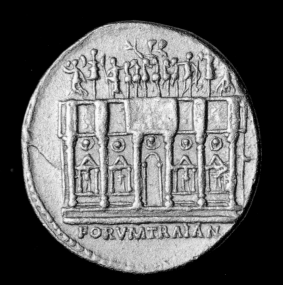
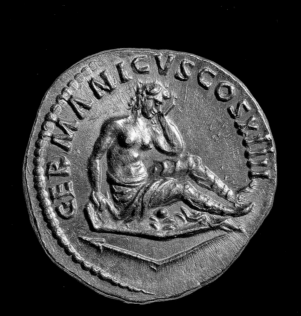
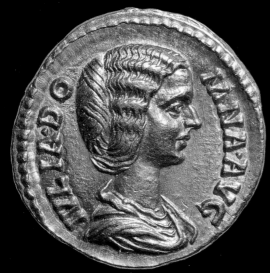
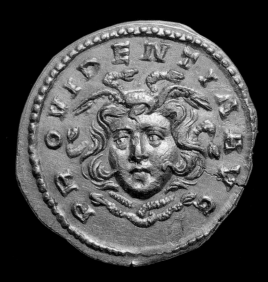

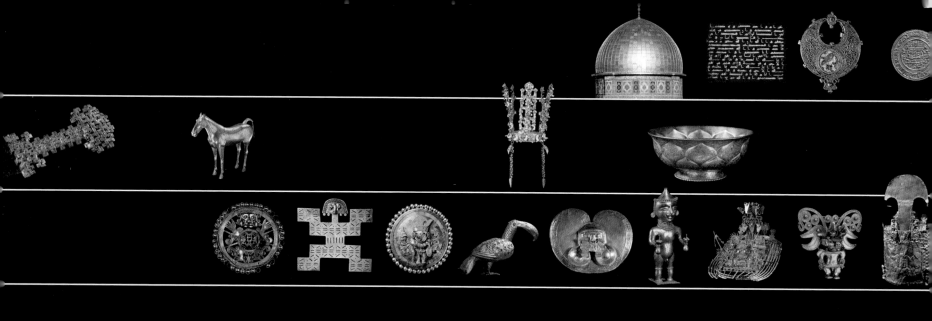

500 0 500 1000

The Islamic World

The Far East

The New World

Africa

1500 2000

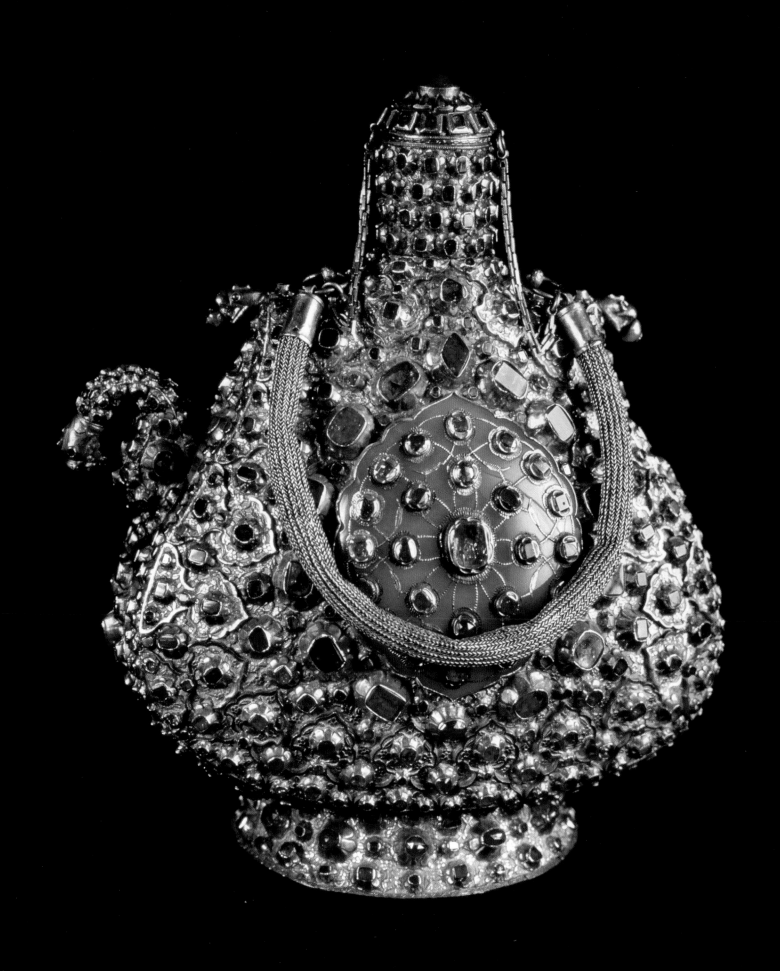

CHAPTER 9

✿✿✿✿✿✿✿✿✿✿✿✿✿✿✿✿✿✿✿✿✿✿✿✿✿✿✿✿✿✿✿✿✿✿✿✿

The Islamic World

BETWEEN MODERATION AND OPULENCE

Islam's relationship to gold has always been an ambivalent one, and it remains so today. The use of the precious metal to worship divine power, widespread in other religions, was limited under Islam; in the sacred realm, apart from a few exceptions, gold was used unostentatiously, not with triumphal radiance. In secular contexts, by contrast, one finds a great love of this gleaming metal (plates 150, 151), which was also easily accessible, as supplies of gold were never lacking.

In the Asian and Arab worlds there were many sources, large and small, of gold, some of which, like the mountainous deposits in Saudi Arabia, were being exploited as early as the first millennium BC. As Islam spread to the Iberian Peninsula and later, during the Ottoman Empire, to the Mediterranean and the Balkans, additional resources became available. In general it may be said that the East had considerably more gold than the European West in the Middle Ages. The same is true of Africa. It is difficult to estimate how much gold Arabs may have brought from African deposits along caravan routes to the courts of the Islamic rulers and Arab cities during the early Islamic period (eighth and ninth centuries AD). Africa's gold trade was tightly controlled by Arabs for many centuries.

GOLD IN THE DIVINE AND THE WORLDLY SPHERES

Although gold never had the same significance in Islam that it did in other monotheistic religions, many objects were left behind that testify to the artful use of gold. Especially in the period from the twelfth to the fourteenth century AD, workshops in Syria specialized in the enameling and gilding of mosque lamps (plate 157), beakers, goblets, and bottles. The artisans worked both for Islamic clerics and for secular clients. Their skills were widely praised; it was, however, forbidden to make vessels of pure gold.

The use of gold in architecture was also restrained, with the exception of such gilded mosque roofs as that of the Dome of the Rock (plate 155) in Jerusalem or the gilded minaret and dome of the Shiite al-Askari Mosque in Samarra in Iraq. When Mehmed II conquered Istanbul, then known as Constantinople, in 1453 and had the largest church of the city consecrated as a mosque, he had the Byzantine gold mosaics whitewashed, and the new decorations for the mosque consisted of several large, black, round shields

◁ 150. *Matara* vessel, Ottoman, second half of sixteenth century AD; gold with pearls, jade, emeralds, and rubies, 11 × 9⁷/₁₆ × 5⁵/₁₆ in. (28 × 24 × 13.5 cm). Topkapi Palace Museum, Istanbul.
This jug with spout, handle, and chained lid is an object of superlatives. In addition to the many gold-working techniques used—chasing, filigree work, and braided and wound knotwork in gold wire or solder—this vessel is decorated all over with precious stones and pearls in gold settings. Given the extravagant opulence, the value of the materials used, and the masterly command of techniques, it must have been made for a great dignitary.

△ 151. Pendant with sparrow, Islamic, Fatimid style, eleventh century AD; gold on silver core, enamel, height: 1⁹/₁₆ in. (4 cm). Museum of Islamic Art, Cairo.
This small, delicately chased pendant is decorated in the center with a colorful enamel inlay of a sparrow with a flower in its beak. Islamic art depicted fauna and flora with great imaginative variety. The chased gold plating covers a silver core that serves as a stabilizing base.

135

with a few suras from the Koran in gold script. The preferred decoration for mosques became glazed ceramic tiles that were painted with inorganic pigments. The ceramic tiles of the eleventh- and twelfth-century manufacturers of Kashan in Iran have become famous for the special surface effects caused by their metallic luster. These effects were achieved by mixing metallic compounds into the glaze (plate 156). When the glaze was fired, the glaze powders fused into transparent coats that obtained a characteristic colored luster depending on the metal they contained: adding copper produced a reddish tone; silver salts, a metallic green; and gold compounds, a warm yellow. Only a few ceramic workshops knew the formulas for effective metallic luster, and they protected their monopoly. In addition to Iran and Syria, Islamic southern Spain produced lusterware, especially bowls and platters used as festive tableware.

As sparingly as gold was used for religious purposes, sultans, sheikhs, emirs, and pashas reveled in it. Their precious personal objects of gold and gems filled the treasuries of their palaces, serving as ornaments, valuables, and refined luxuries in this world. Garments of gold brocade—patterned after Chinese models—were not reserved for rulers; even high officials and dignitaries could wear them. Gold in the Islamic Orient inevitably recalls the gleaming shops of jewelry dealers in the bazaars of Istanbul, Cairo, and Damascus. Gold was widespread not only among the rulers and the middle classes; even the peasant population could afford jewelry made from it. The rings, hoops, and chains that a bride brought to her marriage as dowry remained her personal property, even in case of divorce. The only condition for retaining her property was that she must wear the gold jewelry on her body.

The gold coins that were used throughout the Islamic world and beyond were not only carried in pockets and bags but also worn on the body. A book on "the precious metals gold and silver" written around AD 940 by the polymath al-Hamdani from Sanaa in Yemen is an informed and critical work on the significance of these metals in the Arab world, and especially on the use of precious metals for minting. Arab gold dinars (plates 152, 153) with a standard weight of about a seventh of an ounce (4 g) not only were widespread in Islamic countries from Spain to India but also arrived in medieval Europe via trade routes. Because they were of high purity and correspondingly soft, it is not unusual to find wavy or bent coins. The dinars minted in the eleventh and twelfth centuries AD by the Ghaznavids and Seljuks of Afghanistan were exempted from the purity law and contained more silver than gold (plate 154). Over the course of two centuries, more and more silver was added to the gold, until finally the gold content was only 5 percent and the coins appeared to be silver.

Islamic coins, especially of gold, often included outstanding examples of calligraphic miniatures. In just a tiny space, their die cutters could include the name and title of the ruler, blessings, and the place and year of coinage in a beautiful style of ornamental script.

◁◁ 156. Prayer niche (*mihrab*), Maidan mosque,
Kashan, Persia, 1226; luster faience, height:
9 ft. 2 in. (280 cm), width: 5 ft. 10 in.
(180 cm). Museum für Islamische Kunst,
Staatliche Museen zu Berlin.

*This work, signed by the architect Hasan ibn
Arabshah al-Nakash, is an exquisite example of
the spatial effects achieved using blue and green
tiles from Kashan, which were also glazed with
a gold luster. Such tiles, particularly in cobalt
blue with the discreet gold shimmer of the luster,
were much sought after throughout the Islamic
world.*

◁◁ 157. Mosque lamp, Mamluk sultanate,
c. AD 1355; glass with gold and enamel
decorations, height: 17⅛ in. (43.5 cm).
Museum of Islamic Art, Cairo.

*The glass on this lamp, which bears the name
of the emir Shaiku and is painted with gold and
cobalt blue pigments, recalls the delicate hue of
gold luster glazes. It remains a mystery how the
glassblower managed to achieve this effect, as
many craft techniques once common have now
been lost.*

▽ 158. Page from a Koran manuscript in the
colors of the heavens, Kairouan, Tunisia,
ninth century AD; kufic script in gold on
blue silk. Mrs. Bashir Mohammed
Collection, London.

*Calligraphy using gold ink was usually
executed on paper or parchment. Using silk for
writing is unusual, and the choice suggests it
was for a special occasion. It is not known
whether the silk had to be specially prepared to
prevent the ink from running or whether an
especially glutinous gold ink was required.*

CALLIGRAPHY IN GOLD

Islam strictly prohibits the depiction of the human figure, which is why calligraphy is often employed as a decorative and ornamental element. Islamic calligraphy primarily made use of black and colored inks, but for special works gold ink was indispensable. It was produced by stirring gold dust into a watery solution of gum arabic. Manuscripts of the Koran, often signed by the calligrapher, were particularly masterly examples of its use (plate 158). The suras of the prophet were texts whose presentation and decoration deserved only the best and most valuable, so what would have been better suited for it than gold?

The products of "beautiful writing"—the literal meaning of the Greek-derived word *calligraphy*—were mirrors of their time in terms of how Arabic was written. From the steep, angular forms of the Kufic script used from the ninth to the eleventh century ("flowing Kufi") by way of the rounded elements of Naskhi to the cursivelike Taliq of the fifteenth century, it is not difficult to date a text based on its calligraphic style. Writing in gold complemented colored elements, including ribbon and wicker patterns, arabesques, palmettes, and rosettes. The calligraphic treasures from the heyday of the Ottoman Empire (from the late fifteenth to the seventeenth century) held in the Sabancı Museum in Istanbul are among the most important and most beautiful legacies of this particular current of Islamic art (plate 159). Valuable calligraphic documents called

for suitably designed leather bindings or folders with gold embossing, to provide the manuscripts with a worthy setting.

Gold was said to be one of the joys of paradise, not of this world, but the recommendations of the clergy were not always followed when the need for splendor called for more lavish presentation.

159. Koran, Ottoman, late fifteenth century AD; ink, paint, and gold on paper. Sakip Sabancı Museum, Sabancı University, Istanbul.

This first illuminated double-page spread from a richly ornamented Koran is an especially fine example of late-fifteenth-century manuscript illumination. Arabic script is suited like no other to being distorted into ornament. No restrictions were placed on calligraphers in terms of the lines and curves, as long as the ornamented text remained legible.

CHAPTER 10

❀❀❀❀❀❀❀❀❀❀❀❀❀❀❀❀❀❀❀❀❀❀❀❀❀❀❀❀❀❀❀❀❀❀❀❀

The Far East

FROM THE SHWEDAGON PAGODA TO
HIDEYOSHI'S TEA PAVILION

THE GOLD MINES OF INDIA
AND THE GLEAMING PAGODAS OF MYANMAR

Herodotus, the father of history, lived in the fifth century BC, and in the third book of his *Histories* he mentions in passing that in India giant ants pulled nuggets of gold out of the sand. The details of this fairy tale are so imaginative that philologists and historians have tried in vain to discover the actual background behind the story. Certain contradictions have yet to be resolved, but in South Africa today, it is not uncommon to examine termite hills as a way to find gold deposits. So there could be some truth to Herodotus's report. It is, in any case, a fact that gold washing was practiced in the Indus and other rivers as early as the middle of the second millennium BC and that pieces of jewelry from an even earlier time have been found. India was rich in precious metals, and even more so in precious stones; its goldsmiths were well respected and admired from very early on.

◁ 160. Kyaiktiyo Pagoda, near Kyaikto, Myanmar, eleventh century AD; gold leaf, height: 18 ft. (5.5 m).
This rock, which has been completely covered with little pieces of gold by devout Buddhists, is one of the most important pilgrimage sites in Myanmar. There is a legend that this boulder stays balanced at the edge of a great abyss only because one of the Buddha's hairs has been precisely placed in the stupa built on the rock.

▽ 161. Map of the most important gold cultures and principal empires in East Asia.
The centers of gold mining and working in East Asia have varied across both space and time, from India in the second millennium BC to Japan in the nineteenth century AD. The gold deposit on the island of Sado in the Sea of Japan is marked with a yellow point.

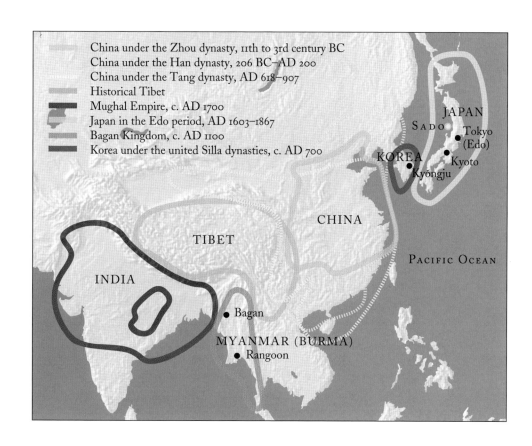

China under the Zhou dynasty, 11th to 3rd century BC
China under the Han dynasty, 206 BC–AD 200
China under the Tang dynasty, AD 618–907
Historical Tibet
Mughal Empire, c. AD 1700
Japan in the Edo period, AD 1603–1867
Bagan Kingdom, c. AD 1100
Korea under the united Silla dynasties, c. AD 700

JAPAN
SADO
Tokyo (Edo)
KOREA
Kyŏngju
Kyoto
CHINA
TIBET
PACIFIC OCEAN
INDIA
Bagan
MYANMAR (BURMA)
Rangoon

In addition to posessing substantial local deposits, India also acquired a great deal of gold through trade, especially in the Roman period, since its spices, cloth, pearls, and other luxury items could be purchased only with gold. Hoard finds of Roman gold coins are thus quite common on the Indian subcontinent. The precious metal was also imported from Arabia. Gold was so abundant in India that its value in relation to silver sank in the early eighteenth century from 1 to 10 to 1 to 9—reason enough for Sir Isaac Newton, then master of the Royal Mint of England, to sail to India and East Asia to purchase "cheap" gold, because in England the ratio of the value of gold to that of silver was 1 to 15.2 at the time.

Talk of gold in India inevitably brings to mind the treasures that the maharajas and feudal lords kept in their palaces, residences, and castles; these treasures are not accessible to the public, however, so one can only speculate about them. Visible and omnipresent, by contrast, is the gold on pagodas, stupas, shrines, and statues on the Indian subcontinent, especially in Myanmar (Burma; plate 162). Three hundred thousand people lived in Bagan, then the capital, during the so-called Golden Age of the eleventh and twelfth centuries AD. The faithful could worship Buddha at five thousand temples and pagodas, the tallest of which had a height of two hundred feet (62 m). The Shwezigon Pagoda, built between AD 1059 and 1096, belongs to the world's cultural heritage, as does the Kyaiktiyo Pagoda (plate 160), with its gilded boulder. The Shwedagon Pagoda (plate 165) in Rangoon, the present capital, is a center for the Buddhist faithful and is said to have gold plating—in addition to countless precious stones—that weighs more than the gold reserves of the Bank of England, at least several hundred tons. Figures of Buddha there have layers of gold

◁ 162. Lion throne from the Myanmar palace, late nineteenth century AD; gilded wood, height of the altar proper: c. 41⁵/16 in. (105 cm). National Museum, Rangoon, Myanmar.
The Myanmar palace once had nine thrones of different woods with various motifs. Two of them were lion thrones, only one of which has survived. The throne, which is completely gilded and decorated with elaborate carving, formerly stood in the large audience hall. It has thirty-five additional gold attributes, including baskets, slippers, fly whisks, boxes for betel nuts, and chin supports.

▽ 163. Reliquary figure, Tibetan, c. AD 1700; gold, gemstones. American Museum of Natural History, New York.
This gilded statue in lotus position is richly adorned with gold jewelry, which stands out from the figure thanks to the numerous colorful gem inlays.

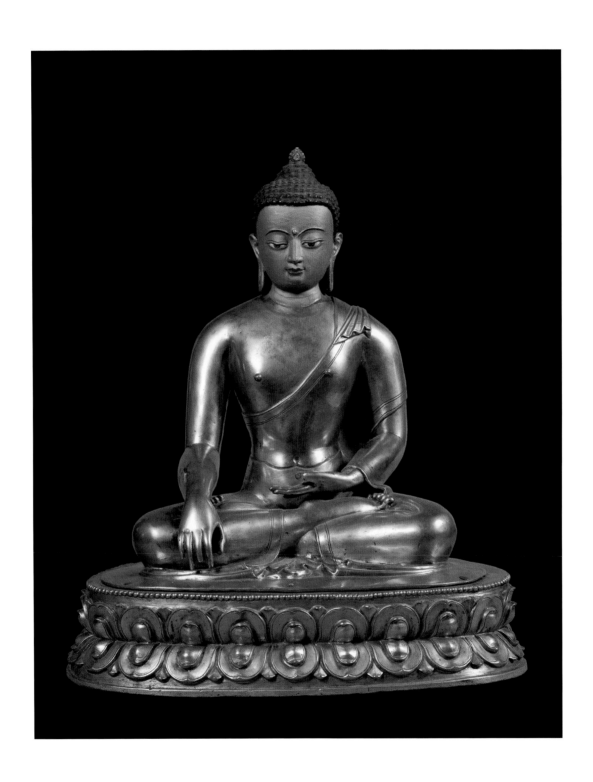

164. Buddha Shakyamuni, seated figure, Bhutan, mid-eighteenth century AD; fire gilded, height: 18⅛ in. (46 cm). Thimphu Dzong monastery, Thimphu, Bhutan.
This Buddha figure is given as an example of countless similar statues, which are found primarily in monasteries. The technique of fire gilding was used, in which a layer of mercury and gold was applied to the figure and then heated to evaporate the mercury.

165. Shwedagon Pagoda on Theingottara Hill, Rangoon, partial view, originally dating to the second half of the first century BC, alterations and expansions since the fifteenth century AD; gold, precious stones, height: 360 feet (110 m).
This lavishly gilded pagoda is the largest in the capital of Myanmar. There is a custom in which the faithful apply new layers of gold leaf to the pagoda and place gilded votive offerings at the numerous altars seen in the foreground.

166. Dagger, Bhutan, twentieth century AD; silver with gold plate. National Museum, Paro, Bhutan.
This richly ornamented dagger in gold-plated silver, an artful example of openwork, was probably part of the royal collection.

up to eight inches (20 cm) thick, and even today it is common for the faithful to express their reverence by applying gold leaf to statues and temple walls with their own hands. No other monotheistic religion revels in gold like Buddhism. From the giant pagodas of Myanmar, resplendent with gold, to monastery roofs and small reliquary figures from Tibet (plate 163), immortal gold expresses the adoration and profound faith of a religion that seeks entrance to nirvana as the ultimate salvation.

As Buddhism spread, gold became—and has remained—the preferred metal for showing reverence to depictions of the Buddha (plate 164) and to his temples in other parts of Asia as well (plate 161). But gold's use as a symbol of spiritualization, redemption, and the absolute did not keep goldsmiths from demonstrating their skills with worldly objects as well. The rich ornaments on the handle and sheath of a dagger from Bhutan testify to such perfection (plate 166).

The Time-honored Art of Chinese Goldsmiths

Some of the earliest testimonials to the art of Chinese goldsmiths are burial offerings from the eighth to the sixth century BC (plate 167). Excavations have uncovered decorative sheets with hammered, chased, or engraved elements that were probably once ornaments for wooden chests, crates, or furniture. China has a long tradition of producing bronzes that

167. Dagger hilt, Yimen, Shaanxi Province, China, eastern Zhou dynasty, 770–481 BC; gold, turquoise, glass paste, length: 5 in. (12.7 cm). Archaeological Mission, Baoji, China.
This dagger hilt is set with countless polished turquoise stones and greenish-blue enamel embedded in the gold base in a symmetrical, rectangular pattern. Early metalwork from China is consistently distinguished by its outstanding quality.

168. Embroidered dragon, formal garment of a mandarin, China, late seventeenth century AD; gold embroidery. Museum für Ostasiatische Kunst, Staatliche Museen zu Berlin.
Silk embroidery with fine gold and silver wires and colorful threads adorns this formal garment for a mandarin to wear for official court ceremonies.

169. Gold bowl, Hochia, Xi'an, Shaanxi Province, China, Tang dynasty, mid-eighth century AD; diameter: 2⅛ in. (5.5 cm). Present whereabouts unknown.
This golden bowl with a pedestal base is decorated on all sides with engraved medallions in the form of flower petals, which in turn contain delicate engravings of stags, birds, and flowers. The vessel is eloquent testimony to the artist's openness to inspiration from other cultures.

dates back to the prehistoric period. Gold played only a minor role, though there was surely plenty of it available. The preferred use for gold in China was purely decorative. Small bronze vessels and large sacred bronzes were ornamented with symmetrically applied gold and silver inlay, producing a charming contrast. In addition to such geometrical patterns, ornamental gilding was widespread (plate 170).

The enormous Chinese empire was a land with open borders that also had trade relations with the West. When the first electrum coins were being minted in Asia Minor, the eastern Zhou dynasty (771–256 BC) in China was already using small stamped gold slabs called *ying yuan* as coins. The Silk Road was not only a means for exchanging goods; it also brought previously unknown techniques and skills to the Middle Kingdom, and thus during the Han dynasty (206 BC–AD 220) Chinese artisans learned granulation, for example.

The Tang dynasty (AD 618–907) represented a particular flowering of the goldsmith's art. The first two centuries of that period were marked by extraordinary tolerance of foreigners and openness to foreign influences. Finds of Byzantine gold coins (*solidi*), for example, testify to connections as far away as the Eastern Roman Empire. Chinese goldsmiths were inspired by external influences, but they also shone in their own artfully decorated artifacts, such as lidded boxes, bowls (plate 169), handled cups, partially gilded silver mirrors, earrings, belt buckles, brooches, and

170. Horse, Wudi, mausoleum, anonymous tomb no. 1, western Han dynasty, c. 130 BC; gilded bronze, size: 24⁷/₁₆ × 29¹⁵/₁₆ in. (62 × 76 cm), weight: 64 lbs. (29 kg). Maoling Museum, Maoling, China.

This relatively large and heavy bronze sculpture is a rarity among Chinese burial offerings. The realistic cast animal figure was gilded to protect against corrosion.

171. Crown, Korean, Silla empire, second half of the fifth century AD; gold with jade jewels, height: 12¹³/₁₆ in. (32.5 cm), diameter: 7⅞ in. (20 cm). National Museum, Kyŏngju, Korea.

The numerous gold paillettes and more than fifty half-moon jade pendants on this crown are applied in such a way that they ring like bells at the slightest movement. The headband and its upper elements of thin sheet gold are attached by means of small gold nails. This crown is a masterpiece of early Korean goldsmith's work, in which the rigorous construction contrasts effectively with the moving pendants.

172. Helmet, Korean, Silla empire, second half of the fifth century AD; gold, height: 6¾ in. (17.2 cm), width: 6¹⁵/₁₆ in. (17.6 cm), weight: 5.5 oz. (155 g). National Museum, Kyŏngju, Korea.

This tall, slender gold helmet was probably crowned with an upper part in the form of gold wings. Despite the visor and the sharp edges, it was worn never in battle but rather in shamanistic ceremonies to demonstrate the power and influence of its wearer.

helmet decorations. Their predominant techniques of working gold were hammering and chasing, and they also had a particular fondness for filigree work. Floral and zoomorphic decorative elements have been interpreted by experts as refinements of Persian influence. Ceramic figures of court officials and palace ladies of the Tang dynasty demonstrate that by then splendid gold-embroidered garments were already esteemed—a tradition that continued in the nineteenth century. Embroidery with gold thread was not simply ornamental; the manner of its execution indicated the rank of mandarins and nobles (plate 168).

With the end of the Tang dynasty, many of these achievements were lost and the connections with other cultures severed. After a time, traditions and techniques of working precious metals would travel to Korea and, after a further delay, to Japan.

THE LEGACY OF THE SILLA KINGS OF KOREA

In the southern part of the Korean peninsula lies Kyŏngju, once the capital of the united Silla dynasties (AD 668–918), which were approximately contemporary with the Tang dynasty in China. Many of the Silla kings were interred near the capital in burial mounds, some of which have been carefully excavated; others have been left untouched as enduring monuments. These deceased rulers were buried with lavish offerings in tomb chambers made of wood.

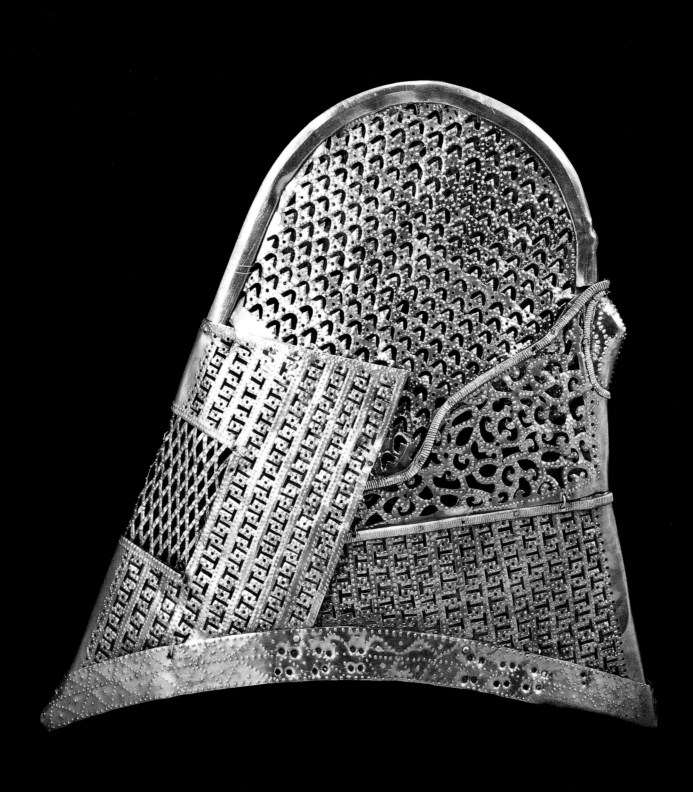

The famous Tomb of the Heavenly Horse contained gold finds that are unparalleled in East Asia, including a helmet of sheet gold incised with floral and geometric motifs, held together by small gold pins and riveted together using appliqué strips (plate 172). Another piece, a crown, has pendants of gold bands and jade appliqué (plate 171). Such lavish burial decorations were not limited to sites near Kyŏngju, though. Similar finds have been made in other areas. These tomb offerings from the heyday of the Silla kings are conscious expressions of the self-image of these rulers, who united a previously riven country.

THE GOLD OF THE SHOGUNS

Marco Polo wrote about the gold wealth of Zipangu from hearsay, without any evidence for his claim, but it is certain that gold played a role in Japan's early history in both the sacred and the profane realms (plate 173). Our knowledge of the use of gold in this period, however, does not extend much beyond vague hints. But in a more recent era of Japanese history—the Edo, or Tokugawa, period from 1603 to 1867—gold is known to have played a decisive role.

When the commander of the Ashikaga, Toyotomi Hideyoshi (r. 1582–1598), broke the dominance of feuding provincial princes and thus ended a period of civil war that had lasted a century, Japan entered a time of internal peace that would continue for more than two centuries. Hideyoshi was succeeded by Tokugawa Ieyasu (r. 1603–1616), the first in a long series of Tokugawa shoguns. With his rule began the Edo period, which owes its name to the seat of its power, present-day Tokyo. One political objective of the Tokugawa shogunate was to isolate Japan completely from the rest of the world and keep external influences at a distance, because it feared an invasion by Christian nations. As late as the sixteenth century, Japan still

175. Garment of the shogun Hideyoshi, sixteenth century AD. Castle Museum, Osaka.

This sleeveless vest with the symbol of the red rising sun was covered with gold foil, which now has a number of creases and tears. This imposing garment must have drawn attention to its wearer even from afar.

had contact and exchange with Christian missionaries, who taught the Japanese, among other things, the basics of metallurgy. The centuries of internal peace and the isolation from the outside world brought Japan's united corporative-feudal society—ultimately thanks to the authority of the Tokugawa shogunate—a flowering of art and science that endured for much of the Edo period.

The Tokugawa shoguns were by far the largest landowners in Japan, and they controlled regions that were rich in mineral resources, including gold deposits. After some initial efforts at extraction elsewhere, mines on Sado Island in the Sea of Japan produced significant amounts of gold, silver, and copper beginning in 1603 and lasting until 1998. Of the eighty tons (72.7 MT) of gold mined during these four centuries, approximately forty-five tons (41 MT) of it were extracted during the Tokugawa period alone. The mining town of Aikawa, now a small fishing village, was a city with more than a hundred thousand residents in the seventeenth century. The miners included not only fortune hunters and adventurers but also exiles and *hinin*, in English, "nonpersons"—that is, asocial,

homeless, or vagrant people who were not registered either as citizens of towns or as farmers.

Hideyoshi had already shown a fondness for gold. With his tea master, confidant, and adviser Ryuku, he celebrated tea ceremonies in a pavilion with gilded walls built for that purpose. The collection of the Osaka Castle Museum includes a gold fan (plate 174) and a vest with gilded front and back (plate 175) from his personal belongings. Gold was considered to be a means to ensure unity and peace: it was employed to pay loyal samurai, reward vassals, build fortresses, and revive the stagnating countryside.

But the Tokugawa rulers did more than use gold as an instrument of power; soon after their period of domination began, they produced gold currency. Coins were minted in large numbers on Sado and increasingly in other places in the empire as well. The coins, known as *koban* or *oban*, were sheet gold in oval shapes weighing between half an ounce and six ounces (15–165 g) and stamped with the *kiri* flower, the family crest of the Hideyoshi. The smaller *koban* were used as currency; the heavier *oban* (plate 176), which were often hand-signed in ink, were given as gifts and medals.

In contrast to the social hierarchy in China, in Japan artisans ranked, along with merchants and traders, on the lowest level of a four-tier order, beneath samurai and civil servants, scholars and artists, and farmers, priests, and physicians. This rank did not, however, prevent certain artisans from enjoying great respect—for example, the Gotō family, whose gold works were reserved for the use of the shoguns. Because warriors were highly respected, swords and decorations for swords were of particularly high quality. Sword blades (*kozuka*) with gold damascening on the handle or sword guards (*tsuba*) with gold inlay work were a necessity for

176. Japanese gold coins (*oban*), probably minted in Aikawa on Sado Island, seventeenth century AD; c. 5.8 oz. (165 g). State Coin Museum, Osaka.
Gold coins from Japan, which are extremely rare today, were oval and minted in two sizes: the smaller koban *(c. 0.5–2.1 oz., or 15–60 g) and the larger* oban *(c. 5.1–5.8 oz., or 145–165 g). Even in the age of the shoguns, the* oban *were not common currency but rather a sign that the recipient enjoyed the ruler's favor.*

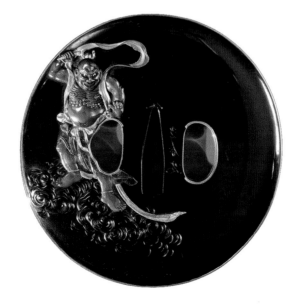

177. *Tsuba*, Japanese, nineteenth century AD; *shakudo* alloy with gold, silver, and copper damascene. Musée des Arts d'Extrême-Orient, Collections Baur, Geneva.
The tsuba, *the cross guard or hand guard of a sword, is a decorative piece found on all samurai swords. Chasing and damascening using gold threads or silver wire often decorated the surface of these disks.*

178. Gold painter in Kyoto.
 The most important material for this artist is gold in the form of gold inks, gold lacquers, and gold leaf. His workshop not only produces wall paintings but also restores or regilds small statues. He gets most of his commissions from the guardians of the many temples around this former imperial capital.

179. Square Japanese lacquerware box, c. 1700; gold lacquer, box: 2⅜ × 4¹³/₁₆ × 4⁷/₁₆ in. (6.1 × 12.2 × 11.2 cm), tray: ⁹/₁₆ × 4⁹/₁₆ × 4³/₁₆ in. (1.4 × 11.6 × 10.7 cm), inner boxes: ¹⁵/₁₆ × 2¼ × 2 in. (2.4 × 5.6 × 5.1 cm) each. Musée National des Arts Asiatiques–Guimet, Paris.
 This set of Japanese lacquerware is artfully decorated. The lid and sides of the box imitate wood grain using gold and silver powder. The lid is adorned with a dead branch of an old plum tree as well as new growth and flowers in relief lacquer (takamakie) and mosaic-like cut gold foil. The interiors are, like the tray, covered with a gold ground made of gold flakes of various sizes and hues.

any samurai of rank. *Tsuba* (plate 177) were often made of alloys that are known only from Japanese artifacts and are thought to have been developed independently there. One of these is *shakudo*, an alloy of copper and gold in which the gold content could vary from 5 to 30 percent, resulting in color that could range from a reddish gray to a violet black. Painters had also developed a penchant for a form of decoration known as *maki-e*, in which gold and silver powder were strewn on damp varnish; other types of lacquer work were much esteemed when they were produced using gold lacquer, known as *kinji* (*kin* = gold; plate 179).

Many of the traditions of the Edo period still survive: goldsmiths work on bequeathed or new samurai weapons, and gold painters (plate 178) decorate and restore temple paintings and statues. Japan's own gold deposits have been fully exploited, but that precious metal is still highly regarded. Increasingly, the need for personal jewelry is satisfied with platinum as well, but for Buddhist temples, with their statues, decorations, and paintings, and also for Shinto shrines, gold is the only suitable precious metal.

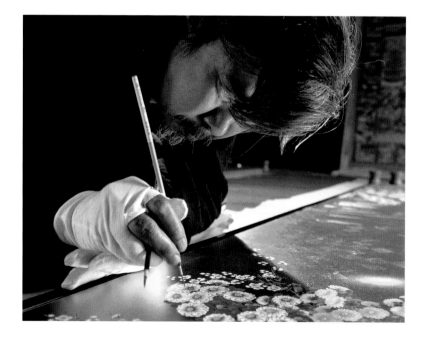

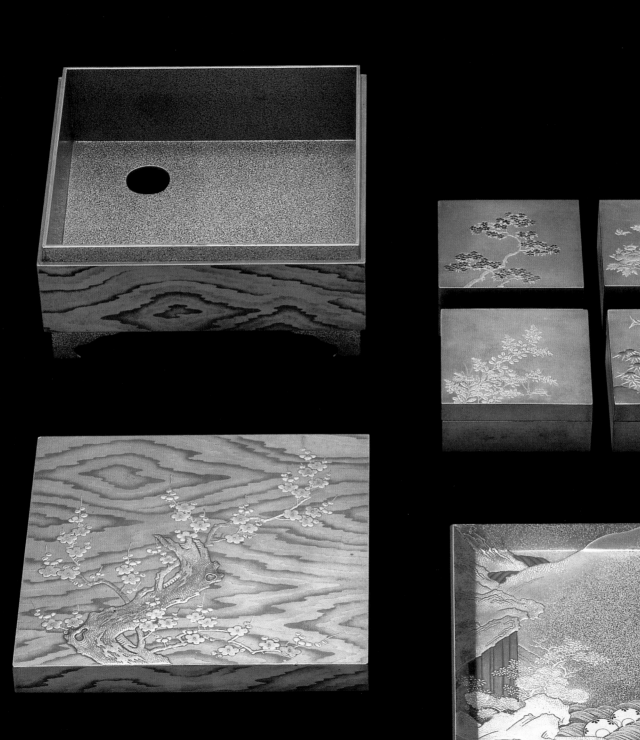

CHAPTER 11

❈◇❈◇❈◇❈◇❈◇❈◇❈◇❈◇❈◇❈◇❈◇❈◇❈◇❈◇❈◇❈◇❈◇❈◇❈◇❈

The New World

THE LEGEND OF EL DORADO

In 1492 Christopher Columbus landed in the Bahamas—America was discovered and with it a large geographical area that had rich gold deposits and an extraordinary tradition of the goldsmith's craft. One goal of the journey as originally planned—it was supposed to lead to India and the Far East—was to find gold. But where were the Central and South American gold deposits that the conquistadores hoped to exploit? They were not immediately apparent, but the gold artifacts of the natives were evidence that gold was present in the country and had been mined previously.

From 1519 to 1521 Hernán Cortés, operating from Cuba, conquered the Aztec empire, and the feuding Mayan ministates were defeated by the Spaniards between 1526 and 1546. The resistance they offered their conquerors was minimal. The four-thousand-year-old Mayan culture did not initially have metals. Their few surviving items of gold jewelry (plate 181) were produced by Mixtec artisans with a long tradition of working with precious metals behind them (plate 182). The finds from the neighboring Aztec empire, which conquered much of the Mixtec territory around

◁ 180. *Tumi*, Sicán culture, tenth to fifteenth century AD; gold. Museo Nacional de Arqueología, Antropología e Historia del Perú, Lima.
 The ceremonial knives of Sicán culture known as tumi, *made of gold, sometimes in combination with silver, express a notion of a dual cosmos. Gold, the masculine metal of the sun, on the hilt depicts the hero or god Naymlap. He dominates the moon, the female attribute. This likeness of the god was probably decorated with turquoise inlay, but all that survives are the empty settings of sheet gold.*

▽ 181. Necklace, Mayan culture, Iximiché, Chimaltenango, Guatemala, tomb 27, AD 1200–1500; gold, length: 10⅝ in. (27 cm). Museo Nacional de Arqueología y Etnología, Guatemala City.
 This unusual piece of Mayan jewelry alternates gold beads, chased as half-spheres and then soldered together, with ten jaguar heads that were either cast in a closed form or chased from thin sheet gold and bent together.

▷ 182. Gold pendant depicting the god Xipe, Mixtec culture, Yanhuitlan, Mexico, AD 800–1500. Museo Nacional de Antropología, Mexico City.
Xipe Totec is the Aztec fertility god, but he was worshipped not only as the god of earth and spring but also as the patron of goldsmiths. This pendant with the figure of the god was probably a goldsmith's talisman. The high relief chasing expresses both adoration for and fear of this powerful divinity.

▽ 183. Chronology, by geographical area, of the pre-Columbian cultures discussed in this chapter.

MEXICO	
Maya	2500 BC–AD 1521
	Classical period AD 200–900
Mixtec	1000 BC–AD 1460
Aztec	AD 13th century–1521
COLOMBIA (north coast)	
Sinú	AD 600–1530
Tairona	AD 1200–1650
COLOMBIA (inland)	
Tolima	AD 300–1100 (uncertain)
Muisca (Chibcha)	AD 650 or 1200–1538
COLOMBIA (west coast)	
Calima	1500 BC–AD 1500
	Classical period c. AD 1–1500
Quimbaya	AD 400–1500
ECUADOR	
Tolita	500 BC–AD 500
PERU	
Chavin	300 BC
Moche (Mochica)	100 BC–AD 800
Lambayeque (Sicán)	AD 900–1100
Chimú	c. AD 1200–1463
Inca	AD 1200–1532

1460, belong to their legacy as well; despite the legendary wealth of their ruler Montezuma, there is no evidence of an independent Aztec tradition of working gold. Nevertheless, without exception, the treasures the native peoples hoarded fell into Spanish hands.

For the art of the goldsmith and its products, South America is incomparably more significant than Central America, with three major areas of Indian metal processing with distinct techniques and styles: first Colombia and parts of Venezuela, second Ecuador, and finally Bolivia with Peru. The variety of regional styles (plate 183) make dating and classification difficult and not always reliable. With certain reservations, art historians divide South American precious metal artifacts into an early period during the first millennium BC known as the Calima style, a middle period from the fifth to the ninth century AD, and a late period with some Spanish influences, such as the use of imported glass beads. Many finds do not fit into this scheme, however, so their origin remains uncertain.

Only a fraction of their works in gold, some of which were produced centuries before the Spanish arrived, have survived. Yet even the few items available are of unprecedented variety. The material value of raw gold in pre-Columbian cultures was scarcely more than that of clay or salt—for the Incas and their predecessors, jade was always far more precious than gold—but designed and shaped, it nevertheless became the symbol of the sun and its creative energy as well as of a divine, otherworldly power. At the same time it was a status symbol for tribal chiefs, priests, and worthy warriors and was lavishly sacrificed to gods and ancestors. The Spaniards' lust for raw gold—which Cortés summed up by saying, "My companions and I suffer from a sickness that only gold can cure"—was therefore utterly incomprehensible to them.

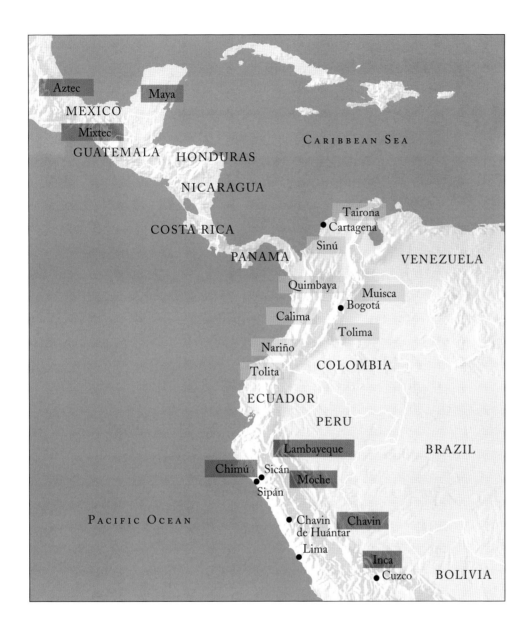

◁ 184. Map of Central and South America indicating the locations of the pre-Columbian cultures discussed in this chapter.

▷▷ 185. Pectoral, Tairona culture, AD 900–1600; *tumbaga*, 4⅛ × 4⁷⁄₁₆ in. (10.6 × 11.3 cm). Museo del Oro, Bogotá.

These quite common Tairona burial objects, usually in the form of sculptural pendants or pectoral figures cast in tumbaga, *were often gilded or treated by pickling in order to bring out the gold in the alloy. This figure is wearing an enormous headdress and the eccentric jewelry of this culture, like the half-moon-shaped earrings, nose ornaments, and labrets.*

▷▷ 186. Earrings, Sinú culture, AD 900–1530; gold, height: 1¹⁵⁄₁₆ in. (5 cm), width: 2 in. (5.1 cm). Museo del Oro, Bogotá.

These earrings are carefully produced examples of so-called false filigree work, including both geometric ornaments and small figures of animals like crocodiles and lizards.

▷▷ 187. Earring, Tairona culture, AD 900–1600; *tumbaga*, height: 1⅝ in. (4.2 cm), width: 3¹⁄₁₆ in. (7.8 cm). Museo del Oro, Bogotá.

This earring is another example of an object probably made of tumbaga *in which the gold has been emphasized by means of surface enrichment. The ends of the broad arch are two stylized snake heads. Appliqué gold beads were either cast or chased.*

The Conquistadores in South America

Under the pretext of missionary work, the Spaniards penetrated the new continent, as dictated by their search for precious metal. Around 1500 the Spaniards and their allies set out from Panama to track down and exploit the alleged wealth of gold in the south; they reached present-day Colombia. On the northwest coast they founded the city of Cartagena, and they turned it into the most important harbor and trading center in the Caribbean. The settlement of the coastal regions by Spaniards was the precondition for the first gold rush in Colombia in 1534. Initially the expeditions had their eye on the Atlantic coast. In the lowlands of the Caribbean coast lived the Sinú, who had rich deposits of placer gold. They had mastered perfectly the *cire perdue* process and used it to make, among other things, large earrings (plate 186). Some of their works look like filigree,

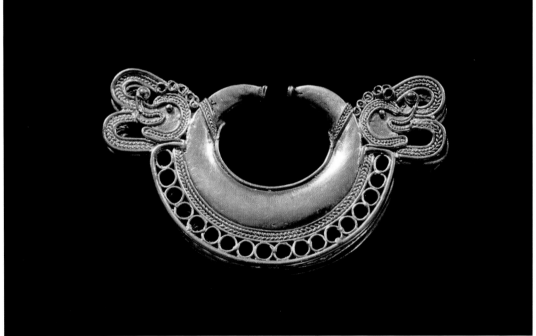

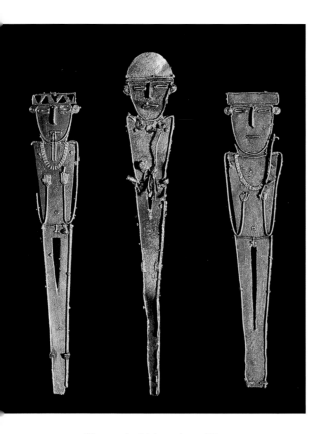

188. Three *tunjos*, Muisca culture, AD 650–1550;
gold, 5½ × 1 in. (14 × 2.6 cm), 6¼ × 1 in.
(15.9 × 2.6 cm), 5⁵⁄₁₆ × 1⅛ in. (13.5 × 2.8 cm).
Museo del Oro, Bogotá.

These elongated tunjo *figures were votive
objects and were presumably cast using the lost-
wax process—sometimes the goldsmith did not
bother to remove the traces of the casting channels
or the seams. Frequently they were hurriedly
mass-produced, but despite all their similarities
many variations have been found.*

but they were in fact cast. Decorations consisting of naturalistic animal
motifs like crocodiles and stags adorned ceremonial staffs and scepters.
The depicted animals symbolized power, courage, danger (crocodile),
and speed (stag). The surviving finds, of extraordinary quality and vari-
ety, were taken from thousands of graves that the Spaniards plundered
with the voluntary or compelled assistance of the natives. Very few of the
looted grave finds escaped being melted down and managed to survive in
museums and private collections.

Other victims of this campaign of exploitation were the neighboring
tribe, the Tairona, who lived near the Caribbean coast. Their breast-
plates and gold ornaments depicting mythological creatures (plates 185,
187)—half human, half animal—were frequently made from an alloy of
copper and gold known as *tumbaga*, which has been found only in South
America. Using a refined corrosion process with salt, alum, and plant sap
containing oxalic acid, their goldsmiths were able to dissolve the copper
from the alloy and thus purify the gold on the surface. By varying the con-
centration and the duration of use of the acid, they could obtain colors
ranging from bright gold to reddish gold (plate 189). By covering certain
areas of an object with wax before applying the corrosive, and thus protect-
ing the copper of those parts from dissolving, they achieved charming
variations in color.

After a few failed attempts, around 1535 two groups set out on a diffi-
cult march into the interior in search of Colombia's gold wealth; in the
heartland of the Muisca tribes in central Colombia, they met a third group
coming northward from Peru. The leaders of these exploratory teams
agreed to work together, and they began by founding the city of Santa Fe
del Nuevo Reino de Granada—present-day Bogotá. Gradually, the Muisca
lands ended up in the hands of the conquistadores; by 1538 Muisca culture
was completely wiped out. It soon became clear that the Muisca had neither
cities of gold nor gold mines, but they did mine, extracting emeralds, cop-
per ore, and salt. They got the precious metals they needed through export,
and a well-developed long-distance trading system ensured that their
products were distributed. Muisca culture produced the unusual *tunjos*
(plate 188): flat, cast bars of gold depicting people who look almost like
stick figures performing various activities; large numbers of these have
been found as burial offerings in tombs.

THE LEGENDARY EL DORADO

Here for the first time the intruders in this region heard of *el indio dorado*,
a ruler covered with gold dust (plate 190), of mysterious ceremonies
on Lake Guatavita (plate 192), high in the Andes not far from Bogotá, and
of inconceivable quantities of gold that were said to have been sunk in the
lake over time. By the time the Spanish arrived, this practice had long since
been abandoned, but a plausible report of this legendary initiation rite was
written by Juan Rodríguez Freyle in 1636, after he heard the story from his
friend Don Juan, a nephew of the last independent Muisca chief:

The first journey he [the chosen heir to the throne] had to make was to go to the great lagoon of Guatavita, to make offerings and sacrifices to the demon which they worshipped as their god and lord.... At this time they stripped the heir to his skin, and anointed him with a sticky earth on which they placed gold dust so that he was completely covered with this metal. They placed him on the raft ... and at his feet they placed a great heap of gold and emeralds for him to offer to his god.... The gilded Indian then made his offering, throwing out all the pile of gold into the middle of the lake ... As the raft moved towards the shore, the shouting began again, with pipes, flutes, and large teams of singers and dancers. With this ceremony the new ruler was received, and was recognized as lord and king. From this ceremony came the celebrated name of El Dorado, which has cost so many lives.

When gold artifacts were found on the banks of Guatavita, a crater lake, all doubts about the legend vanished. It was decided to bail out or drain the lake. A drainage channel that Antonio de Sépulveda had dug by eight thousand Indians around 1580 reduced the level of the water in the lake by sixty-five feet (20 m), but they did not reach bottom. In his *Vue des Cordillères* of 1810, Alexander von Humboldt was the first to illustrate the lake and the artificial drainage channel (plate 191). He estimated that five hundred thousand gold objects, with a value of approximately three hundred million dollars, had been lowered into the lake. All the efforts to uncover these treasures were in vain, but attempts continued until 1914, when the Colombian government enacted a law to prohibit such threats to its cultural heritage.

△ 189. Pectoral, Popayán culture, c. AD 100–1500; *tumbaga*, height: 3¹/₁₆ in. (7.7 cm). British Museum, London.
 This pectoral features an eagle with a human head; its body is depicted in the characteristic style of the Popayán culture. The head and chest, by contrast, are in the style of Tolima artifacts. The figure was cast in an open form from the uniquely South American gold-copper alloy known as tumbaga.

▽ 190. Theodor de Bry, *How the Emperor of Guyana Groomed His Noblemen When He Had Them as Guests*, 1599; engraving.
 The illustrations in Theodor de Bry's Historia Americae sive Novi Orbis *(History of America, or the New World) were based on reports from travelers; the illustration shown here depicts the preparations of the new Muisca ruler for the ceremony at Lake Guatavita. One assistant is rubbing the chosen man with wax or resin while the other blows gold dust on him through a tube.*

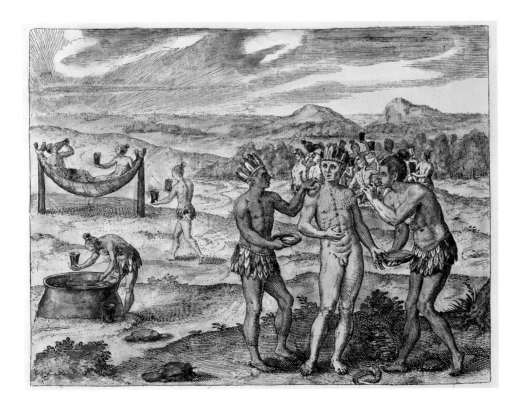

191. Lake Guatavita in Colombia, from a
sketch by Alexander von Humboldt in his
travelogue *Vue des Cordillères*, Paris, 1810–15;
aquatint.
 *This sketch shows Lake Guatavita, the site of
the El Dorado ceremonies, which still looks like
this today. A cleft is clearly visible where
excavations were made to drain the water from
the lake in an effort to retrieve its legendary
gold treasures.*

192. *Tunjo*, Muisca culture, AD 650–1550;
gold, c. 11³/16 × 7⅞ × 7⅞ in. (30 × 20 × 20 cm).
Museo del Oro, Bogotá.
 *This detailed model of a balsa raft shows El
Dorado and his retinue. It records, in delicate
filigree, the moment of the inauguration ritual
and the gold sacrifice.*

The Diversity of Cultures and Their Products

Our imaginary journey through the confusing diversity of South
American gold cultures leads from the center of Colombia farther
south. In Buriticá, roughly 125 miles (200 km) northwest of Bogotá, there
was an industrial center that not only extracted placer gold but also mined
gold from the mountains year-round, whereas the placer mining in other
regions was a seasonal activity. There were also numerous workshops that
produced jewelry, which was traded for food or other necessities. Their cus-
tomers included the Quimbaya and Muisca as well as the Sinú in the north.

Among the surviving legacies of the Tolima, the Muiscas' neighbors,
large cast and hammered pendants (plates 1, 194) deserve special mention;
they depict hybrid creatures. Their gold works are especially massive.
The tribes referred to under the collective name Quimbaya also lived in
present-day Colombia, specifically along the central Rio Cauca, between
AD 400 and 1500. One highlight of their gold working was the produc-
tion of naturalistic figures and vessels by hollow casting (plate 195).
Chased helmetlike headgear and other objects demonstrate that they
had also mastered numerous other techniques, such as embossing and
making alloys.

Farther south were the lands of the Calima, whose name is derived from
the Rio Calima in Colombia and is used to designate the earliest period of
the goldsmith's art in South America. Their long history extends approx-
imately from the middle of the second millennium BC to AD 1500, with
their cultural heyday in the Christian era. The style of their precious
works in gold is unmistakable. Their characteristic pectorals with pen-
dants (plate 193), masks of sheet gold, earrings as large as soup bowls, and
immense gold wings that were clipped to the nasal septum inspired their
neighbors to imitations and refinements.

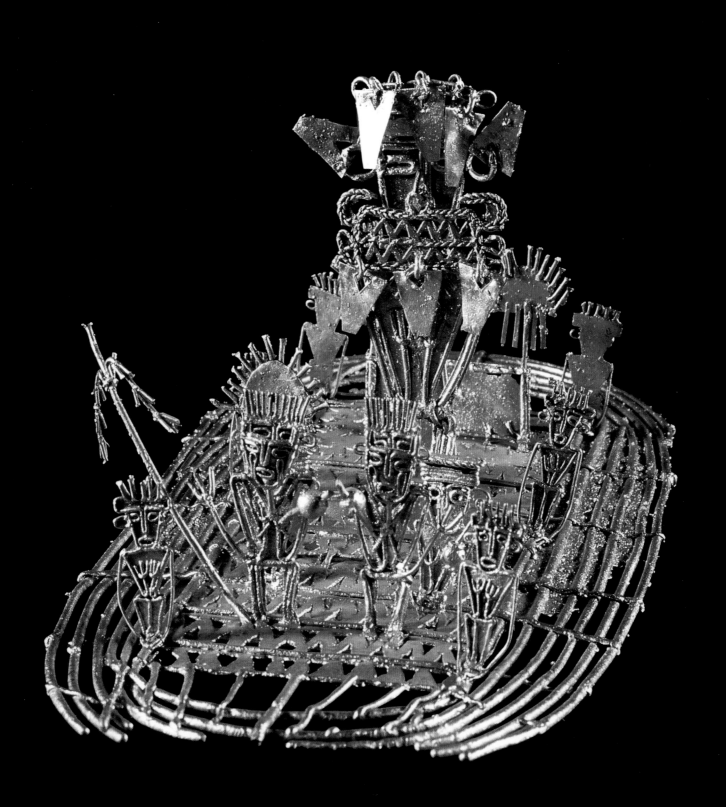

The next state to the south, on the coast of Ecuador, was that of the Tolita, who were the first to work platinum for jewelry (plates 196, 197). Platinum is often found in the gold of the coastal sands of Colombia. Supposedly the gold washers would separate the platinum nuggets from their placer gold and toss it back into the sea as "unripe" gold. This legend is, however, contradicted by the deliberate combination of platinum and gold in jewelry. The Tolita were able to melt gold, but the melting point of platinum, 3200 degrees Fahrenheit (1800°C), was beyond their reach. So they would mix platinum nuggets with a little gold dust and heat this mixture until the gold liquefied and bonded to the platinum nuggets. This mixture of gold and platinum would be alternately hammered and heated until it produced a compact mass that could be forged and cast. Many of their objects—nose rings and brooches and also bars and pins—are nearly pure platinum, with only a minimum quantity of gold; others contain between 26 and 72 percent gold.

THE SEÑOR DE SIPÁN AND THE PRIEST-KING OF SICÁN

In the central Andes, in present-day Peru and Bolivia, there is evidence that metalworking was practiced from 1800 to 1000 BC. This dating is based on the tomb finds in Huayhuaca in the upper Andes. Around 1500 BC metalworkers of the Chavin culture—whose name derives from its most important archaeological site, Chavin de Huántar, the ruins of a temple in the western part of central Peru—used stones to hammer gold

195. Lime holder, Quimbaya culture,
AD 200–1000; *tumbaga*, 10¼ × 4⅛ × 3⅛ in.
(26 × 10.5 × 8 cm). Ethnologisches Museum,
Staatliche Museen zu Berlin.

 *In South American cultures, containers for
lime to be chewed with coca leaves—whose
effect is heightened if ingested with lime—are
common. This lively, carefully chased sculpture
of* tumbaga *has two different shades of gold, an
effect that may have been achieved by using two
different picklings.*

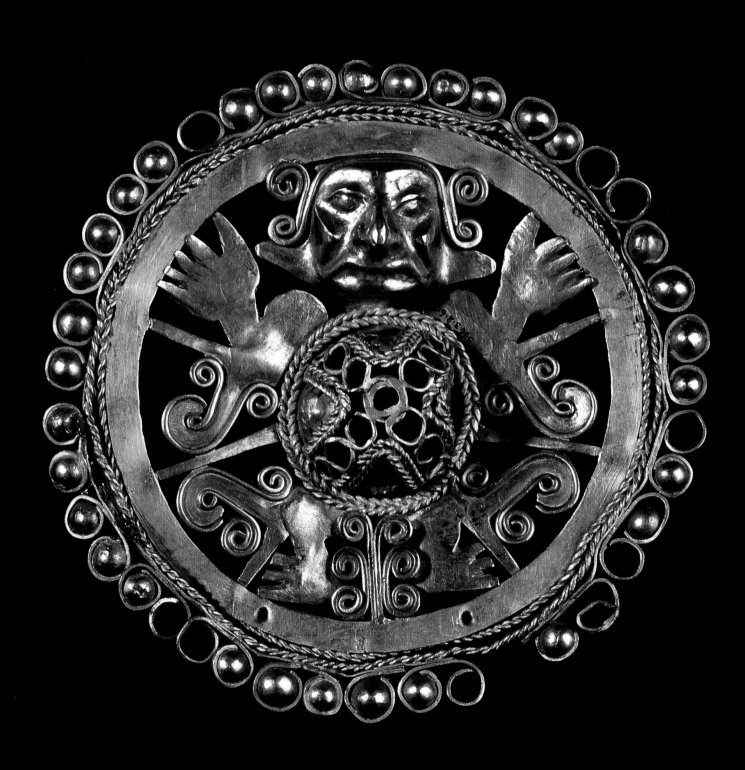

into extraordinarily thin foil. The typical bas-reliefs produced there, often embedded in round or rectangular basic forms, often depict divine hybrids, like predatory-bird gods with human features. The central Andes were not especially rich in gold deposits, so the Chavin deliberately employed *tumbaga* alloys with a low gold content and treated them to give them the look and luster of pure gold. The advanced technical level of the goldsmith's art they achieved over the long period between 300 BC and AD 600 was later adopted by the Moche culture.

The Moche lived between the Rio Lambayeque and the Rio Casma, and their cultural peak occurred approximately between AD 100 and 800 (plate 198). Among their sensational legacies are unique treasures from the grave of a chief: in 1987 near the village of Sipán, roughly five hundred miles (800 km) north of Lima, the capital of Peru, the mausoleum of a leader who died around AD 260 was found. The discovery of this site, with its extremely lavish burial gifts, was enthusiastically compared with the discovery of Tutankhamun's tomb in 1922. The complex—which along with Batan Grande, discovered later, is one of the most valuable in Peru—was systematically excavated using scientific methods. Whereas most earlier individual finds were purchased from tomb robbers and hence difficult to date, having been removed from the location in which they were found and reduced to precious objects without any context, it now became possible to gain valuable data, yet to be exhausted, about the cultures of the Andes.

◁ 196. Pectoral, Tolita culture, 300 BC–AD 500; gold and platinum, diameter: 3¾ in. (9.5 cm), thickness: ³/₁₆ in. (2 cm). Museos Arqueológicos del Banco Central del Ecuador, Quito.
The filigree frame of this ingeniously designed pectoral surrounds a figure with abbreviated legs and spread fingers, stripping it of anything human and lending it a conjuring, threatening air. The impression is heightened by the contrast between gold and platinum, something that always provokes astonishment and admiration when found in an object this old.

△ 197. Pendant, Tolita culture, 500 BC–AD 500; gold and platinum. Museos Arqueológicos del Banco Central del Ecuador, Quito.
This small head of gold and platinum is another example of the art and skill of artisans from the Tolita culture. It is not known whether combining the two metals merely represented a challenge for goldsmiths or had a symbolic background.

198. Bird, northern coast of Peru, Moche culture, AD 200–650; gold with turquoise inlay. Private collection.

Depictions of birds, which were worn as pendants or adorned batons and poles, are found among the artifacts of nearly all the peoples of South America. This example, which was made with great sensitivity, is probably a miniature toucan. The lavish turquoise inlay represents the bird's bright feathers.

▷ 199. Emblem, tomb of the Señor de Sipán, Peru, northern coast, Moche culture, c. AD 260; gilded copper, turquoise, 16¾ × 27⁹⁄₁₆ in. (42.5 × 70 cm). Museo Arqueológico Nacional Brüning, Lambayeque, Peru.

In the center of this object with human limbs, made from gilded sheet copper, is a small relief figure of a deity with turquoise bracelets and a shallow helmet. A mythical snake with two heads is engraved above it. This so-called emblem, an object of unknown purpose, was reinforced on the back by an additional sheet of copper.

The complex includes two pyramids and five tombs of princes or priests from the period between around AD 100 and 350. The large burial chamber of the Señor de Sipán contained not only the skeletons of servants buried together with him to serve him in the hereafter but also everything that had adorned him in life and emphasized his position and rank. Among the gold objects found are disks used as earrings with figural turquoise inlay work (plate 201), standards with divinities and depictions of fruit, emblems with human silhouettes (plate 199) and mythological snakes, and countless other unique objects like necklaces with gold and silver peanuts, a necklace with flattened, soldered *dégradé* (gold pellets that depart from spherical form), and a rattle (*chalchalcha*) hammered from a single sheet of gold. This list of burial objects could go on and on. One particularly interesting feature of these burial finds is that they reveal a dualism between gold and silver: the former was considered the male metal and the symbol of the sun; silver was considered feminine and the symbol of the moon. That the sun stood out among the celestial bodies worshipped is evident from a find of fourteen pieces of jewelry: gold disks measuring twelve inches (30 cm) in diameter, with rays emanating from the center. These objects, part of a set of priestly vestments in gold, may have been used in a burial ritual or worn during the bearer's lifetime, to emphasize his gleaming form.

The Moche were succeeded in this region by the Sicán or Lambayeque people, whose prime lasted from AD 900 to 1100. In 1991 another grave, also untouched and no less impressive, was discovered near Huaca Loro

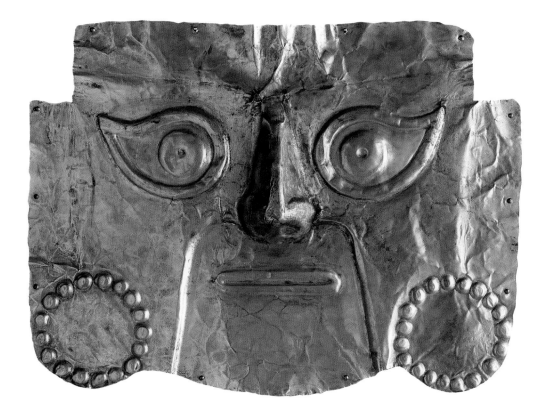

200. Mummy mask, Chimú culture,
c. AD 1200–1450; sheet gold, 9⁷/₁₆ × 12⅝ in.
(24 × 32 cm). Present whereabouts unknown.
 *Masks for mummies are burial offerings
found in cultures of both the Old and New
Worlds. This face, punched from sheet gold and
chased in low relief, is less an attempt at a
likeness of the deceased than an expression of
mourning and melancholy.*

(Batan Grande). Underneath a pyramid the excavators found a shaft forty
feet (12 m) deep that provided access to the lavishly decorated burial
chamber of a Sicán ruler. This priest-king, who reigned theocratically over
his subjects, had been placed in a sedan chair of gold. His face was covered
by a gold mask with an ornament on the forehead. The precisely trape-
zoidal death masks found here and in neighboring tombs correspond to
those made earlier by the Chimú (plate 200). Tears of gold pellets or emer-
alds in the almond-shaped eyes of the masks express sadness. In order to
glorify the ruler, his children and wives were sacrificed and buried along
with him. All of the burial offerings were luxury goods appropriate to the
nobility and available only to them. One box contained a cache of sixty
gold objects, including ritual sacrificial knives with crescent-shaped
blades known as *tumi* (plate 180), jewelry to decorate the head (plate 202),
and various ornaments with closely set gold plates. Is it possible to con-
clude from these finds as well that the secular power of the ruler corre-
sponded to a claim to religious power? Many of the gold objects of the
Sicán have one characteristic feature: engraved grooves in cups and masks
are decorated with cinnabar (plate 203), a naturally occurring red mer-
curic sulfide.

The Sicán were conquered in 1373 by the Chimú, who in 1463 became, in
turn, part of the Inca empire, which until 1532 was the greatest empire on
the South American continent, covering an area of more than 380,000
square miles (1 million km²). The Inca were subjugated and destroyed by
Francisco Pizarro and his 180 soldiers. Sources indicate that the ransom

▷▷ 201. Earring, tomb of the Señor de Sipán,
Peru, north coast, Moche culture, c. AD 260;
gold with turquoise; diameter: 3⅝ in.
(9.2 cm). Museo Tumbas Reales de Sipán,
Lambayeque, Peru.
 *In the tomb of the so-called Señor de Sipán,
excavators found several pairs of earrings, all of
which are gilded copper with turquoise in
shades ranging from bright to dark bluish
green. The center sometimes has a human figure,
sometimes an animal one; this one depicts the
Señor de Sipán with the insignia of his office,
including his scepter and a magnificent nose
ornament, along with two attendants.*

▷▷ 202. Ceremonial crown, Sicán culture,
c. AD 1000–1300; gold. Museo de Oro del
Perú y Armas del Mundo; Fundación
Miguel Mujica Gallo.
 *This crown, made of chased sheet gold, is
ornamented with three richly adorned engraved
human figures. The top of the crown is shaped
like a towering* tumi—*a knife with a curved
blade used in ritual sacrifices.*

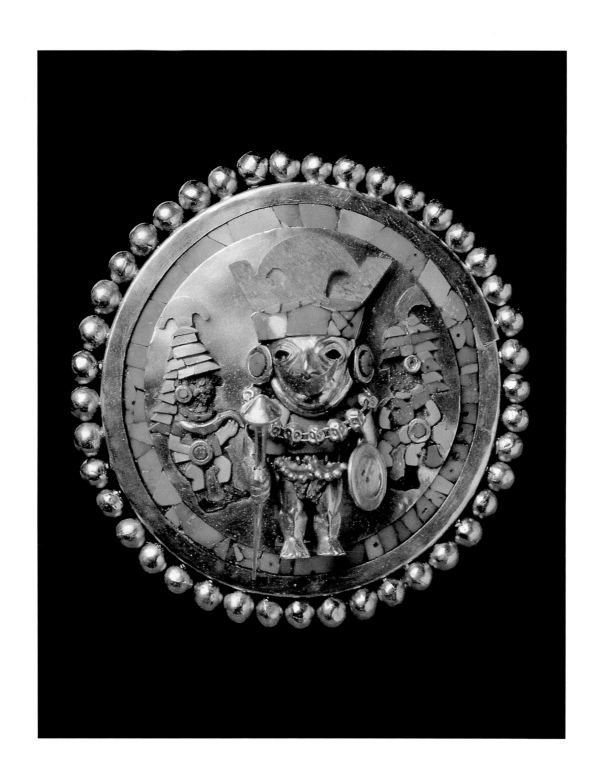

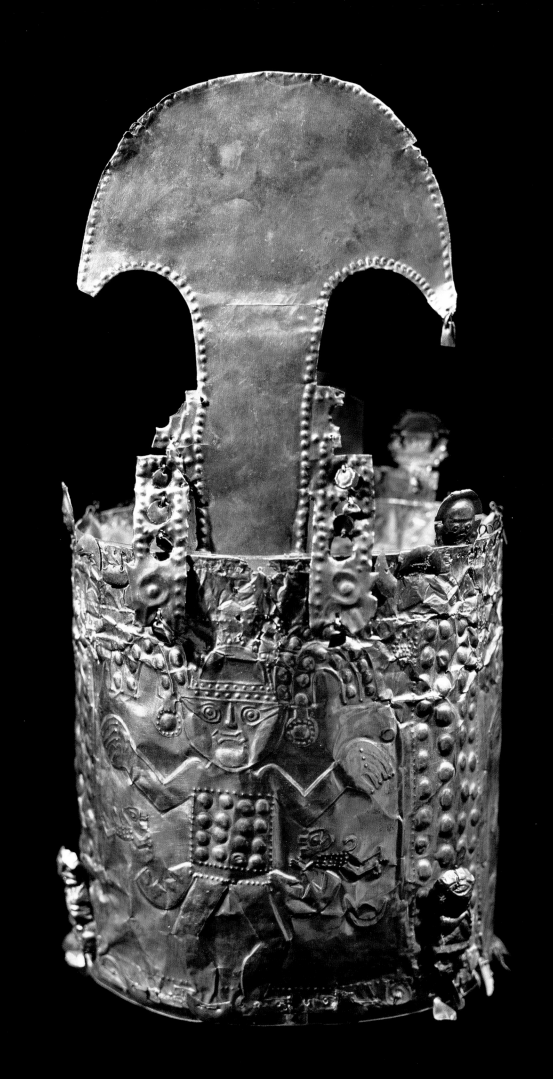

203. Cup, Sicán culture, ninth to tenth century AD; gold with cinnabar coloring, height: 4¾ in. (12 cm). Linden-Museum, Stuttgart.

One unusual feature of the Sicán culture was the use of cinnabar, the most important mercury ore, from local deposits. The chased sculptural decorations and grooves on these gold cups were rubbed with cinnabar to produce a charming, distinctive contrast of colors.

204. Mask, Inca culture, c. AD 1200–1530; sheet gold. Museo de la Nación, Lima.

A gold mask as a symbol of the Inca sun god—hammered from thick sheet gold into low relief—is an impressive relic of a culture that was once among the greatest and most powerful in South America. The detailed chased facial features of this mask convey a threatening grimace to the viewer. Mysterious ornaments are found in the area surrounding the face.

Pizarro demanded from the last Inca ruler, Atahualpa, was 12,240 pounds (5,552 kg) of gold and 26,060 pounds (11,822 kg) of silver. When the Inca capital of Cuzco was conquered, the conquistadores tore out the wall decorations of the Korikancha Temple and destroyed furniture, weapons, and much more to obtain another 2,500 pounds (1,100 kg) of gold and 33,000 pounds (15,000 kg) of silver. For the Incas, gold was the symbol of the state religion of the sun cult (plate 204), given visual expression in their golden temple. It is unlikely that the Inca empire had more gold than that which Pizarro took, and yet the gold robbed from the New World and melted down into bars increased the quantity of that metal in Europe by no more than 1 percent.

At first, no one there had any interest in the artistic value of "pagan" objects. While traveling in the Netherlands in 1520, Albrecht Dürer had the good fortune to see some of the gifts that the Aztec prince Montezuma had sent to Emperor Charles V. As a trained goldsmith, he noted enthusiastically "all kinds of the most wonderful things . . . and I have wondered at the subtle *Ingenia* of men in foreign lands." Systematic research, excavations, antiquities laws, and the reacquisition of stolen materials have shown us once again what fascinating creations and achievements the native goldsmiths of South and Central America were capable of.

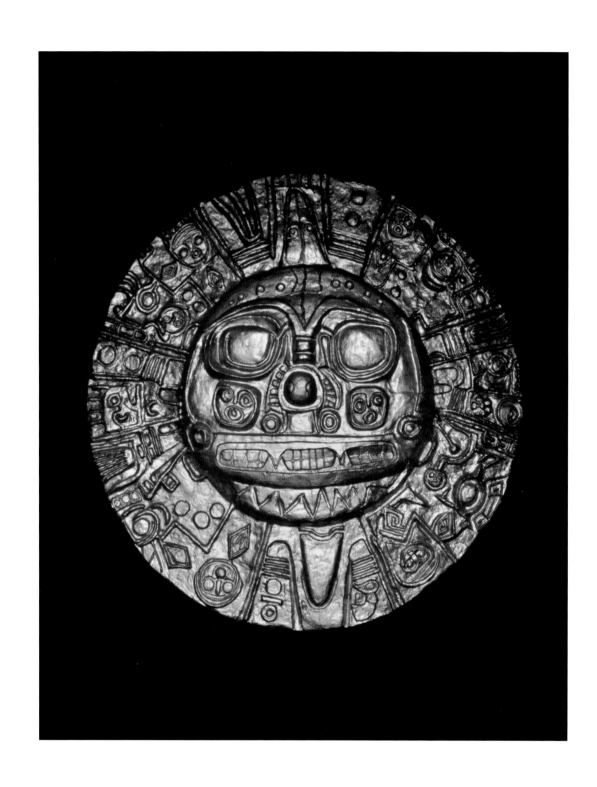

CHAPTER 12

✼◈✼◈✼◈✼◈✼◈✼◈✼◈✼◈✼◈✼◈✼◈✼◈✼◈✼◈✼◈✼◈✼◈✼

Africa

SPLENDOR ON THE GOLD COAST

TIMBUKTU AND THE KING OF MALI

Kanga Mussa, king of Mali, made a stop in Cairo on his pilgrimage to Mecca in AD 1324. He was on his way from his residence in Timbuktu and rested for a few days before continuing on to Arabia. Contemporary witnesses tell that during his stay on the Nile the immeasurably wealthy ruler spent 20,000 gold pieces: approximately 220 pounds (100 kg) of pure gold.

For more than a millennium (700–1850), Timbuktu (Belad-ed-Dahab, in Arabic) was the city of gold and the center of the gold trade between Arabia and Africa. The source of the precious metal was kept secret. The Arab scholar Ibn al-Faqih, who wrote in the early tenth century AD, assumed that where the Arabs traded cloth, paper, weapons, and copper for slaves and gold must also be where the deposits of precious metals were located, or he would never have written that "gold grows in the sand like carrots and is picked at sunrise." Timbuktu lay at the intersection of the caravan routes by which the Tuaregs brought goods to the city on their camels. The people of the city were in the habit of saying "gold from the south, salt from the north," the "south" in this case being the Inner Niger Delta, with its thousand branches. Every load of cargo that arrived in the city was subject to a duty of one dinar, and those leaving had to pay a duty of two dinars; no doubt this was one of the sources of the wealth of the kings of Mali.

In southern Mali, some 310 miles (500 km) as the crow flies from Timbuktu, lie the ancient cities Mopti and Djenné. In the savannah there the Fulbe tribe has lived for several hundred years. They preserve the secret of the exact location of many small gold deposits that have been exploited for ages and still provide some gold. The method for extracting it has not changed since the days of Kanga Mussa. The miners climb down steps in shafts three feet (1 m) in diameter and fifteen to fifty feet (5–15 m) deep, at the bottom of which low crawl tunnels branch out. These lead to the gold-bearing soil, which is dug out with picks and packed into baskets and buckets. The baskets are then pulled up on ropes, and women wash this infertile soil in calabashes to separate out the specks of gold. This laborious and dangerous work seldom produces more than a quarter ounce a day, a poor yield, which is then sold to traders or goldsmiths.

Fulbe women with wealthy husbands or a good dowry wear large twisted earrings weighing three and a half ounces (100 g) or more (plates 206, 207). The village goldsmith produces them from flat rods that have

205. Jewelry, Baule, Ivory Coast, nineteenth century AD; gold. Musée Barbier-Mueller, Geneva.

This collection of jewelry by the Baule, an African people from the Ivory Coast, is an excursion toward modernist abstraction. The masklike faces have striking physiognomies. All are unique objects produced by lost-wax casting. The rich gold deposits in Baule regions enabled them to revel in gold.

206. Earring, Fulbe, Mopti, Mali, late twentieth century AD; gold, length: c. 1¼ –2¾ in. (5–7 cm), weight: c. 3½ oz. (100 g). Museum für Völkerkunde, Frankfurt am Main.
The heavy twisted earrings of the Fulbe women of Mali are not only sought-after pieces of jewelry but also symbols of tribal identity. Local goldsmiths in Fulbe villages make such traditional earrings to measure, following handed-down models.

207. Woman with flat gold earrings, Mali.
Not all such earrings are twisted; some are left flat and straight. This dispenses with the last stage of work, the twisting of the finished gold bar, but still results in a beautiful piece.

been hammered into a cruciform shape using a small chisel. This bar is first twisted and then bent into a semicircle. One unusual characteristic of the way the Fulbe work gold is pickling: the finished jewelry is placed in a reddish-brown concoction of iron rust and plant sap for several days, giving the gold a kind of red patina, but one that cannot be attacked by the elements and hardly loses its luster at all. Even poor Fulbe women do not go without the traditional twisted earrings; however, rather than being forged from gold, theirs are woven of straw, and they look like real gold pendants only from a distance.

GOLDEN SUNS: THE SOUL DISKS OF THE ASHANTI CHIEFS

Farther south, in present-day Ghana and the coastal regions that played a large role during European colonial rule as the Ivory, Gold, and Slave Coasts, lies another traditional gold-mining region of Africa that was just as important as a provider of gold as Mali in central Africa. It was home to tribes of the Akan group, for whom gold was a sacred symbol of vitality and the central divinity who created the world and all life. The goldsmiths of the Adyukru, Anyl, Ashanti, Atye, Baule, and Bete provided splendid gold jewelry, especially for their chiefs, to emphasize their status and rank. As a symbol of their office, these men wore gold soul disks that were decorated with symbols of the sun (plate 208), because they were considered the living sons or incarnations of the sun divinity, and thus these decorative disks visibly represented them to their subjects as the elect.

Europeans, who began visiting the Gold Coast in the seventeenth century, were overwhelmed by the wealth of the natives' gold. The powerful empire of the Ashanti, who owned numerous gold fields, was preeminent among them. Their king, Osei Tutu (r. 1697–1731), employed his shrewdness and powerful army to unite numerous splinter groups of the Akan and other tribes into a federation. As late as 1817, the Englishman Thomas Edward Bowdich wrote of the Ashanti king Osai Osibe:

[H]e wore . . . a necklace of gold cockspur shells strung by their largest ends, and over his right shoulder a red silk cord, suspending three saphies [amulets] cased in gold; his bracelets were the richest mixtures of beads and gold, and his fingers covered with rings; . . . his knee-bands

were of aggry-beads, and his ancle [sic] strings of gold ornaments of the most delicate workmanship, small drums, sankos, stools, swords, guns, and birds, clustered together.

The artisans of the Ashanti and neighboring tribes had mastered nearly all the common techniques for working precious metals. Their specialty was lost-wax casting (plate 209), but they also practiced hammering and chasing, and finished objects with faux-filigree decoration. The latter looked as if gold wire had been soldered to a base, as with true filigree, but was in fact produced by casting. The goldsmiths were not idle when there was a shortage of gold in their workshops; they also produced jewelry from so-called fetish gold—alloys of gold with copper, silver, or brass.

The art for the courts included rulers' insignias and wooden masks covered with gold foil. The pendants, belts, and appliqué of the Baule and neighboring tribes (plates 205, 211) reveal a wide repertoire of jewelry design that includes not only chased work but, above all, objects produced by lost-wax casting. Pieces with masklike, rigid faces recall paintings by Paul Klee and Amedeo Modigliani that were inspired by African art.

208. Gold disk with symbols of the sun, Ashanti, Ghana, nineteenth century AD; cast or chased gold, diameter: 8⁷⁄₁₆ in. (21.5 cm), thickness: ⁹⁄₁₆ in. (1.5 cm). British Museum, London.

Ashanti kings wore many such gold objects during ceremonies as signs of their power; not infrequently the kings were accompanied by attendants who had to bear part of the weight.

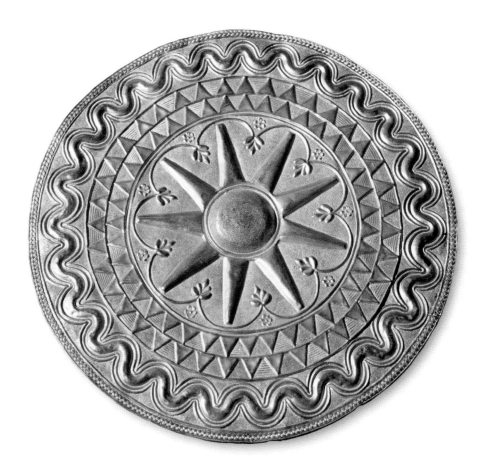

209. Elephant brooch, Ashanti, Ghana, nineteenth century AD; gold, length: 3⁵/₁₆ in. (8.4 cm), width: 2¼ in. (5.7 cm). British Museum, London.

On this gold brooch, produced by lost-wax casting, three elephants have been artfully linked. Ashanti gold ornaments often depicted four-legged creatures, birds, fish, and fruit. The goldsmiths were highly respected and were given royal protection. Certain pieces of jewelry could be produced only with a special permit from the ruler, to whom the goldsmith then had to pay a tax.

210. Weights for a gold scale, Akan, Ghana; brass. Musée National, Bediat Collection, Abidjan, Ivory Coast.

These brass weights for weighing gold were produced by lost-wax casting. This small selection includes a fish, a claw of a predatory bird, a bird, a swastika-like symbol, and a knotted corn husk.

Whereas some African peoples considered gold the only way to emphasize the godlike status of their chiefs and others saw it as a material to produce jewelry for women or to accumulate wealth, for centuries it served still others primarily as a commodity in exchanging goods. An indispensable tool for such trade was the weights with which the precious metal could be measured. Known as Ashanti weights, they are figural works cast in bronze (plate 210): animals, people, everyday objects, and much more, that correspond to units of measure unfamiliar today. They are products of a flourishing imagination, and yet they reveal a great deal about everyday life and the circumstances of African tribes. The pleasure their creators derived from inventing new scenes and lifelike events is palpable, and such gold weights have become popular collector's items.

211. Pendant, Akan, Ghana; gold, 4⁵/₁₆ × 4 in. (11 × 10.6 cm). Musée National, Abidjan, Ivory Coast.

This cast gold pendant with a human face resembles Baule jewelry and is characteristic of the work of African goldsmiths in general. For all its abstraction, the low relief includes essential details, such as the grooves, which represent decorative scarring.

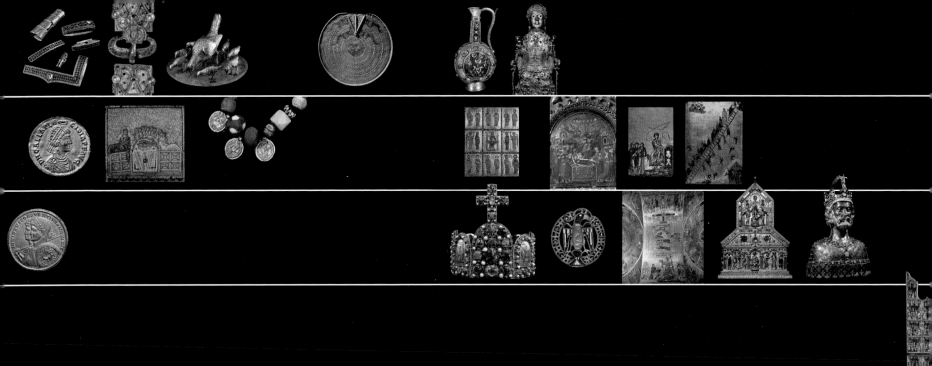

The Age of Migrations
and the Early Middle Ages

Byzantium

The High and Late
Middle Ages

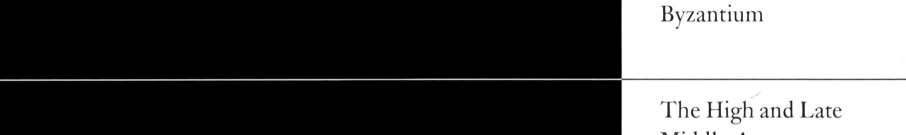

The Renaissance, the Baroque, and Neoclassicism

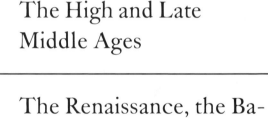

The Modern Age

2000

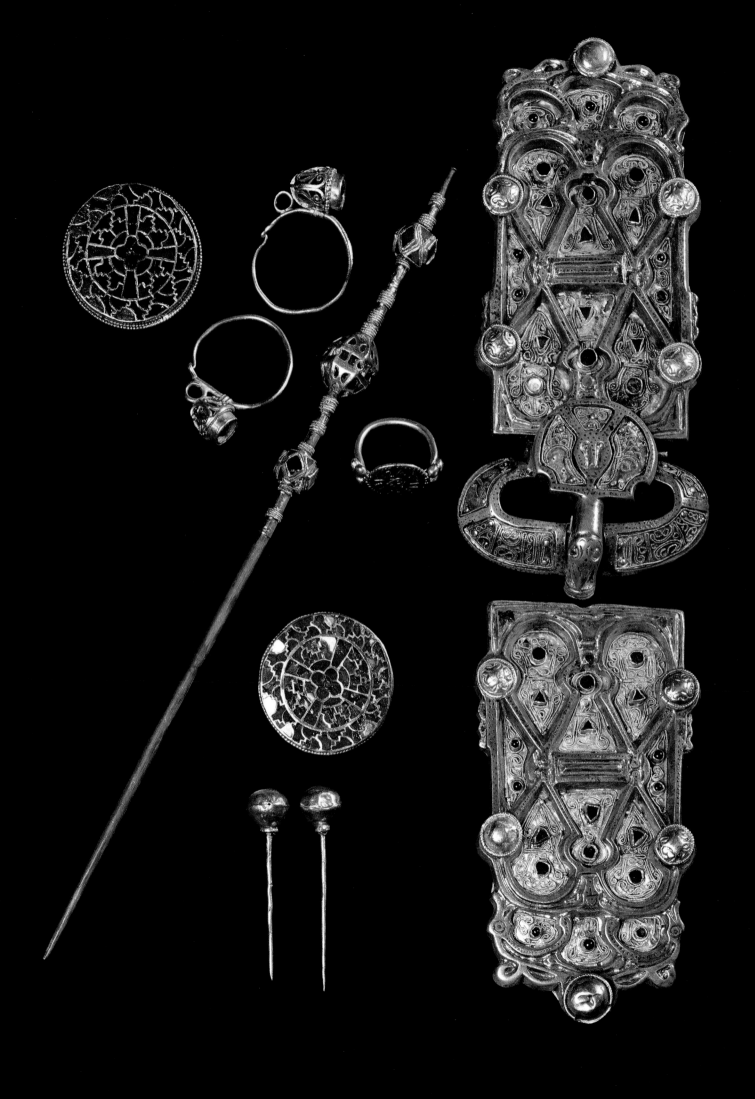

Chapter 13

❀❀❀❀❀❀❀❀❀❀❀❀❀❀❀❀❀❀❀❀❀❀❀❀❀❀❀❀❀❀❀❀❀❀❀

The Age of Migrations and the Early Middle Ages

Cathedral Treasuries and Royal Crowns

When the Turkic peoples appeared in Europe in AD 375 and invaded the Danube-Tisza plain, the Germanic tribes began to migrate; the *limes*, the border armies of the Roman empire on the Danube and the Rhine, could not withstand the pressure. This advance marked the true beginning of the migration of peoples that completely redrew the map of Europe and triggered a political and cultural reordering of the world around the Mediterranean. The migration of the Germanic tribes from the second to the sixth centuries AD ultimately led to the decline of the Western Roman Empire; at the same time, those centuries marked the transition to medieval Europe. The Frankish empire founded by Clovis I (r. 481–511) annexed Thuringia in 531 and Burgundy in 532–34. In western Europe, a new political center gradually evolved under Charlemagne (r. 768–814), who brought all the Germanic tribes on the continent under his control and had himself crowned emperor in Rome in AD 800. The beginning of the reign of East Frankish king Conrad I (r. 911–918) marked the end of the early Middle Ages.

In northern Europe the migrations affected the Vikings as well from the eighth century onward. They moved from their tribal homelands in Scandinavia to Britain, to the coasts of Normandy and Brittany, and down to the Mediterranean; around 800 they crossed the Atlantic to the Orkney and Shetland islands, Iceland, and Greenland.

Gold Becomes Scarce

The considerable scarcity of gold in the final phase of Roman history continued during the age of migrations and the early Middle Ages, with considerable declines in the rate of gold extraction. It is estimated that from 50 BC to AD 500, 1,900 tons (1,700 MT) of gold were extracted and processed; for a medieval period almost twice as long, from AD 500 to 1500, only 635 tons (575 MT) of the precious metal were mined. What were the causes for this striking difference? First, some of the deposits that had been mined earlier were exhausted; second, where extraction on a large scale was still possible, the organization necessary for recruiting, training, and overseeing large numbers of miners was lacking. For that reason the only sources of gold in the Middle Ages were small, usually alluvial deposits that could be mined by individuals or small groups acting

212. Jewelry of the Frankish queen Aregund, Paris, Saint-Denis, tomb 49, Merovingian, last third of sixth century; gold, silver, garnets. Musée du Louvre, Paris.

This ensemble of exceptional gold works for the wife of the Frankish king Clotaire I (r. 511–561) includes two earrings, a signet ring, an ornamental pin, two round gold-garnet disk fibulae, two small needles with gold heads, and a buckle with matching clasp. The latter is made of gold, silver, and small gemstones and is without a doubt the finest piece. Punching, granulation, and attractive alternation of the two precious metals in geometric patterns made this piece a worthy attribute of a ruler.

on their own without too much effort. Newly mined gold was sold either directly to workshops or via traders, but it appears that a considerable portion of the precious metal available in the Middle Ages was old gold that was reprocessed. Gold was thus obtained primarily from melting coins and spoils and from the tributes paid by Roman and Byzantine emperors.

There are two important reasons why this period managed to develop the characteristic signs of a highly advanced goldsmith's art despite the limited availability of gold. First, in the early Middle Ages gold currency played only a limited role, even though the Germanic kings before Charlemagne had minted gold coins, such as the early Merovingian *solidus* (plate 224), modeled on the coins of Byzantine emperors like Anastasius I (r. 491–518). The few gold coins that Charlemagne had minted are numismatic rarities. The first uniform European system of currency was based on silver coins, due to the tapping and mining of many newly discovered deposits of this metal. Despite this shift in the availability of precious metals, the ratio in value of gold to silver hardly differed at all from that of antiquity: 1:12. Gold supplies for coining were thus not a factor. Second, in times when it was necessary to economize with gold, it was important to master gilding techniques perfectly. Even coatings and coverings designed to save on precious metals could still bring out the qualities of gold: its color, luster, and durability. With a limited supply of gold but a sufficient amount of silver, metalsmiths produced works of art in which the two metals could produce powerful effects. Silver was coated with either gold leaf or gold foil, or the two metals were combined. The gold coatings on silver, bronze, or copper in lieu of solid gold were applied mechanically or, for more durable results, by means of fire gilding, which involves the amalgamation process.

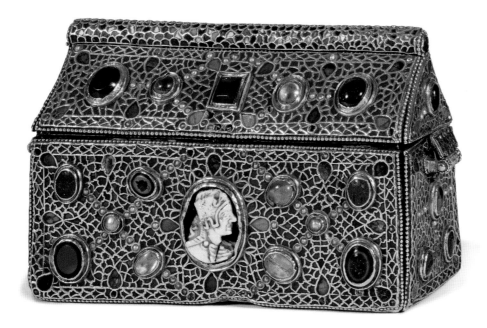

213. Box of Theodoric, Merovingian, seventh century; gold, enamel, stones, gems, 5 × 2⅝ × 7¼ in. (12.7 × 6.6 × 18.4 cm). Abbey treasury, Saint Maurice, Switzerland.

This box, lavishly ornamented with stones, is an outstanding example of the goldsmith's art of the Merovingian period. Like countless such objects, it was donated to the abbey by pilgrims, but it was unusual for the donor to have his name applied to it by the goldsmith.

The Germanic tribes of the age of migrations and the early Middle Ages loved not only the luster of gold but also jewelry with colored stones, with red garnets being particularly prized (plates 212, 214, 215). These gems were either used in their natural form or set in regular patterns between gold crosspieces and then polished. Such compositions, known as cell mosaics, are found on fibulae, sword hilts, votive crowns, and much more. Cloisonné, or cell enameling, was commonly used to produce decorations, ornaments, and images on artifacts. Enamel was produced by mixing sand with potash, sodium bicarbonate, and calcium carbonate and melting them together with metal oxides that provided the color. This glasslike mixture could be powdered and dampened and then applied with a brush to sheet gold and, if desired or required, framed with gold crosspieces. The enameled objects were then fired at around 1500 degrees Fahrenheit (800°C)—just below the melting point of gold—and then polished to achieve a surface luster that could be heightened by gold shining through from the base.

Germanic goldsmiths preferred geometric ornaments for jewelry motifs, and their skillful symmetrical arrangements testify to their distinctive sense of form. During their wanderings they proved open to foreign influences, not infrequently copying Roman decorative elements and the Scythian animal style. The Vikings, by contrast, developed their own types of jewelry, and their unique bracteates are particularly outstanding (plate 217). Bracteates, or gold disks, sometimes inscribed with runes, measured as much as four inches (10 cm) or more in diameter and were worn on the chest. These disks bore stylized heads, perhaps in imitation of Roman emperors, whose portraits had reached the north on coins and became models for jewelry. Bracteates were used as amulets, which were given as gifts or awarded as honors.

214. Armlet, ring, and belt buckles, tomb of a man, Pouan-les-Vallées, Aube, France, third quarter of the fifth century; gold, garnets, diameter of bracelet: 3 in. (7.6 cm). Musée des Beaux-Arts, Troyes, France.
This ensemble, probably taken from the tomb of a tribal chief, seems modern in its clear forms. The combination of gold with red garnets was in keeping with the dominant taste of the period.

△ 215. Sword hilts and scabbards, Tournai, Merovingian, fifth century; gold, garnets, cloisonné. Bibliothèque Nationale de France, Paris.

The royal weapons from the tomb of the Frankish king Childeric I (r. 457–482) are, other than part of one scabbard that has been hammered from sheet gold, all made in the gold-garnet-enamel style. The gold crosspieces were placed on the solid gold bases in precise patterns and filled with either cloisonné or small tiles of red garnet. The slight differences in the color of the polished gemstones is a sure sign they are genuine.

▷ 216. Water pitcher, Carolingian, ninth century; Persian or Sassanian enamel mounted on gold, cloisonné. Abbey treasury, Saint Maurice, Switzerland.

This vessel, said to have belonged to Charlemagne, features a Carolingian spout and base that were forged onto a pitcher of the sort used in the Orient. The origin of the enamel—detailed, colored ornaments applied to a gold base—is uncertain, perhaps Persian or Sassanian.

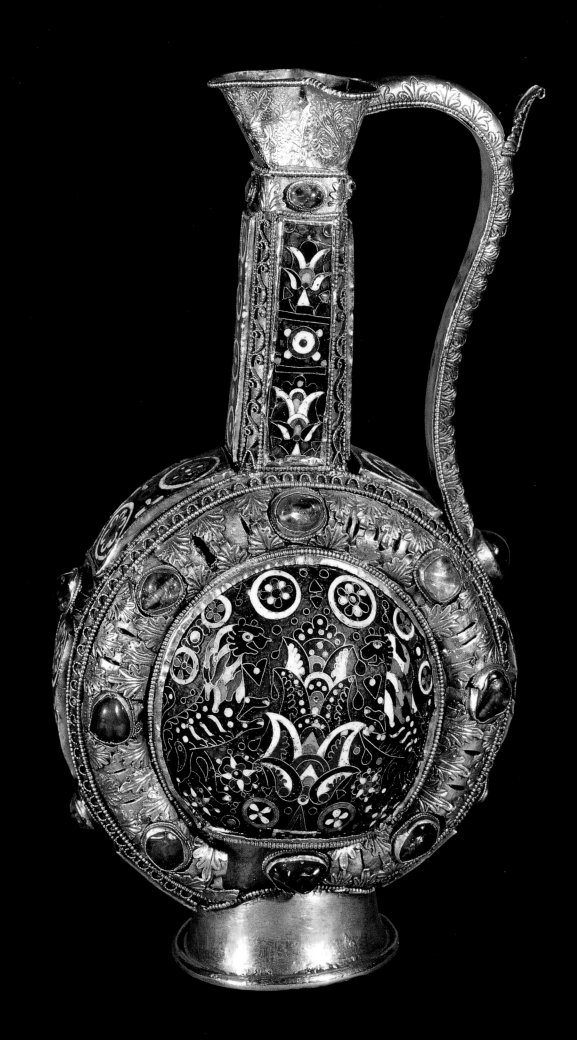

217. Bracteate, Asum, Skåne province, Sweden, Viking, c. 700; gold, diameter: 4¹³/₁₆ in. (12.3 cm). Statens Historiska Museum, Stockholm.
Bracteates were a popular and widespread form of gold jewelry from the age of the Germanic migrations. They are usually imprinted on only one side, feature an eyelet from which they can be hung, and vary in diameter from half an inch to four inches or more (1–10 cm), and in weight from a sixtieth of an ounce to around three and a half ounces (0.5–100 g).

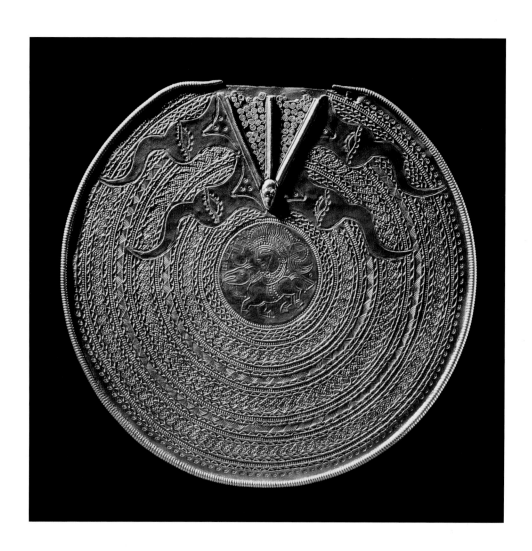

GLORIFYING THE LORDS OF HEAVEN AND EARTH

The gold treasures of the German realms were the property of royal families and the nobility (plate 216), on the one hand, and of the church, on the other (plates 213, 220, 221). In the secular context, precious metals were encountered as dowries, gifts, and spoils, and the objects made from them included bars, coins, tableware, pots and pans, ornaments on clothing, and rings. Among the more remarkable surviving gifts to the church are the cathedral treasures, like the one in Monza that was donated by the Lombard queen Theodolinda (plate 219).

Secular valuables and artifacts of gold in cathedral treasures were of comparable quality, and while they reveal different emphases in their choice of motifs, their levels of meaning overlap. For example, the imperial crown of Charlemagne, which weighed seven pounds fourteen ounces (3.59 kg), symbolized the splendor of ancient Rome, as it included antique gems and coins. Such symbols were connected with the glory of this medieval champion of Christianity, who had been crowned by the pope. Among ecclesiastical decorations, the quantities of precious metals used

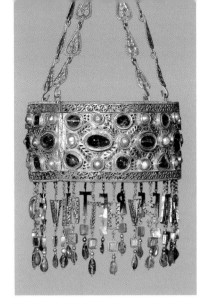

for the altars and liturgical implements of the Lateran basilica in Rome should be mentioned: more than 6,000 pounds of silver and 460 pounds of gold. Church treasuries also held such special votive gifts as the crown of the Visigoth king Recceswinth (plate 218), who earned his place in history with the *Lex visigothorum*, a common law for Goths and Romans that he issued in 654.

Gold was used in churches and iconographic representations to depict, based on early Byzantine models, what could not be depicted—the hereafter of Christianity—by symbolizing it with brightness and light, creating a deliberate contrast to threatening, dark powers. The resulting extravagance and splendor was often considerable, and must have underlined the message *ad maiorem Dei gloriam* (to the greater glory of God) enough to impress even skeptics who still clung to pagan beliefs and persuade them of the "New Jerusalem." Gold as a symbol of wisdom and the everlasting *logos*, which was not subject to the "rust of the ephemeral," was in every one of its forms an epiphany of the divine for the faithful of the Middle Ages.

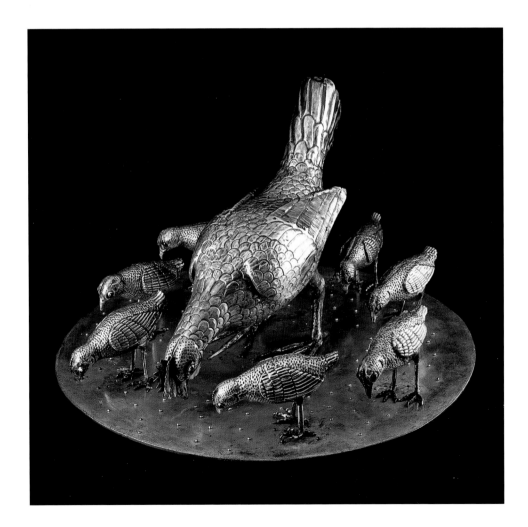

△ 218. Votive crown, Guarrazar, Toledo province, seventh century; gold, gemstones, diameter: 8⅛ in. (20.6 cm). Museo Arqueológico, Madrid.
The votive crown of King Recceswinth (r. c. 653–672) is only one small part of an extensive find at Guarrazar. The crown, with its pendants of gold and countless gems and precious stones, was suspended from the chains attached to its upper edge. It was found with other precious objects, like votive crosses and more votive crowns, in a hoard that was buried for unknown reasons.

◁ 219. Hen with seven chicks, sixth century; gilded silver, rubies, emeralds, diameter: 18⅛ in. (46 cm). Museo del Duomo, Monza, Italy.
In all ages items from royal treasures were bequeathed to the church to guarantee salvation and eternal peace. The objects given by the Lombard queen Theodolinda, now in the treasury in Monza, are especially fine examples of such donations. They include this astonishing ensemble of a hen with seven chicks, a realistic depiction of a henhouse scene in gilded silver with rubies and emeralds.

220. Reliquary box, ninth to tenth century; sheet gold hammered over a wooden core, precious stones, antique gems, beads, enamel, height: 6¹¹⁄₁₆ in. (17 cm), width: 7¹⁄₁₆ in. (18 cm). Sainte-Foy, Conques, France.

This small box for preserving relics is from the collection of the Pépins, the mayors of the palace and kings of the Franks, and has a depiction of Christ on the cross between the Virgin and Saint John. The chased sheet gold with rich ornamentation of precious stones, antique gems, beads, and enamel covers a wooden core.

221. *Sainte-Foy*, French, ninth century; gold, precious stones, rock crystal, height: 33½ in. (85 cm). Sainte-Foy, Conques, France.

This work of the French school skillfully recycles a head from late antiquity. A reliquary statuette, it consists of a wooden core clad with gold and numerous precious stones in gold settings distributed around the entire figure. The many details, like the small shield with the Lamb of God and the delicate crown, make this statue an admirable precious object.

Legacies of gold from the migration of peoples and the early Middle Ages are also found in the form of burial offerings for nobles and chiefs, which give evidence of a highly developed goldsmith's art among the many Germanic tribes that had not yet converted to Christianity. To these tribes, who still worshipped pagan gods, the concept of an asceticism that turned away from the world was utterly foreign. Of course, such devotion to a pagan past existed alongside the upheaval, transition, and reorientation characteristic of this turbulent age, an age to which both secular jewelry and ecclesiastical artworks in gold bear valuable witness.

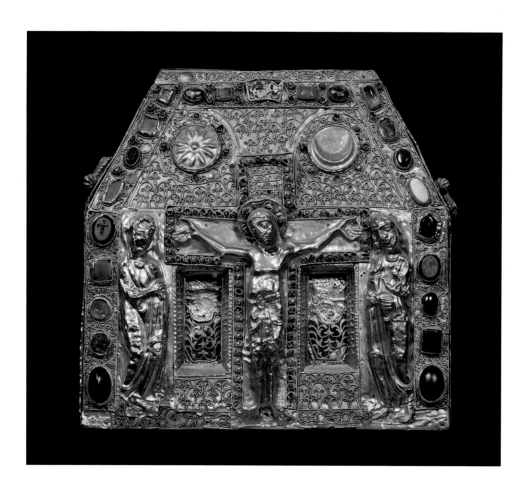

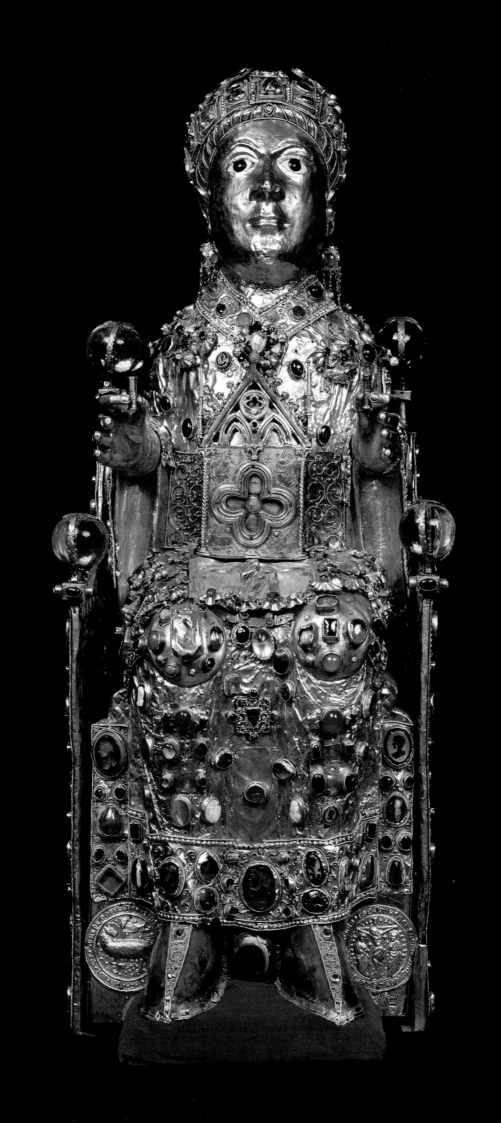

CHAPTER 14

✺✺✺

Byzantium

A GLITTERING BASTION OF CHRISTIANITY

THE LEGACY OF THE ROMAN EMPIRE

In AD 313 Constantine I (r. 306–337) enacted the Edict of Milan, which granted Christians the freedom to practice their religion and led, not quite seventy years later, to the recognition of Christianity as the state religion. In 330 the emperor consecrated Constantinople as the second capital of the Roman Empire, which in 395 was divided among the two sons of Theodosius I (r. 379–395): Honorius (r. 393–423) received the western half, and Arcadius (r. 383–408), the eastern half. After the western empire collapsed during the reign of Romulus Augustus (r. 475–476) as a consequence of the onslaught of Germanic tribes during the migration of peoples, the Eastern Roman Empire tried to continue the tradition of the empire as a whole, while incorporating its territory's Greek and Hellenistic legacy. This attempt to carry on the tradition of Roman history and culture remained only that. Although Justinian I (r. 527–565) sought to reestablish the Roman Empire with its former borders, he was unsuccessful. Christian emphases and currents became increasingly important in the east, and the new capital Constantinople, also known as Byzantium, developed into a Christian Rome that survived more than a millennium before being conquered by the Ottoman sultan Mehmed II in 1453.

Constantinople played a preeminent role during the late Roman Empire because all the talent of the enormous imperial territories came to be concentrated there, and this development influenced every one of the arts. The need for precious metals was consequently substantial, but it could be met by deliveries from the empire's own deposits in the Balkans, for throughout its existence the Eastern Roman Empire evidently had more gold than central Europe.

A link to the legacy of ancient Rome and its use of gold is evident from Byzantine coinage. The minting of gold coins was continued in the Eastern Roman Empire almost a thousand years longer than it was in the west. The gold coins of the eastern Roman emperors (plates 7, 8), which were produced in large numbers, lack the striking profiles and realistic features of the portraits on coins of the earlier Roman Empire. They are less individualized in their design, frequently showing just a schematic frontal view that scarcely changed from ruler to ruler. By contrast, some portraits on coins, like that of the empress Galla Placidia (plate 223), who died in Ravenna in 450, do have a certain individuality, but they are not comparable to the concise portraits of the Julio-Claudian emperors. Christian

222. *The Ladder of Divine Ascent*, Byzantine, twelfth century; painting on wood, 16⅛ × 11⁹⁄₁₆ in. (41 × 29.3 cm). Saint Catherine's Monastery, Sinai Peninsula, Egypt.

This famous icon depicts, against a matte, darkened gold ground, the ascent of monks on the ladder of virtues to Christ; those who are not worthy of the kingdom of heaven are knocked down by devils. The image refers to a guide to asceticism written by Saint John Climacus, the abbot of the monastery in the early seventh century.

223. Solidus, obverse: Galla Placidia, minted in Ravenna, 425–29; gold, c. ⅞ in. (2.3 cm). British Museum, London.

The obverse shows a bust of Galla Placidia (390–450) wearing a pearl diadem, with the hand of God placing a wreath on her from above. This is a characteristic minting from the middle years of the reign of Valentinian III, the son of the woman depicted, who had most of his gold and silver coins struck in Rome and Ravenna.

symbols are found on both obverses and reverses, but they were not so much state propaganda as a stereotypical declaration of faith. As far as the purity of the gold went, the Eastern Roman Empire did not follow the principle of maximum purity either.

A REFLECTION OF THE GLORY OF GOD

The eastern Roman emperors distinguished themselves by donating generously to the clergy and the churches, very much in the tradition of donations to pagan temples in earlier periods. One of the most famous churches of late antiquity was the so-called Golden Octagon in Antioch, a cathedral or palace church begun in 327 and consecrated in 341; its interior is said to have been lavishly gilded at one time. It served as the seat of the patriarch as well as a location for the emperor's public appearances. The Church of the Holy Sepulcher in Jerusalem and the Church of the Apostles in Constantinople were also famous for their magnificent decorations: the ceilings of both churches were gilded at the behest of the emperor. Although previously gold had been the symbol of worldly power and pagan gods, the early Christian church adopted the tradition of accepting gold as a votive offering and put it to adroit use for its own purposes and concerns. The imperial house believed it was performing good by interpreting the gold treasures and ornaments mentioned in the Old Testament as symbols of divine worship, and so it established churches and monasteries. How else was one to understand the biblical directive to build the temple in Jerusalem (Exodus 25:8–9)?

Gold was used not only to decorate churches but also for iconographic depictions, garments, liturgical implements, and much more. As in the early Middle Ages, a common technique for illustrating figures or for ornamentation was cell enameling, or cloisonné, in which artisans would solder forms made with gold wire onto a base and then fill them with colored enamel that was then fired to make it durable (plate 225). For the Byzantine church, gold, worked in a variety of ways and for various uses, was the only material that could express proper reverence for the Supreme Being and demonstrate to the faithful divine omnipotence and eternity. In the semidarkness of the churches, glimmering gold and candlelight ensured an atmosphere of worship, awe, and wonder. For some strict fathers of the church, this extravagance was suspect. They rejected such splendor as incompatible with the poverty, renunciation of property, and humility that Christ had asked

224. Armlet and necklace with mid-sixth-
century gold coins, Merovingian, Munich-
Aubing, Bavarian tombs; gold, glass beads,
coins: 0.053–0.09 oz. (1.5–2.56 g).
Archäologische Staatssammlung, Museum
für Vor- und Frühgeschichte, Munich.

*One especially refined feature of these
pieces of Merovingian jewelry is the placing
of gold coins between round, polished colored
stones and beads of millefiori glass. They
are Merovingian imitations of the* solidi *of
Emperor Justinian I (r. 527–565) from an
Italian mint.*

227. Death of the Virgin, Byzantine, detail of the *Pala d'oro* (retable of the Basilica di San Marco), tenth century; gold and silver panels, gems, pearls, cloisonné, height: 55⅛ in. (140 cm), width: 137¹³⁄₁₆ in. (350 cm). Basilica di San Marco, Venice.

The famous "golden pall" was commissioned in Byzantium by the doge of Venice in 976 and later reworked a number of times. The gold and silver panels depict scenes from the life of Christ. Outstanding chased work is combined here with cloisonné, precious stones, and pearls.

228. *Staurothek*, reliquary for the True Cross, central field of lid, Byzantine, c. 965; gold, cloisonné, set precious stones, 18⅞ × 13⅜ × 2⅜ in. (48 × 34 × 6 cm). Diözesanmuseum, Limburg an der Lahn, Germany.

This reliquary, in the form of a double-armed cross in a gold setting, is one of the most important examples of the art of Byzantine goldsmiths. The relic is preserved in a gold container with a sliding lid decorated with nine pairs of enamelwork figures, which are in turn framed by bands of precious stones set in groups. In the central row, Christ is depicted on a throne, flanked by the Virgin and John the Baptist, with six apostles each along the top and bottom.

225. Detail of a crown, Byzantine, 1042–50; gold, cloisonné, average height of the plaques: 3⁹⁄₁₆ in. (9 cm), average width: 1¾ in. (4.5 cm). Hungarian National Museum, Budapest.

The central field of this piece shows the Byzantine emperor Constantine IX Monomachus (r. 1042–1055). All of the parts of this crown, which is ornamented with various pictorial motifs, are decorated with enamel figures on a gold ground.

226. Cruciform pendant, probably from Constantinople, Byzantine, tenth century; gold, champlevé, height: 2⁷⁄₁₆ in. (6.12 cm), width: 1³⁄₁₆ in. (3.09 cm), thickness: ⁵⁄₁₆ in. (0.87 cm). British Museum, London.

The enamel plaque of this beautifully worked cruciform pendant depicts the Mother of God with her hands crossed on her chest. A capsule on top held a relic. The cross is made by the champlevé process, so that the silhouettes of the figures seem to float on the gold ground.

of the faithful. Their admonishments fell on deaf ears, though, for the early Byzantine world of the fifth century was inconceivable without worldly and sacred ornament, which were not always easy to distinguish from each other.

Precious objects were produced almost exclusively in imperial workshops that had been granted concessions, and it was punishable by death to withhold them from the imperial house. Following an ancient tradition, gold and crimson remained the symbols of the elite in the Eastern Roman Empire. Because jewelry indicated rank, approval had to be obtained from the highest authorities before a goldsmith's work reached its user. Gold objects were status symbols, and some of them were also thought to be amulets that could ward off evil. As a concession to the new religion, many objects bore a cross (plate 226), but this was more than a universal decoration—it was considered the very symbol of belonging to the new Christian faith in the (eastern) Roman world.

Byzantine art was well known and admired in the west also. Byzantium produced implements for ecclesiastical use, including reliquaries, paintings of saints, and bookbindings. San Marco in Venice has an especially rich collection, as well as the famous altarpiece *Pala d'oro*, which was started in Byzantium in 976 and is four feet seven inches (1.4 m) tall and eleven feet five inches (3.5 m) wide. The *Pala d'oro* incorporates Byzantine gold and silver plaques that depict scenes from the life of Christ and are lavishly ornamented with cloisonné and precious stones (plate 227). The treasury of the cathedral of Limburg holds the famous *Staurothek* (plate 228), a container for relics of the True Cross. It too is from Byzantium, and its figures of Christ, the apostles, and saints are executed in comparable decorative techniques.

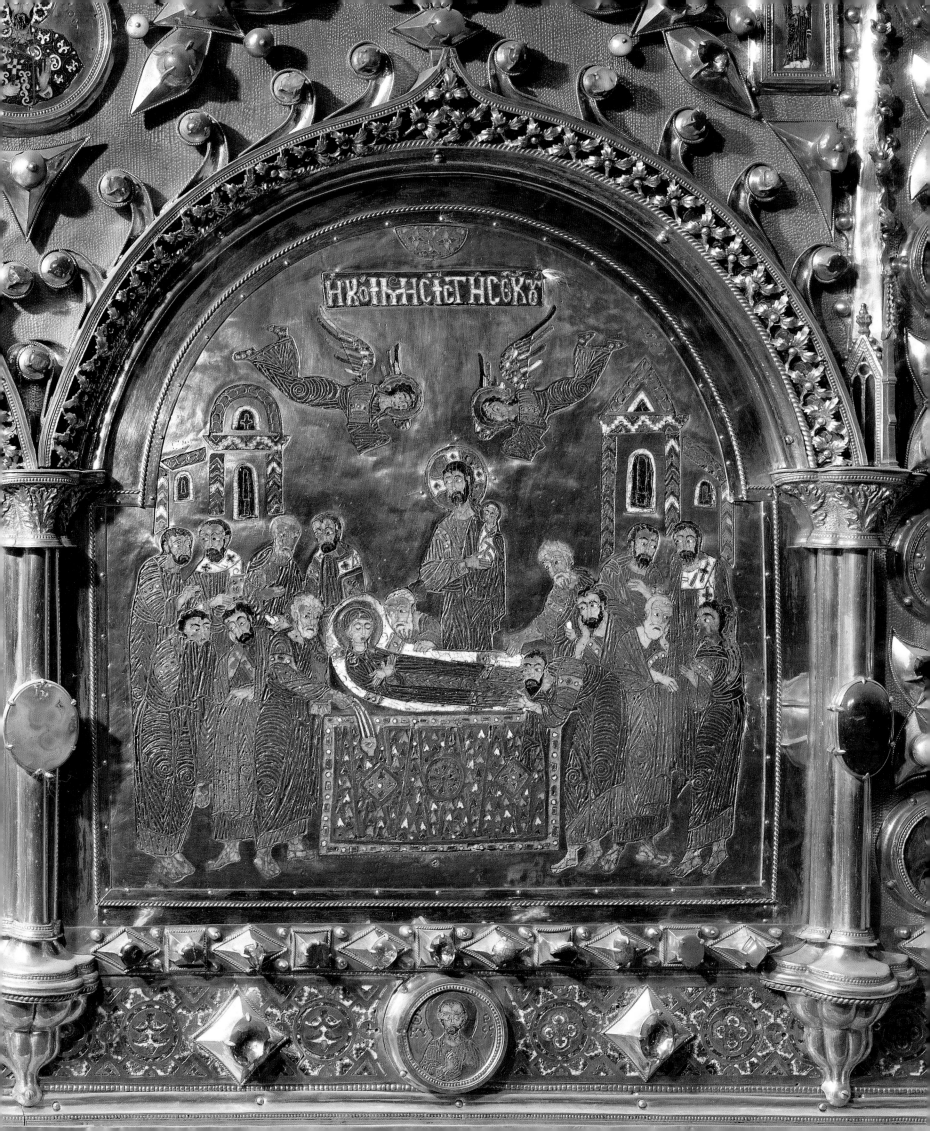

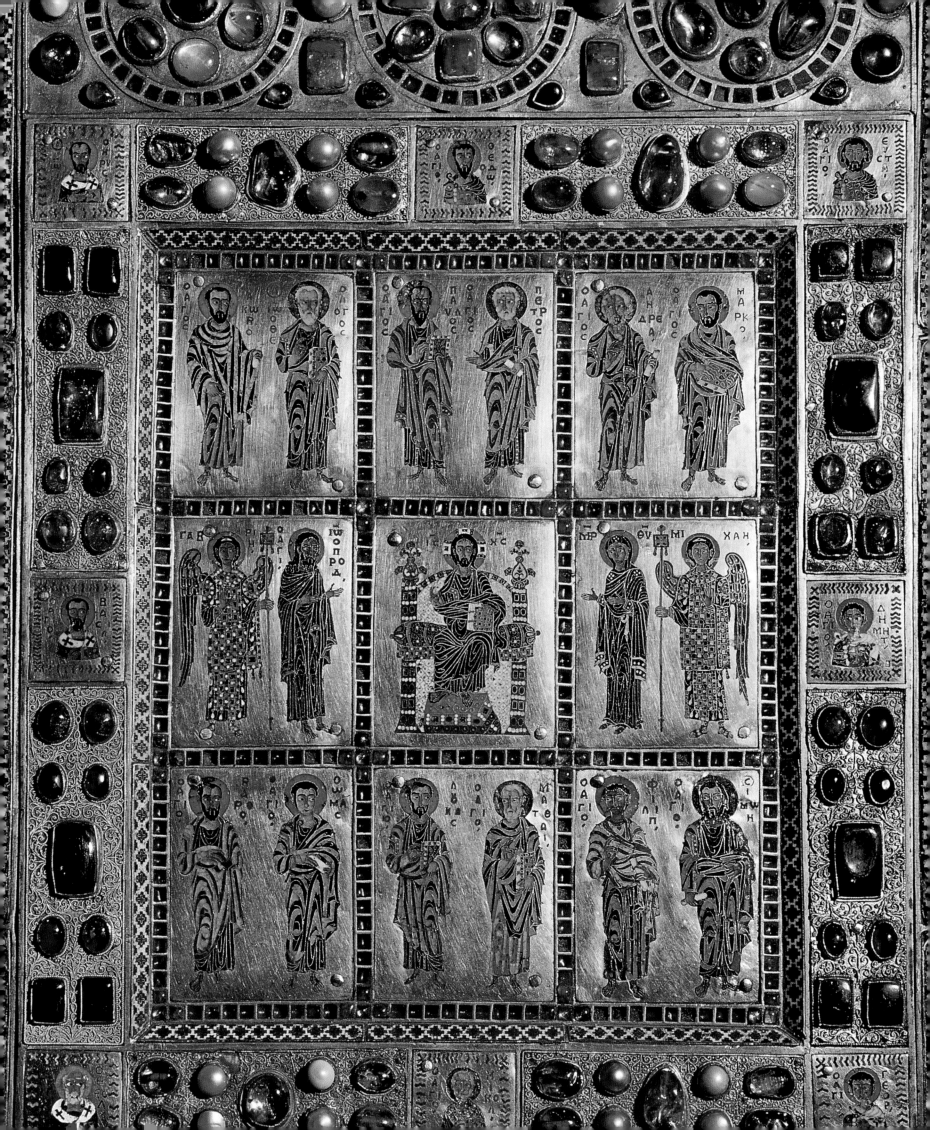

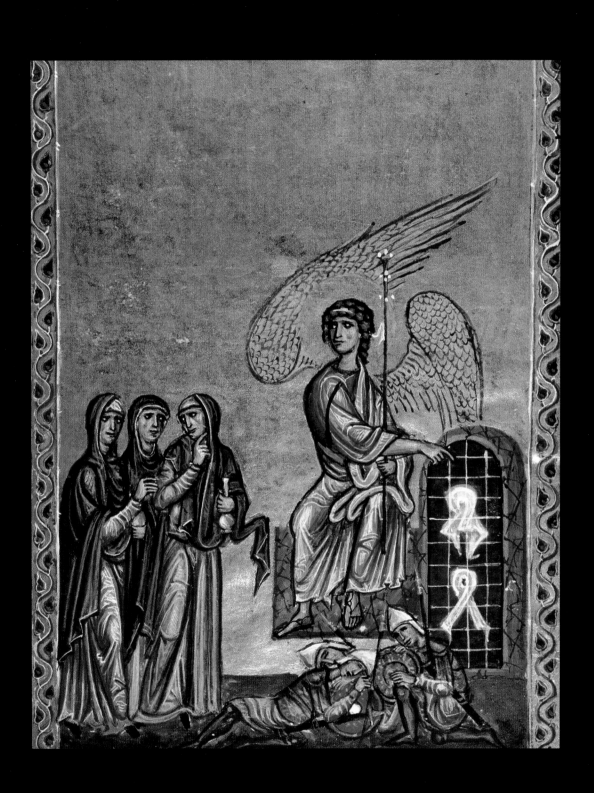

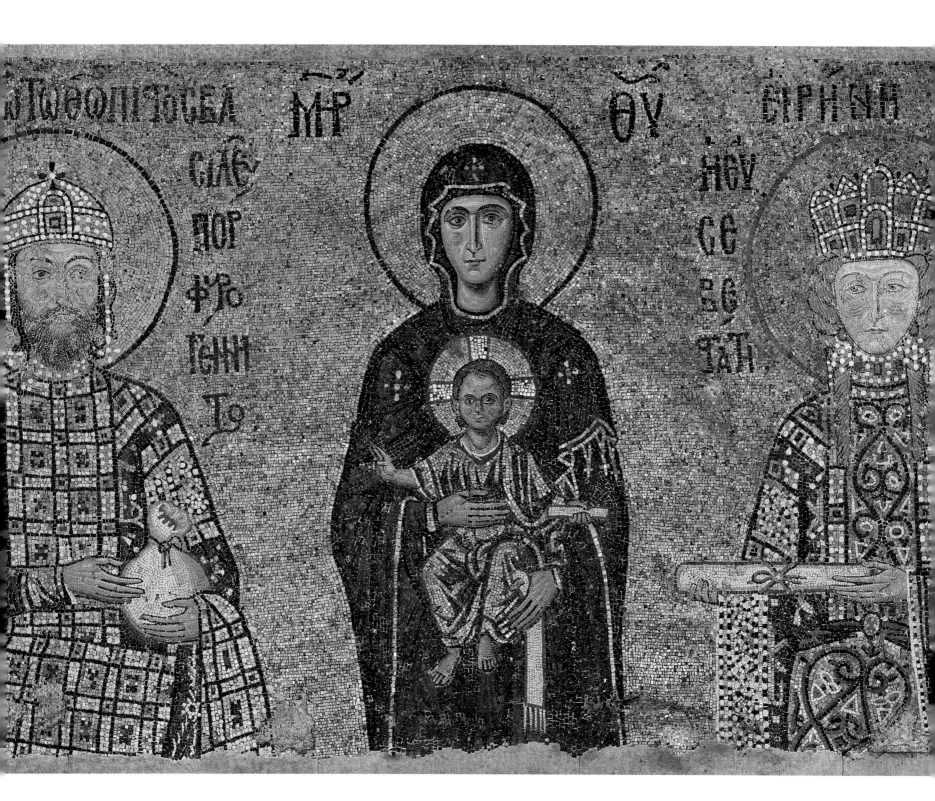

The Gold Ground

Among the new artistic developments of the Byzantine period were gold mosaics, which became the dominant medium of both decoration and depiction in churches, monasteries, palaces, and villas. The ancient tradition of decorating rooms with mosaics, known in Rome as *opus musivum*, was usually based on the use of squares of colored stone, including marble. In Byzantium a sensational innovation was made: in lieu of stones that had been split and hewn into small pieces, artisans used squares of gold and colored glass to create mosaics of supreme perfection. The gold tesserae were made by applying gold foil to sheets of glass and then covering the foil with colorless glass. This pane of layers of glass, gold, and glass again was cooled and then cut into small squares that could be pressed into a foundation of mortar. The resulting luminosity, seen in the mosaics of Hagia Sophia in Istanbul (plate 230), built between 532 and 537, is as fascinating today as it was the day this church was erected. The contemporary works in the churches of Ravenna (plate 231), Byzantium's outpost in Europe, reveal a preference for mosaics of colored glass over those of gold.

The faceted gold background created a cohesive expanse that seemed to shut out the outside world and lent the depicted saints an aura of solemnity seemingly unlimited by space, an effect first found in early Byzantine mosaics. In the churches of early Christendom, gold mosaics served the function of making the omnipresence of God visible, and the same effect can be found in such western churches as Santa Maria Maggiore in Rome. In manuscript illumination, panel painting, and figural altar retables, a gold background was common (plate 229); in icon painting, it was even obligatory (plate 222). The painting of icons of the saints was practiced especially in monasteries, as was the production of illuminated manuscripts, for which both gold ink and gold paint were indispensable means of decoration.

For centuries Byzantium remained the model for a style in ecclesiastical art that still molds the decoration of Orthodox churches but was particularly influential on western churches during the early centuries of the Middle Ages. Byzantine art made its way there either legitimately or in the spoils from Constantinople after the city was sacked during the Fourth Crusade (1202–4). Its realm of static forms, in which worldly and religious figures depicted in a rigid frontal perspective convey an otherworldly solemnity that is heightened by the luster of gold, gives it an utterly original character.

229. *Three Women at the Tomb*, Melisende Psalter, Ms. Egerton 1139, fol. 10r, Byzantine, c. 1131–44; illumination. British Library, London.
This manuscript illumination shows three women at Christ's tomb. The rich gold ground, which takes up the entire top half of the image field and brings out the brilliant color of the figures even more, elevates this scene out of the earthly sphere.

230. *Virgin with Child and Emperor John II Comnenus and His Wife, Irene*, Byzantine, 1118–22; gold mosaic, height: 8 ft. 1 in. (2.47 m), width: 14 ft. 7 in. (4.45 m). South Gallery, Hagia Sophia, Istanbul.
This is one of the most important large surviving Byzantine mosaics. The Virgin's dark garment contrasts strongly with the shimmering gold mosaic background and gives the Mother of God a serious dignity between the two rulers in ceremonial garb.

231. *The Last Supper*, early sixth century; gold mosaic. Upper gallery of the nave, San Apollinare Nuovo, Ravenna, Italy.
Ravenna's churches are famous for their mosaics. This depiction of the Last Supper is from a series of scenes from the life of Christ. The artist placed the disciples in a close circle around the table with two large fish and applied a gold ground behind the figures.

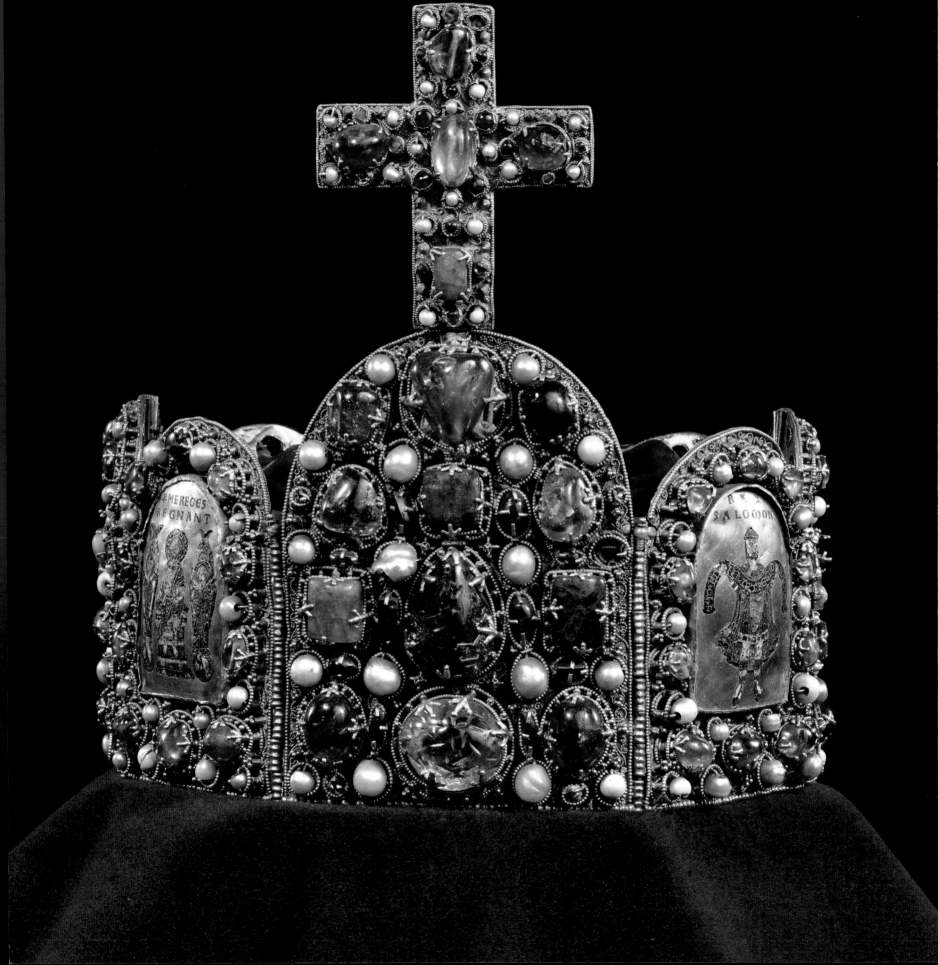

Chapter 15

✵✵✵✵✵✵✵✵✵✵✵✵✵✵✵✵✵✵✵✵✵✵✵✵✵✵✵✵✵✵✵✵✵✵✵✵✵✵✵

The High and Late Middle Ages
Symbols of Light and Power

Theophilus and the Goldsmith's Art

A t the end of the eleventh century, in a monastery near Bad Karlshafen on the Weser River, lived the Benedictine monk Roger of Helmarshausen. It is generally assumed that he can be identified as the Theophilus who wrote a book entitled *Schedula diversarum artium* or *De diversis artibus* (*On Divers Arts*) that continues to be much admired and published in many languages today. This work, in which he summarized his own knowledge and experience as an artisan, is considered the most important medieval handbook of crafts and techniques. With precise instructions, Theophilus provided information on the practices of metalworking and processing used in many monastery workshops in his day, including the production of alloys, but he also collected advice on casting bells, painting, and glass making. He devoted particular attention to gold and gilding. In order to provide examples of his instructions and formulas, he created, among other things, a portable altar for Bishop Heinrich of Werl (plate 233), which fortunately has survived and is held in the treasury of the cathedral of Paderborn.

The High Middle Ages, which began with the accession of Conrad I to the East Frankish throne in AD 911, a good hundred years after the founding of the Holy Roman Empire, and ended with the death of Emperor Frederick II in AD 1250, included the Romanesque period (eleventh to mid-twelfth century). During the Romanesque era not only the workplace of Theophilus but also many other important monastery workshops in

◁ 232. Crown of the Holy Roman Emperor, Reichenau (?), c. 962, arch and cross from c. 1027; gold, enamel, precious stones, pearls, cloisonné, 6⅛ × 8¼ × 8¾ in. (15.6 × 20.9 × 22.2 cm). Kunsthistorisches Museum, Vienna.
The headband of this crown was made around 962, probably on Reichenau Island in Lake Constance. The arch and cross were added later. In keeping with its purpose, the imperial crown is made of gold and decorated with large and colorful precious stones. The smaller inset plates have enamel depictions of figures from the Old Testament.

▷ 233. Roger of Helmarshausen, portable altar, early twelfth century; oak, gilded silver, set stones, pearls, 6½ × 8⅜ × 13⅝ in. (16.5 × 21.2 × 34.5 cm). Erzbischöfliches Diözesanmuseum, Paderborn, Germany.
In making this portable altar, Roger of Helmarshausen, a monk and goldsmith also known as Theophilus, used many of the techniques described in his book. The wooden box was clad with sheet silver and gilded, engraved, chased, decorated with niello inlay, and set with stones and pearls.

▽ 234. Shrine of Saint Elizabeth, west
German, 1236–1249; gilded copper, set
stones, 53⅛ × 73⅝ × 24³/16 in. (135 × 187 × 63
cm). Elisabethkirche, Marburg an der
Lahn, Germany.
*The shrine of Saint Elizabeth, landgravine
of Thuringia, is one of the most important
shrines of medieval Germany. The techniques
used are varied: cast objects alternate with
chased and chiseled parts, and the lavish use
of set precious stones contrasts with the gleam
of the metal. The artist did not go without the
luster of gold, though he achieved it with just
a thin coating. This illustration shows the
so-called Christ side, where Jesus is depicted
in the center along with his apostles.*

central and western Europe dedicated themselves to church art and prac-
ticed the careful working of gold, which had become very rare. Important
workshops were to be found in Trier and Regensburg, on Reichenau
Island, in Essen and Hildesheim, and later in monasteries in the Nether-
lands, along the Maas River, and in Cologne and Aachen. In addition to
Theophilus, other masters of the art of working gold and other metals,
such as Bishop Bernward of Hildesheim, Eilbert of Cologne, Master
Fridericus, Godefroid de Claire, and Nicholas of Verdun, were immortal-
ized in their works. Their most important pieces include altar decorations
and large reliquaries (plate 234), for which a wide variety of architectural
forms were used. The *Dreikönigsschrein* (Shrine of the Three Kings) in
Cologne (plates 9, 235) and the Verdun Altar in Klosterneuburg Monastery
in Austria (plate 236) are artworks of the highest rank. The *Dreikönigs-
schrein* is said to contain the bones of the Magi, the eldest of whom offered
gold to the Christ Child in the manger as a symbol of regal dignity.

The artists and artisans of the period knew how to effectively combine
a variety of techniques in these *Gesamtkunstwerke*. Precious metals domi-
nated, but gems, enamel, and other surface decorations were used as well,
such as *niello*, a type of inlay work using a paste of black silver sulfide.
The practice of decorating gold or gilded reliquaries with not only gems
and figures of saints or apostles but also the figures of the donors became

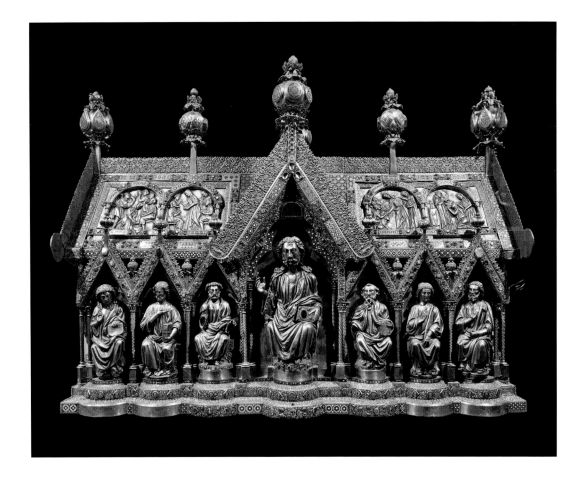

▷ 235. Nicholas of Verdun and workshop,
Dreikönigsschrein (Shrine of the Three
Kings), short side, c. 1181–1230; gold and
gilded silver, copper, and bronze, with
precious stones and gems, filigree,
cloisonné, champlevé, and *émail brun*,
60¼ × 43⁵/16 × 86⅝ in. (153 × 110 × 220 cm).
Cologne Cathedral.
*This reliquary shrine, made over a period of
nearly fifty years, is one of the most important
artworks of the thirteenth century, and it
demonstrates the repertoire of the goldsmith's
art of the period. Chased sheets of gold, silver,
and (sometimes gilded) copper and bronze
were mounted on the oak core of this shrine
built to resemble a cathedral. The display on
the short side in front depicts in thick sheet
gold the three Magi and Emperor Otto IV
before the Virgin on the left, the baptism of
Christ on the right, and Christ as Judge of the
World, flanked by angels, on top.*

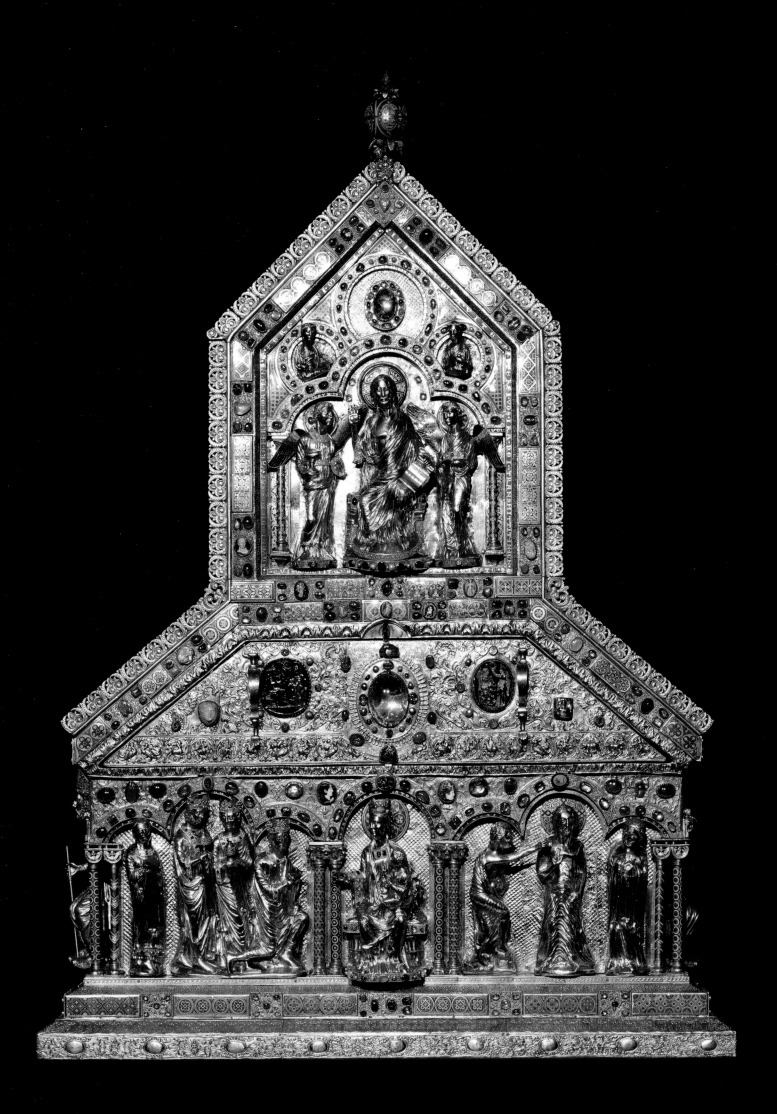

236. Nicholas of Verdun and workshop, *The Angels of the Resurrection*, detail of the Verdun Altar, 1181; enamel, gilded copper, cloisonné, champlevé, c. 8 × 14 in. (20 × 35 cm). Stift Klosterneuburg, Austria.

This altarpiece, named after the artist, is an undisputed masterpiece in terms of technique. Fifty-one scenes from the Old and New Testaments are rendered with great variety and vividness in champlevé and cloisonné on gilded copper.

common from the tenth century onward. The primary consideration was to glorify the donors, but by making valuable votive offerings the donors were also offering symbols of penance and improving their prospects for heavenly reward. The versatile workshops produced small portable gilded altars for processions, crosses (plates 237, 238), chalices, patens (plates for communion wafers), candlesticks, book covers, and other objects for services. In Christian liturgy, for example, the use of valuable materials for the chalice and paten (plate 241) symbolized reverence for the sacrament. Faithful to the Byzantine tradition, gilding was combined with champlevé and cloisonné. Gilded reliquaries in the form of sculpted busts, like that of Charlemagne in the cathedral treasury in Aachen (plate 240), are among the numerous surviving sacred and liturgical objects created by experienced and inventive gold- and silversmiths.

THE METAPHYSICS OF LIGHT

In the art of the High Middle Ages, the decorations on sacred objects often referred to the days of creation as described in Genesis. In the symbolism of color, gold stood for the light of the first day of Creation, as it did, for example, on the book cover of the *Codex aureus* of Freckenhorst, the Golden Gospels of Echternach (plate 239). Blue, in the form of blue gems, was reserved for the sea of the second day, and enamel was used to represent the separation of the waters from the firmament. Red symbolized the creation of Adam on the sixth day. Chapter 35 of Exodus describes

the decoration of the Tabernacle, which became the source for the traditions in decorating churches. Emperor Constantine I had donated gold altars and liturgical implements for Roman basilicas; the cathedrals of the High Middle Ages adopted the golden glimmer of those early church buildings. Gold was part of a medieval metaphysics of light because it brought light—the symbol of God and Christ, with the resurrection as climax—into the church. According to this interpretation, the abbey church of Saint-Denis is something like the prototype of Gothic cathedrals: the western facade has a roundel window as a symbol of the sun. At the time, such windows were gilded or filled with golden-yellow glass, and doors were covered with gold as a reference to the "New Jerusalem" and the tradition of the decoration of the Temple.

Gold was processed in a variety of ways for ecclesiastical purposes. As the material basis for artistic design—here again faithful to early Christian and Byzantine tradition—it was used to sculpturally form halos and nimbuses, which were embossed, chased, and set with precious stones. The gold ground for paintings evolved out of mosaic techniques (plate 242) and was applied as a flat surface behind individual pictorial elements. In paintings of the late Middle Ages (AD 1250 to around 1500), it was used for the sky (plate 243). Even in realistic depictions of scenes, a gold

▽ 237. Disk cross, first half of the twelfth century; cast copper, engraved and gilded, filigree, set stones, diameter: 16¼ in. (41.2 cm). Dommuseum, Hildesheim, Germany.
 The arms of this disk cross feature delicate filigree work and large precious stones. The openwork interior of the disk is crossed with gold vines that lend the object a lightness and immateriality reinforced by the brilliance of the stones.

▷▷ 238. Reliquary cross, late eleventh century; wooden core, chased sheet gold and silver, precious stones, pearls, filigree, height: 8⁷⁄₁₆ in. (21.5 cm), width: 6⅞ in. (17.5 cm). Church of Saint Mauritz, Münster, Germany.
 This cross, also known as the Erpho cross, is said to have been donated to the Mauritz monastery, which was founded in the late eleventh century by Bishop Erpho. Chased sheets of gold and silver were placed over a wooden core; filigree work and set precious stones complete the contour of the cross on the front side.

▷▷ 239. Cover for the *Codex aureus* of Freckenhorst, c. 1100; wooden lid, sheet gold, filigree, pearls, mother-of-pearl, stones, ivory, height: 8⅞ in. (22.6 cm), width: 6¹¹⁄₁₆ in. (17.5 cm). Staatsarchiv, Münster, Germany.
 The ornate design of this cover for the Codex aureus offers a precious frame for its contents. Sheet gold was hammered around the wooden book cover. The ornaments applied to it—filigree, pearls, mother-of-pearl, stones, and precious stones—frame the delicate ivory carving in the central field that depicts Christ in Majesty.

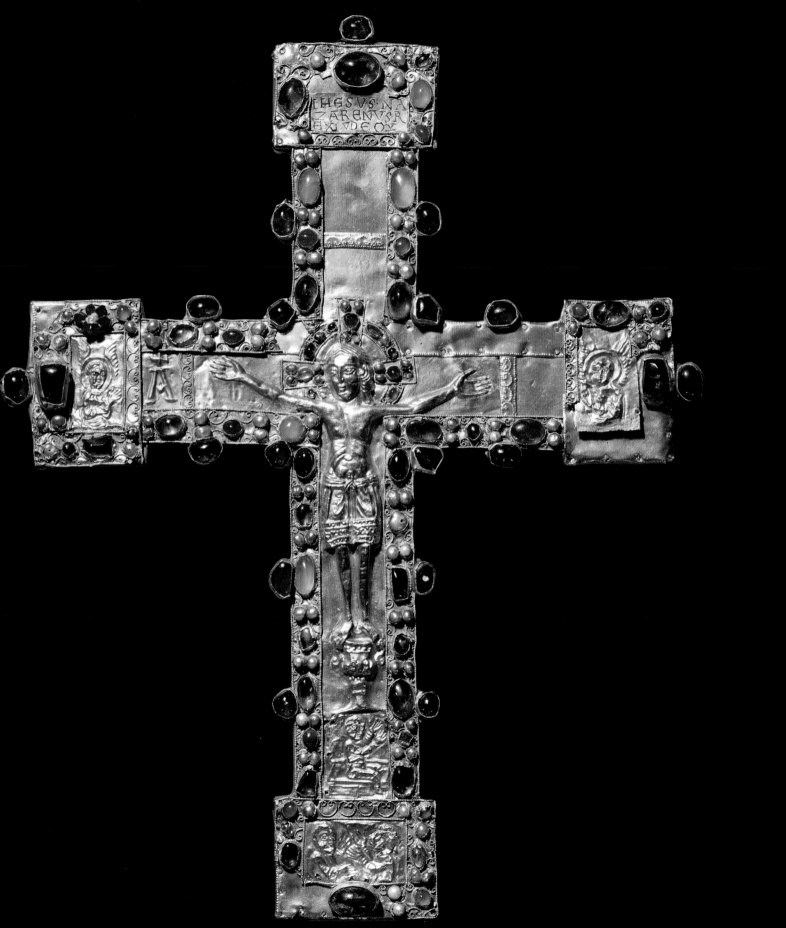

background was used to lift the figures out of the temporality of earthly existence and turn the painting into a vision . As late as the fifteenth and sixteenth centuries—for example, in the work of Albrecht Dürer, who was trained as a goldsmith—gold backgrounds were often elaborately chased and decorated with ornaments and, together with nimbuses, created a clear demarcation from the other, secular pictorial elements in a painting. Over time nimbuses became increasingly lavish in their design and execution, and the boundaries between the art of the goldsmith and that of the painter blurred. Excesses led to a certain hostility toward the material, which in the transition from the late Middle Ages to the early Renaissance culminated in the admonition that *materiam superabat opus* (the work is superior to the material). Finally, in his treatise *De pictura*, published in 1436, Leon Battista Alberti advised against using gold in painting.

SECULAR USES OF GOLD

Increasingly, the secular use of gold went hand in hand with its religious use. In the late Middle Ages, gold was held more and more in private hands and served, as it always has, to make social rank evident. Gifts and

◁ 240. Reliquary bust of Charlemagne, German, donated 1349; gold, height: 34 in. (86.3 cm), width: 22½ in. (57.2 cm). Domschatzkammer, Aachen, Germany.
This lavishly adorned bust with imperial crown is made of chased gold and silver. Both metals were used skillfully to achieve contrasts between the crown, the beard, the face, the chest, and the upper part of the garment. The patina on the silver parts has altered the original appearance so that Charlemagne appears to have darkened. This masterpiece of the goldsmith's art is one of the most important pieces in the cathedral treasury in Aachen.

▽ 241. Paten and chalice, second quarter of the thirteenth century; chased, engraved, and gilded silver, filigree, precious stones, height of chalice: 7 in. (17.9 cm), diameter of paten: 6¹⁵/₁₆ in. (17.7 cm). Church of Saint Godehard, Hildesheim, Germany.
Chalices and patens are the most important of the altar implements known as the vasa sacra *because they serve to represent the Eucharistic offering. This particular set is traditionally called the Bernward chalice and paten, though they postdate the famous bishop-goldsmith of Hildesheim.*

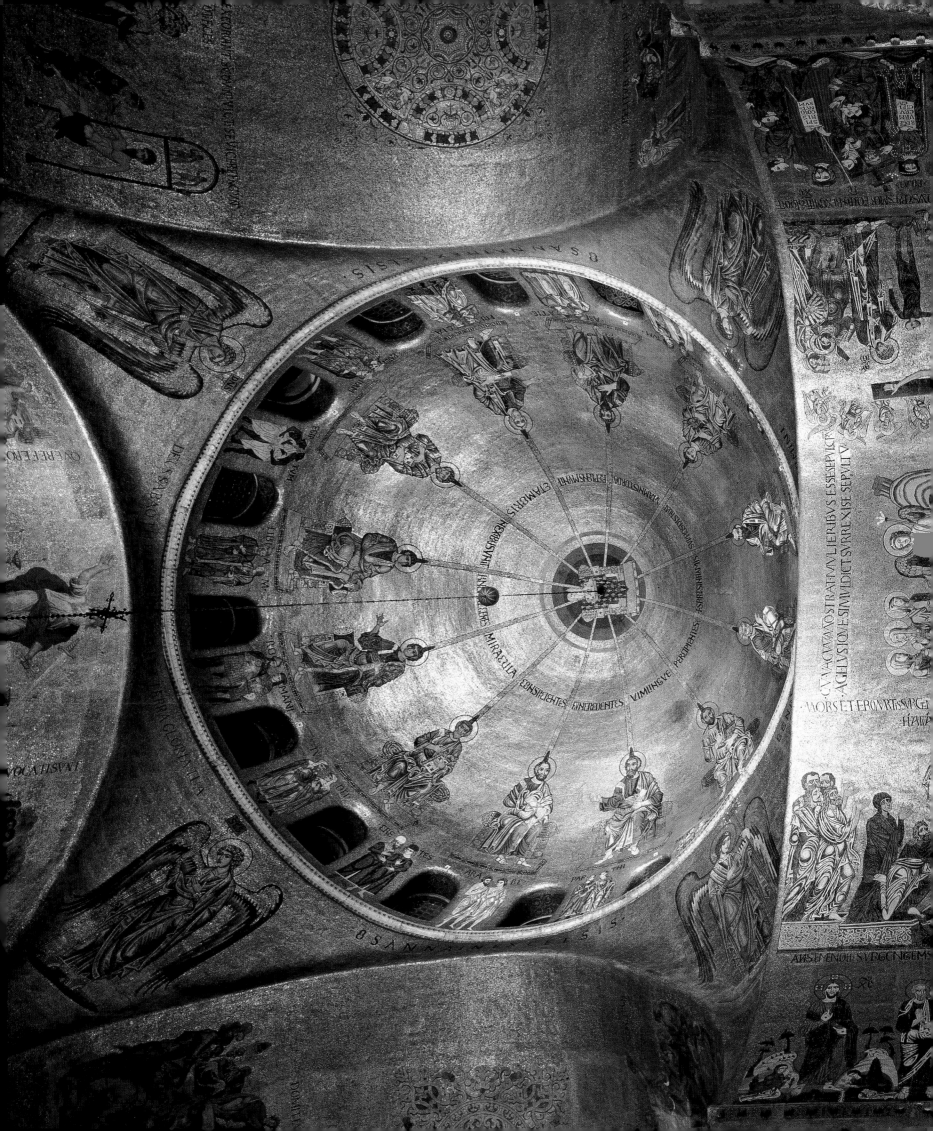

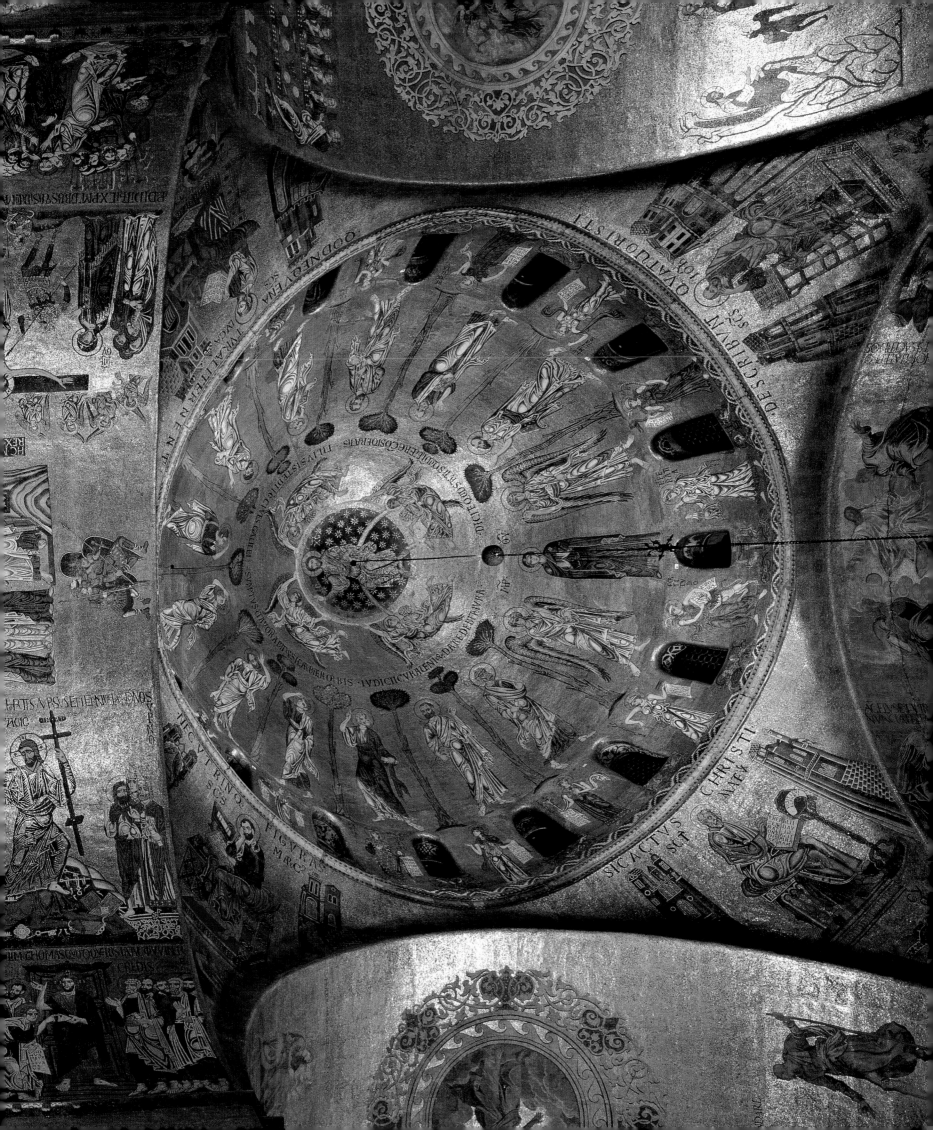

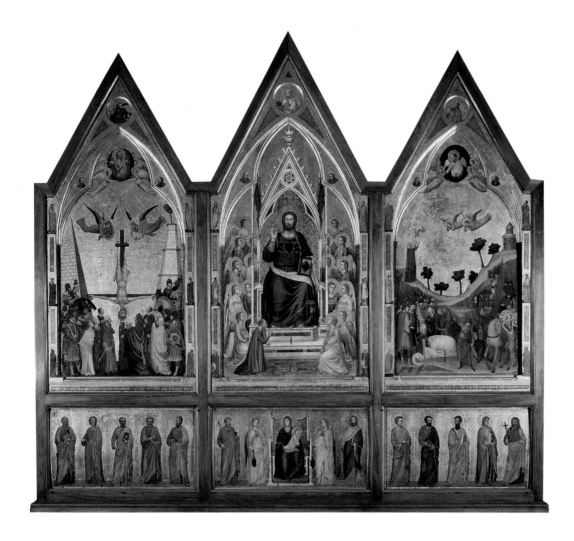

243. Giotto di Bondone, *Stefaneschi Triptych*, Christ side, Old Saint Peter's, 1320–30; tempera on wood, central panel: 70 × 35 in. (178 × 89 cm), side panels, each: c. 66⅛ × 32⅝ in. (168 × 83 cm), panels of the predella, each: c. 17¾ × 32⅝ in. (45 × 83 cm). Pinacoteca Vaticana, Rome.

The triptych Giotto painted for the main altar of Old Saint Peter's depicts the enthroned Christ blessing on the center panel and the martyrdoms of the apostles Peter and Paul on the side panels. The artist still used the traditional gold as background, but in the works of his successors it would gradually be replaced by naturalistic depictions of landscapes.

242. Interior of the dome of San Marco, twelfth century; gold mosaic. Basilica di San Marco, Venice.

Mosaics dominate the interior of this basilica, the most important church in Venice, which is decorated in Oriental splendor. On a surface totaling 45,640 square feet (4,240 m²), biblical scenes with countless figures are rendered in lively colors and meticulous detail against a radiant gold background.

the exchange of rings—at weddings, for example—were already fashionable among the wealthy and powerful at this time. The wearer of gold jewelry was often expressing claims to political power, for gold was a symbol of wealth and success and was thus equated with authority and moral integrity (plate 244). Kings and emperors presented themselves wearing the gold insignia of power and rank: crown (plate 232), imperial orb (plate 245), and scepter.

In the late Middle Ages, magnificent drinking vessels became fashionable, albeit infrequently used, items, in which architectonic decoration was supplemented with or even replaced by naturalist ornaments. These display vessels were popular gifts and sought-after decorations for guilds and brotherhoods. Goblets with antique coins and gems that lent them a special flair were the first signs of the renewed turn to and admiration for ancient models that would become common in the Renaissance.

In 1252 it was decided to mint gold coins in Florence for use in long-distance trade, which even then still largely passed through the cities of northern Italy. These coins, known as florins, were 100 percent gold. Three to four thousand were minted each year, making them the leading currency for trading. They weighed about an eighth of an ounce (3.5 g)

each, so the annual quantity of gold required to make them was between one and one and a half tons. Beginning in 1284, Venice joined in by issuing a gold coin called a *zecchino* (sequin), or ducat, that had a purity of 23⅔ karats (98.6 percent). It became the longest-lived gold coin in Western history, still in circulation in the same quality until 1797 (plates 255, 256).

No consideration of the secular jewelry of the Middle Ages can ignore the treasure of the Nibelungen. According to a legend that emerged around 1200, this treasure consisted of large quantities of gold and precious stones that were held at Worms but later lowered into the Rhine near Lochheim, supposedly because Kriemhild—the widow of Siegfried, the hero who had possessed this hoard—was too spendthrift with it. Richard Wagner made this gold treasure the focus of the plot of his four-part opera cycle *Der Ring des Nibelungen* and human greed for gold its dominant theme. The precious cache was never found, and we do not know whether the legend and the opera cycle have their roots in a true story.

According to the social order of the time, the use of gold was still the privilege of the rich and powerful. The common people were left to see and admire the splendor of gold in churches and processions, where, very much in the early medieval tradition, the precious metal was often encountered in the form of highly treasured and venerated objects. The resumption of the minting of gold coins, by contrast, was an innovation of the late Middle Ages and a sign of the coming new age.

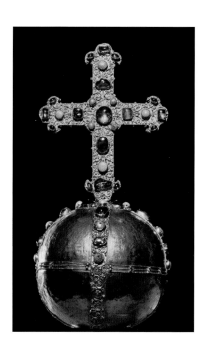

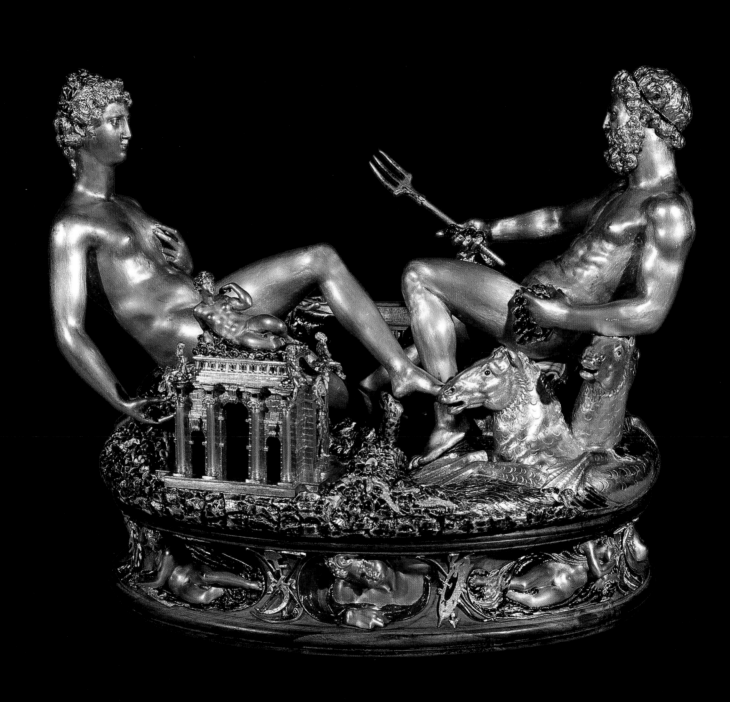

CHAPTER 16

✻✻✻

The Renaissance, the Baroque, and Neoclassicism

ARTISTS, ALCHEMISTS, AND KINGS

SCIENCE AND ALCHEMY

In 1556 a book titled *De re metallica libri XII* (Twelve Books on Metallurgy) was published in Basel; its author, Georgius Agricola (1494–1555), was a Renaissance man par excellence: an outstanding scientist and physician, recognized as a Latin teacher, rector, and mayor of Chemnitz. As an interpreter of the technical achievements of his time, Agricola, while firmly rooted in the intellectual traditions of antiquity and humanism, was able to report comprehensively on gold and its extraction, purification, and analysis. At the end of the third book he wrote, "Now, since gold . . . is torn away from the veins and stringers and settled in the sands of torrents and water-courses, in whatever direction the rivers or streams flow, therefore it is reasonable to expect to find gold therein; which is not opposed by experience. Nevertheless, we do not deny that gold is generated in veins and stringers which lie under the beds of rivers or streams, as in other places." Gold was nonetheless a rare metal during the Renaissance, as primary extraction produced only small quantities and the hopes of the conquistadores and those who commissioned them of finding rich deposits in the New World went unfulfilled. Agricola too could list only sources that had already been known and exploited in the Middle Ages, such as the Tauern mountains in Austria, the mines of the Balkans, and several small deposits of placer gold in central Europe, but the recycling of old gold largely fulfilled the demand for the metal.

Agricola's epochal work, disseminated in numerous editions and translations and excellently illustrated with numerous woodcuts (plates 14, 15), contrasts sharply with the wide variety of alchemical works—more than five thousand in the seventeenth century alone—that also deal with metals and their properties, but from completely different points of view. Alchemists had been experimenting since the Middle Ages (plate 247), trying to produce gold, find the philosopher's stone, and develop elixirs that were supposed to extend life indefinitely. Producing gold from base materials was the goal of many charlatans but also of convinced dreamers. Princes and kings listened only too gladly to their promises, for the prospect of being relieved of their worries about money by the arts of these gold makers was all too tempting (plate 250). Alchemical experiments did at least help found the beginnings of chemistry as one of the exact sciences and led to discoveries with far-reaching consequences, such as the invention of porcelain in 1709 by Johann Friedrich Böttger, who was

◁ 246. Benvenuto Cellini, *Saliera*, 1540–43; gold, enamel, ivory, ebony base, 10¼ × 13³/₁₆ in. (26 × 33.5 cm). Kunsthistorisches Museum, Vienna.
 Cellini's saltcellar is one of those small creations that cause all current standards to be forgotten. The base has relief figures representing the times of day and the winds; atop the base rest Terra (goddess of the earth) and Neptune (god of the sea), surrounded by land and sea creatures. This artful object was used to hold salt and pepper: on Neptune's side is the "ship of salt," and to the right of Terra is the "temple of pepper."

△ 247. Jan van der Straet, *Alchemy*, 1570; fresco. *Studiolo* of Francesco I, Palazzo Vecchio, Florence.
 This painting belongs to a cycle that was painted under the direction of Giorgio Vasari for Grand Duke Francesco I de' Medici. The painter rendered a lively laboratory scene in his fresco: the central figure is holding a receptacle full of greenish fluid; assistants are stirring vessels, filling apparatuses, and using a press.

223

248. Order of the Golden Fleece, Burgundian, second or third quarter of the fifteenth century; gold, painted enamel, weight: 17⁵/₁₆ oz. (508 g). Kunsthistorisches Museum, Vienna.

This is the only surviving example from the early days of the order. Its technique expresses the order's fundamental ideals, equality and fraternity: only when the individual links of the chain are hooked together does the chain form a whole, and the pendant with the symbol of the order, a ram that hangs from an eyelet, provides the necessary stability.

249. Ruby glass, southern Germany, late seventeenth century; gilded silver setting by Johann Jebenz, Augsburg, height: 7⁹/₁₆ in. (19.2 cm). Museum für Angewandte Kunst, Frankfurt am Main.

The gilded silver settings of this ruby-colored glass were produced by a variety of techniques. They were chased, cast, engraved, chiseled, filigreed, and decorated with emeralds, rubies, and white enamel. Acanthus vines crown the ruby-adorned initials of its owner, Friedrich Carl, duke of Württemberg (1652–1698).

250. Christoph Müller (attributed), gilded distillery oven for the alchemical experiments of the Landgrave Moritz of Hesse-Cassel, vines and grotesque by Hans Jacob Emk, c. 1600; bronze, fire gilded, height: 16¹⁵/₁₆ in. (43 cm), diameter: 25³/₁₆ in. (64 cm). Staatliche Museen, Kassel.

Kassel owes its remarkable collection of scientific instruments of all kinds to the interests of the multitalented Landgrave Moritz (r. 1592–1627). This fire-gilded laboratory oven consists of a cubic lower section and a double boiler with three openings. The engraved ornaments, like vines and grotesques, make this piece of equipment a fine display piece. It is a matter of speculation whether this oven ever touched fire.

actually trying to produce gold for the elector of Saxony, August the Strong. The glassmaker Johann Kunckel (c. 1630–1702) was also employed to make gold, at the court of the great elector of Prussia Frederick William, and was granted permission to build a laboratory on Pfaueninsel (Peacock Island) in Berlin's Wannsee, to protect his secret experiments from prying eyes. When his laboratory exploded one day, it spelled the end of his patron's favor, but in the rubble and remains of his workshop, the Berlin chemist discovered pieces of glass that proved that he had produced a pigment based on gold that could be used to give glass and glazes a deep ruby-red color (plate 249). The Hamburg physician Andreas Cassius had described earlier, in 1685, how to produce a beautiful new type of color based on gold; he had made the same discovery Kunckel would make, and the name "purple of Cassius" gained currency. It was produced by getting part of a soluble gold compound (hydrochloric acid of gold) to react with tin chloride under precisely controlled conditions. The precipitated gold is ruby red, finely distributed, and consists of particles just four millionths of an inch (0.0001 mm) in size. A ratio of 1:1,280 of purple of Cassius to crystal frit (glass material) is sufficient to produce a luminous purple. That corresponds to glass with a gold content of just 0.08 percent, the exact concentration that has been measured in the fragments of glass from Kunckel's alchemical kitchen on Pfaueninsel.

ARTISTS' USE OF GOLD

Beginning in the early fifteenth century, there was a gradual transition from medieval to modern thought, ideas, and forms of expression, and increasingly people began to show an interest in antiquity. In terms of gold, this is seen, for example, in the Order of the Golden Fleece (plate 248), established in 1430 by Philip III of Burgundy; one of the highest awards of its day, it alluded to the myth of the Argonauts. The Renaissance, with its new, varied art, flowered in Italy in particular. Borrowing from architecture and sculpture, the work of gold- and silversmiths took on strict forms and clear structures. The depiction of the naked body—often combined with decorations in the form of naturalistic vegetal ornaments—was a deliberate contrast to the veiled or symbolic works of earlier epochs.

251. Alessandro Algardi, *Jupiter Hurls Lighting Bolts at the Titans*, second half of the seventeenth century, after a model prior to 1654; bronze, patinated and partially gilded, height: 44⅛ in. (112 cm). Musée du Louvre, Paris.

 This impressively lifelike sculpture, on which the dark patinated bronze contrasts with the gilded sections, records the moment when Jupiter hurled lightning bolts at the Titans. It served as the allegory of fire in a series of depictions of the four elements.

252. Hans Petzolt, large lidded goblet, Nuremberg, c. 1600; silver, chased, cast, chiseled, punched, gilded, height: 48¹³⁄₁₆ in. (124 cm), diameter of *cuppa*: 10¼ in. (26 cm). Kremlin armory, Moscow.

 This goblet by Petzolt, one of the most important goldsmiths in Nuremberg, has an overall structure typical of Renaissance goblets, which emphasizes the broad, cylindrical rim of the cuppa *(cup). Its astonishing dimensions suggest it was exclusively a showpiece. This skillfully worked silver object, with its perfect gilding, was a gift to Czar Peter I from the Swedish king Charles XI in 1684.*

One of the greatest masters of the Italian Renaissance was the goldsmith and medallion maker Benvenuto Cellini (1500–1571), whose famous works include the bronze statue of Perseus in the Loggia dei Lanzi in Florence. The great detail of this work and others like it, which sometimes border on Mannerism, reveals the characteristics of a talented, imaginative metalworker, but the only surviving testimony to his work in gold itself is a saltcellar (*saliera*) that he produced between 1539 and 1543 for Francis I of France, which fortunately survived a recent spectacular theft to be returned in spring 2006 almost entirely undamaged (plate 246). It was the dual challenge of a theme from antiquity, the contrast of Terra and Neptune, and of contrasting materials, cast and chased gold, enamel, and ivory, that inspired the master to extraordinary creativity. In his *Trattati dell'oreficeria* (Treatise on the Goldsmith's Art), Cellini dedicated a detailed passage to this *saliera*. He wanted to present the precious vessel to the French king, but the king was so deeply impressed that he could only caress it with his eyes; he did not dare touch it with his hands, and he refused to accept possession of it. Cellini went on to report that he brought the valuable work back home, where he officially commenced its use as a saltcellar during a banquet with fellow artists. The combination of gold with other metals and materials was not limited to Cellini's work. The admixture of gold and bronze proved ideal, as the cheaper and easily worked alloy made it possible to produce larger forms that could be given the desired luster with gilding or gold plate to increase the object's value (plate 251).

In other European countries, like France, Belgium, the Netherlands, and Germany, artists and artisans also preferred to combine precious metals with other materials like gems, silver, and enamel. In workshops in Augsburg in particular, precious objects continued to be produced with the

same wealth of imagination into the eighteenth century, and late Renaissance forms were only gradually replaced by Baroque and Rococo styles. Unadorned, smooth rings became popular only in the seventeenth century. The goldsmith's art revealed a penchant for bosses and grooves that heightened the play of light on the metal. Broken lines and rich ornamentation intensified these effects even more.

Goldsmiths produced such outstanding secular showpieces as goblets (plate 252), tankards, pitchers, and bowls. Beginning in the late Renaissance and increasingly during the Baroque, art displays and cabinets of curiosities became fashionable. Religious and secular dignitaries kept oddities and valuable display pieces in such cabinets, including rare natural objects (rhinoceros horns, seashells, ostrich eggs, coconuts and *cocos de mer*, griffin claws, and much more) set in gold to show them off to best advantage (plate 254). The most important task of court goldsmiths was designing and producing such cabinet pieces. Works of art in the Renaissance—whether crowns, chains, or medallions—reveal just how much artisans were guided and inspired by antique models. Medallions in particular are worthy of Roman coins in their realistic portraits and have provided us with a gallery of important eyewitnesses to the period (plates 253, 257). Gold played a certain role in minting, but it by no means compared to silver, which was the dominant metal for coins at the time. Ducats continued to be minted in gold (plates 255, 256), especially after 1559, when the imperial mint made them its standard gold coin, at a weight of an eighth of an ounce (3.44 g).

Although solid gold was reserved for coins, gold leaf enjoyed popularity for many other uses during the Renaissance and Baroque, and artisans who knew how to employ it were much sought after. Gold beaten into thin sheets was a preferred design element for architecture. The Goldenes Dachl (Golden Roof) in Innsbruck, for example, was built under King Maximilian (later Emperor Maximilian I) between 1494 and 1496 as a landmark for the town. The Augsburg

△ 255/256. *Zecchino* (sequin), obverse: lily of Florence with the name of Grand Duke Pietro Leopoldo of Tuscany, reverse: John the Baptist, patron saint of Florence, 1789; gold. Museo Nazionale del Bargello, Florence.
 The zecchino, originally a Venetian gold coin first minted in 1284, spread across Italy and to neighboring countries and was in circulation for a very long time.

◁ 257. Quinten Massys, Erasmus medallion, 1519; gold. Bibliothèque Nationale de France, Paris.
 The Renaissance was famous for its medallions, most of which were minted in bronze; gold examples like this one, which shows the great humanist in strict profile, are rare exceptions.

▷ 258. Saint Peter's altarpiece, early sixteenth century; carved wood, gilded, height: 18 ft. (5.5 m), width: 25 ft. (7.5 m). Sankt Petri, Dortmund, Germany.
 In its open state, this enormous masterpiece displays the Crucifixion of Christ. The retable, also known as the Golden Miracle, was commissioned in Antwerp in 1521 and has been in Dortmund ever since. In 2005 it was regilded.

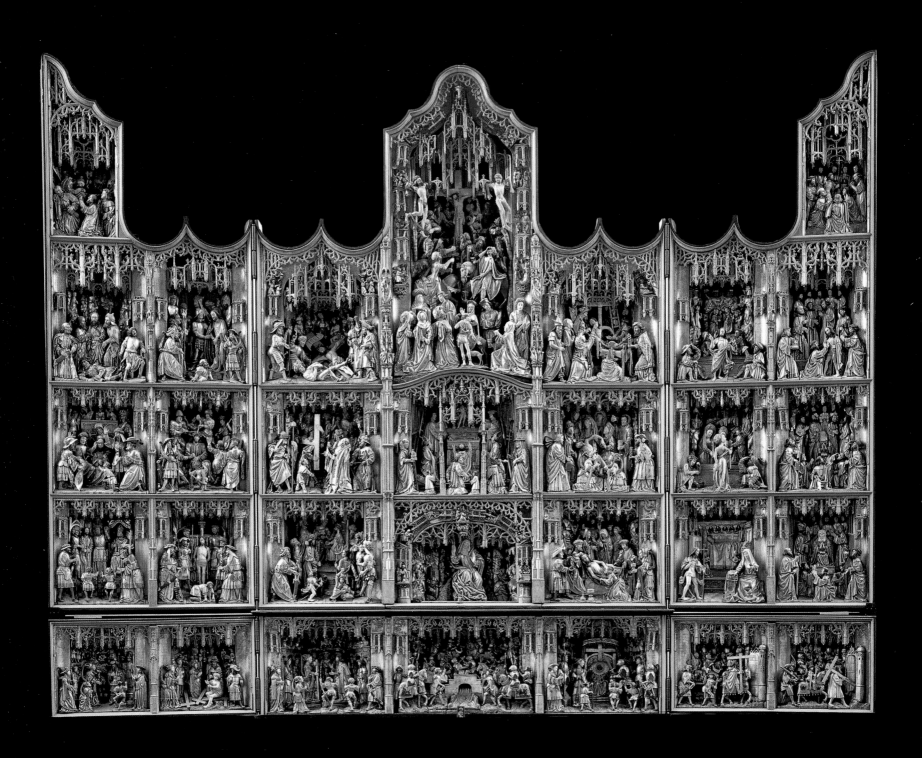

eGem
pone
mihi
domi
ne u
am iu

stificationum tuarum
et exquiri eam sepe
a mihi intellectu
et scrutabor legem
tuam: et custodi i il
lam in toto cord me
educ me in semit

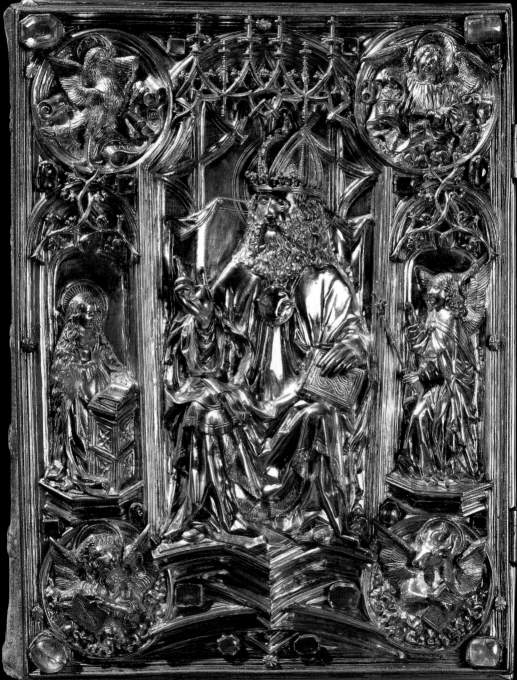

259. Monte del Fora, *Presentation of the Keys to Peter*, illuminated manuscript, Ms. 542, fol. 3v, 1515. Museo di San Marco, Florence.

This illuminated manuscript page is captivating for its lavish use of gold, which has an especially fine effect thanks to its combination with various shades of blue. In this depiction of the presentation of the keys to Peter, gold leaf was probably applied first and then supplemented by gold ink.

260. Hans von Reutlingen, binding cover of the imperial Gospel, regalia of the Holy Roman Empire, c. 1500; silver, gilded, precious stones, 13 9/16 × 10 1/4 in. (34.5 × 26.1 cm). Kunsthistorisches Museum, Vienna.

This book cover, a precious part of the regalia of the Holy Roman Empire, is a later enhancement to the surviving text of the Gospel used at Charlemagne's coronation. The chased and gilded silver figures, in unusually high relief for a book cover, show God the Father, the Annunciation to the Virgin, and the symbols of the four evangelists. They are presented in a lavishly designed frame with late Gothic architectural elements.

town hall was decorated with gold between 1618 and 1620, as was the castle Ludwigslust between 1772 and 1776.

For sacred use, whether to decorate book covers (plate 260) and illuminations (plate 259) or to gild figures on altars (plate 258), gold was applied unobtrusively in many tasteful variations. Examples of sacred art include calligraphy with gold lettering and incunabula decorated with gold. Fine powders of gold or silver were suspended in water containing gum to produce gold and silver inks. In particularly valuable texts, such script would be applied to a crimson-prepared ground. Icon painting, which was inconceivable without a gold ground behind the figure depicted, took things a step further. Ornamented sheets of gold or silver, known as *oklads*, were placed over paintings to create a window effect (plate 261). Goldsmiths also produced spectacular ecclesiastical implements, especially candlesticks and containers for incense.

THE AGE OF THE SUN KING

The repertoire of forms and themes borrowed from antiquity during the Renaissance was followed by an ostentatiously new conception of art during the Baroque. Originally applied to architecture from the sixteenth to the eighteenth century, the curved line in outline, structure, and

261. *Skladen* with the icon of the Mother of God of Jerusalem, Moscow (?), first third of the seventeenth century; gold, silver, chased, engraved, gilded, precious stones, pearls, fabric, height: 10 3/8 in. (26.3 cm), width (open): 14 1/8 in. (36 cm). Kremlin armory, Moscow.

Skladen is the name for a folding icon with two or more wings. This example has an oklad, *which was designed not only to ornament but also to protect the icon painting proper. The motif of this icon, the Mother of God of Jerusalem, was frequently depicted.*

262. Monstrance of Louis XI of France, c. 1460; silver, gilded, 16⁹/₁₆ × 20¹³/₁₆ in. (42 × 53 cm). Sint-Martinuskerk, Halle, Belgium.
The composition of this forged and cast monstrance of the sun, with a strict, symmetrically centered structure, plays with the contrast of gilded and ungilded silver on three sculptured figures. At the intersection of the arms of the cross, the Host is displayed in a round window.

ornament was also embraced by the other arts, especially that of the gold-smith. The Baroque attitude toward gold was, however, ambivalent. The precious metal was used as a measure of wealth, but excessive possession of it could lead to greed. Gold was the symbol of fidelity and purification but also a counterexample to transcendent values, very much in the spirit of the remark of the philosopher Democritus (b. c. 460 BC): "Happiness resides not in possessions and not in gold; the feeling of happiness dwells in the soul."

The Catholic Church of the period tried to provide the faithful with a festive, cheerful form of the worship and veneration of God. Bright, light-flooded churches decorated with fluttering gilded banners and mischie-vously grinning, gracefully floating putti with barely covered white bodies were produced above all in southern Germany and Austria (plate 263). Even more than in the Renaissance, the sun, light, and gold evolved into indispensable accoutrements of monstrances and glorioles on Baroque altars (plate 262).

In the secular art of the Baroque, absolutists saw the sun and gold as fit-ting symbols of power. Louis XIV of France, the *Roi Soleil*, or Sun King, conceived his château at Versailles as the site of a secular worship of the sun, with allées arranged radially to imitate the sun's rays. The design and

decoration of the interior of the château were based even more closely on this idea, and consequently gold was employed lavishly. A hall of mirrors like the one in Versailles (plate 264), with gilded candelabra, stuccoed ceilings, and wood paneling, was something no ruler who wanted to make an impression could do without. As the influence of France's courtly culture grew, the art of the French goldsmith also became increasingly significant; under Louis XIV, state factories were founded to make works especially for the needs of the court. Tableware—terrines, trays, pitchers, and candlesticks—were the most commonly produced objects, though usually in silver. Later, under Louis XV, the elegant rocaille decorative style evolved, from which the Rococo got its name. Rampant with foliate forms, slender gilded decorative elements spread from France to adorn the rooms of summer residences and palaces, especially in German-speaking countries and, above all, under the Prussian kings (plate 2).

The German counterpart and imitator of the Sun King, the elector of Saxony and king of Poland, August the Strong, had a passion for gold in every form. His splendid clothing was always tailored for the occasion and was inconceivable without gold decoration. In 1709 his famous goldsmith Johann Melchior Dinglinger (1664–1731) created a sun mask with August's facial features (plate 31), which the king wore in 1719 to personify Apollo during the four-week celebration in Dresden for the wedding of the prince-elector. The court jeweler was barely able to satisfy the constantly increasing demands of his patron. In 1701 he began a work whose size, expense, and composition would rank it among the most outstanding items any goldsmith had ever made. For his ruler, whose empire then extended to the gates of the Orient, Johann Melchior and his brothers, Georg Friedrich and Georg Christoph, fashioned a model—including figures, animals, vessels, and magnificent gifts of all kinds—of the court of Delhi on the birthday of the Great Mogul Aurangzeb, at that time the richest and most powerful sovereign in the world (plate 265). On an area of about ten square feet (1 m²), they created a miniature world with 132 figures and 33 gifts in enameled gold on a

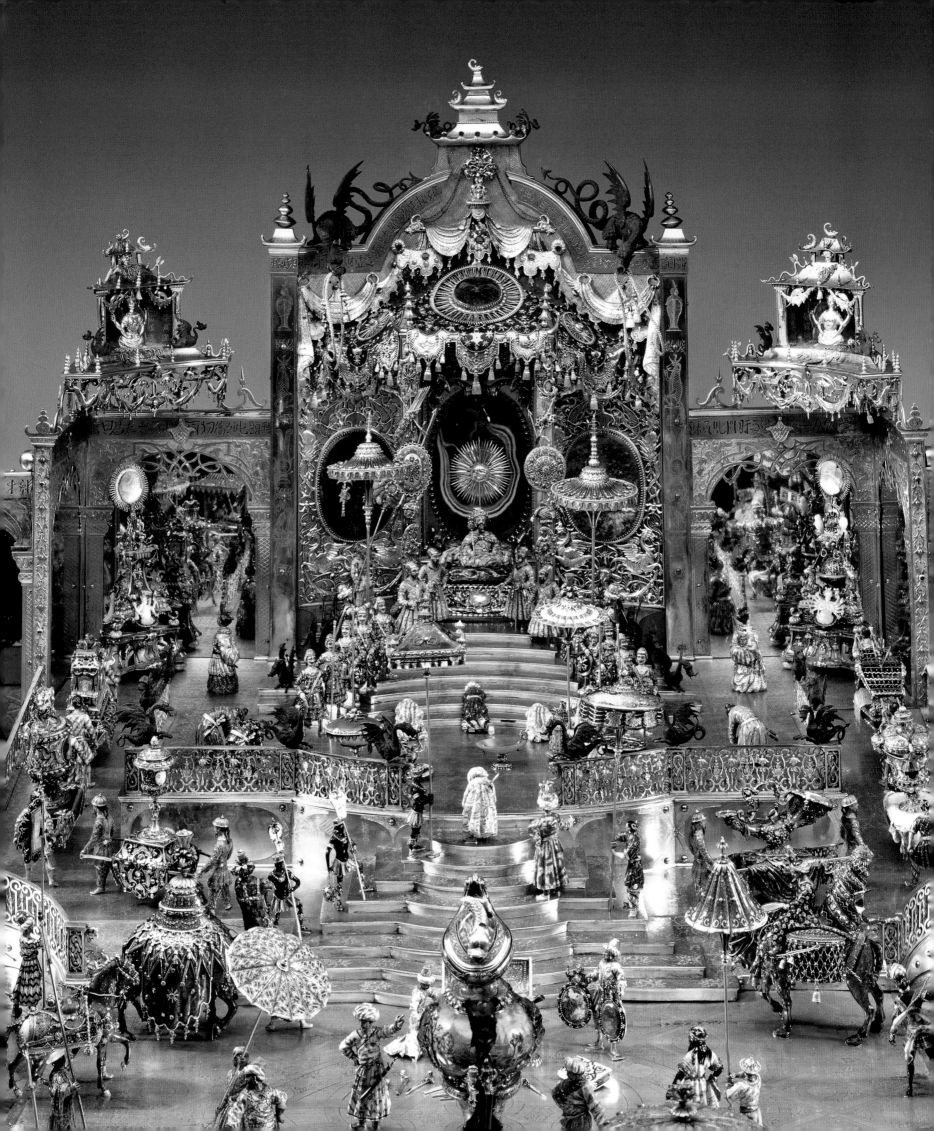

partially gilded stage of silver adorned with 4,909 diamonds, 164 emeralds, 160 rubies, 16 pearls, 2 cameos, a sapphire, and 391 more gems and pearls that have been lost over time.

After Peter the Great (r. 1682–1725) traveled incognito through Holland, England, and Austria from 1697 to 1698, the Baroque style spread to his new Russian residence in Saint Petersburg, and the city became a radiant ensemble. Gold had been used in Russian architecture earlier, of course, particularly for the gilded domes that are typical of Russian churches as well as the Kremlin in Moscow (plate 266). From the czar's crown (plate 267) to the table service of Czarina Anna Ivanovna (plate 268), the splendor of gold documented the power of the Russian Empire.

Neoclassicism

The Neoclassicism that followed the Baroque and Rococo evolved in France into an ornate variant, the so-called Empire style, which took its lead from the forms of the late Roman imperial period. Napoleon I, emperor of France (r. 1804–1814/15), had a particular fondness for this style, and he wanted it to be used for furniture, interiors, and all kinds of imperial showpieces (plate 270). His throne is an eloquent example (plate 269). The fashion for publicly displaying gold ornaments may also be appreciated in a ceremonial carriage known as L'Egiziana (the Egyptian), built in Turin in 1817, which can be admired today in the Quirinal Palace in Rome (plate 271).

England followed its own path in the arts of gold- and silversmiths. During the reign of the Hanoverian kings George I to George IV (1660–1830), simple, clear forms dominated, as is particularly evident in

cutlery, candlesticks, and candelabra from 1800 onward. This uniquely English style of classicism is known among art historians as the Regency or Georgian style.

From the return to antiquity in the Renaissance, through the curving of all straight lines in the Baroque and the playfulness of Rococo, to a renewed consideration of restrained, antique ornament in the Neoclassical period, the successive artistic styles of the fifteenth through nineteenth centuries could hardly have been more different, but gold always played a significant role. Although the discovery of major new gold deposits and their exploitation came only in the modern era, by the end of the Neoclassical period gold was no longer reserved for the privileged class; through trade and social transformation, the precious metal became associated with the rise of other social circles and classes, in the form of increasingly affordable objects like gold wedding bands and confirmation watches.

269. François-Honoré-Georges Jacob-Desmalter, imperial throne of Napoleon I, 1804; gilded wood, 48 1/16 × 34 1/4 × 27 9/16 in. (122 × 87 × 70 cm). Musée du Louvre, Paris.
Napoleon Bonaparte's throne is a classic example of the Empire style. For Napoleon, gold was an indispensable means for displaying his status as emperor, as the lapidary gold initial N on the backrest demonstrates.

270. Sauceboat, 1809; Sèvres porcelain, gold paint. Museo delle Porcellane, Florence.
This sauceboat and tray, elaborately decorated with cobalt blue and gold paint, belonged to Elisa Bacciocchi, grand duchess of Tuscany, and was part of a service that she received as a gift from her brother, Napoleon I. The gold paint was applied cold—that is, after firing—as gold foil that could withstand firing was not developed until the late nineteenth century.

271. Ceremonial coach, known as L'Egiziana (the Egyptian), Turin, 1817. Palazzo del Quirinale, Rome.
Gold in effective combination with elaborate carving gives this coach an imposing appearance. The lavish decoration with quasi-Egyptian motifs earned the coach its nickname.

CHAPTER 17

✦✦✦✦✦✦✦✦✦✦✦✦✦✦✦✦✦✦✦✦✦✦✦✦✦✦✦✦✦✦✦✦✦

The Modern Age

FROM THE GOLD RUSH TO MASS PRODUCTION

On January 24, 1848, James W. Marshall found the first gold nugget at Sutter's Mill on the Sacramento River. Soon afterward the first adventurers were heeding the siren call of gold, and in the years that followed hundreds of thousands of them sought a quick fortune in California (plate 273). As a result of its rapid population growth and increasing wealth, in the autumn of 1850 the region was made the thirty-first state of the United States of America. That was perhaps the only enduring result of the gold rush in California, since naturally, like all rushes, it did not last very long. There were in fact a few gold miners who became rich in California; for the majority, however, the reverse was the case. One factor was the extortionate prices that had to be paid for the simplest necessities in the areas around the goldfields. Many a fortune was soon used up unless additional finds were made.

The Indians were also among the losers in the California gold rush. Before the precious metal was discovered, there were more than one hundred fifty thousand of them living in the region that would become the state of California. Just twenty years later, their population was a fifth of that: countless Indians were driven off, sold, or massacred, though most died from diseases introduced by the gold seekers. The consequences of the gold rush were thus dramatic and enduring for the indigenous populations, but the phase of private panning for gold in the Sacramento River ended within a few years. From 1854 onward, gold was extracted in California on a large scale using industrial methods.

There is, perhaps, no other event in the cultural history of gold that marks the beginning of the modern period as clearly as the California gold rush of 1849. For millennia, gold had been reserved for the upper levels of society and above all for the higher powers—the gods—and it symbolized the chosen, the superior, and the wealthy. Now adventurers came to California from all over the country, indeed the world, to seek their fortunes in the waters of the Sacramento. All at once they were pushing their way into social regions to which previously one had to be born—the common people took possession of gold.

◁ 272. Yves Klein, *Untitled Monogold (MG 11),* 1961; gold leaf on canvas, 29½ × 23⅝ in. (75 × 60 cm). Kunstsammlung Nordrhein-Westfalen, Düsseldorf, Germany.
In his series of monochromes Yves Klein explored the artistic expressiveness of a pure color. In the gold versions, the aspect of value played a role in his reflections as well: "the real value of the painting" that is independent of the material value of a work of art.

△ 273. *Panning for Gold in California,* woodcut, c. 1890.
The siren call of gold spread like wildfire throughout the land and soon around the world. Countless men came to the goldfields on the Sacramento River to sift their supposed material happiness from the sand of the riverbed by strenuous manual labor.

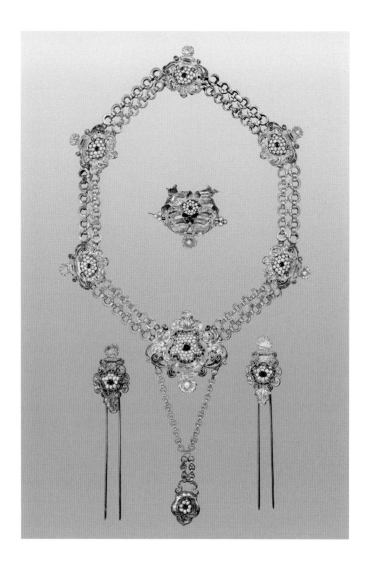

274. Set of diamond jewelry: necklace, two hairpins, brooch, pendant, Germany, c. 1840; gold, pearls, rubies, emeralds, diameter of necklace: c. 5 5/16 in. (16 cm), central agrafe: 2 1/16 × 2 1/8 in. (5.3 × 5.5 cm), small agrafes: 1 1/4 × 1 1/8 in. (3.2 × 3 cm). Kunstgewerbemuseum, Staatliche Museen zu Berlin.

The necklace in this set of jewelry in the hybrid late Biedermeier style has paired chains of round links that derive their form from Renaissance jewelry. They are joined by agrafes and clasps that conform more to the eighteenth-century repertoire of forms but also incorporate the naturalistic elements of Biedermeier.

The Symbolic Value of Gold

The ideas associated with gold are traditional in nature, even today. In the modern period, the value of gold as a sign of social status has not changed, nor has it developed any new significance beyond that which it had for past eras and cultures: gold symbolizes wealth, power, superiority. The winner of a competition, whether in sports or wine making, receives a gold medal (plate 275); a recording that sells in large numbers is awarded a gold record; and those who can look back on fifty years of marriage celebrate their golden anniversary. Gold has always stood for the highest achievement, for profit, but also for the unusual, the enduring—a symbolism that is closely connected with gold's unusual physical characteristics.

The traditional concept of gold is also reflected in how it has been used in both the applied and the fine arts in the modern era. In the second half of the nineteenth century, the arts and crafts began to reverse the historicist tendency toward an eclectic variety of styles and forms (plate 274), which not infrequently was perceived as arbitrary and kitschy. Art Nouveau was one expression of this desire for reform. It combined the traditional idea of gold with the reformist trends in art at the time and produced grand

creations by goldsmiths, such as those of René Lalique (1860–1945), who can be thought of as virtually the embodiment of Parisian taste in Art Nouveau (plate 279). Initially he worked primarily for large Paris jewelers like Boucheron and Vever, but beginning in 1895 Lalique showed his creations under his own name. A high point in his career was his presentation at the World's Fair in Paris in 1900.

Another name that is all but unparalleled as the epitome of the luxurious jewelry of the modern age is Cartier (plate 287). Founded in Paris in 1847, this family operation was able to expand its market to such a degree that by the turn of the century—even while eschewing the Art Nouveau style, with its overextravagant use of natural motifs—it combined the reputation of a luxury jeweler with an international clientele. From the fin de siècle to the Second World War, the firm's jewelry exceeded everything that had preceded it in terms of opulence and radiance—it was a half-century that made Cartier the most famous jeweler in the world.

Along with Paris, the other important center of the goldsmith's art at the turn of the century was Saint Petersburg—inseparably associated with the name Fabergé. Until this time it had been primarily the size and weight of the precious stones used in a piece that made an impression, but the young Carl Fabergé (1846–1920) was able to convince people that the value of an item of jewelry was determined by the originality of its design and the quality of its execution (plate 276). The Russian aristocracy, a society marked by boredom and surfeit in the last years of the czarist empire,

275. Gold medal from the Olympic Games in Atlanta, 1996. Collections Musée Olympique, Lausanne, Switzerland.
 Olympic gold—the gold medal introduced in the modern era—is the culmination of a life in sports; the one shown here is from the twenty-sixth Olympic Games in Atlanta.

276. Carl Fabergé, imperial jewelry box, c. 1900; gold, diamonds, enamel, 3¼ × 3⅜ × 1 in. (8.3 × 8.5 × 2.6 cm). Victoria & Albert Museum, London.
 This lavishly enameled octagonal jewelry box of gold—whose workmanship and formal rigor make it a masterpiece from the house of Fabergé—was produced in Saint Petersburg around 1900 for Czar Nicholas II. The crowned imperial initial in set diamonds is framed by four imperial eagles.

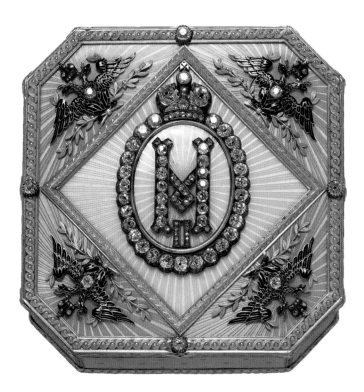

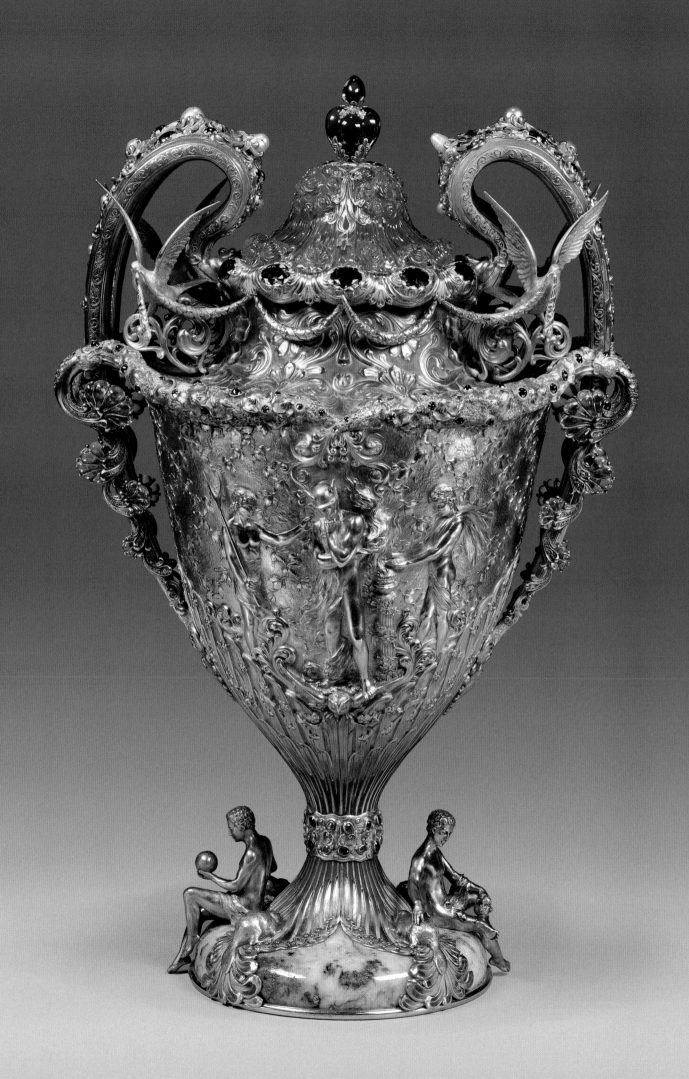

enthusiastically embraced the extravagant and luxurious creations of the house of Fabergé.

In the United States, the New York jeweler Tiffany (plate 277) was the first to generate enthusiasm, beginning in the mid-nineteenth century, with its elaborate creations. It was above all the world's fairs that turned this small family operation into the internationally successful brand Tiffany & Co. At the 1889 World's Fair in Paris, the house presented "American jewelry," which was influenced by, among other things, Indian artifacts; the company's selection of pearls and precious stones also reflected a greater interest in goods of American origin.

In nineteenth-century painting, the gold ground was revived, having disappeared almost entirely from the repertoire of artists. In the early part of the century Philipp Otto Runge employed gold as a background to lend an aura to his cycle on the times of day, and in paintings by the Nazarenes the precious metal once again obtained a central significance. Painters like Mikhail Vrubel and Gustav Klimt (plate 280) consciously studied the gold grounds of early Christian mosaics in Venice and Ravenna to give their paintings a comparably elaborate style. The town hall of Stockholm (plate 278), which was completed in 1923 and soon became a landmark for the city, makes use of this symbolism as well. Its splendid Golden Hall is decorated with wall mosaics in a neo-Byzantine style with heroic depictions of the history of Sweden and its capital. The artist, Einar Forseth, used more than nineteen million gold-leaf tiles to achieve the desired extravagance. And artists of the second half of

◁ 277. Tiffany & Company, *Adams Vase*, 1893–95; gold, amethysts, quartzes, spessartites, tourmalines, freshwater pearls, enamel, height: 19⁷⁄₁₆ in. (49.4 cm). Metropolitan Museum of Art, New York; Gift of Edward Dean Adams.
This historicizing vase, whose form is probably in imitation of a cotton plant, was designed by Paulding Farnham, who was head designer and director of the jewelry department at Tiffany from 1893 onward. For this vase he used more than two hundred precious stones and pearls, exclusively of American origin.

▽ 278. Golden Hall, town hall, Stockholm, 1923.
The end wall of the Golden Hall in the town hall of Stockholm features the principal image of the imposing gold mosaic cycle by Einar Forseth: the allegorical depiction of Sweden and its capital, Stockholm.

▷▷ 279. René Lalique, *Ophelia Brooch*, c. 1899–1900; gold, ⅞ × 1¾ in. (2.2 × 4.5 cm). Calouste Gulbenkian Museum, Lisbon.
For this brooch, René Lalique dispensed entirely with the use of precious stones, pearls, or enamel so typical of his work. Lalique glorified the emotional suicide of Ophelia in his choice of material.

▷▷ 280. Gustav Klimt, *The Kiss*, 1907–8; oil and silver and gold foil on canvas, 70⅞ × 70⅞ in. (180 × 180 cm). Österreichische Galerie Belvedere, Vienna.
To give the merging couple in one of the major works of his gold period a superior, even cosmic dimension, the painter applied gold leaf to create the starry sky that forms a backdrop for the lovers.

the twentieth century did not question this function of gold either, even if they did introduce an ironic twist to the tradition, as demonstrated by countless figures, including Yves Klein (plate 272), Joseph Beuys, Paul McCarthy, and Sylvie Fleury (plate 281).

ELECTROFORMING, GILDING, AND ARTIFICIAL GOLD

By the mid-nineteenth century, gold- and silversmiths had a new technique for producing gold objects: electroforming, or galvanoplasty, which owes its name to the Italian scientist Luigi Galvani, who did groundbreaking research on electrochemical elements in the late eighteenth century. Companies like Elkington and Shore, both in Birmingham, England, and Christofle in Paris began using electroforming around 1840 to reproduce art objects, which quickly found a large market in the century of world's fairs and a historicist pluralism of styles.

To produce something by electroforming, one first creates a plaster model of the object to be made. An application of lacquer and fine graphite dust turns the plaster into a conductor of electricity. The plaster model and a piece of the desired metal—gold, for example—are placed in an electrolysis bath under current, causing the metal particles to move from the anode (+), in this case sheet gold, to the cathode (−), the graphite-coated plaster, and cover it with a metal coat, whose thickness varies according to the duration of the electrolysis. Then the plaster core can be destroyed and the metal object worked.

Galvanic processes lend themselves not only to producing objects of solid gold but also to gilding base metals (plate 282)—an application that became increasingly important as the mass production of jewelry expanded. Jewelry with a thin layer of gold is called *gold doublé* if the gold content of the object is no less than one ten-thousandth of its total weight. Gold doublé can also be produced mechanically, by fusing a thin sheet of gold to a block of base metal under very high pressure. When this dual metal is rolled out, the resulting sheet has a perfect layer of gold on the side to be displayed, even though 99 percent of it is a less expensive metal.

Another technical innovation in gold working during the nineteenth century was so-called "Frankfurt gold foil." The process on which it is based—in which gold is dissolved in volatile oils and organic fluids—results in a heat-resistant and durable application of gold to porcelain, ceramics, and glass. The demand for utensils processed in this way was enormous: gold foil was produced by the method patented by Heinrich Roessler of Frankfurt from 1880 onward, and in 1882 the Roessler brothers began to produce it in Brooklyn, New York, with many more production sites following.

The new processes just described contributed to a more sparing use of the precious metal, but the dream that had both fascinated and corrupted people for centuries was the artificial production of gold. It is to this ancient endeavor that we owe not only the basic groundwork for the

281. Sylvie Fleury, *ELA 75/K, Easy. Breezy. Beautiful. (Nr. 6)*, 2000; gilded shopping cart, mirrored pedestal, $32^{11}/_{16} \times 21^{5}/_{8} \times 37^{13}/_{16}$ in. (83 × 55 × 96 cm). Copyright © the artist; courtesy Galerie Eva Presenhuber, Zurich.
 In 1990 the artist Sylvie Fleury declared luxury goods to be works of art by placing them in an art context. In the work illustrated here, consumption is raised to an art form: the artist gilded a traditional shopping cart and displayed it on a rotating mirrored pedestal. It evokes associations with the Old Testament story of the Golden Calf. The luxury article becomes a fetish; art, a consumer good.

282. Pitcher, Elkington & Co., Birmingham, England, c. 1888; gold electroplating, height: $12^{3}/_{8}$ in. (31.5 cm). Victoria & Albert Museum, London.
 The technological innovation of electroforming made jewelry and utensils affordable to the middle classes of the late nineteenth century. This typically English metal pitcher has a bulbous body with floral ornaments that have been gilded by electroplating.

283. Michael Zobel, earrings, 1997; red gold, platinum, champagne diamonds, citrine (polished by Tom Munsteiner), diameter: 1⅜ in. (3.5 cm). Private collection.

To give his jewelry an effect that corresponds ideally to the material used, Michael Zobel employs craft techniques that have long been forgotten. For example, he uses a method employed by the Tolita of the coast of Ecuador in which platinum is effectively welded into the gold (plates 196–97); Zobel essentially rediscovered the technique and has used it in numerous works since then.

284. Elisabeth Treskow, grape brooch, c. 1941; gold, diamonds, pearls, height: 2½ in. (6.4 cm). Schmuckmuseum, Pforzheim, Germany.

The jewelry creations of Elisabeth Treskow are associated above all with the ancient technique of granulation, which had been largely forgotten in the modern age until goldsmiths rediscovered it. Treskow used granulation beginning in the 1930s, above all for motifs from ancient mythology and elements from the world of flora and fauna. This gold brooch in the form of grapes is one of her masterpieces in terms of both technique and form.

development of scientific chemistry, thanks to the laboratory work of alchemists, but also wonderful artistic creations such as the illuminated alchemical manuscript *Splendor solis* (Splendor of the Sun). One of the most magnificent secular manuscripts of the Renaissance, it is an unusual cycle of images that illustrate the abstract doctrines of gold making in ways that are as imaginative as they are mysterious. In the mid-twentieth century, this dream was finally realized: the artificial production of gold no longer presents any technical problems to today's scientists. In a lecture on the theme "modern alchemy," the chemist and atomic physicist Otto Hahn explained the fundamental significance of core meltdown: "The uranium pile is the 'philosopher's stone,' by means of which nearly all the elements of the Periodic Table can be activated artificially." The artificial production of gold in an atomic reactor proves that alchemists were correct in their idea about the transmutation of metals, though it was not possible with the chemical methods available to them at the time. The use of modern alchemy to that end, however, is so costly, given the exorbitant expenditure of energy involved, that it can be employed only for scientific ends. Because the cost of making gold artificially exceeds by far the value of the material produced, we are still limited to natural gold deposits, which were formed free of charge, so to speak, in the depths of the earth.

THE USE OF GOLD IN CURRENCY, SCIENCE, AND JEWELRY

One decisive event in the cultural history of gold was the separation of money and gold. True gold coins were already fairly exotic in the nineteenth and twentieth centuries, but as late as 1944 there was a direct correlation between a country's existing money supply and its gold reserves. In the summer of that year, in the midst of the Second World War, a world monetary conference was held in Bretton Woods, New Hampshire. The treaties signed on July 23, known as the Bretton Woods Agreement, not only established the World Bank and the International Monetary Fund but also put an end to a rigid gold standard. The latter was a country's guarantee that its paper currency could be redeemed at any time according to an established exchange rate—the gold parity. This entailed an obligation to keep gold reserves, and a distant echo of this obligation is found in the national gold reserves that exist to this day (plate 291). The central bank of the United States still holds a gold reserve of about 8,900 tons (8,100 MT), followed by Germany with about 3,900 tons (3,500 MT), and the International Monetary Fund with 3,500 tons (3,200 MT); the People's Republic of China is reported to be purchasing massive amounts of gold. One gleaming symbol of this state possession of gold is the legendary Fort Knox, where about half of the gold reserves of the United States are kept. Films like *Goldfinger*, with Gert Fröbe as the gold-hungry villain and James Bond's adversary, have paid tribute to Fort Knox as a kind of modern El Dorado. An increasing number of small investors looking for an inflation-proof asset have turned to gold.

285. Georges Fouquet, triangular clip, 1936–37; gold, 1¾ × 2⁹⁄₁₆ in. (4.5 × 6.5 cm). Musées des Arts Décoratifs, Paris.

This triangular gold clip, produced from a design by the sculptor Jean Lambert-Rucki, is a classic example of the clear, technically refined jewelry of the New Objectivity, with its minimizing of materials and reduction to elementary forms. It represents a radical counter to the natural forms used, for example, by Art Nouveau.

Nevertheless, the quantity of gold presently in state or private reserves is not very significant in comparison to the annual gold extraction rate, currently about 2,800 tons (2,500 MT).

The quantity of gold used for medical and technical applications is also tiny. Nevertheless, gold's specific properties—in particular, its resistance to corrosion and its reliability—have given it an eminent role in science and technology, as in microsurgery, for example. Its high conductivity also makes gold an ideal material for circuit boards and microchips. In nanoresearch—the epitome of futuristic science—the material properties of gold are of central importance: the use of nanoshells, tiny spherical shells of gold around a core of silicon dioxide, promises to revolutionize in the near future the battle against cancer cells.

Approximately 75 percent of the annual production of gold, or about 2,200 tons (2,000 MT), is still used to make jewelry. Even in the nineteenth century, the trend toward mass production was already affecting the jewelry industry; inexpensive Art Nouveau jewelry was flooding the market at the turn of the century. For René Lalique, who was frequently confronted with cheap imitations of his own pieces, the disappointment was so great that he abandoned jewelry, and until his death in 1945 he was concerned almost exclusively with the design and production of glass objects. The second half of the twentieth century would achieve an entirely new scale of industrially produced jewelry, sold both through mail-order catalogs and in Asian bazaars: standardized goods, affordable to anyone, that have democratized the need for gold-glimmering status symbols. Artist's jewelry and unique, handmade items (plates 283–90, 292) represent the opposite pole, still meeting the need for distinctiveness and inimitability.

The role of gold as a status symbol and sign of (newly acquired) wealth has recently exploded in the so-called "pimp style" of the hip-hop scene. Almost nowhere else can, or should, wealth be displayed in such an uninhibited and unhindered manner as here. Whereas elsewhere the rich and

the nouveaux riches make some effort to maintain a certain discretion—not least to avoid attracting the envy or disdain of others—the pimp style allows jewelry lovers to display a copious amount of glittering wealth around their necks, arms, and fingers. The exponents of the pimp style are, of course, not really pimps; the pimp style is really more of a quotation by which trendsetters like Snoop Dogg, P. Diddy, and 50 Cent present themselves to the media. The model and icon of the style is a man by the name of Iceberg Slim, whose 1967 autobiography *Pimp* not only relates his experiences in the trade but also provides details about the dress code and jewelry of a pimp. The preferred jeweler on the hip-hop scene is the New Yorker Jacob Arabo, known as Jacob the Jeweler. Since the early 1990s, he has been providing the stars with oversize, diamond-encrusted "bling-bling," as the slang expression goes. The creator of this jewelry has become a star of the scene in his own right, though he does not appreciate having his work dismissed as mere "hip-hop jewels."

A NEVER-ENDING FASCINATION

In the modern age, gold has retained not only its status as a luxury item but also its importance as an investment; indeed, in times of economic crisis, its value in the latter sense is even greater. Increasingly, fortune hunters are returning to prospecting, no longer using just a simple gold pan, but employing new technologies that make it a more lucrative process. The news that the Rhine has once again attracted the attention of gold seekers should come as no surprise. The river has always had gold in it, but the concentration of the metal was never sufficient to justify the economics of its systematic extraction. A more effective technique now promises greater

286. Hermann Jünger, necklace, 1963; gold, various precious stones, length of pendant: 2½ in. (6.3 cm). Schmuckmuseum, Pforzheim, Germany.
The elements of this necklace appear to have been assembled without a recognizable system, as they are totally heterogeneous in their form and color; this lends them an almost painterly quality that is characteristic of Jünger's jewelry and made him one of the most important German goldsmiths of the second half of the twentieth century.

287. Cartier, bracelet, c. 1940; gold, length: c. 8 in. (21 cm). Private collection.
This gold bracelet from the house of Cartier is distinguished by a remarkably timeless look. The forms chosen for the links have a line that make it impossible to put a date on them. The use of gold alone underlines the eternal nature of this masterwork.

288. Giampaolo Babetto, bangle, 1988; gold, diameter: 2^{11}/$_{16}$ in. (6.9 cm), width: 2 in. (5.2 cm). Schmuckmuseum, Pforzheim, Germany.

In this bangle Giampaolo Babetto lets the material speak for itself almost entirely. Produced from a single piece of gold, the bracelet adjusts perfectly to every arm because of the metal's tensile quality. The facets of the surface create a play of light and luster effects.

289. Yasuki Hiramatsu, necklace, 1972; gold, fine gold, length of pendant: 11^{13}/$_{16}$ in. (30 cm). Schmuckmuseum, Pforzheim, Germany.

Strips of pure gold spread like tinsel on the chest of the person wearing this necklace by Yasuki Hiramatsu. The irregular surfaces and wind- or movement-triggered fluttering of these wafer-thin gold bands makes them seem as ephemeral as they are opulent.

△ 290. Silke Knetsch and Christian Streit, earrings, 2005; gold, fine gold, engraved carnelians, yellow sapphires, length: 1⅛ in. (3 cm), width: ⅞ in. (2.3 cm). Private collection.

The carnelians, engraved around 1890, but above all the ornament of the gold pendants of these earrings designed by Silke Knetsch, evoke associations from ancient Egypt to Art Nouveau.

▷ 291. Gold bars in the treasury of the South African Reserve Bank.

A view of the South African Reserve Bank's gold repository in Pretoria, where the South African currency reserves are held in the form of stacked bars of gold.

efficiency, at least in those regions of the riverbed where the geological conditions make for a higher concentration of gold. The essential difference, however, will probably be a new awareness of ecology on the part of both producers and consumers, which will make it possible to charge more for Rhine gold.

Will we soon see a new gold rush on the Rhine? The times of wild upheaval along the Sacramento in California or along the Klondike in Alaska are not likely to return, as this procedure will not be promising enough even for the adventurers and gamblers who chased the dream of gold as late as the nineteenth century. That promise of fortune was well suited to the United States of America, where the "pursuit of happiness" is one of the unalienable rights cited in the Declaration of Independence. Extracting gold today is a high-technology business, in which surprising discoveries of new sources are all but impossible.

The enthusiasm for the metal of the sun continues unabated, however; from the time it was first discovered, it has given wing to both the imagination and the greed of human beings of every era. Although at the beginning of the third millennium the mysteries of its properties, its deposits, and its production by artificial means appear to have been solved, gold has lost nothing of its fascination: the myth of the metal of the gods survives.

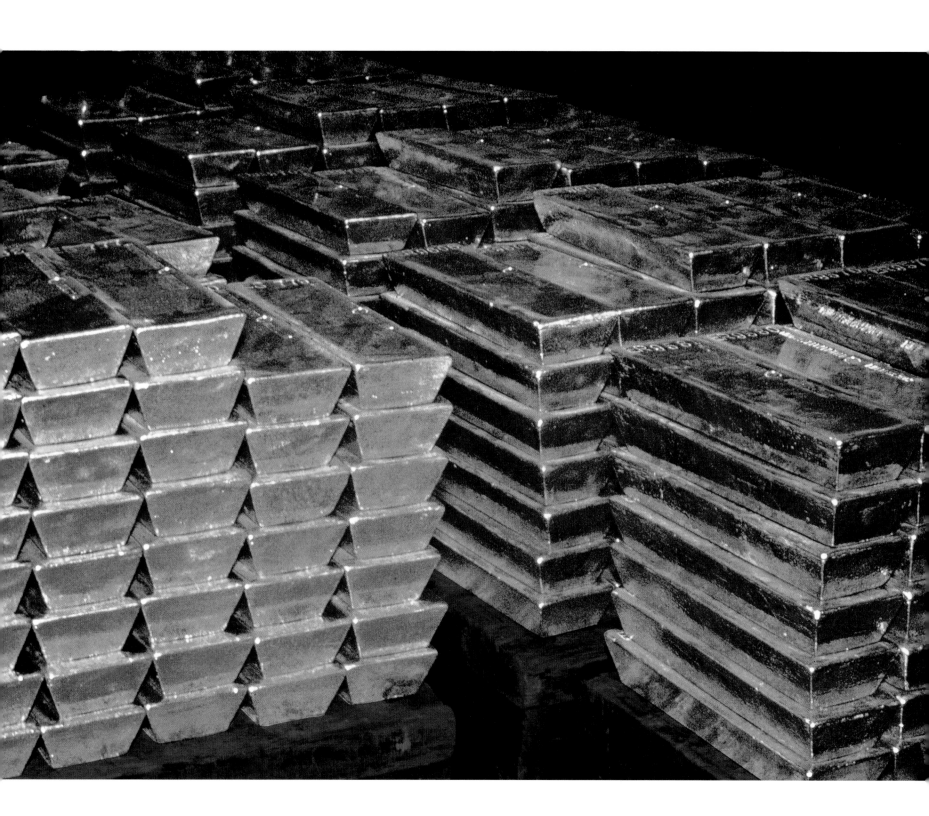

ALLOY
Combination of two or more metals.

AMALGAM
Alloy of mercury and gold used especially for fire gilding and, in mining, for separating gold from its accompanying stone.

CEMENTATION
Method of removing the silver from the gold-silver alloy in which gold is usually found in nature. Sustained heating of the alloy in a cement powder (salt and brick dust) at a temperature of about 1450–1650 degrees Fahrenheit (800–900°C) causes the silver to react with the salt to form silver chloride, and the gold is left behind.

CHAMPLEVÉ
Type of enamel decoration. A chisel is used to create depressions in a copper or bronze ground to hold the enamel paste. The metal parts that remain are gilded to emphasize the outline.

CHASING
Sculptural forming of metal by hammering.

CHISELING
Technique for producing detailed forms on metal surfaces using carving tools.

CIRE PERDUE
See *lost-wax casting*.

CLOISONNÉ
Type of enamel decoration. Slender, ductile bands or wires of gold are applied to a gold surface and filled with enamel paste.

DAMASCENING
Decorative technique in which a strip of softer metal is hammered into an engraved groove in another metal. The surface is then smoothed and polished, resulting in a charming contrast of colors between the different metals (gold wire in iron, for example).

ELECTROFORMING
Method for producing gilded copies of metal objects. A negative form of the object to be copied is used to make a conductive positive plaster impression, which is hung in an electrolytic bath with a metallic salt solution. When an electrical circuit is created between the cathode (the object to be gilded) and anode (the sheet gold), a gold coating is deposited on the plaster object at the cathode.

ENAMELING
Decoration of metal objects using glass pastes (mixtures of sand, soda, and limestone) that have been colored with metal oxides and melt like glass when heated. See also *champlevé* and *cloisonné*.

ENGRAVING
Technique for producing even, deep furrows in a metal surface with burins of various types.

ETCHING
Process in which an etching agent (an acid, alkaline solution, or other aggressive chemical) is used to corrode and thereby partially dissolve a metal object.

FILIGREE
Term used by goldsmiths to designate soldered wires that are attached to a metal base, with or without forming a bond, as ornament.

FIRE ASSAY
Process for determining the gold and silver content of ores and metals. The sample to be tested is heated to about 1800 degrees Fahrenheit (1000°C) in a crucible to which molten lead is added. The precious metals in the sample become concentrated in the lead. In a further step, they are isolated from the lead in order to be weighed.

FIRE GILDING
Gilding process using gold *amalgam*. An amalgam paste applied to an object is heated to about 750 degrees Fahrenheit (400°C), at which point the mercury evaporates, and the gold is left behind as a coating.

FORGING
Shaping metal with tools for hammering or pressing. A distinction is made between free-form forging and forging with or in a form (die).

GILDING
Coating of surfaces with a thin layer of gold. The simplest method is to apply gold leaf or foil, usually after roughing up the surface to which the gold is to adhere; organic adhesives are also common. Extremely fine gold powder can also be applied to a surface covered with an adhesive. See also *fire gilding*.

GOLD DOUBLÉ
Rolling together of two metal plates, one of which is gold. See also *plating*.

GRANULATION
Decorative technique in which small metal pellets (grains) of gold are attached to metal surfaces in ornamental or figural arrangements by means of metallic bonding.

KARAT
Unit of measure for the purity (gold content) of a gold alloy. An alloy of $^1/_{24}$ gold has one karat; pure (100 percent) gold has twenty-four karats.

LEACHING
Removal of metal from ores using suitable fluids, such as cyanide solutions in the cyanide leaching of gold ores.

LOST-WAX CASTING
Casting process in which a wax model is produced and then embedded in several layers of wet clay. After this clay shell has dried, it is carefully heated to melt out the wax and harden the now-hollow form. Molten metal is poured into the form, producing an accurate reproduction of the original model. When the cast object inside it has cooled, the form, which can be used only once, is broken off.

NIELLO
Ornamentation of metal objects by means of an alloy of sulfur, silver, copper, lead, and borax. It is placed in powder form into engraved or scratched lines and heated together with the base until the alloy melts and fills the engraved lines evenly. After grinding and polishing, the black niello contrasts with the metal (gold or silver) ground.

PLACER
Mass of sand or gravel containing precious metals, especially gold, that can be extracted.

PLATING
Covering one metal with another, either by rolling the two sheets together or with solder as an intermediate layer, so that both metals form an inseparable, uniform whole. See also *gold doublé*.

PUNCH
Metal die with an engraved motif or lettering. Punching this stamp against another metal that is less hard than the die transfers (imprints) the motif.

REPOUSSÉ
Technique for creating relief decorations in gold. Hammers, punches, or metal and stone styli are used to impress a predrawn pattern on the back side of a sheet of gold that is lying on a mat of putty, resin, or lead.

ROASTING
Heating ores in air to remove certain undesirable elements, like sulfur.

SHAKUDO
Alloy of copper and gold that is common in Japan, ranging in color from reddish gray to purplish black.

SOLDERING
Joining two metal parts by means of a third—the solder—which has a lower melting point than the other two. With an appropriate tool (a soldering iron), the molten solder is placed between the metal parts to be joined so as to produce a durable bond.

STAMPING
Cutting forms from sheet metal using pressure. A stamping tool has sharp cutting edges in the outline of the form to be stamped out.

SURFACE ENRICHMENT *or* SURFACE DEPLETION
Removal of the baser metals from the surface layer of a gold-silver-copper alloy by means of heating and subsequent corrosion, in order to increase the surface layer's gold content.

WASHING
Extraction of particles and flakes of gold from sediment (placers) by swirling and rotating the sediment with water in a wash pan, so that the lighter impurities are washed away.

Ammerer, Gerhard, and Alfred St. Weiß, eds. *Das Tauerngold im europäischen Vergleich. Archäologische und historische Beiträge des Internationalen Kongresses in Rauris vom 7. bis 9. Oktober 2000.* Salzburg, 2001.

Anikin, Andrej. *Gold.* Berlin, 1987.

Bernstein, Peter L. *The Power of Gold: The History of an Obsession.* New York, 2000.

Berton, Pierre. *Klondike: The Last Great Gold Rush 1896–1899.* Toronto, 1986.

Biegel, Gerd, ed. *Das erste Gold der Menschheit. Die älteste Zivilisation in Europa.* Freiburg im Breisgau, 1986. Catalog of an exhibition at the Museum für Ur- und Frühgeschichte der Stadt Freiburg.

Biesty, Stephen, and Meredith Hooper. *Jagd nach dem Gold.* Hildesheim, 2002.

Bray, Warwick. *The Gold of El Dorado.* London, 1978. Catalog of an exhibition at the Royal Academy of Arts, London, and the American Museum of Natural History, New York.

Cauuet, Béatrice. *Les mines d'or gauloises du Limousin.* Limoges, 1994.

Derman, M. Uğur. *Siegel des Sultans. Osmanische Kalligrafie aus dem Sakip Sabancı Museum, Sabancı Universität, Istanbul.* Munich, 1999. Catalog of an exhibition at the Kulturstiftung Ruhr Essen/Villa Hügel Essen.

Éluère, Christiane. *Les secrets de l'or antique.* Paris, 1990.

Friedensburg, Ferdinand. *Gold.* Stuttgart, 1953.

Furger, Andres, and Felix Müller, eds. *Gold der Helvetier. Keltische Kostbarkeiten aus der Schweiz.* Zurich, 1991. Catalog of an exhibition at the Schweizerisches Landesmuseum Zürich.

Gilbert, Katharine Stoddert, Joan K. Holt, and Sava Hudson, eds. *Treasures of Tutankhamun.* New York, 1976. Catalog of an exhibition at the National Gallery of Art, Washington, DC, and the Metropolitan Museum of Art, New York.

Das Gold aus dem Kreml. Munich, 1989. Catalog of an exhibition at the Übersee-Museum Bremen.

Gopher, Avi, and Tsvika Tsuk. *Ancient Gold: Rare Finds from the Nahal Qanah Cave.* Jerusalem, 1991.

Graichen, Gisela, ed. *Goldfieber. Von den Minen der Skythen zu den Schätzen Timbuktus.* München, 2002.

Green, Timothy. *Die Welt des Goldes. Vom Goldfieber zum Goldboom.* Frankfurt am Main, 1968.

Gruber, Fritz. *Via Aurea. Wege des Tauerngoldes.* Salzburg, 2000.

Gutgesell, Manfred, et al. *Faszination Gold. Verheißung des Göttlichen. Fluch der Menschheit.* München, 2002.

Haaf, Ernst. *Sika Amapa—Gold aus Afrika.* Munich, 1974.

Hagenberg, Monika, ed. *Gold aus dem alten Peru. Die Königsgräber von Sipán.* Ostfildern-Ruit, 2001. Catalog of an exhibition at the Kunst- und Ausstellungshalle der Bundesrepublik Deutschland, Bonn.

Hurter, Silvia Mani. *Kaiser Roms im Münzporträt. 55 Aurei der Sammlung Götz Grabert.* Stuttgart, 2003.

Knape, Anita, ed. *The Magic of Gold in Life and Legend.* Stockholm, 1994.

Korea. Die Alten Königreiche. Munich, 1999. Catalog of an exhibition at the Kulturstiftung Ruhr Essen/Villa Hügel Essen.

Lehrberger, Gerhard, and Wilhelm Völcker-Janssen. *Gold in Deutschland und Österreich.* Korbach, 2002.

Martos, Manuel Castillo, and Mervyn Francis Lang. *Metales Preciosos. Union de dos Mundos. Tecnología, comercio y politica de la minería y metalurgía Iberoamericana.* Seville, 1995.

Meller, Harald, ed. *Der geschmiedete Himmel. Die weite Welt im Herzen Europas vor 3600 Jahren.* Stuttgart, 2004.

Mitchell, T. C. *The Treasure of the Oxus.* Zurich, 1989.

Morteani, Giulio, and Jeremy P. Northover, eds. *Prehistoric Gold in Europe: Mines, Metallurgy and Manufacture.* Dordrecht, 1995.

Nestler, Gerhard, and Edilberto Formigli. *Etruskische Granulation. Eine antike Goldschmiedetechnik.* Siena, 1993.

Ogden, Jack. *Jewellery of the Ancient World.* London, 1983.

Pernot, François. *L'Or.* Losange, 2004.

Quiring, Heinrich. *Geschichte des Goldes. Die Goldenen Zeitalter in ihrer kulturellen und wirtschaftlichen Bedeutung.* Stuttgart, 1948.

Radnoti-Alföldi, Maria, Ursula Hagen-Jahnke, and Joachim Weschke, eds. *Antike Goldmünzen in der Münzensammlung der Deutschen Bundesbank.* Frankfurt am Main, 1980.

Ramage, Andrew, and Paul Craddock. *King Croesus's Gold: Excavations at Sardis and the History of Gold Refining.* London, 2000.

Rickenbach, Judith. *Sicán. Ein Fürstengrab in Alt-Peru.* Zurich, 1997. Catalog of an exhibition at the Museum Rietberg Zürich in cooperation with the Peruvian Ministry of Culture.

Röhrig, Floridus. *Der Verduner Altar.* Vienna, 1955.

Roth, Christian. *Gold aus Irland. Gold-, Silber- und Bronzeschmuck dreier Jahrtausende.* Frankfurt am Main, 1981. Catalog of an exhibition at the Museum für Vor- und Frühgeschichte Frankfurt am Main.

Rudolph, Wolf. *A Golden Legacy: Ancient Jewelry from the Burton Y. Berry Collection at the Indiana University Art Museum.* Bloomington, IN, 1995.

Schadt, Hermann. *Goldschmiedekunst. 5000 Jahre Schmuck und Gerät von der Antike bis zur Gegenwart.* Stuttgart, 1996.

Schätze aus dem Kreml. Peter der Große in Westeuropa. Munich, 1991. Catalog of an exhibition at the Übersee-Museum Bremen.

Stöver, Ulla. *Aurum—Geschichte und Geschichten um Gold.* Munich, 1973.

Vilar, Pierre. *Gold und Geld in der Geschichte. Vom Ausgang des Mittelalters bis zur Gegenwart.* Munich, 1984.

Wamser, Ludwig, and Gerhard Rupert, eds. *Gold. Magie Mythos Macht. Gold der Alten und Neuen Welt.* Stuttgart, 2001. Catalog of an exhibition at the Archäologische Staatssammlung–Museum für Vor- und Frühgeschichte München.

Winkelmann, Heinrich. *Altjapanischer Goldbergbau.* Wethmar, 1964.

Wolters, Jochem. *Der Gold- und Silberschmied. Werkstoffe und Materialien.* Stuttgart, 1981.

———. *Die Granulation. Geschichte und Technik einer alten Goldschmiedekunst.* Munich, 1983.

Ziegaus, Bernward. *Der Münzfund von Großbissendorf. Eine numismatisch-historische Untersuchung zu den spätkeltischen Goldprägungen in Südbayern.* Munich, 1995. Catalog of an exhibition at the Prähistorischen Staatsammlung München.

42. Bronze disk, Nebra, Saxony-Anhalt, Germany, twelfth century BC; bronze with gold appliqué, diameter: c. 12⅝ in. (32 cm). Landesmuseum für Vorgeschichte, Halle.

CHAPTER 2.
EGYPT

43. Mask of Tutankhamun, Thebes West, Valley of the Kings, tomb of Tutankhamun, New Kingdom, Eighteenth Dynasty, 1334–1325 BC; chased and polished gold, lapis lazuli, semiprecious stones, faience, height: 21¼ in. (54 cm), width: 15⁹/₁₆ in. (39.5 cm). Egyptian Museum, Cairo.

44. Map of the Wadi Hammamat, New Kingdom, Twentieth Dynasty, 1151–1145 BC; papyrus fragment, height: 16⅛ in. (41 cm), length: 27¹⁵/₁₆ in. (71 cm). Museo Egizio, Turin.

45. Diadem of Sit-Hathor-yunet, Dahshur, tomb area of Sesostris II, tomb of Princess Sit-Hathor-yunet, Middle Kingdom, Twelfth Dynasty, 1842–1779 BC; gold, lapis lazuli, carnelian, green faience, height: c. 17⁵/₁₆ in. (44 cm), width: 7⁹/₁₆ in. (19.2 cm). Egyptian Museum, Cairo.

46. Horus falcon with asp and feather crown, Nekhen (Hierakonpolis), Old Kingdom, Sixth Dynasty, c. 2345–2181 BC; chased gold, eyes of obsidian, height: 13⅞–14¾ in. (35.3–37.5 cm). Egyptian Museum, Cairo.

47. Pectoral of King Sesostris II, Dahshur, tomb area of Sesostris II, tomb of Princess Sit-Hathor-yunet, Middle Kingdom, Twelfth Dynasty, 1842–1779 BC; gold with inlay of carnelian, lapis lazuli, and turquoise, height: 2¹/₁₆ in. (5.2 cm). Egyptian Museum, Cairo.

48. Pectoral, Thebes West, Valley of the Kings, tomb of Tutankhamun, New Kingdom, Eighteenth Dynasty, 1334–1325 BC; sheet gold with inlay of colored glass paste and semiprecious stones, width and height: c. 5⁵/₁₆ in. (13.5 cm). Egyptian Museum, Cairo.

49. Tutankhamun with harpoon, Thebes West, Valley of the Kings, tomb of Tutankhamun, New Kingdom, Eighteenth Dynasty, 1334–1325 BC; gilded wood, sandals, harpoon, rope, and asp of bronze, height: 27⅜ in. (69.5 cm). Egyptian Museum, Cairo.

50. Gold necklace with fly pendants, Thebes, Dra Abu el-Naga, tomb of Queen Ahhotep I, Seventeenth to Eighteenth Dynasty, 1650–1550 BC. Egyptian Museum, Cairo.

51. Wooden shrine in the tomb chamber of Tutankhamun, historical photograph, c. 1927; height of shrine: c. 78 in. (198 cm).

52. Gold coffin of King Tutankhamun, Thebes West, Valley of the Kings, tomb of Tutankhamun, New Kingdom, Eighteenth Dynasty, 1334–1325 BC;

solid gold, carnelian, lapis lazuli, length: 72¹³/₁₆ in. (185 cm), thickness of walls: c. ⅛ in. (0.25–0.35 cm), weight: 243 lbs. 6 oz. (110.4 kg). Egyptian Museum, Cairo.

53. Throne of King Tutankhamun, Thebes West, Valley of the Kings, tomb of Tutankhamun, New Kingdom, Eighteenth Dynasty, 1334–1325 BC; gold and silver mounted on wood, with opaque glass and semiprecious stones, 40 × 21¼ × 23⅝ in. (102 × 54 × 60 cm). Egyptian Museum, Cairo.

54. Shrine of King Tutankhamun, Thebes West, Valley of the Kings, tomb of Tutankhamun, New Kingdom, Eighteenth Dynasty, 1334–1325 BC, wood sheathed with repoussé sheet gold, height: 19⅞ in. (50.5 cm). Egyptian Museum, Cairo.

55. Foot ring from the mummy of Psusennes I, Tanis, tomb 3, Third Intermediate Period, Twenty-first Dynasty, 1039–991 BC; gold, lapis lazuli, carnelian, diameter: 2⅜ in. (6.1 cm). Egyptian Museum, Cairo.

56. Small sculpture or pendant, dedicated to Osorkon II, Third Intermediate Period, Twenty-third Dynasty, 874–850 BC; gold, lapis lazuli, red glass, height: 3⁹/₁₆ in. (9 cm), width: 2⅝ in. (6.6 cm). Musée du Louvre, Paris.

57. Octadrachm, obverse: head of Berenice II, probably minted in Ephesus under Ptolemy III, 246–221 BC; gold, 1 oz. (27.73 g). Münzsammlung, Staatliche Museen zu Berlin.

CHAPTER 3.
THE ANCIENT NEAR EAST

58. Gold helmet of Prince (?) Meskalamdug, royal cemetery of Ur, Sumerian, end of the twenty-seventh century BC; maximum diameter: 9¾ in. (24.8 cm). Iraq Museum, Baghdad.

59. Map of the ancient Near East with the most important advanced civilizations of the second half of the second millennium BC.

60. Gold pendant, Susa, Persia, early Persian, 3300–3100 BC; ⁹/₁₆ × ⁹/₁₆ in. (1.5 × 1.38 cm), c. 0.1 oz. (2.3 g). Musée du Louvre, Paris.

61. Necklace, Ur, Sumerian, twenty-sixth to twenty-fourth century BC; gold with lapis lazuli and carnelian, length: 16⅛ in. (41 cm). Iraq Museum, Baghdad.

62. Beaker, Ur, Sumerian, twenty-fifth century BC; gold, height: 5⁵/₁₆ in. (13.5 cm), diameter: 2 in. (5 cm). Iraq Museum, Baghdad.

63. Gold dish, Ugarit, central Syria, fourteenth century BC; diameter: 6⅝–6¹¹/₁₆ in. (16.8–17.5 cm). National Museum, Damascus, Syria.

64. Seated divinity, statuette, Ugarit, central Syria, fourteenth century BC; gilded bronze, height: 5⁵/₁₆ in. (13.5 cm). National Museum, Damascus, Syria.

65. Necklace, Canaanite, 1550–1200 BC; gold with amethyst, rock crystal. Rockefeller Museum of Archaeology, Jerusalem.

66. Pendant, Tel al-Ajjul, Israel, Canaanite, fifteenth to thirteenth century BC; gold. The Israel Museum, Jerusalem.

67. Diadem, Alaca Höyük, Turkey, pre-Hittite, 2300–2100 BC; gold, diameter: 7⅝ in. (19.4 cm). Archaeological Museum, Ankara.

68. Vessel, Alaca Höyük, Turkey, pre-Hittite, 2300–2100 BC; gold, six carnelians attached with gold pins, height: 2⁵/₁₆ in. (5.8 cm). Archaeological Museum, Ankara.

69. Ewer, Alaca Höyük, Turkey, pre-Hittite, 2300–2100 BC; gold, height: 6 in. (15.3 cm). Archaeological Museum, Ankara.

70. Pendant, Yozgat, near Boğazköy, Turkey, Hittite, sixteenth to thirteenth century BC; solid gold, height: 1½ in. (3.9 cm). Musée du Louvre, Paris.

71. Pendant earring, Troy II, Heinrich Schliemann excavation, 2300 BC; replica: gilded silver. Museum für Vor- und Frühgeschichte, Staatliche Museen zu Berlin.

72. Sophie Schliemann wearing gold jewelry from the "Treasure of Priam"; colored photograph, 1882.

CHAPTER 4.
THE MINOANS AND MYCENAEANS

73. Vaphio cup (one of two), Laconia, Peloponnese, *tholos* tomb, Mycenae, 1500 BC; gold, repoussé, diameter: 4¼ in. (10.8 cm). National Archaeological Museum, Athens.

74. Minoan signet ring, Isopata, near Knossos, fifteenth century BC; gold. Archaeological Museum, Heraklion, Crete.

75. Rhyton, Mycenae, c. 1500 BC; sheet gold, chased, height: 7⅞ in. (20 cm). National Archaeological Museum, Athens.

76. Death mask of a warrior, Mycenae, second half of the sixteenth century BC; sheet gold, repoussé, height: 9¹³/₁₆ in. (25 cm), width: 10⅝ in. (27 cm). National Archaeological Museum, Athens.

77. Dagger with inlay decoration, Mycenae, sixteenth to fifteenth century BC; gold, silver, and niello, length: 9¹⁵/₁₆ in. (23.7 cm), width: 2½ in. (6.3 cm). National Archaeological Museum, Athens.

78. Oil vessel, Helladic, 2500–2000 BC; sheet gold, chased, height: 3⅞ in. (9.8 cm). Musée du Louvre, Paris.

PART II.
EUROPE IN THE FIRST
MILLENNIUM

CHAPTER 5.
THE EASTERN MEDITERRANEAN

79. Bracelet, Roccagloriosa, La Scala, tomb 9, Greek, first half of the fourth century BC; gold, diameter: 2⅝ in. (6.5 cm). Soprintendenza Archeologica, Salerno, Italy.

80. Phanes stater, minted in Ephesus (?), c. 630 BC; electrum, size: 0.63 × 0.95 in. (1.61 × 2.42 cm), weight: 0.5 oz. (14.3 g). Geldmuseum, Deutsche Bundesbank, Frankfurt am Main.

81. Stater (*kroiseios*) of King Croesus of Lydia, minted in Sardis, c. 550 BC; gold with seal, diameter: ½ in. (1.32 cm), weight: 0.28 oz. (8.11 g). Geldmuseum, Deutsche Bundesbank, Frankfurt am Main.

82. ¹⁄₉₆ stater, mint location unknown, c. 600–550 BC; electrum, diameter: ³⁄₁₆ in. (0.48 cm), weight: 0.006 oz. (0.18 g). Geldmuseum, Deutsche Bundesbank, Frankfurt am Main.

83. Chain with pendants, Hellenistic, late third to first century BC; gold, gold beads, garnets, length: 21⁵⁄₁₆ in. (54.1 cm). Indiana University Art Museum, Bloomington; Burton Y. Berry Collection.

84. Map of Greece, Asia Minor, and the Middle East, c. 500 BC.

85. Death mask, tomb chamber, Sindos, Greece, late sixth century BC; gold leaf on bronze (?). Archaeological Museum, Thessaloniki, Greece.

86. Gold death wreath, Armento, southern Italy, Greek, fourth century BC. Staatliche Antikensammlung und Glyptothek, Munich.

87. Diadem, Ginosa, Italy, Chiaradonna, Girifalco tombs, Greek, fourth century BC; gold filigree work, length: 12¹¹⁄₁₆ in. (32.2 cm). Museo Archeologico, Tarentum.

88. Earrings, Tarentum, Greek, late third century BC; gold, height: 2⅜ in. (6.1 cm). Private collection.

89/90. *Hektrolitron* (hundred liters), obverse: Artemis-Arethusa, reverse: Hercules fighting the Nemean lion, minted in Syracuse, Sicily, c. 413–406 BC, signed by Euainetos (c. 413–406 BC); gold, 0.2 oz. (5.8 g). Münzkabinett, Staatliche Museen zu Berlin.

91. Stater, obverse: head of Apollo, Macedonian, minted c. 336 BC under Philip II (359–336 BC); gold, 0.3 oz. (8.56 g). Münzkabinett, Staatliche Museen zu Berlin.

92. Stater, obverse: Pan, minted in Pantikapaion (now Kerch, on the Black Sea in Ukraine), 350–320 BC; gold, 0.32 oz. (9.10 g). Münzkabinett, Staatliche Museen zu Berlin.

93. Stater, obverse: head of Zeus with laurel wreath, minted in Lampsacus, Mysia, Asia Minor, 350–340 BC; gold, 0.3 oz. (8.41 g). Location unknown.

94. Decorative clasp, Letnitsa find, Bulgaria, Thracian, 400–350 BC; gilded silver, height: 2 in. (5 cm). Historical Museum, Lovech, Bulgaria.

95. Gold ring, Ezerovo, near Parvomai, Bulgaria, Thracian, late fifth century BC; gold, diameter: 1⅛ in. (2.7 cm), weight: 1.1 oz. (31.3 g). Archaeological Museum, Sofia.

96. *Rhyton*, Panagyurishte find, Bulgaria, Thracian, late fourth to early third century BC; gold, height: 4⅞ in. (12.5 cm). Archaeological Museum, Plovdiv, Bulgaria.

97. Ceremonial helmet, Poiana Cotofenesti, Romania, Thracian, c. fourth century BC; embossed gold, height: 9¹³⁄₁₆ in. (25.0 cm). Romanian National History Museum, Bucharest.

98. Beard comb, Solokha kurgan, steppe of the Dnieper region, Ukraine, Scythian, fifth to fourth century BC; gold, height: 4¹³⁄₁₆ in. (12.3 cm), width: 4 in. (10.2 cm). Hermitage, Saint Petersburg.

99. Plaque with tiger and wolf, Scythian, seventh to sixth century BC; gold relief, length: 6⅝ in. (16.8 cm), height: 3⅞ in. (9.9 cm). Hermitage, Saint Petersburg.

100. Shield decoration, Kelermes, northern Caucasus, Scythian, seventh to sixth century BC; gold, length: 12¹³⁄₁₆ in. (32.6 cm), height: 6⅜ in. (16.2 cm). Hermitage, Saint Petersburg.

101. Jewelry (brooch?), Zoeldhalompuszta, Hungary, Scythian, sixth to first century BC; gold, height: 9⅛ in. (23.0 cm). National Museum, Budapest.

102. Armlet, Oxus treasure, Takhti-Kobad, Tajikistan, Achaemenid, fifth to fourth century BC; cast and hammered gold, chased horns, width: 4⁹⁄₁₆ in. (11.57 cm), height: 5 in. (12.8 cm), thickness of the armlet (measured at the horns): 1¹⁄₁₆ in. (2.61 cm), weight: c. 12.8 oz. (364 g). British Museum, London.

103. Jewelry appliqué, Vettersfelde, near Guben (now Witaszkowo, Poland), Scythian, sixth century BC; gold, length: 16 in. (41 cm). Antikensammlung, Staatliche Museen zu Berlin.

104. Plaque from the Oxus treasure, Takhti-Kobad, Tajikistan, Achaemenid, fifth to fourth century BC; chased sheet gold, height: 5⅞ in. (15.0 cm), weight: 2.7 oz. (75.5 g). British Museum, London.

105. Double daric, obverse: Darius the Great with spear, bow, and quiver in so-called kneeling-running stance, minted in Babylon by Mazaios, satrap of Babylon, 331–328 BC; gold, diameter: ¹³⁄₁₆ in. (2.13 cm), weight: 0.59 oz. (16.68 g). Geldmuseum, Deutsche Bundesbank, Frankfurt am Main.

CHAPTER 6.
THE CELTS

106/107. Diadem, tomb of La Dame de Vix, Burgundy, Hallstatt period, 500 BC; solid gold, length: 8⅝ in. (22 cm). Musée Archéologique, Châtillon-sur-Seine.

108. Map of the areas of Celtic settlement.

109. Covering of a wooden drinking bowl, princely tomb of Schwarzenbach, near Sankt Wendel, Saar, Germany, c. 400 BC; hammered, punched, and chased ornaments (reattached by restorers), diameter: 4¹¹⁄₁₆ in. (12.0 cm), height: 3⁵⁄₁₆ in. (8.5 cm). Antikensammlung, Staatliche Museen zu Berlin.

110/111. Gold jewelry, princely tomb near Rheinheim, Germany, early fourth century BC; diameter of the torques: 6¹¹⁄₁₆ in. (17.2 cm), of the armlets: 3⁵⁄₁₆ and 2⁵⁄₁₆ in. (8.4 and 6.8 cm). Landesmuseum für Vor- und Frühgeschichte, Saarbrücken.

112. Torques and necklaces, Ribitäler, near Erstfeld, Canton of Uri, Switzerland, probably around 300 BC; solid gold, total weight: 22.6 oz. (639.8 g). Schweizerisches Landesmuseum, Zurich.

113. Possible interpretations of the gold finds of Erstfeld (plate 112).

114. Decorative disk, Auvers-sur-Oise, France, early fourth century BC; hammered sheet gold with filigree ornamentation and coral inlay on bronze plaque, diameter: 3⅞ in. (10 cm). Cabinet des Médailles, Bibliothèque Nationale, Paris.

115. Model of a ship, Broighter, Ireland, first century BC or first century AD; gold, length: 3⅞ in. (10 cm). National Museum of Ireland, Dublin.

116/117. Stater, obverse: head with ornamental hairstyle, reverse: running horse, from one of the first mints of the Parisii in Gaul, sixth to first century BC; gold, diameter: c. 1 in. (2.5 cm). Moravian Museum, Brno, Czech Republic.

118. Head of Apollo, coin of the Ambiani, northern Gaul, second century BC; gold, diameter: c. 1 in. (2.5 cm). British Museum, London.

119. Rainbow cups (gold coins), Grossbissendorf, Bavaria, location of mint unknown, c. 200–30 BC. Archäologische Staatssammlung, Museum für Vor- und Frühgeschichte, Munich.

162. Lion throne from the Myanmar palace, late nineteenth century AD; gilded wood, height of the altar proper: c. 41^{5}/$_{16}$ in. (105 cm). National Museum, Rangoon, Myanmar.

163. Reliquary figure, Tibetan, c. AD 1700; gold, gemstones. American Museum of Natural History, New York.

164. Buddha Shakyamuni, seated figure, Bhutan, mid-eighteenth century AD; fire gilded, height: 18^{1}/$_{8}$ in. (46 cm). Thimphu Dzong monastery, Thimphu, Bhutan.

165. Shwedagon Pagoda on Theingottara Hill, Rangoon, partial view, originally dating to the second half of the first century BC, alterations and expansions since the fifteenth century AD; gold, precious stones, height: 360 feet (110 m).

166. Dagger, Bhutan, twentieth century AD; silver with gold plate. National Museum, Paro, Bhutan.

167. Dagger hilt, Yimen, Shaanxi Province, China, eastern Zhou dynasty, 770–481 BC; gold, turquoise, glass paste, length: 5 in. (12.7 cm). Archaeological Mission, Baoji, China.

168. Embroidered dragon, formal garment of a mandarin, China, late seventeenth century AD; gold embroidery. Museum für Ostasiatische Kunst, Staatliche Museen zu Berlin.

169. Gold bowl, Hochia, Xi'an, Shaanxi Province, China, Tang dynasty, mid-eighth century AD; diameter: 2^{1}/$_{8}$ in. (5.5 cm). Present whereabouts unknown.

170. Horse, Wudi, mausoleum, anonymous tomb no. 1, western Han dynasty, c. 130 BC; gilded bronze, size: 24^{7}/$_{16}$ × 29^{15}/$_{16}$ in. (62 × 76 cm), weight: 64 lbs. (29 kg). Maoling Museum, Maoling, China.

171. Crown, Korean, Silla empire, second half of the fifth century AD; gold with jade jewels, height: 12^{13}/$_{16}$ in. (32.5 cm), diameter: 7^{7}/$_{8}$ in. (20 cm). National Museum, Kyŏngju, Korea.

172. Helmet, Korean, Silla empire, second half of the fifth century AD; gold, height: 6^{3}/$_{4}$ in. (17.2 cm), width: 6^{15}/$_{16}$ in. (17.6 cm), weight: 5.5 oz. (155 g). National Museum, Kyŏngju, Korea.

173. Kinkakuji (Golden Pavilion), Rokuon-ji Temple, Kyoto, fourteenth century AD; gold leaf.

174. Fan of the shogun Hideyoshi, sixteenth century AD. Castle Museum, Osaka.

175. Garment of the shogun Hideyoshi, sixteenth century AD. Castle Museum, Osaka.

176. Japanese gold coins (oban), probably minted in Aikawa on Sado Island, seventeenth century AD; c. 5.8 oz. (165 g). State Coin Museum, Osaka.

177. Tsuba, Japanese, nineteenth century AD; shakudo alloy with gold, silver, and copper damascene. Musée des Arts d'Extrême-Orient, Collections Baur, Geneva.

178. Gold painter in Kyoto.

179. Square Japanese lacquerware box, c. 1700; gold lacquer, box: 2^{3}/$_{8}$ × 4^{13}/$_{16}$ × 4^{7}/$_{16}$ in. (6.1 × 12.2 × 11.2 cm), tray: 9/$_{16}$ × 4^{9}/$_{16}$ × 4^{3}/$_{16}$ in. (1.4 × 11.6 × 10.7 cm), inner boxes: 15/$_{16}$ × 2^{1}/$_{4}$ × 2 in. (2.4 × 5.6 × 5.1 cm) each. Musée National des Arts Asiatiques–Guimet, Paris.

CHAPTER 11.
THE NEW WORLD

180. Tumi, Sicán culture, tenth to fifteenth century AD; gold. Museo Nacional de Arqueología, Antropología e Historia del Perú, Lima.

181. Necklace, Mayan culture, Iximiché, Chimaltenango, Guatemala, tomb 27, AD 1200–1500; gold, length: 10^{5}/$_{8}$ in. (27 cm). Museo Nacional de Arqueología y Etnología, Guatemala City.

182. Gold pendant depicting the god Xipe, Mixtec culture, Yanhuitlan, Mexico, AD 800–1500. Museo Nacional de Antropología, Mexico City.

183. Chronology, by geographical area, of the pre-Columbian cultures discussed in this chapter.

184. Map of Central and South America indicating the locations of the pre-Columbian cultures discussed in this chapter.

185. Pectoral, Tairona culture, AD 900–1600; tumbaga, 4^{1}/$_{8}$ × 4^{7}/$_{16}$ in. (10.6 × 11.3 cm). Museo del Oro, Bogotá.

186. Earrings, Sinú culture, AD 900–1530; gold, height: 1^{15}/$_{16}$ in. (5 cm), width: 2 in. (5.1 cm). Museo del Oro, Bogotá.

187. Earring, Tairona culture, AD 900–1600; tumbaga, height: 1^{5}/$_{8}$ in. (4.2 cm), width: 3^{1}/$_{16}$ in. (7.8 cm). Museo del Oro, Bogotá.

188. Three tunjos, Muisca culture, AD 650–1550; gold, 5^{1}/$_{2}$ × 1 in. (14 × 2.6 cm), 6^{1}/$_{4}$ × 1 in. (15.9 × 2.6 cm), 5^{5}/$_{16}$ × 1^{1}/$_{8}$ in. (13.5 × 2.8 cm). Museo del Oro, Bogotá.

189. Pectoral, Popayán culture, c. AD 100–1500; tumbaga, height: 3^{1}/$_{16}$ in. (7.7 cm). British Museum, London.

190. Theodor de Bry, How the Emperor of Guyana Groomed His Noblemen When He Had Them as Guests, 1599; engraving.

191. Lake Guatavita in Colombia, from a sketch by Alexander von Humboldt in his travelogue Vue des Cordillères, Paris, 1810–15; aquatint.

192. Tunjo, Muisca culture, AD 650–1550; gold, c. 11^{3}/$_{16}$ × 7^{7}/$_{8}$ × 7^{7}/$_{8}$ in. (30 × 20 × 20 cm). Museo del Oro, Bogotá.

193. Pectoral, early Calima style, first to twelfth century AD; sheet gold, 8^{3}/$_{4}$ × 11 in. (22.3 × 28 cm). Museo del Oro, Bogotá.

194. Gold pendant or pectoral, Tolima culture, AD 500–1000; gold. Museo del Oro, Bogotá.

195. Lime holder, Quimbaya culture, AD 200–1000; tumbaga, 10^{1}/$_{4}$ × 4^{1}/$_{8}$ × 3^{1}/$_{8}$ in. (26 × 10.5 × 8 cm). Ethnologisches Museum, Staatliche Museen zu Berlin.

196. Pectoral, Tolita culture, 300 BC–AD 500; gold and platinum, diameter: 3^{3}/$_{4}$ in. (9.5 cm), thickness: 3/$_{16}$ in. (2 cm). Museos Arqueológicos del Banco Central del Ecuador, Quito.

197. Pendant, Tolita culture, 500 BC–AD 500; gold and platinum. Museos Arqueológicos del Banco Central del Ecuador, Quito.

198. Bird, northern coast of Peru, Moche culture, AD 200–650; gold with turquoise inlay. Private collection.

199. Emblem, tomb of the Señor de Sipán, Peru, northern coast, Moche culture, c. AD 260; gilded copper, turquoise, 16^{3}/$_{4}$ × 27^{9}/$_{16}$ in. (42.5 × 70 cm). Museo Arqueológico Nacional Brüning, Lambayeque, Peru.

200. Mummy mask, Chimú culture, c. AD 1200–1450; sheet gold, 9^{7}/$_{16}$ × 12^{5}/$_{8}$ in. (24 × 32 cm). Present whereabouts unknown.

201. Earring, tomb of the Señor de Sipán, Peru, north coast, Moche culture, c. AD 260; gold with turquoise; diameter: 3^{5}/$_{8}$ in. (9.2 cm). Museo Tumbas Reales de Sipán, Lambayeque, Peru.

202. Ceremonial crown, Sicán culture, c. AD 1000–1300; gold. Museo de Oro del Perú y Armas del Mundo; Fundación Miguel Mujica Gallo.

203. Cup, Sicán culture, ninth to tenth century AD; gold with cinnabar coloring, height: 4^{3}/$_{4}$ in. (12 cm). Linden-Museum, Stuttgart.

204. Mask, Inca culture, c. AD 1200–1530; sheet gold. Museo de la Nación, Lima.

CHAPTER 12.
AFRICA

205. Jewelry, Baule, Ivory Coast, nineteenth century AD; gold. Musée Barbier-Mueller, Geneva.

206. Earring, Fulbe, Mopti, Mali, late twentieth century AD; gold, length: c. 1^{1}/$_{4}$ –2^{3}/$_{4}$ in. (5–7 cm), weight: c. 3^{1}/$_{2}$ oz. (100 g). Museum für Völkerkunde, Frankfurt am Main.

207. Woman with flat gold earrings, Mali.

208. Gold disk with symbols of the sun, Ashanti, Ghana, nineteenth century AD; cast or chased gold, diameter: 8⁷/₁₆ in. (21.5 cm), thickness: ⁹/₁₆ in. (1.5 cm). British Museum, London.

209. Elephant brooch, Ashanti, Ghana, nineteenth century AD; gold, length: 3⁵/₁₆ in. (8.4 cm), width: 2¼ in. (5.7 cm). British Museum, London.

210. Weights for a gold scale, Akan, Ghana; brass. Musée National, Bediat Collection, Abidjan, Ivory Coast.

211. Pendant, Akan, Ghana; gold, 4⁵/₁₆ × 4 in. (11 × 10.6 cm). Musée National, Abidjan, Ivory Coast.

PART IV.
THE WESTERN WORLD FROM THE MIDDLE AGES TO THE PRESENT DAY

CHAPTER 13.
THE AGE OF MIGRATIONS AND THE EARLY MIDDLE AGES

212. Jewelry of the Frankish queen Aregund, Paris, Saint-Denis, tomb 49, Merovingian, last third of sixth century; gold, silver, garnets. Musée du Louvre, Paris.

213. Box of Theodoric, Merovingian, seventh century; gold, enamel, stones, gems, 5 × 2⅝ × 7¼ in. (12.7 × 6.6 × 18.4 cm). Abbey treasury, Saint Maurice, Switzerland.

214. Armlet, ring, and belt buckles, tomb of a man, Pouan-les-Vallées, Aube, France, third quarter of the fifth century; gold, garnets, diameter of bracelet: 3 in. (7.6 cm). Musée des Beaux-Arts, Troyes, France.

215. Sword hilts and scabbards, Tournai, Merovingian, fifth century; gold, garnets, cloisonné. Bibliothèque Nationale de France, Paris.

216. Water pitcher, Carolingian, ninth century; Persian or Sassanian enamel mounted on gold, cloisonné. Abbey treasury, Saint Maurice, Switzerland.

217. Bracteate, Asum, Skåne province, Sweden, Viking, c. 700; gold, diameter: 4¹³/₁₆ in. (12.3 cm). Statens Historiska Museum, Stockholm.

218. Votive crown, Guarrazar, Toledo province, seventh century; gold, gemstones, diameter: 8⅛ in. (20.6 cm). Museo Arqueológico, Madrid.

219. Hen with seven chicks, sixth century; gilded silver, rubies, emeralds, diameter: 18⅛ in. (46 cm). Museo del Duomo, Monza, Italy.

220. Reliquary box, ninth to tenth century; sheet gold hammered over a wooden core, precious stones, antique gems, beads, enamel, height: 6¹¹/₁₆ in. (17 cm), width: 7¹/₁₆ in. (18 cm). Sainte-Foy, Conques, France.

221. *Sainte-Foy*, French, ninth century; gold, precious stones, rock crystal, height: 33½ in. (85 cm). Sainte-Foy, Conques, France.

CHAPTER 14.
BYZANTIUM

222. *The Ladder of Divine Ascent*, Byzantine, twelfth century; painting on wood, 16⅛ × 11⁹/₁₆ in. (41 × 29.3 cm). Saint Catherine's Monastery, Sinai Peninsula, Egypt.

223. Solidus, obverse: Galla Placidia, minted in Ravenna, 425–29; gold, c. ⅞ in. (2.3 cm). British Museum, London.

224. Armlet and necklace with mid-sixth-century gold coins, Merovingian, Munich-Aubing, Bavarian tombs; gold, glass beads, coins: 0.053–0.09 oz. (1.5–2.56 g). Archäologische Staatssammlung, Museum für Vor- und Frühgeschichte, Munich.

225. Detail of a crown, Byzantine, 1042–50; gold, cloisonné, average height of the plaques: 3⁹/₁₆ in. (9 cm), average width: 1¾ in. (4.5 cm). Hungarian National Museum, Budapest.

226. Cruciform pendant, probably from Constantinople, Byzantine, tenth century; gold, champlevé, height: 2⁷/₁₆ in. (6.12 cm), width: 1³/₁₆ in. (3.09 cm), thickness: ⁵/₁₆ in. (0.87 cm). British Museum, London.

227. Death of the Virgin, Byzantine, detail of the *Pala d'oro* (retable of the Basilica di San Marco), tenth century; gold and silver panels, gems, pearls, cloisonné, height: 55⅛ in. (140 cm), width: 137¹³/₁₆ in. (350 cm). Basilica di San Marco, Venice.

228. *Staurothek*, reliquary for the True Cross, central field of lid, Byzantine, c. 965; gold, cloisonné, set precious stones, 18⅞ × 13⅜ × 2⅜ in. (48 × 34 × 6 cm). Diözesanmuseum, Limburg an der Lahn, Germany.

229. *Three Women at the Tomb*, Melisende Psalter, Ms. Egerton 1139, fol. 10r, Byzantine, c. 1131–44; illumination. British Library, London.

230. *Virgin with Child and Emperor John II Comnenus and His Wife, Irene*, Byzantine, 1118–22; gold mosaic, height: 8 ft. 1 in. (2.47 m), width: 14 ft. 7 in. (4.45 m). South Gallery, Hagia Sophia, Istanbul.

231. *The Last Supper*, early sixth century; gold mosaic. Upper gallery of the nave, San Apollinare Nuovo, Ravenna, Italy.

CHAPTER 15.
THE HIGH AND LATE MIDDLE AGES

232. Crown of the Holy Roman Emperor, Reichenau (?), c. 962, arch and cross from c. 1027; gold, enamel, precious stones, pearls, cloisonné, 6⅛ × 8¼ × 8¾ in. (15.6 × 20.9 × 22.2 cm). Kunsthistorisches Museum, Vienna.

233. Roger of Helmarshausen, portable altar, early twelfth century; oak, gilded silver, set stones, pearls, 6½ × 8⅜ × 13⅝ in. (16.5 × 21.2 × 34.5 cm). Erzbischöfliches Diözesanmuseum, Paderborn, Germany.

234. Shrine of Saint Elizabeth, west German, 1236–1249; gilded copper, set stones, 53⅛ × 73⅝ × 24³/₁₆ in. (135 × 187 × 63 cm). Elisabethkirche, Marburg an der Lahn, Germany.

235. Nicholas of Verdun and workshop, *Dreikönigsschrein* (Shrine of the Three Kings), short side, c. 1181–1230; gold and gilded silver, copper, and bronze, with precious stones and gems, filigree, cloisonné, champlevé, and *émail brun*, 60¼ × 43⁵/₁₆ × 86⅝ in. (153 × 110 × 220 cm). Cologne Cathedral.

236. Nicholas of Verdun and workshop, *The Angels of the Resurrection*, detail of the Verdun Altar, 1181; enamel, gilded copper, cloisonné, champlevé, c. 8 × 14 in. (20 × 35 cm). Stift Klosterneuburg, Austria.

237. Disk cross, first half of the twelfth century; cast copper, engraved and gilded, filigree, set stones, diameter: 16¼ in. (41.2 cm). Dommuseum, Hildesheim, Germany.

238. Reliquary cross, late eleventh century; wooden core, chased sheet gold and silver, precious stones, pearls, filigree, height: 8⁷/₁₆ in. (21.5 cm), width: 6⅞ in. (17.5 cm). Church of Saint Mauritz, Münster, Germany.

239. Cover for the *Codex aureus* of Freckenhorst, c. 1100; wooden lid, sheet gold, filigree, pearls, mother-of-pearl, stones, ivory, height: 8⅞ in. (22.6 cm), width: 6¹¹/₁₆ in. (17.5 cm). Staatsarchiv, Münster, Germany.

240. Reliquary bust of Charlemagne, German, donated 1349; gold, height: 34 in. (86.3 cm), width: 22½ in. (57.2 cm). Domschatzkammer, Aachen, Germany.

241. Paten and chalice, second quarter of the thirteenth century; chased, engraved, and gilded silver, filigree, precious stones, height of chalice: 7 in. (17.9 cm), diameter of paten: 6¹⁵/₁₆ in. (17.7 cm). Church of Saint Godehard, Hildesheim, Germany.

242. Interior of the dome of San Marco, twelfth century; gold mosaic. Basilica di San Marco, Venice.

243. Giotto di Bondone, *Stefaneschi Triptych,* Christ side, Old Saint Peter's, 1320–30; tempera on wood, central panel: 70 × 35 in. (178 × 89 cm), side panels, each: c. 66⅛ × 32⅝ in. (168 × 83 cm), panels of the predella, each: c. 17¾ × 32⅝ in. (45 × 83 cm). Pinacoteca Vaticana, Rome.

244. Eagle fibula, western German, c. 1000; gold, enamel, sapphire, cloisonné, height: 3⁵/₁₆ in. (10 cm), width: 3¹¹/₁₆ in. (9.3 cm). Mittelrheinisches Landesmuseum, Mainz, Germany.

245. Imperial orb, regalia of the Holy Roman Empire, late twelfth century; gold, precious stones, filigree, height: 8¼ in. (21 cm). Kunsthistorisches Museum, Vienna.

CHAPTER 16.
THE RENAISSANCE, THE BAROQUE, AND NEOCLASSICISM

246. Benvenuto Cellini, *Saliera,* 1540–43; gold, enamel, ivory, ebony base, 10¼ × 13³/₁₆ in. (26 × 33.5 cm). Kunsthistorisches Museum, Vienna.

247. Jan van der Straet, *Alchemy,* 1570; fresco. *Studiolo* of Francesco I, Palazzo Vecchio, Florence.

248. Order of the Golden Fleece, Burgundian, second or third quarter of the fifteenth century; gold, painted enamel, weight: 17⁵/₁₆ oz. (508 g). Kunsthistorisches Museum, Vienna.

249. Ruby glass, southern Germany, late seventeenth century; gilded silver setting by Johann Jebenz, Augsburg, height: 7⁹/₁₆ in. (19.2 cm). Museum für Angewandte Kunst, Frankfurt am Main.

250. Christoph Müller (attributed), gilded distillery oven for the alchemical experiments of the Landgrave Moritz of Hesse-Cassel, vines and grotesque by Hans Jacob Emk, c. 1600; bronze, fire gilded, height: 16¹⁵/₁₆ in. (43 cm), diameter: 25³/₁₆ in. (64 cm). Staatliche Museen, Kassel.

251. Alessandro Algardi, *Jupiter Hurls Lighting Bolts at the Titans,* second half of the seventeenth century, after a model prior to 1654; bronze, patinated and partially gilded, height: 44⅛ in. (112 cm). Musée du Louvre, Paris.

252. Hans Petzolt, large lidded goblet, Nuremberg, c. 1600; silver, chased, cast, chiseled, punched, gilded, height: 48¹³/₁₆ in. (124 cm), diameter of *cuppa:* 10¼ in. (26 cm). Kremlin armory, Moscow.

253. Giancristoforo Romano, medallion with portrait of Isabella d'Este, 1505; gold, precious stones, diameter: 1¹³/₁₆ in. (4.6 cm), weight: 3⅞ oz. (109.7 g). Kunsthistorisches Museum, Vienna.

254. Vessel of two nautilus shells, Florence (?), early seventeenth century; gold on nautilus shell. Museo degli Argenti, Florence.

255/256. *Zecchino* (sequin), obverse: lily of Florence with the name of Grand Duke Pietro Leopoldo of Tuscany, reverse: John the Baptist, patron saint of Florence, 1789; gold. Museo Nazionale del Bargello, Florence.

257. Quinten Massys, Erasmus medallion, 1519; gold. Bibliothèque Nationale de France, Paris.

258. Saint Peter's altarpiece, early sixteenth century; carved wood, gilded, height: 18 ft. (5.5 m), width: 25 ft. (7.5 m). Sankt Petri, Dortmund, Germany.

259. Monte del Fora, *Presentation of the Keys to Peter,* illuminated manuscript, Ms. 542, fol. 3v, 1515. Museo di San Marco, Florence.

260. Hans von Reutlingen, binding cover of the imperial Gospel, regalia of the Holy Roman Empire, c. 1500; silver, gilded, precious stones, 13⁹/₁₆ × 10¼ in. (34.5 × 26.1 cm). Kunsthistorisches Museum, Vienna.

261. *Skladen* with the icon of the Mother of God of Jerusalem, Moscow (?), first third of the seventeenth century; gold, silver, chased, engraved, gilded, precious stones, pearls, fabric, height: 10⅜ in. (26.3 cm), width (open): 14⅛ in. (36 cm). Kremlin armory, Moscow.

262. Monstrance of Louis XI of France, c. 1460; silver, gilded, 16⁹/₁₆ × 20¹³/₁₆ in. (42 × 53 cm). Sint-Martinuskerk, Halle, Belgium.

263. Putto on the pulpit, Wieskirche, Steingaden, Bavaria, Germany, built 1745–54 by Dominikus Zimmermann, with stuccowork by Johann Baptist Zimmermann.

264. Hall of Mirrors, Château de Versailles, France, gallery built beginning in 1678 by Jules Hardouin-Mansart, interior decoration, 1679–86, under the direction of Charles Le Brun.

265. Johann Melchior Dinglinger and Georg Friedrich and Georg Christoph Dinglinger, *The Court at Delhi on the Birthday of the Great Mogul Aurangzeb,* 1701–8; wooden core, gold, silver, steel, enamel, precious stones, rock crystal, pearls, lacquer, height: 22¹³/₁₆ in. (58 cm), width: 55⅞ in. (142 cm), depth: 44¹³/₁₆ in. (114 cm). Grünes Gewölbe, Staatliche Kunstsammlungen, Dresden.

266. Gilded domes of the Kremlin, Terem Palace, Moscow, 1680–81.

267. Czar's crown, workshops of the Kremlin, 1682; chased gold, rubies, sapphire, emeralds, tourmalines, carnelian, pearls, sable, height: 8 in. (20.3 cm), diameter: 24 in. (61 cm). Kremlin armory, Moscow.

268. Johann Ludwig II Biller and Johann Jakob Wald, gold service, Czarina Anna Ivanovna, Augsburg, c. 1736–40; gold, cast, chased, engraved. Hermitage, Saint Petersburg.

269. François-Honoré-Georges Jacob-Desmalter, imperial throne of Napoleon I, 1804; gilded wood, 48¹/₁₆ × 34¼ × 27⁹/₁₆ in. (122 × 87 × 70 cm). Musée du Louvre, Paris.

270. Sauceboat, 1809; Sèvres porcelain, gold paint. Museo delle Porcellane, Florence.

271. Ceremonial coach, known as L'Egiziana (the Egyptian), Turin, 1817. Palazzo del Quirinale, Rome.

CHAPTER 17.
THE MODERN AGE

272. Yves Klein, *Untitled Monogold (MG 11),* 1961; gold leaf on canvas, 29½ × 23⅝ in. (75 × 60 cm). Kunstsammlung Nordrhein-Westfalen, Düsseldorf, Germany.

273. *Panning for Gold in California,* woodcut, c. 1890.

274. Set of diamond jewelry: necklace, two hairpins, brooch, pendant, Germany, c. 1840; gold, pearls, rubies, emeralds, diameter of necklace: c. 5⁵/₁₆ in. (16 cm), central agrafe: 2¹/₈ × 2⅛ in. (5.3 × 5.5 cm), small agrafes: 1¼ × 1⅛ in. (3.2 × 3 cm). Kunstgewerbemuseum, Staatliche Museen zu Berlin.

275. Gold medal from the Olympic Games in Atlanta, 1996. Collections Musée Olympique, Lausanne, Switzerland.

276. Carl Fabergé, imperial jewelry box, c. 1900; gold, diamonds, enamel, 3¼ × 3⅜ × 1 in. (8.3 × 8.5 × 2.6 cm). Victoria & Albert Museum, London.

277. Tiffany & Company, *Adams Vase,* 1893–95; gold, amethysts, quartzes, spessartites, tourmalines, freshwater pearls, enamel, height: 19⁷/₁₆ in. (49.4 cm). Metropolitan Museum of Art, New York; Gift of Edward Dean Adams.

278. Golden Hall, town hall, Stockholm, 1923.

279. René Lalique, *Ophelia Brooch,* c. 1899–1900; gold, ⅞ × 1¾ in. (2.2 × 4.5 cm). Calouste Gulbenkian Museum, Lisbon.

280. Gustav Klimt, *The Kiss,* 1907–8; oil and silver and gold foil on canvas, 70⅞ × 70⅞ in. (180 × 180 cm). Österreichische Galerie Belvedere, Vienna.

281. Sylvie Fleury, *ELA 75/K, Easy. Breezy. Beautiful. (Nr. 6),* 2000; gilded shopping cart, mirrored pedestal, 32¹¹/₁₆ × 21⅝ × 37¹³/₁₆ in. (83 × 55 × 96 cm). Copyright © the artist; courtesy Galerie Eva Presenhuber, Zurich.

282. Pitcher, Elkington & Co., Birmingham, England, c. 1888; gold electroplating, height: 12⅜ in. (31.5 cm). Victoria & Albert Museum, London.

283. Michael Zobel, earrings, 1997; red gold, platinum, champagne diamonds, citrine (polished by Tom Munsteiner), diameter: 1⅜ in. (3.5 cm). Private collection.

284. Elisabeth Treskow, grape brooch, c. 1941; gold, diamonds, pearls, height: 2½ in. (6.4 cm). Schmuckmuseum, Pforzheim, Germany.

285. Georges Fouquet, triangular clip, 1936–37; gold, 1¾ × 2⁹⁄₁₆ in. (4.5 × 6.5 cm). Musées des Arts Décoratifs, Paris.

286. Hermann Jünger, necklace, 1963; gold, various precious stones, length of pendant: 2½ in. (6.3 cm). Schmuckmuseum, Pforzheim, Germany.

287. Cartier, bracelet, c. 1940; gold, length: c. 8 in. (21 cm). Private collection.

288. Giampaolo Babetto, bangle, 1988; gold, diameter: 2¹¹⁄₁₆ in. (6.9 cm), width: 2 in. (5.2 cm). Schmuckmuseum, Pforzheim, Germany.

289. Yasuki Hiramatsu, necklace, 1972; gold, fine gold, length of pendant: 11¹³⁄₁₆ in. (30 cm). Schmuckmuseum, Pforzheim, Germany.

290. Silke Knetsch and Christian Streit, earrings, 2005; gold, fine gold, engraved carnelians, yellow sapphires, length: 1⅛ in. (3 cm), width: ⅞ in. (2.3 cm). Private collection.

291. Gold bars in the treasury of the South African Reserve Bank.

292. Mario Pinton, *Bangle*, 1976; gold, diameter: 2¹³⁄₁₆ in. (7.1 cm). Schmuckmuseum, Pforzheim.

Numbers in *italic* refer to plates.

▷▷ 292. Mario Pinton, *Bangle*, 1976; gold, diameter: 2¹³/₁₆ in. (7.1 cm). Schmuckmuseum, Pforzheim.
 This gold bangle recalls ancient jewelry, and not by coincidence. Pinton, as the founder of the so-called Padua school, has had an enduring influence on the younger generation of Italian jewelers. He situates his design within a historical tradition that goes back to the greatest creations of ancient Rome and the Etruscans.

ILLUSTRATION CREDITS

The illustrations are from akg-images, Berlin, unless indicated otherwise below. The publisher made every effort to identify other owners of copyrights. Individuals and institutions who may not have been contacted but claim rights to the illustrations used are asked to contact the publisher. The numbers listed first below refer to plates; works illustrated on the timelines are indicated by page number and row.

1, 185–187, pp. 132–33, row 3, images 2, 8: Museo del Oro del Banca de la República, Bogotá, Colombia

3: Museum für Lackkunst, Münster

4, 40, pp. 32–33, row 1, image 8: bpk, Staatliche Museen zu Berlin, Stiftung Preußischer Kulturbesitz, Museum für Vor- und Frühgeschichte, II c 6068, photo: Klaus Göken; 109, 136, pp. 76–77, row 2, image 3, row 4, image 3: idem, Antikensammlung, photo: Ingrid Geske-Heiden; 123: idem, Antikensammlung, photo: Johannes Laurentius; 156, pp. 132–33, row 1, image 5: idem, Museum für Islamische Kunst, photo: Gudrun Stenzel; 195, pp. 132–33, row 3, image 6: idem, Ethnologisches Museum, photo: Dietrich Graf; 274: idem, Kunstgewerbemuseum, photo: Emil Funke

7, 9, 47, 48, 52, 54, 57, 58, 63, 67–69, 75, 88–93, 120, 134, 138–40, 142–44, 147–49, 179, 213, 218, 221, 223, 233, 235, 237–39, 241, 252, 261, 267, 268, pp. 32–33, row 2, images 4, 7, row 3, images 2, 5, 8, pp. 76–77, row 1, image 8, row 3, image 1, row 4, image 6, pp. 132–33, row 2, image 8, pp. 186–87, row 1, image 6, row 2, image 1, row 3, images 1, 4, 6: Hirmer photoarchiv, Munich

10, 208, 209: Ancient Art & Architecture Collection Ltd, Pinner; 204, pp. 132–33, row 3, image 11: idem, Prisma

12, 284, 286, 288, 289, 292, pp. 186–87, row 5, images 2, 3: Schmuckmuseum, Pforzheim, photo: Rüdiger Flöter, Pforzheim

13, 18, 19: Gerhard Lehrberger, Pfaffenhofen

14, 15: private collection; 17, 22, 23, 24, 26: idem, photo: Achim Bunz, Munich; 287: idem, photo: Jacques Boulay

16: Thomas Lautz, Geldgeschichtliche Sammlung Kreissparkasse, Cologne

20, 59, 84, 108, 122, 130, 161, 184: Heike Boschmann/Computerkartographie Carrle and Hirmer Verlag, Munich

28: Newmont Mining Corporation, Denver

29, 173, 175, 176, 178, pp. 132–33, row 2, image 7: © 2005 Resa Asarschahab, Hamburg

30: Umicore AG & Co. KG, Hanau

31, pp. 186–87, row 4, image 5: Staatliche Kunstsammlungen Dresden, Rüstkammer, photo: Jürgen Karpinski, Dresden; 265: idem, Grünes Gewölbe, photo: Jürgen Karpinski, Dresden

33, pp. 32–33, row 1, image 1: Varna Archaeological Museum

36, pp. 32–33, row 1, image 3: Staff Archaeological Officer in the Civil Administration of Judea and Samaria, photo © Israel Museum, Jerusalem

37, pp. 32–33, row 1, image 6: The Art Archive, London, British Museum; 85, pp. 76–77, row 1, image 3: idem, Archaeological Museum Salonica/

Dagli Orti (A); 133, pp. 76–77, row 4, image 1: idem, Dagli Orti; 169, pp. 132–33, row 2, image 4: idem, Genius of China Exhibition; 180: idem, Archaeological Museum Lima/Dagli Orti; 182: idem, National Anthropological Museum Mexico/Dagli Orti; 202, pp. 132–33, row 3, image 9: idem, Museo del Oro Lima/Dagli Orti; 271: idem, Dagli Orti

38, pp. 32–33, row 1, image 5: Amt für Archäologie des Kantons Thurgau (www.archaeologie.tg.ch), photo: Daniel Steiner

39: Ludwig Wamser and Gerhard Rupert, eds., *Gold. Magie Mythos Macht. Gold der Alten und Neuen Welt* (Stuttgart, 2001; catalog of an exhibition at the Archäologische Staatssammlung/Museum für Vor- und Frühgeschichte München), p. 58

42: Landesamt für Denkmalpflege und Archäologie Sachsen-Anhalt (LDA), photo: Juraj Lipták

50, pp. 32–33, row 2, image 2: Jürgen Liepe, Berlin

51: Griffith Institute, Oxford, OX1 2LG

74, pp. 32–33, row 4, image 4: Archaeological Museum of Heraklion, © Archaeological Receipts Fund

80, 82, 105, 145, pp. 76–77, row 1, image 1, row 4, image 2: Deutsche Bundesbank, Geldmuseum, Frankfurt am Main

83, pp. 76–77, row 1, image 9: © Indiana University Art Museum, Burton Y. Berry Collection, photo: Michael Cavanagh, Kevin Montague

86: Staatliche Antikensammlung und Glyptothek, Munich

112, pp. 76–77, row 2, image 4: photo Schweizerisches Landesmuseum, Zurich, photo-Nr. COL-6427

113: Andres Furger and Felix Müller, eds., *Gold der Helvetier. Keltische Kostbarkeiten aus der Schweiz* (Zurich, 1991; catalog of an exhibition at the Schweizerisches Landesmuseum Zürich), p. 21

119, 224, pp. 186–87, row 2, image 3: Archäologische Staatssammlung, Munich, photo: M. Eberlein

129, pp. 76–77, row 4, image 5: Site et musée romains d'Avenches, photo: Jürg Zbinden, Bern

131: Corbis, © Mimmo Jodice; 155, pp. 132–33, row 1, image 1: idem, © Annie Griffiths Belt; 174, pp. 132–33, row 2, image 5: idem, © Brooks Kraft; 291: idem, © Charles & Josette Lenars

135: Provinciaal Gallo-Romeins Museum, Tongeren, photo: Guido Schalenbourg

137: Verulamium Museum, Saint Albans Museums

141: Rheinisches Landesmuseum, Trier, photo: Th. Zühmer

146, pp. 76–77, row 4, image 4: Staatliche Münzsammlung, Munich, Hartwig Hotter

150, pp. 132–33, row 1, image 8: Topkapi Palace Museum, Istanbul

152, 153, 154, pp. 132–33, row 1, image 4: Münzsammlung der Universität Tübingen, Inv. Nr. GD6 E4, Inv. Nr. BB7D6, Inv. Nr. 96-37-26, photo: Lutz Ilisch

159, pp. 132–33, row 1, image 7: Sakip Sabancı Museum, Sabancı University, Istanbul

160, 162, 165, pp. 132–33, row 2, image 6: Achim Bunz, Munich

171, 172, pp. 132–33, row 2, image 3: National Museum, Kyŏngju, Korea

183: after Warwick Bray, *The Gold of El Dorado* (London, 1978; catalog of an exhibition at the Royal Academy of Arts, London, and the American Museum of Natural History, New York)

201, pp. 132–33, row 3, image 3: Museo Tumbas Reales de Sipán, Lambayeque, Peru

203: Linden-Museum, Stuttgart, photo: Anatol Dreyer, Stuttgart

207: Barbara Armbruster, Toulouse

219, pp. 186–87, row 1, image 3: Museo del Duomo di Monza e Biblioteca Capitolare

249: Museum für Angewandte Kunst, Frankfurt am Main

250: Staatliche Museen, Kassel

272: Kunstsammlung Nordrhein-Westfalen, Düsseldorf, photo: Walter Klein, Düsseldorf

272, 279, 285: © VG Bild-Kunst, Bonn, 2006

275: © CIO Collections Musée Olympique, Lausanne

276: V&A Images/Victoria and Albert Museum, London

277: Metropolitan Museum of Art, New York; gift of Edward D. Adams, 1904 (04.1); photo © 1989 Metropolitan Museum of Art

278: City Hall, Stockholm, photo: Ulf Börjesson

279: Calouste Gulbenkian Museum, Lisbon, photo: Reinaldo Viegas

281: © Sylvie Fleury, courtesy Galerie Eva Presenhuber, Zurich

282: Dominic Naish/V&A Images/Victoria and Albert Museum, London

283: Schmuckatelier Michael Zobel, Konstanz, photo: Fred Thomas

285: Les Arts décoratifs, Paris, photo: Laurent Sully Jaulmes

290: Silke Knetsch and Christian Streit, Freiburg im Breisgau, photo: Christoph Eberle